NAVAJO TEXTILES

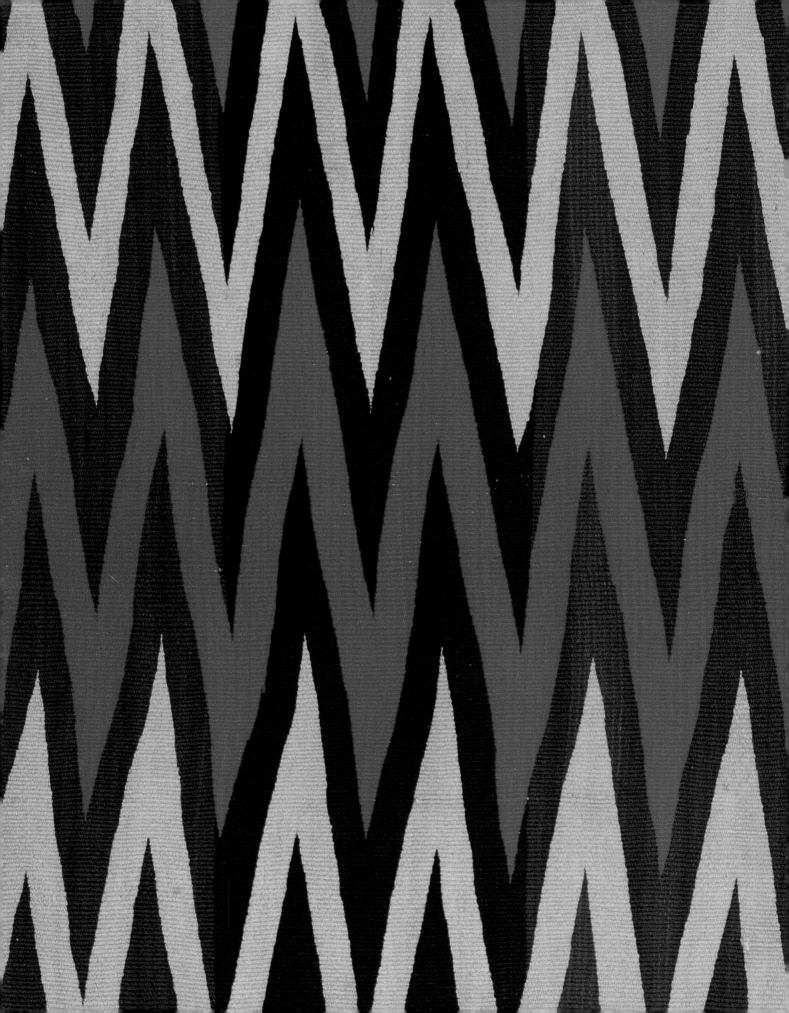

NAVAJO TEXTILES

The William Randolph Hearst Collection

Nancy J. Blomberg

The University of Arizona Press, Tucson

Published in conjunction with the exhibition:

ART FROM THE NAVAJO LOOM: The William Randolph Hearst Collection

Natural History Museum of Los Angeles County
March 25 to July 31, 1988

Made possible by the generous support of May Company, an anonymous donor, and The Chase Manhattan Corporation.

THE UNIVERSITY OF ARIZONA PRESS
Copyright © 1988
The Arizona Board of Regents
All Rights Reserved

This book was set in 10/13 Linotron 202 Trump Medieval.
Typeset by Tseng Information Systems, Inc., Durham, North Carolina
Printed by Toppan Printing Company Inc., Japan
Designed by Kaelin Chappell

Library of Congress Cataloging-in-Publication Data

Blomberg, Nancy J., 1946–
 Navajo textiles.

 Bibliography: p.
 Includes index.
 1. Navajo Indians—Textile industry and fabrics—
Catalogs. 2. Indians of North America—Southwest,
New—Textile industry and fabrics—Catalogs. 3. Hearst,
William Randolph, 1863–1951—Ethnographic collections—
Catalogs. I. Title.
E99.N3B56 1988 746.1'4'08997 88-4794
ISBN 0-8165-1078-4 (alk. paper)

British Library Cataloguing in Publication data are available.

To my parents Art and Helen Bastian

for the opportunity to learn

and to my husband Art

for the inspiration to persevere

Contents

Preface

~~~~~~~~~~~~~~~~~~~~~~~~~~~~~~~~~~~~~~~~~~~~~~~~~~~~~~~~~~~

The colorful product of the Navajo loom has long been an object of admiration. Tribes living adjacent to the Navajo in the eighteenth and nineteenth centuries coveted the tightly woven and elegantly patterned textiles as clothing. Increased Anglo contact in the nineteenth century brought a whole new set of admirers, including soldiers seeking souvenirs from their western campaigns, reservation traders eager to expand their businesses, eastern buyers desiring the unusual for their homes, anthropologists studying tribal peoples, museum curators collecting the material culture produced by these peoples, and avid collectors eager to own a beautiful and increasingly scarce commodity.

William Randolph Hearst, newspaperman and consummate collector, also appreciated the Navajo weaver's art. During the first portion of this century he assembled a remarkably complete collection of all of the major types of Navajo textiles woven between 1800 and 1920. Now housed at the Los Angeles County Museum of Natural History (LACMNH), the Hearst textiles are only one portion of a larger and mostly unpublished collection.

The study of Navajo weaving has progressed steadily since the scattered descriptive reports of the late nineteenth and early twentieth centuries up to Amsden's (1934) thorough treatment. Many notable scholars have taken up where Amsden left off to advance our knowledge considerably in this area. The serious student should refer to the bibliography for a full treatment of the history of Navajo weaving. The Hearst textiles are presented here in the context of this well-established framework of Navajo textile studies.

Chapter 1, which outlines Navajo weaving history, is intended to provide the layman with a background against which to view the economic and analytical chapters that follow. Chapter 2 documents Hearst's role as an important collector and patron of this art and places his efforts in a larger historical context. An investigation of his interaction with the famous Fred Harvey Company Indian Department and his relationship with its manager, Herman Schweizer, provides new insights about Hearst himself and also important economic information about the role of the consumer in the development and marketing of Navajo textiles. Chapter 3, the heart of the book, provides a detailed scholarly analysis of each textile.

A primary aim of this publication is to bring to the attention of both researchers and the general public this heretofore largely unknown resource. It is an inaugural effort to make the anthropological collections at LACMNH more accessible to scholars and more meaningful to the public at large.

# Acknowledgments

~~~~~~~~~~~~~~~~~~~~~~~~~~~~~~~~~~~~~~~~~~~

Credit and thanks must be given to dozens of people who have helped me in one way or another to complete this book. No work on Navajo textiles is written without the mark of the fine hand of Joe Ben Wheat. He is intimately familiar with this particular collection as well as being the foremost Navajo textile scholar. His critical comments, combined with David Wenger's dye analyses, have greatly enhanced this publication.

The final draft of this manuscript benefited enormously from the advice of Louis Hieb. His constructive criticism enabled me to rethink crucial sections to provide for a sharper economic and historical context.

Thanks also to Kathleen Whitaker, who spent many hours with me discussing Navajo weaving in general and numerous problem pieces in particular.

Byron Harvey III, great-grandson of the founder of the Fred Harvey Company, cracked the price codes established by Herman Schweizer and very graciously assisted me in the tedious process of ravelling the initial codes designating the collectors. His help was invaluable also in locating much primary source material about the company.

Barney H. Sievert, who worked for the Harvey Company Indian Department at Albuquerque in the 1920s and 1930s (and who was located with the help of Don Bennett), provided insight into the operations of the Harvey Company, their Indian Department, and Schweizer's relationship with Hearst.

I also owe thanks to Rick Smith, manager of Ortega's Indian Shop at La Fonda Hotel in Santa Fe, for allowing me access to boxes and boxes of Harvey Company business correspondence, especially those materials dealing with W. R. Hearst.

To all my colleagues in museums, special archives, and trading posts who answered my pleas for help, a very big thank you, especially to the following: Cindy Davies and Ann Marshall at the Heard Museum, Phoenix; Roberta Erickson, Corporate Historian for the Harvey Company/Amfac, Brisbane, California; Nora Fisher and Christine Mather, Museum of International Folk Art, Santa Fe; Denise Fourie, Nancy Loe, and Mary Weaver at the Special Collections Library of California Polytechnic State University, San Luis Obispo; Louis Hieb, head of Special Collections, University of Arizona Library, Tucson; Leif Johnson, Grand Canyon National Park Lodge; Jere Krakow, Southwest Missouri State University, Springfield; Ann Miller,

Hearst Historical Monument, San Simeon, California; Marian Rodee, Maxwell Museum of Anthropology, Albuquerque; Richard Salazar, State of New Mexico Records Center and Archives, Santa Fe; Conrad Sheffling and Donald Ungarelli, C. W. Post Center of Long Island University, Greenvale; Orlando Romero, Museum of New Mexico History Library, Santa Fe; and Tom Woodard, Gallup, New Mexico.

Within LACMNH I would like to acknowledge Charles Rozaire for expertise in weaving technology and for his patient and careful translations of many scribbled notes in Spanish found among the papers of Lorenzo Hubbell from his earliest textile suppliers.

A grateful thank you to my hardworking cadre of volunteers, who organized a small army of workers to assist in the unrolling, photographing, and rerolling of nearly two hundred weighty textiles. Thanks are also due Rita Lear and Renee Levin for tediously computing each and every price from the codes.

Thank you also to Dick Meier and John De Leon for stunning photography and to Terri Togiai for her patient and flawless typing of a very tediously formatted manuscript.

And last but not least, thanks to William Randolph Hearst, for without his collecting passion this book could not have been written, and to a very special patron (who prefers to remain anonymous), for without her generosity this book could not have been published.

NANCY J. BLOMBERG

NAVAJO TEXTILES

1. From Blanket to Rug

The Historical Development of Navajo Textiles

According to Navajo mythology, Spider Woman taught Navajo women to weave (Reichard 1934). Although scholars have not been able to put a precise date on the beginnings of Navajo loom weaving, evidence points to a time after the group's migration into the Southwest from the north, and most likely the second half of the seventeenth century. Similarities in looms and early designs, as well as historical evidence, suggest a Pueblo source.

Puebloan peoples had been raising cotton and weaving it into clothing on upright looms since A.D. 1100. When the Spaniards arrived in the Southwest in the sixteenth century, they brought churro sheep and introduced the concept of weaving their wool into cloth. After increasingly oppressive Spanish rule caused the Puebloan peoples to revolt, many Pueblo men and women left their villages to escape retaliation and found refuge among the Navajos. This close contact would have afforded the Navajos an excellent opportunity to learn weaving. Among the Pueblo groups it was traditionally the men who practiced weaving. If the two groups intermarried during the seventeenth century, Navajo women would have been able to observe closely and master the techniques of the Pueblo loom.

Speculation aside, Spanish documents (Hill 1940) describing the Navajos from 1706 to 1743 mention their weaving skills and the production of wool blankets. Furthermore, the documents tell of trade in these blankets to the Pueblos. The concept of trade infers a sufficient surplus to sustain the activity and a certain degree of weaving excellence to rank the blankets as a valuable commodity.

Scholars have divided the more than three centuries of Navajo weaving into many time periods for ease of analysis and description. For purposes of this book, I have used the broadest and most generally accepted outline:

> Classic Period (1650–1868)
> Transitional Period (1868–1890)
> Rug Period (1890–1920)

The reader should bear in mind that these dates are not absolute but rather represent a rough chronology with many instances of overlap between them.

The Classic Period (1650–1868)

During the Classic Period the Navajos wove utilitarian items of clothing such as blankets, shirts, dresses, and belts for their own use and for trade to

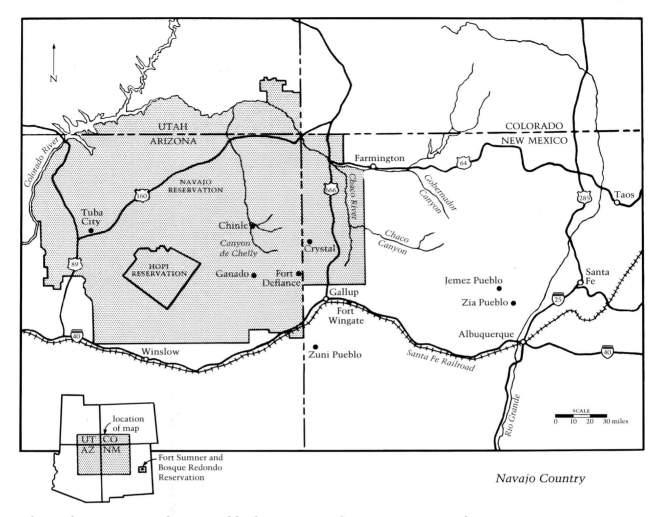

Navajo Country

other Indian groups. Early Navajo blankets were used as outer garments for protection from the elements. Tightly woven of wool, they provided warmth and shed water. This function was primary until exposure to western culture and clothing brought major changes. Although generally woven on the loom in a longer-than-wide rectangular shape, Navajo blankets were worn in exactly the opposite orientation, with the width across the shoulders and the ends joined in front.

The earliest Navajo textiles are known only from archaeological fragments excavated in the Gobernador Valley of northern New Mexico and date to the middle of the eighteenth century. These fragments, others found in Canyon de Chelly from the early nineteenth century, and references in miscellaneous Spanish documents all indicate that the material used was wool, the design was primarily stripes, and the weaving techniques included sophisticated diamond and diagonal twill as well as some plain tapestry (Kent 1985). Whole textiles that survive from the Classic Period are best represented by elegant serapes, the so-called chief's blankets, women's dresses, and some smaller, child's blankets.

Although the earliest Navajo textile fragments bear primarily a striped design, by the early nineteenth century the spectacular serape style was emerging. Inspired by the brightly colored and boldly patterned Saltillo serapes of Mexico, early Navajo serapes departed in shape and design from Pueblo-style wearing blankets. The Classic Period Navajo serape was characterized by designs of elaborately terraced zigzags and diamond motifs, a plain tap-

estry weave, and a red, blue, and white color scheme. Further, the weaving technique was highly refined.

During this period weavers augmented the natural white and brown colors of the wool with navy blue and vivid reds brought by the Spanish. The blue was obtained from indigo plant dye, and the red was available from commercially woven bolts of cloth, or *bayeta*. Unable to obtain bright red colors from local plants, the Navajos avidly sought to procure this bayeta and then tediously ravelled it, thread by solitary thread! Once apart, the thread was plied to produce a thickness equal to the weight of the other yarns to be used in the blanket, and then rewoven into the new textile. (Contrary to popular stories, this ravelled yarn was not obtained from the jackets of dead soldiers.) Reds with a blue or purple tinge generally were obtained from imported cloth. Later, orange-red shades were often ravelled from bolts of American flannel.

Dye studies conducted by Joe Ben Wheat and David Wenger have sought to determine the sources of dyestuffs used to produce the blue and purple reds. Preliminary results indicate the use of lac (obtained from resin deposited on trees by certain scale insects) prior to 1860. After that date, cochineal (obtained from the dried and pulverized bodies of small insects that feed on the opuntia cactus in Mexico) was the source. American flannel cloth of the late 1860s and 1870s was aniline-dyed.

Another type of yarn occasionally found in Classic Period textiles dating from 1840 to 1860 is referred to as *Saxony*. This commercially spun, three-ply yarn was manufactured in Europe and derives its name from the silky fleece of the Saxony-Merino sheep. Most often it appears in soft-colored vegetal dye shades of yellow and green.

One of the most widely recognized blanket types to emerge during the Classic Period was the so-called chief style, a very specific type of man's wearing blanket. The word *chief* is misleading, however, for the Navajos did not have tribal chiefs. Rather, these blankets were rare and valuable trade goods carried to adjacent and distant tribes over lengthy trade routes (Bennett 1981). Their purchase and use would have been restricted to persons of some wealth and achievement, hence the misnomer. Chief-style blankets were especially popular with the Ute Indians of the Great Basin and Plains. Historical records, which include the drawings of early artists and explorers such as Karl Bodmer, as well as documentation by later photographers, show Plains Indians proudly wearing these distinctly striped blankets.

Like the Pueblo wearing blanket, from which it no doubt evolved, the Navajo chief blanket was woven broader than long with wide horizontal stripe elements dominating the design. Over the course of the nineteenth century the design of this type of blanket evolved in very rigid and easily identifiable patterning phases. Navajo textile scholars have named and numbered these phases sequentially as first, second, third, and (sometimes) fourth.

The first phase is categorized by a simple combination of broad white, brown, red, and blue horizontal stripes and was woven during the first half of the nineteenth century. By 1850 innovations in this style were being seen as the weaver interrupted and expanded the center and end stripes by adding elongated rectangles in a twelve-position layout across the blanket. The broad white and brown bands then served as a background for the pattern bands of this second phase.

Within a decade the third phase in the development of the chief-style blanket was signaled by a shift from squares and rectangles to a nine-position

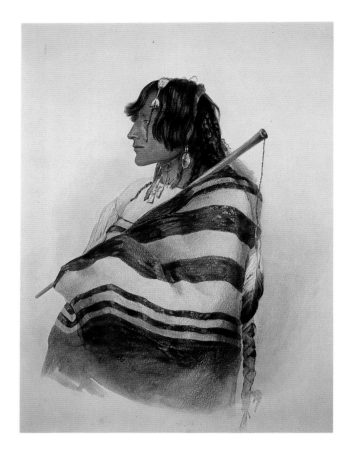

Piegan Blackfeet Indian wearing a Navajo first-phase, chief-style blanket. Watercolor by Karl Bodmer, 1833. Courtesy of the Joslyn Art Museum, Omaha, Nebraska.

layout of a central diamond, half diamonds along the four edges, and quarter diamonds in the corners. The same broad white and brown stripes were retained. Some scholars (Kent 1985) add a fourth phase toward the end of the nineteenth century, when the diamonds were made so large that they eventually completely overshadowed the horizontal stripes.

Another, even less-agreed-upon, category of chief-style blankets comprises those referred to in the catalogue as *variants*. Many blankets produced in a wider-than-long shape have the basic layout of groupings of broad white and brown/black horizontal stripes with associated patterning but do not fit a strict definition of the style.

Child's blankets, another category of Classic Period textiles, are distinguished from serapes largely on the basis of size. Often bearing the same terraced line and diamond patterning, they appear as miniature serapes from as early as the 1840s until well into the 1870s and 1880s. The design motifs, yarns, and dyes used in the child's blankets, as well as their degree of technical refinement, often rival those of later serapes.

In general, men's and women's shoulder blankets and dresses dominate Classic Period textiles. Pueblo and Spanish influences are evident in design format and textile shape, and new yarns and dyes begin to provide the basis for a more colorful textile. Technically, the Navajo weaver achieved a level of excellence seldom reached since, producing a functional blanket as well as a premier work of art.

The closing five years of the Classic Period, 1863 to 1868, were to change Navajo textiles and Navajo life forever. The United States government, weary of constant skirmishes with the so-called uncivilized Indians—meaning the Navajos—decided that the final solution to this problem was to remove them from their homes and land. To this end army troops led by Colonel Kit

Carson were ordered to round up members of the Navajo tribe and march them to Fort Sumner, New Mexico, near Bosque Redondo. Hundreds of miles from Navajo country, men, women, and children were forced to walk the entire distance with only what they could carry on their backs. During their devastating confinement and separation from their large herds, the army issued them American-style clothing and Mackinaw Indian blankets from the Hudson Bay Company. These five years of confinement were to prove watershed years for the Navajos.

The Transitional Period (1868–1890)

Technically, many of the textiles woven in this twenty-two-year period seem to be neither blankets nor rugs, thus giving rise to the name *transitional*. As the market began to shift from native to tourist consumption, the textiles also changed.

Exposure to new ideas and materials at Bosque Redondo permanently altered Navajo life. When finally allowed to return to their homes in 1868, the Navajos discovered the land overrun and their large herds destroyed. Government attempts at assistance proved inadequate to the needs of the Indians.

Shoulder blankets and dresses were no longer as indispensable to the Navajos as before Bosque Redondo, where they had become accustomed to American clothing. With sheep in short supply, the raw material available for weaving was limited, and the textiles woven in the years immediately following confinement reflect these shortages. Many small bits of yarn had to be gathered to complete a textile. The natural grey wool of the sheep was extensively used during the years immediately following Bosque Redondo. Another trait typical of the 1870s was the carding of natural white fleece with small amounts of ravelled yarn to produce a pink color. Overall, however, less native handspun yarn was being used, because commercial yarns were readily available, required no tedious processing, and came in a riot of colors.

Chemical or aniline dyes were invented in England in 1856 and quickly imported into America. Eastern yarn manufacturers switched to this new, cheaper dyestuff, which provided a wider and more vivid color palette. By 1865 three-ply yarns with these new dyes had reached the Navajos and by 1875 had been largely replaced by four-ply yarns of a slightly heavier weight. Textiles that were woven primarily from the new three- and four-ply commercial yarns are referred to as *Germantowns*, a name that reflects the Pennsylvania town where much of the yarn originated.

Designs were also changing, primarily in response to two factors: the Navajos' exposure to new design elements at Bosque Redondo and the beginning of a shift in function from blanket to rug. The serrate-edged motifs from Mexican serapes heavily influenced Navajo textiles, and a reorientation of the design layout from a horizontal to a vertical format began to occur.

Two new types of textiles developed during this period: the pictorial blanket, with design elements such as plants and animals, and the brightly colored and visually stunning eyedazzlers, which used commercial yarns in dizzying patterns. In addition, the Navajos began to be influenced by another factor—the reservation trader. Licensed by the United States government to provide services and supplies to the Indians, these traders became inextricably linked with the lives of the Navajos on several levels. When it came to textiles, traders provided new weaving materials and design ideas, as well as

helping to establish a new market. McNitt (1962) provides a fuller discussion of specific traders and their wide-ranging influence.

Economic life on the reservation was also changing. Prior to Bosque Redondo, the Navajo economy included hunting, gathering, herding, and farming. After 1868 and the gradual reestablishment of the flocks, herding became the primary occupation. Finally, the coming of the railroad in the 1880s and the opening of the West ended the relative isolation of the Navajos once and for all, and a new Navajo textile emerged.

The Rug Period (1890–1920)

Firmly entrenched on the reservation by this time, the traders played a crucial role in the development of the Navajo rug. At the urging of these traders, weavers gradually transformed the thin, tightly woven blankets into much heavier and thicker rugs suitable for use on the floors of Victorian homes. To accommodate the tastes of eastern buyers, the rugs were embellished with new patterns contained within borders for a more pleasing effect under furniture.

Many of these new designs were actually created by the traders, and others were inspired by motifs used in Oriental carpets and were a far cry from Classic Period blankets. One person who attempted to remedy this situation was J. L. (Lorenzo) Hubbell, the famous trader at Ganado, Arizona. He went to some lengths to urge his weavers to return to earlier traditions by selecting Classic Period designs that he wished the weavers to emulate and placing drawings of them conspicuously throughout his trading post. Hubbell's advertising to the general public touted his offerings of modern blankets woven with old patterns:

> I have been at the greatest pains to perpetuate the old patterns, colors and weaves, now so rapidly passing out of existence even in the memory of the best weavers.

> I have even at times unraveled some of the old genuine Navajo blankets to show these modern weavers how the pattern was made. I can guarantee the reproduction of these antique patterns. The next thing to possessing a genuine old blanket is owning one made exactly on the pattern of such blankets.

> The old blankets are passing away, in the nature of things. I can supply genuine reproductions of the old weaves.

The arrival of the railroad was also a key factor in changing the lives and textiles of the Navajos. The railroad brought traders and merchants, new materials and design inspiration, as well as new purchasers for the textiles. It also brought the Fred Harvey Company and its Indian Department, whose role in developing and enhancing this new market will be seen in the following chapter, and William Randolph Hearst, whose enthusiasm for Navajo textiles is the basis of this volume.

The railroad brought one segment of the market to the reservation. However, in order to reach that much larger portion of the population that could not travel west, key traders such as J. B. Moore at Crystal, New Mexico, published mail-order catalogues. Complete with photographs of weavers and rugs, price lists, and anecdotal stories about the designs, these catalogues added yet another dimension to the rug market.

Throughout this period weavers continued to experiment with new ma-

Plate XIX from a mail-order catalogue published in 1911 by J. B. Moore, owner of the trading post at Crystal, New Mexico. Textile A.5141.42-200 in the Hearst collection very nearly duplicates this original pattern. Courtesy of the Maxwell Museum, University of New Mexico, Albuquerque.

terials. Commercial cotton twine, originally introduced decades earlier as a time-saving substitute for handspun wool warp, was found to produce an inferior rug. Its use was strongly discouraged by most traders and was finally abandoned by 1900. When the practice was revived a few years later, Herman Schweizer, head of the Fred Harvey Company Indian Department, warned, in a letter of September 12, 1907:

> I learn that cotton warp blankets are again being made on the reservation in great quantities.
>
> When we started in the curio business several years ago, we made it a point to keep the general public informed in regard to cotton warp blankets, and succeeded to a great extent in killing the sale of this class of goods.
>
> When cotton string is used for warp, the blanket is not at all durable, as it breaks very easily, and as you know, when the warp in a blanket breaks, the blanket is worthless.
>
> Native wool blankets should be all wool, and I believe it is necessary that we must again keep this information before the public at all times, not only to protect our own interests, but in an endeavor to again stop as much as possible, the production of cotton warp blankets. . . .(Hubbell Papers)

Indigo dye, once so popular among the Navajos in the late eighteenth and nineteenth centuries, had largely disappeared from use by 1890. As the new consumer of the early twentieth century favored more somber and natural

whites, greys, and browns, the colorful Germantown yarns were also discarded.

Navajo weaving did not cease after 1920. Many developments have taken place since then which have led to the complex patterning and technical excellence found in modern Navajo textiles. These creative products of the Navajo loom are highly valued as art objects to adorn walls or as beautifully crafted rugs for floors.

2. From Consumer to Weaver

~~~~~~~~~~~~~~~~~~~~~~~~~~~~~~~~~~~~~~~~~~~~~~~~~~~~~~~~~~~~~~~~~

## *The Marketing of Navajo Textiles*

Over the years the flexible and innovative nature of the Navajo people has enabled them to adapt to ever-changing circumstances. When introduced to cultures and ideas different from their own, the Navajos have usually selected and adapted parts of each to their best advantage. Two crafts thought of by many people to be uniquely Navajo are weaving and silversmithing. Yet both were a direct result of contact with peoples who had already developed the techniques. However, as practiced by the Navajos, the execution, development, and refinement of each craft became distinctively their own.

In the roughly three centuries that the Navajos have been weaving, their lives have profoundly changed, largely due to external influences, and these changes are directly mirrored in their textiles. Unlike their Pueblo teachers, who wove primarily for ceremonial use and thus maintained conservative patterning, Navajo weavers produced for a very different, secular market. They began with simple horizontal stripes, progressed through elegant Classic Period serapes and chief-style blankets, dynamic Germantown eyedazzlers, whimsical pictorials, somber turn-of-the-century rugs, to the spectacular technical refinement of the late twentieth century. Each of these stages in weaving reflected the changing situation of the Navajo people and associated consumer demand. As new dyes and yarns became available and inspirations for new designs presented themselves, Navajo weavers eagerly experimented with an ever-changing product for the marketplace. Whatever the situation, the weaver has primarily responded to the needs and wants of the consumer.

The Changing Consumer

The earliest consumers of Navajo textiles were the Navajos themselves, but adjacent Indian tribes also used them whenever they could be acquired. The meager historical evidence indicates that handspun wool and striped patterning were relatively constant for the first century and a half of Navajo weaving. Native use and relative isolation resulted in a blanket that changed very little compared to its development in the following century and a half.

With the events of Bosque Redondo and the large-scale opening of the West, the consumer of Navajo textiles shifted from Indian to non-Indian. Although still influencing the weaver to a large degree, the new consumers

*William Randolph
Hearst. Courtesy of The
Hearst Corporation.*

were often far removed from the reservation. In order to reach this new market, the weaver often had to go through one or two levels of middleman: the local reservation trader and the more distant, big-city merchant or dealer. Or, conversely, with the consumer as controller, if you will, the consumer expressed his wants and needs to the merchant, who in turn passed them on to the trader, who interpreted these preferences to the weaver. This general pattern of marketing developed at the turn of the century in response to growing consumer demand for Indian goods as souvenirs and curios to decorate Victorian homes.

As a consequence of working through a middleman, the weaver generally produced for a consumer she rarely if ever saw and whose world was vastly different. Perhaps no greater contrast existed than the two lifestyles represented by the weaver and by William Randolph Hearst. Wealthy, well-educated, and worldly, Hearst collected omnivorously on his world travels. As we will see, the beauty of Navajo textiles captured his attention and caused him to include them among his collections of fine art.

## History of the Hearst Collection

Turn-of-the-century Arizona and New Mexico included uncounted numbers of weavers and traders. All across the country, merchants and collectors at many levels interacted eagerly and competitively in the Navajo textile market. The Hearst collection presents an excellent opportunity to examine closely the role of one consumer in the development and marketing of the textiles. Four levels of interaction in the process from loom to buyer are clearly represented by this remarkable collection:

    (1) consumer (Hearst)

    (2) merchant (Fred Harvey Company)

    (3) reservation trader (Lorenzo Hubbell and others)

    (4) weaver

Surviving records relating to Hearst, Harvey, and Hubbell provide evidence of this chain of interaction. They also serve as a case study of the marketing of Indian goods at the turn of the century.

To many people William Randolph Hearst's name is synonymous with newspaper publishing. To others, the name brings to mind the magnificent castle atop the hill at San Simeon, lavishly filled with room after room of European antiquities. But few people know of his passion for collecting American Indian artifacts, most notably Navajo textiles. According to an early biographer, Mrs. Fremont Older, Hearst originally visualized the castle at San Simeon as a showplace for his Navajo textile collection: "In 1919, Hearst said to Miss Julia Morgan, the architect, that he would like to have plans drawn for a permanent camp of spacious, cool, comfortable concrete buildings with tiled floors, where he could place his large collection of Indian rugs" (Older 1936:529). Just exactly when and why Hearst changed his mind is not known, for the Navajo textiles apparently never assumed the place of prominence he once intended them to have. On the contrary, available records indicate that they spent the early part of this century in Hearst's vast warehouses at San Simeon.

Hearst's collection was built largely from the huge holdings of the famous Fred Harvey Company Indian Department. Extensive records are lacking from Hearst's end of the transactions, with surviving documents available only for a limited number of purchases. These documents do reveal, however, a fairly clear picture of the very substantial depth and direction of his buying habits as well as his patronage of the Fred Harvey Company Indian Department.

Hearst's first contact with the Harvey Company apparently came after he viewed a small temporary exhibit of Indian artifacts in Chicago with his mother, Phoebe Apperson Hearst, just after the turn of the century. Not wanting to sell artifacts out of an advertising display, Herman Schweizer, manager for the Harvey Company, wrote to Hearst on December 31, 1905, explaining that "the first object in establishing this exhibit was to furnish an attraction for the Santa Fe [Railroad] . . . to bring people who wanted to see or purchase them over the Santa Fe . . . and to further give people an idea of what there was here [in Albuquerque]." Although the exhibit was never intended to be a retail outlet an exception was made to accommodate the Hearsts and a forty-year association began.

As with his newspaper interests, Hearst jumped into collecting Indian artifacts wholeheartedly. Although he had developed a reputation for being an omnivorous and indiscriminate collector of antiquities, his interests in Navajo textiles were fairly well directed, as analysis of surviving Fred Harvey Company correspondence reveals. Characteristically, Hearst bought from the Harvey Company in large quantities with the intention of amassing a great many artifacts: "I would be obliged if you would send me a considerable number of your best blankets" (n.d.), and "send me to New York any first class blankets, bridles other good things" (1912). The "considerable number" Hearst sought finally totaled more than two hundred southwestern textiles, often purchased in lots of ten to fifteen pieces. But quantity was not his sole objective, for he also sought quality, as the following excerpts from his letters to the Harvey Company reveal:

> I would like rarer and more interesting blankets. [n.d.]

> Send me a lot of first class blankets—the *real* things. There is no use of my describing them. You know what I want and you know that I know what is good. [n.d.]

Kindly send very best old blankets from the safe and the rack. [1913]

If you find any good bridles or good Hopie [sic] blankets or chiefs blankets or all Bazetta [sic] blankets or saddle blankets send them along. [1913]

Schweizer was obviously able to comply with these requests, for there are thirty-nine chief-style blankets in the Hearst collection as well as eighty-six containing "Bazetta" (ravelled) yarns and forty-two child's or saddle blankets. By 1915 the collection had grown to a sufficient size for Hearst to be more selective: "Of course, you know I have so many Indian things now that I only want the finest and rarest pieces. I do not mean that that is always the most expensive pieces, but those that have some unique character."

These unique characteristics are represented in Hearst's collection by such items as five variants of the standard chief-style blanket, three wedge weaves, one blanket with embroidered pile designs, and a dress made entirely from commercial cotton string. Seeking to round out his collection, composed primarily of Classic Period textiles, Hearst actively pursued unusual pieces: "In addition to sending me some fine blankets you might send some quaint and curious ones with odd designs or figures of men or animals. These add variety to a collection although they may not be of themselves particularly valuable." Nine textiles with some pictorial elements are in the Hearst collection.

An extremely busy man, Hearst frequently dashed off cryptic letters and telegrams to Schweizer. One quick note was penned in a shaky hand while Hearst was riding on the train just after leaving Albuquerque. Apparently he had decided on additional purchases and gave the following uncomplimentary description: "Send me on with the others . . . that pale faced aenemic looking blanket that was hanging on the rack."

An extremely powerful man, accustomed to having his way, Hearst chided Schweizer for not sending more rare blankets:

> I wired you to send me on to New York the blankets and some other things. Haven't you got some interesting stuff at the Canon. I will bet you two huge Mexican dollars that you haven't shown me your real treasures. Out with them now Mr. Schweitzer [sic] or I shall feel that I am not being treated fairly.

But Hearst was also aware that Schweizer was amassing a collection of his own for the Harvey Company. The "safe" that Hearst mentioned in one of his letters referred to the storerooms where Schweizer kept items he did not wish to sell. With great reluctance, he occasionally sold some of these pieces to Hearst. The Harvey Company retained the bulk of this collection over the intervening years, and it is now divided between the Heard Museum in Phoenix and the Museum of International Folk Art in Santa Fe.

Although technically not a part of the Fred Harvey Fine Arts Collection in Phoenix and Santa Fe, the Hearst collection at the Los Angeles County Museum of Natural History (LACMNH) could be considered an extension of the main collection. Hearst relied heavily on Herman Schweizer for his Indian material, for 158 out of a total of 186 textiles (85 percent) originated with the Harvey Company. Many other museums share the legacy of the Harvey Company Indian Department, as Schweizer actively worked with eastern and foreign curators to increase their collections.

The majority of Hearst's Navajo textiles came through Herman Schweizer and the Harvey Company, but exact selling dates and purchase prices are

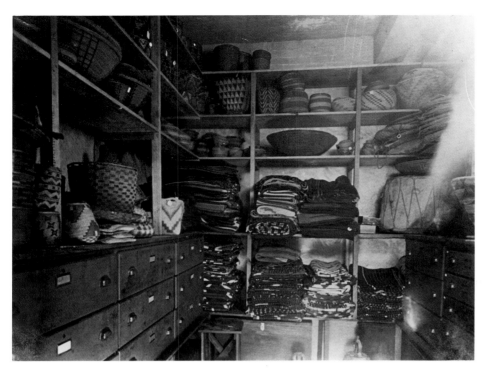

One of Schweizer's storerooms in the Indian Building in Albuquerque, where large stocks of textiles and baskets were kept. Courtesy of Special Collections, University of Arizona Library, Tucson.

available for only a few pieces. However, by examining bills of sales we can see that prices generally escalated until about 1913. For instance, according to Harvey Company correspondence, Blanket A.5141.42-27 was priced at $400.00 in 1911 and sold to Hearst for $600.00 just two years later, and Blanket A.5141.42-35, priced at $95.00 in 1903, was sold to Hearst for $440.00 in 1911. However, from about 1915 to 1917, prices often decreased: Blanket A.5141.42-54 was priced at $300.00 in 1908 and sold to Hearst for $262.50 in 1917, and Blanket A.5141.42-112, priced at $1,000.00 in 1903, was sold to Hearst for $750.00 in 1915. Perhaps the market in old textiles had declined by the late teens from its peak earlier in the century. Not enough data are available for a conclusive statement.

No matter what price Hearst was charged, Herman Schweizer had a difficult time collecting. Notoriously slow in paying his bills, Hearst had to be billed over and over again by the Harvey Company. Furthermore, Hearst repeatedly insisted on receiving a discount of twenty to twenty-five percent on all his purchases from the Harvey Company. He offered free advertising in his newspapers in exchange, but company officials declined the offer and Schweizer unwillingly continued the practice of discounting the merchandise to Hearst. (All prices paid by Hearst reflect the discount.)

Clearly, Hearst did amass a collection of "real treasures." The donation to LACMNH numbers more than two hundred southwestern textiles, primarily Navajo but also including some Rio Grande, Pueblo, and Saltillo pieces. It is a remarkably complete collection, spanning more than a century of Navajo weaving, and includes nearly every major type produced from 1800 to 1920.

In the late 1930s and early 1940s Hearst began to divest himself of portions of his huge holdings. In 1942 the Los Angeles County Museum of Natural History (then the Los Angeles Museum of History, Science and Art) re-

ceived a donation of 222 American Indian artifacts, the bulk of them Navajo textiles. The catalogue deals specifically with that portion of the donation.

## The Fred Harvey Company and Its Indian Department

Because of the extent of Hearst's interaction with the Fred Harvey Company Indian Department, the history of the Hearst collection is, in many ways, a history of the Harvey Company. Correspondence, company records, and ledger books (among many other sources) probed in search of information on the relationship between Hearst and the Harvey Company have revealed new evidence about the influential role that the company played in developing and sustaining consumer interest in Indian material, as well as about the marketing practices employed in both the buying and selling of these goods.

In an attempt to improve the deplorable food and lodging available to railroad passengers in the late nineteenth century, British immigrant Frederick Harvey persuaded the Santa Fe Railroad to allow him to establish a series of restaurants, hotels, and dining cars along its western route. An extension of that service was the Indian Department.

Established by J. F. Huckel in 1901 and managed thereafter by Herman Schweizer, the Indian Department was intended to be a tourist attraction for its parent company, the Santa Fe Railroad. Eager to increase ridership on western trains, railroad officials saw the department as a way to attract additional passengers and thereby boost revenues. Instead, through Schweizer's

*Herman Schweizer (right), and J. F. Huckel, sometime during the first decade of the twentieth century. Courtesy of Special Collections, University of Arizona Library, Tucson.*

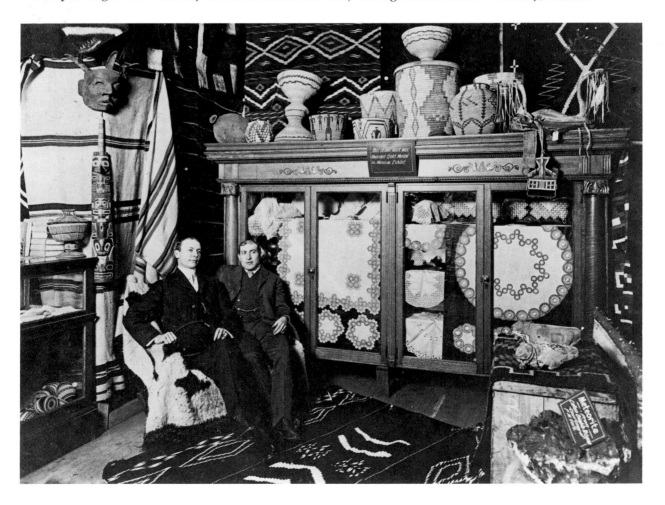

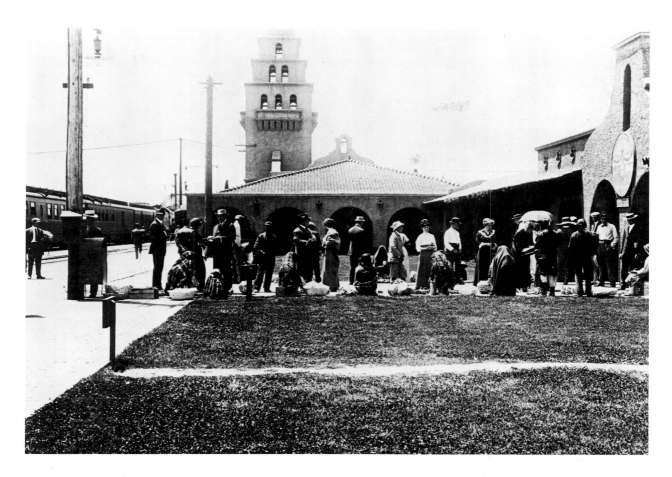

aggressive business strategies, the Indian Department became so popular with tourists that it assumed a life of its own. Because the showrooms were placed in such crucial locations as the Hopi House, at the south rim of the Grand Canyon, and the Alvarado Hotel, immediately adjacent to the railroad tracks in Albuquerque, tourists were a captive audience. Passengers leaving the train found many Indians seated outside the building selling pottery and jewelry. Inside, the Harvey Company created mock Navajo and Pueblo villages and hired weavers and silversmiths to demonstrate their skills. Many of these native craftspeople were obtained through contact with Lorenzo Hubbell, owner of the trading post at Ganado, Arizona. As shown by a letter from Schweizer to Hubbell dated March 13, 1903, the working schedule was deliberately arranged by the Harvey Company to coincide with the arrival of the daily trains: "it is the principal thing for them to be at work when trains are in. They should be working from 7:30 am to noon. They can work as much or as little as they want to in the afternoon but must come back after supper for about one hour for evening trains" (Hubbell Papers). Apparently there was some problem with these arrangements, for shortly thereafter Schweizer wrote to Huckel to complain of a delay in the Indians' arrival time, saying, "I like to see my factory in full blast" (Hubbell Papers). Schweizer's description of the weaving, silverworking, and pottery demonstrations as a "factory" reveals his eagerness to capitalize on any situation.

Schweizer's sales practices attempted to take advantage of the Indian craze in home decorating that was sweeping the country at the turn of the century. Postcards sold by the company featured a photo of the interior of the Indian Building with a caption noting that "many of the exhibits suggest practical uses of the various articles, as furnishings and decorations."

*Railroad passengers at a stopover in Albuquerque purchasing souvenirs in front of the Fred Harvey Company Indian Building, sometime between 1907 and 1915. Courtesy of Special Collections, University of Arizona Library, Tucson.*

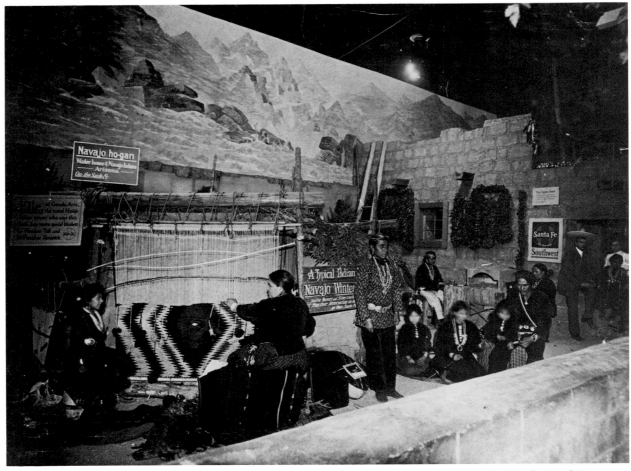

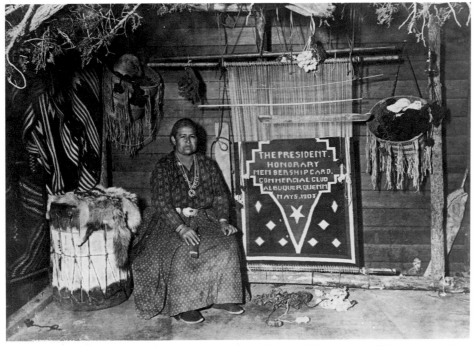

Inside the Fred Harvey Building in Albuquerque native craftspeople demonstrated their skills in front of recreated villages. Courtesy of Special Collections, University of Arizona Library, Tucson.

A Navajo weaver posing at her loom inside the Fred Harvey Building, 1903. The textile to her left, being used as a prop, was purchased by Hearst (see A.5141.42-68). Courtesy of Special Collections, University of Arizona Library, Tucson.

Herman Schweizer bought textiles for the Harvey Company from three main sources: reservation traders and other small merchants (such as Hubbell, Muniz, and Olivas); private individuals (such as Seligman, Spiegelberg, and McLeod); and the Navajo weavers themselves.

*Schweizer and Hubbell*

Lorenzo Hubbell and Herman Schweizer maintained a continuous business relationship for twenty-eight years, from the start-up of the Harvey Company Indian Department until Hubbell's death in 1930. Schweizer summed up this relationship in a letter to T. E. Purdy just after Hubbell's death:

> Mr. Hubbell cooperated with us in a big way in stabilizing the value of good blankets.
>
> We made an arrangement with him, guaranteeing him a certain, definite price for all blankets he could get coming up to required specifications as to quality, design, etc., and we took all such blankets from him at the agreed price for many years, regardless of how much blankets fluctuated on the rest of the Reservation, or regardless of what we could buy them for elsewhere.
>
> In time that had its effect so that the public appreciated the better quality of blankets. (Hubbell Papers)

Correspondence from 1902 between Schweizer and Hubbell indicates that the "agreed price was 65¢ per pound" (Hubbell Papers). Analysis of surviving

*This 1905 photograph of the main Harvey salesroom in Albuquerque shows the diversity of artifacts collected by Schweizer and Huckel, including southwestern baskets and textiles, Samoan tapa cloth, Maori carvings, Zulu shields, a Chilkat blanket, and even an Eskimo kayak suspended from the ceiling. In the center of the photo, hanging from a hook, may be one of the textiles in the Hearst collection, A.5141.42-78. G. W. Hance photograph, courtesy of Special Collections, University of Arizona Library, Tucson.*

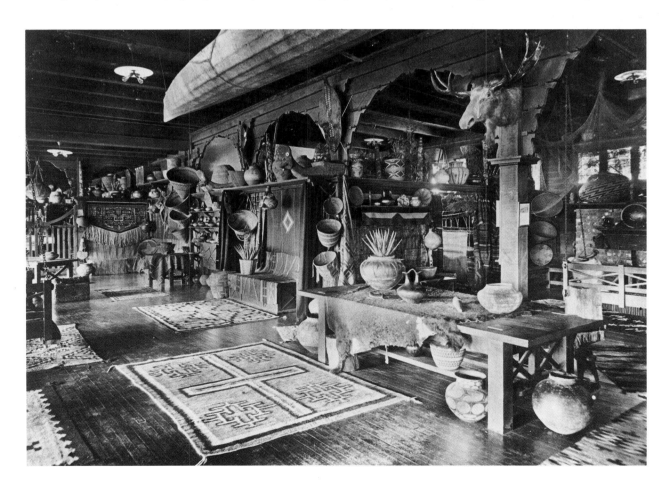

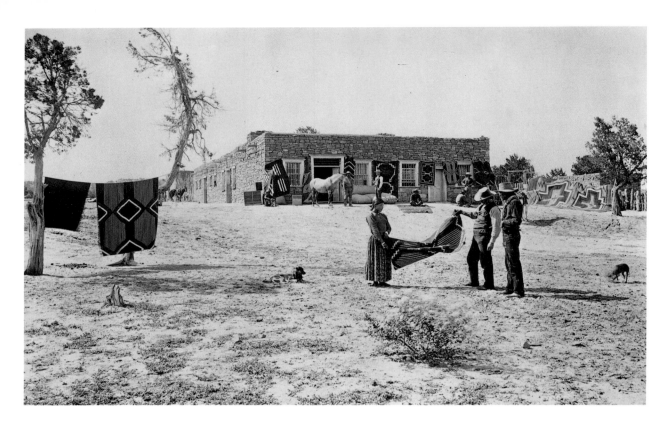

correspondence reveals that Schweizer was by far the dominant party and that Hubbell was seemingly compliant to the other's continual demands. Furthermore, Schweizer played a very definite role in shaping the final product of the Navajo loom by specifying yarn types and colors, as well as design motifs.

As the following series of letters from the Hubbell Papers clearly indicates, Schweizer and Huckel repeatedly spelled out these "required specifications" for Hubbell in great detail, reflecting market fluctuations and the preferences of their consumers. Huckel wrote to Hubbell on October 23, 1902, that "we desire the softer colors at present—the blacks, greys and whites—only a few with red in them." Schweizer issued another directive on March 15, 1903: "Regarding pattern—I think they would be better without any border just a center design on solid ground or perhaps a little scroll on the sides or corners." Two years later, in a letter of May 3, 1905, Huckel reversed his color preferences: "We can use some good native wool blankets of good weaves in grey, white and black with a litle red. A little red in the blankets helps to sell them; the plain greys do not sell with us so fast."

Special requests were accommodated by the Hubbell weavers if a Harvey Company customer could not find exactly what he wanted in size, color, and/or pattern. On September 27, 1905, Schweizer wrote to Hubbell:

> I have a special order for one grey blanket to be not more than 3′ 9″ wide and 7′ long. Black, white and grey. Good design with no red. If you have any of the kind please send as soon as possible. I would also suggest to you that you make up blankets of these dimensions as we have many calls for long, narrow blankets for bathrooms, and if they are made up without red they will not be likely to run.

By 1908 and 1909 the supply of modern rugs and blankets had greatly exceeded consumer demand. Hubbell's weavers apparently had been rapidly producing very similar pieces, which Schweizer had difficulty selling. The

*The Hubbell Trading Post. Lorenzo Hubbell is shown, with unidentified weaver and colleague, examining a possible purchase. Photo by Ben Wittick, courtesy of School of American Research Collections in The Museum of New Mexico (Neg No. 16479).*

Hubbell Papers reveal that, in an effort to reduce this trend, Schweizer made a series of very specific recommendations to Hubbell, beginning on March 4, 1908:

> and referring particularly to the swastikas these are not nearly so much in demand as they used to be and the trouble with the blankets is that they were all pretty much the same design, which gives us no variety. I am making every effort to sell all the blankets we can, but although we sell a good many, it is not a drop in the bucket compared to the stocks that are lying around the country.

On July 15, 1908, Schweizer requested more brown in the rugs and reminded Hubbell that his compliance would mean more business:

> By the way, can't you arrange to use more of the brown wool in your blankets? People are getting tired of the grey body blankets with black & white designs. We have got to get up something new all the time to keep the public interested so they will buy. This is good business for you as well as for us.

Schweizer complained on January 15, 1909, that "nine out of every 10 have either crosses or a double cross," and five days later he lamented, "There are a great many people going to California but they are not buying as readily as before the panic."

By 1916 the steady and heavy flow of quality textiles from Hubbell to the Harvey Company had dwindled. Either Hubbell's weavers were not producing what the Harvey Company wanted or Hubbell was sending the textiles elsewhere. In a letter of March 29, 1916, to F. M. Parker, an employee of Hubbell's, Schweizer expresses his concern:

> I am not getting the good blankets from you anymore that we used to get. There is only one good one now and then and I am depending now on other people for some of my best blankets where it used to be just the other way round. Some how you do not get the good weaves anymore. (Hubbell Papers)

As Hubbell grew older, his family took greater control of his business, perhaps changing its direction.

Final proof of Schweizer's hard-nosed attempts to closely control the products produced by the Navajos comes from an undated letter to Hubbell:

> I would advise you to be very independent in your buying, and let your Indians take their blankets somewhere else if they want to; I think you will find that they will come back. ... In regard to small blankets, I believe if the situation continues the Indians will be glad enough to make whatever you want them to. (Hubbell Papers)

Hubbell not only supplied textiles to suit the Harvey Company but also answered Schweizer's requests for Indians capable of demonstrating their skills before the tourists in Albuquerque and at the Grand Canyon. These demonstrations were so successful for the company that, when Schweizer was planning for the Santa Fe Railway exhibit at the 1915 Panama-Pacific Exposition in San Diego, he called upon Hubbell to provide Indians to take up residence for the enjoyment of fairgoers.

### Private Collections and other Sources

In addition to buying mostly modern textiles from Hubbell and others, Herman Schweizer was continually seeking to augment his dwindling stock

of Classic Period textiles for consumers such as Hearst. As Schweizer explained to Marian Hollenbach in 1942, these blankets were to be found mainly among private individuals: "we obtained a great many of these old blankets from collectors to whom they appealed, and who made little collections which in time they sold to us" (LACMNH correspondence).

Several of these individuals were early New Mexico and Arizona merchants who had had the opportunity and foresight to amass fine collections for pleasure and/or profit. Many sold these collections to the Harvey Company as they advanced in age. Two of the most prominent names represented in the Hearst collection are A. F. Spiegelberg and Arthur Seligman, both of whom Schweizer described as "being the first to appreciate these things" (LACMNH correspondence).

New Mexico apparently was home to numerous merchants with the name Spiegelberg in the mid- to late nineteenth century, and their relationships have been obscured with the passage of time. The work of historian Floyd Fierman (1964) on the early Jewish merchant families in the region sheds some light on these confusing relationships.

There appear to have been two senior Spiegelbergs with nearly identical names: Solomon and Solomon Jacob, who were distant cousins. Solomon Jacob was the father of five sons, who formed the famous Spiegelberg Brothers, a merchant firm in Santa Fe. Solomon was father to Abraham Fillmore Spiegelberg (1848–1927), who sold his textile collection to the Harvey Company.

The paths of all of these Spiegelbergs crossed again and again, thus adding to the confusion. A short obituary in the *New Mexico Historical Review* (3:116–19) for "Abe" Spiegelberg provides sketchy information on his life. As a young man (in the 1870s?), Abe recalled accompanying his father to Fort Wingate shortly after the internment of the Navajos at Bosque Redondo. One of Abe's prized possessions was a Navajo blanket, which he acquired in 1874. Perhaps this was the start of his interest in Navajo textiles. Abe worked as a traveling salesman in both Mexico and New Mexico for Spiegelberg Brothers and would have had ample opportunity to build a collection. In 1884 he opened a curio shop in his own name in Santa Fe, and the cover for one of his brochures stated his insistence on quality.

Although there is no firm documentation on Spiegelberg's dates of acquisition for specific textiles, his obituary comments on the significance of his collection as well as his personal integrity:

> He assembled one of the finest collections of Navajo and other Indian and native blankets and rugs in the Southwest, which was sold to the Fred Harvey company and is kept intact at Albuquerque. He became recognized as the premier expert authority on such fabrics in New Mexico. He was well known for his strict honesty in handling curios, and those now in the business testify that he put it on a sound and stable basis by insisting that neither the origin, age nor workmanship of any specimen of curios or handicraft should ever be misrepresented to a customer. (*NMHR* 3:117)

According to Schweizer's correspondence, Spiegelberg sold his collection to the Harvey Company in 1901 for $7,000.00. Hearst purchased three (possibly four) of these textiles: a first-phase chief-style blanket (#38), an early Classic Period serape (#168), and a late Classic child's/saddle blanket (#97). If these three textiles typify the entire collection, the superlatives used in Spiegelberg's obituary were certainly justified.

## NAVAJO BLANKETS.

# A. F. SPIEGELBERG,

## SANTA FE, NEW MEXICO,

**Is the longest experienced dealer and has
the Oldest Curio Shop in the Southwest and**

# THE ONLY ONE

in this City which has been continuously
under the same management since its
establishment in 1884, making it a specialty
to handle nothing except the

## GENUINE AND BEST

of Everything in the Line.

*Cover of an advertising
brochure for Abraham
Spiegelberg's curio shop.
Courtesy of The Hunting-
ton Library, San Marino,
California.*

Arthur Seligman (1871–1933) was also a member of one of the early New Mexico merchant families; he became governor of the state. No documentation has been found up to this point to describe the Seligman textile collection in detail. Those pieces later sold to Hearst were purchased by the Harvey Company in the early years of this century, when Seligman was still a relatively young man.

As with the Spiegelberg sample, the Seligman textiles reveal a preference for blankets rather than transitional pieces or rugs. The textiles purchased by Hearst were a cross section of what the Navajo weavers were producing from 1865 to 1885, including such types as serapes (#167, 112, 87), chief's (#25, 139), child's (#73, 177), and banded-background blankets (#53, 55, 57, 58). Also represented is the full array of yarn types available to the weavers during this period.

Four of the textiles in the Hearst collection came to the Harvey Company from Bert Phillips (1868–1951), a well-known painter. According to Schweizer, he was "the first artist to settle in Taos and collected blankets which we later bought."

Although Phillips's taste cannot be conclusively determined by this small sample, his preference appeared to be for the more traditional textiles, as two are serapes, one a chief style, and another a child's blanket. All are from the late Classic Period, were woven between 1865 and 1875, and contain some ravelled yarn. Each blanket bears a striking design, especially serape number 162 with its bold patterning and color combinations. As a fellow artist, Phillips obviously appreciated the artistry created by Navajo weavers and felt compelled to collect their work.

Schweizer also purchased textiles from the estates or the surviving family members of earlier collectors. Two such people were Richard Wetherill (1858–1910) and E. L. McLeod (d. 1908). Three of Hearst's textiles were sold by Richard Wetherill's widow to the Harvey Company not long after his death in 1910. Times were hard for a single woman with five children and mounting debts, so we may assume the sales were made in an effort to obtain needed cash. Their original acquisition dates by the Wetherills are unknown, but as a long-standing trader and amateur archaeologist in the Southwest, Wetherill, like Seligman and Spiegelberg, had had years of contact with the Navajo in the late nineteenth century.

The McLeod purchase by the Harvey Company shows just how aggressive Schweizer could be. E. L. McLeod was first and foremost a basket collector, but photographs of his home in Bakersfield, California, reveal that he also collected other Indian artifacts. When he died, his entire collection was left to his sister, Mrs. G. H. Taylor, of Fresno, California. Although not a widow, Mrs. Taylor was in some financial need and was repeatedly contacted by Herman Schweizer to sell the collection (see comments in Chapter 3 regarding textiles 47 and 89). His persistence paid off, for in 1911 and 1912 Mrs. Taylor sold part of the collection to the Harvey Company. McLeod's dates of acquisition for the textiles are unknown at the time of this writing, but as the remainder of his collection and notes are in the Lowie Museum in Berkeley, further research may uncover them.

Leaving no stone unturned in his quest to obtain early textiles, Schweizer actively used the services of itinerant merchants or peddlers who traveled to remote villages. Two names that appear with great regularity in the Harvey ledgers and in the Hearst collection are Pedro Muniz and his brother-in-law, Juan Olivas. As Schweizer wrote in 1942,

> practically all of the old Navajo rugs were obtained from Mexicans who either obtained them in warfare or in trade before 1860.

> In early days we had native Mexicans going out with wagons to the highways and byways which they brought to us, and we would simply have the name of the Mexican who did the collecting.

The "native Mexicans" he refers to are Pedro Muniz and Juan Olivas; letters in the Hubbell Papers and the Harvey Company ledgers suggest that the "early days" of collecting were concentrated in the years 1901 to 1906, although there is one entry as late as 1925. Early documentation on these textiles is, no doubt, lost forever, as Schweizer apparently did not question Muniz or Olivas about their sources.

Finally, Harvey Company textiles were occasionally bought directly from the Indians. As with Schweizer's dealings with Hubbell, these purchases primarily were modern pieces, and they do not appear to be identifiable in the Hearst collection. Schweizer mentioned the practice only rarely, an example being in a letter to Hubbell in 1908:

At the present time we are selling blankets at the Grand Canyon that we have been compelled to buy from Indians coming in from Tuba City, fine grade blankets for very little more than I would be paying you for these. In other words as I wrote you, we are buying fine grade blankets up there, for all the way from 70¢ to $1.00 a pound. (Hubbell Papers)

From the comments about prices, it seems that the Indians did better to sell directly to the Harvey Company, when they had a chance, than to go through Hubbell as a middleman.

*Pricing Structure and Codes*

Tens of thousands of Navajo textiles passed through the doors of the Fred Harvey Company in Albuquerque during the early part of the twentieth century. Herman Schweizer, as head of the Indian Department, devised a system to keep track of them in a series of ledger books. In his own hand Schweizer carefully assigned each textile a consecutive number, recorded the wholesale and retail prices, the name of the person he bought the piece from, the date of the purchase and a brief description of it. Correspondingly, he securely affixed a tag to each textile using wire and a metal seal bearing the name "Fred Harvey." Again, usually in Schweizer's own hand, the tag bore much the same information as the ledger books but in code. Several of the original ledger books have survived and are currently in two locations: the Heard Museum in Phoenix and the Museum of International Folk Art in Santa Fe.

*Pages from the Harvey Company's Navajo blanket ledger. Courtesy of Spanish Colonial Arts Society, Inc. Collections on loan to the Museum of New Mexico, Museum of International Folk Art, Santa Fe.*

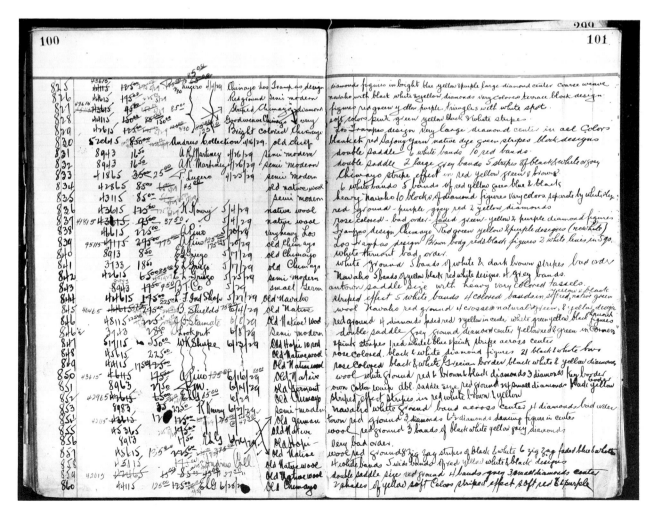

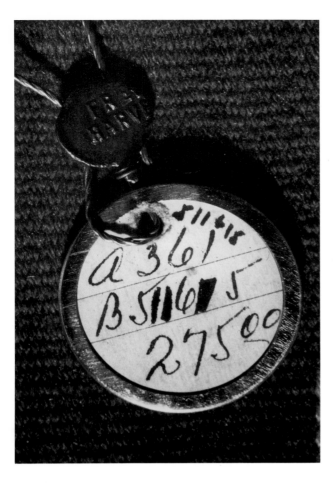

*Harvey Company metal-and-paper tag affixed to textiles to record pricing and provenience information.*

Herman Schweizer's meticulous habits have left a wealth of information for researchers on early trading practices in the Southwest. When the information on the tags is combined with the entries in the ledger books, the Fred Harvey collection data may be ascertained for most pieces in the Hearst collection.

As revealed by Byron Harvey III (pers. comm., 1978, 1979), three different price codes were used by the Harvey Company: the "Hydraulics," "615," and "102" codes.

"Hydraulics" was the most straightforward, as each letter of the word simply equaled a number:

H Y D R A U L I C S
1 2 3 4 5 6 7 8 9 0

Additionally, X = 0. So if a price was written on the tag as "DAXSS," decoded it read $350.00.

Likewise, the "615" code was relatively simple. The first number in the sequence indicated the number of digits in the price, and the sum 615 was subtracted from the remaining numbers to give the correct price. For example, if the code read "510615," the price had five digits and could be determined as follows:

$$10615$$
$$-\ 615$$
$$\$100.00\ \text{correct price}$$

The last code, "102," proved to be the most involved. The coded numbers first had to be reversed in order:

$$89314 = 41398$$

As with the "615" code, the first number indicated the number of digits in the price. Once this was removed, 102 was added to the remaining numbers to give the final price:

$$\begin{array}{r} 1398 \\ + 102 \\ \hline \end{array}$$
$15.00 correct price

Generally, the wholesale prices were recorded in the ledger books and on the blanket tags with the "102" and "615" codes, and "HYDRAULICS" was reserved for the retail price on the tags. In a 1905 letter to Hubbell, Huckel says that the Harvey Company was "obliged to put the prices in cipher because people have looked at them, read the prices and gone some where else to buy" (Hubbell Papers). Barney Sievert, assistant to Herman Schweizer from 1925 to 1936, likewise recalls that price codes were used in the retail store to discourage critical comments from tourists about high prices (pers. comm., 1979). Many southwestern trading posts retain the practice today.

# 3. From Collector to Curator

## *The Catalogue*

This catalogue and the detailed analysis that accompanies it is presented for scholars and interested layman alike and has been formatted to allow successful reading on two levels. Those persons who wish only to enjoy the beauty of the overall collection may survey the various categories by selecting the appropriate pages. At the other end of the spectrum, serious Navajo textile scholars will want to spend time carefully considering all of the details presented by the yarn analysis.

The textiles speak for themselves in this portion of the book. The catalogue is a testimony to the resilient and creative skills of the Navajo weaver; it also bears witness to the foresight of the Fred Harvey Company and its "anthropologist" Herman Schweizer; and it stands as yet another legacy of the eclectic and omnivorous collecting passion of William Randolph Hearst.

### Format Notes

*Classification*

Each textile is categorized into one of three broad categories: *blanket, rug,* or an intermediate period referred to appropriately as *transitional.* This classification is based loosely on function, or the intended use of the textile. Within the two broad functional categories of blankets and rugs, Navajo weaving scholars, collectors, and dealers recognize many subcategories. In a more descriptive but somewhat confusing mixed analysis, blankets are often categorized by *design* (banded, striped, zoned, chief's, pictorial, and eyedazzlers), *function* (serape; poncho; saddle; man's, woman's, or child's wearing blanket), *yarn type* (Germantown and dyugi), and in one instance by *weaving technique* (wedge weave or pulled warp).

In this publication the Hearst textiles are organized into the broad categories of blankets, transitional blankets/rugs, and rugs in a loose chronology of development. Within that larger scheme each is categorized further by using the subcategories outlined above, and a date is assigned. For the interested scholar the LACMNH accession number is provided. Measurements are given in centimeters with the length (warp dimension) always preceding width (weft dimension). All photographs are positioned as the textile was woven on the loom.

*Diagnostic Features*

A standard textile analysis format is used to describe each piece according to yarn type and color found in both warp and weft. The tightness (*count per inch*) of the weaving is measured, and the nature of the *fiber* (wool or cotton) is determined, along with the method of spinning for each *yarn* (native hand-spun or commercially spun) as well as the number of *plies* and the direction of *spin*. The last is graphically referred to as *Z* or *S* to indicate a left- or right-hand direction of spin to the fibers. When yarns are plied to produce a heavier weight, the direction of *twist* is always opposite the direction of spin.

The additional category of *diameter* was created for the ravelled yarns. Just as specific yarn types, dye sources, and design layouts are useful diagnostic tools, perhaps additional data in this category will help determine whether or not there is a diameter/time correlation. Further research is planned to ascertain whether recorded variations in diameter have significance for Navajo textile studies.

Most Navajo textiles have a *selvage* along both the ends and the sides as an integral part of the weaving. The selvage was usually made of two- or three-ply handspun yarns tied together at the corners. When original, these yarns are included in the analysis. Undoubtedly, when first collected by the Harvey Company, many of the textiles showed signs of wear. In an effort to present a more saleable product the Harvey Company apparently often rewove damaged portions of textiles and replaced torn selvages. The commercial replacements are not analyzed.

*Documentation*

The original documentation from each textile's Harvey Company tag and from information recorded in LACMNH catalogue cards is presented verbatim (including misspellings). For example, the tag for textile A.5141.42–168 provides the following information:

> H-6055 = consecutive number assigned each textile purchased by the Harvey Company
>
> B-521615 = numerical code used to indicate wholesale price
>
> UAXSS = alphabetical code used to indicate retail price
>
> AFS = initials of Harvey Company source for textile (either seller or original collector)
>
> 1-16-3 = date obtained by Harvey Company

Also included verbatim, for comparison, is the corresponding ledger book entry made by Herman Schweizer to record the transaction. For the same textile, the ledger book lists the following:

> 6055 = consecutive number
>
> $450.00 = retail price
>
> $200.00 = wholesale price
>
> Large full bayetta red white and blue = brief description of textile
>
> Algert, Spiegelberg Private Collection = Harvey Company source and original collector; AFS = A. F. Spiegelberg
>
> 1-16-3 = date obtained

Not all textiles have Harvey Company tags, and even when a tag is extant there is not always a perfect match with the company ledger books. Some small variations exist, most commonly in the retail prices, which reflect fluctuations in the market. Serious discrepancies occur for textiles 47, 84, 87, 114, 121, 126, 136, 163, 170, and 189, and the reader should note each accompanying discussion.

All textiles were woven in weft-faced plain weave unless noted otherwise.

*Assignment of Dates*

Nearly all of the textiles in the Hearst collection date from the nineteenth century. Unlike the modern textile, for which the weaver's name, date, and village or reservation area are carefully recorded, the historic textile generally lacks all original documentation.

Dates for the Hearst textiles and others are assigned by analyzing the specific features exhibited by each piece. Examination, first, of each type of yarn used in the textile for type of fiber (cotton or wool), the method of spinning (handspun or commercial), and the direction of spin (Z or S) can disclose the original source of the yarn.

Historical records indicate what specific types of commercial yarns were manufactured in the industrial world as well as when and by what routes they may have been traded to the Navajos. Therefore, for example, the presence of a three-ply commercial yarn from Germantown, Pennsylvania, in a Navajo textile indicates a very narrow probable time of weaving, from 1865 to 1875. After that time, records indicate a shift to four-ply yarns.

Colors of yarn, weaving techniques, design elements and their layout on the textile are all meticulously recorded and then compared to documented collections of textiles, dated historic photographs and drawings, and historical records. These comparisons of the diagnostic features of the textiles have helped scholars to arrive at an approximate date of manufacture for specific textiles, often to within ten years.

Future studies may refine the process even further. Dye studies on Navajo textiles are really in their infancy. For this reason the usual speculation on dye source has been omitted from these analyses. Selected red yarns were chemically tested by David Wenger of the University of Colorado, Boulder, for Joe Ben Wheat's research, and the results are included here with his permission (see textiles 32, 36, 37, 88, 114, 126, 129, 130, 168, 170, 173). Prior to Wheat's study it was generally assumed that the most common dyestuff used to produce a red color in the English and Spanish cloth traded to the Navajos was cochineal. Wenger's tests show a surprising prevalence of lac prior to 1860, whereas cochineal appears to be dominant after 1860 (pers. comm. 1981).

*Missing Textiles*

In 1973 the Los Angeles County Museum of Natural History was the victim of a large-scale theft of many of its Navajo textiles. Fortunately, most were eventually recovered, but as of 1988 twelve of the Hearst pieces are still missing (#42, 75, 115, 149, 157, 164, 172, 178, 193, 194, 197, and 204). Nonetheless, they are included in this catalogue, for three reasons:

(1) they are an integral part of the whole Hearst collection, reflecting its range and diversity;

(2) the accompanying analysis and economic information adds to the body of knowledge about Navajo textile studies; and

(3) their presentation may serve as an aid to their identification and eventual recovery.

Since the textiles were missing before this study began, a complete analysis and color photo of each is not available. The brief technical analysis, description, and black-and-white photo available for each is taken verbatim from the original LACMNH catalogue cards completed at the time of the donation in 1942. The reader should keep in mind that Navajo textile studies have advanced considerably in the forty years since the original cataloguing was accomplished.

The analysis sheets for numbers 75 and 115 were completed in the spring of 1973, prior to the theft, by Joe Ben Wheat, and are included here with his kind permission.

# Serapes

This particular category of wearing blanket is somewhat difficult to define precisely. Amsden (1934:103) describes it as "the universal type garment of the Navajo, the type that more than all others is behind the broad phrase of 'Indian blanket.' " The Navajo weavers used a terraced and largely horizontal format of bright red, blue, and white color combinations to produce spectacular results. Not only were the blankets visually appealing, but they served as the primary item of outerwear and as sleeping blankets.

Early Classic Period serapes dating to the first part of the nineteenth century are among the most highly sought-after Navajo textiles and can command prices into six figures in today's rarified art market. Hearst's keen eye appears to have appreciated these serapes, for the style is well represented in his collection by eighteen examples.

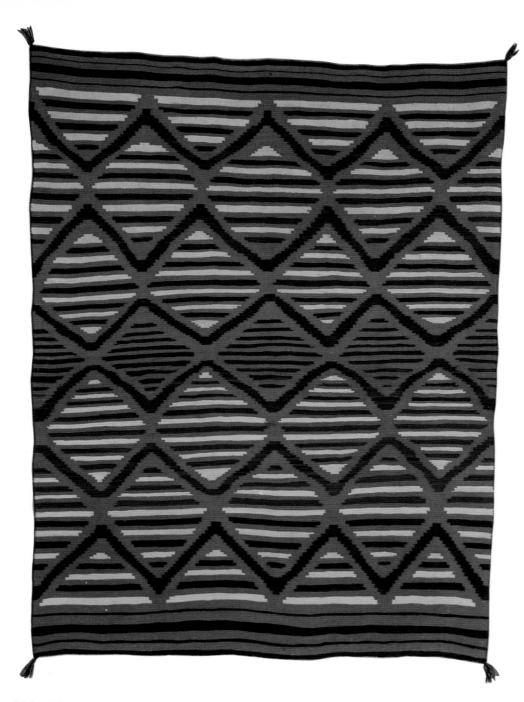

BLANKET, serape, circa 1840–1860

A.5141.42-168

171.5 cm × 131.0 cm

	Color	Count (per inch)	Fiber	Yarn	Ply	Spin	Diameter (mm)
Warp	white	15	wool	handspun	1	Z	
Weft	white	72	wool	handspun	1	Z	
	red (cochineal dye)	68	wool	ravelled	2	S	0.3
	blue	70	wool	handspun	1	Z	

Selvage: replaced

Harvey Company tag: "H-6055    B-521615    UAXSS    AFS    1-16-3"

Ledger book: "6055    $450.00    $200.00    Large full bayetta    red white and blue
     Algert [or Altgert]    1/16/3    Spiegelberg Private Collection"

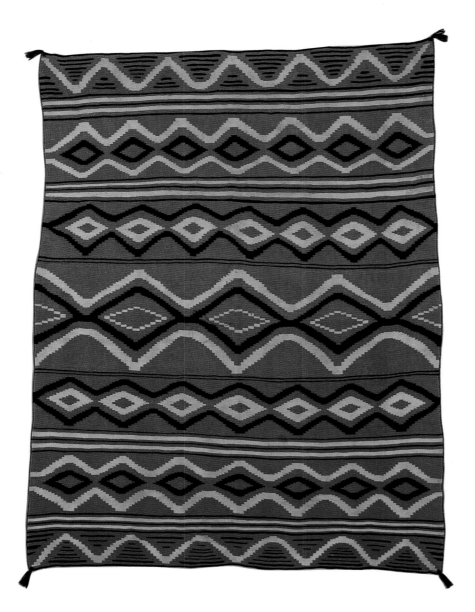

BLANKET, serape, circa 1850
A.5141.42-170
170.0 cm × 130.5 cm

	Color	Count (per inch)	Fiber	Yarn	Ply	Spin	Diameter (mm)
Warp	white	13	wool	handspun	1	Z	
Weft	white	68	wool	handspun	1	Z	
	red (lac dye)	72	wool	ravelled	2	S	0.3
	blue	68	wool	handspun	1	Z	

*Selvage:* replaced

*Harvey Company tag:* "H-11575     B-59615     L 2236"

*Ledger book:* "11575     $22.50     $11.00     B. F. Zahm     3/21/06
    Natural wools"

The discrepancies in prices, names, and descriptions on the Harvey tag and in the ledger entries for this piece leads to the conclusion that our textile is probably not the one entered by Schweizer as 11,575. Since tens of thousands of textiles passed through his hands, and he apparently kept duplicate ledger books for some portions of the collection, it is not surprising that he occasionally made an error in transcription. (Further such discrepancies will be signaled by the symbol [–].)

BLANKET, serape, circa 1850–1860
A.5141.42-107
214.0 cm × 152.6 cm

	Color	Count (per inch)	Fiber	Yarn	Ply	Spin	Diameter (mm)
Warp	white	12	wool	handspun	1		
Weft	white	52	wool	handspun	1		
	blue	52	wool	handspun	1		
	red	34	wool	ravelled	14	S	0.3

*Selvage:* both: two, 3-ply navy, handspun, Z, S

*Harvey Company tag:* "H-7833     #89844     P.M.     5-13-3"

*Ledger book:* "7833     $225.00     $50.00     Muniz     5/13/3
    Large blue & red figures in center"

This very large, old serape is a masterpiece of design. The main color scheme of blue and white suggests Rio Grande influence. The addition of a solitary, central red band heightens the electric patterning of stripes and zigzags. When the piece was worn, the red band ran vertically down the back of the wearer and must have created a stunning visual and psychological effect. Also noteworthy is the exceptionally fine diameter of the ravelled red yarn, which required the weaver to ply fourteen strands in order to create an acceptable weight of yarn for her weaving.

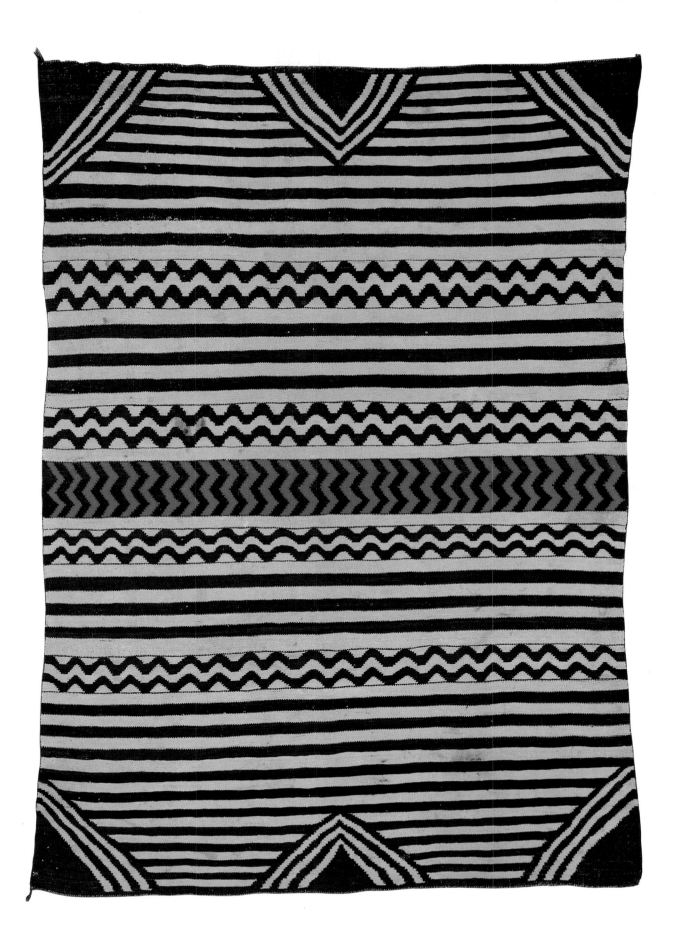

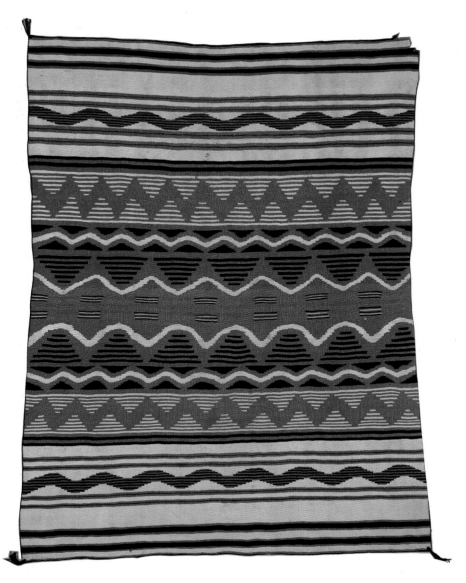

BLANKET, serape, circa 1850–1860
A.5141.42-165
175.6 cm × 134.4 cm

	Color	Count (per inch)	Fiber	Yarn	Ply	Spin	Diameter (mm)
Warp	white	16	wool	handspun	1	Z	
Weft	white	72	wool	handspun	1	Z	
	red	80	wool	ravelled	2	S	0.3
	blue	74	wool	handspun	1	Z	

*Selvage:* replaced

*Harvey Company tag:* "H-13560     B-49615     IAXSS     L.447"

*Ledger book:* "13560     $350.00     $55.00     Langer     4/4/7     Full bayetta
  red white & blue shaded to the center white ends"

This textile embodies all of the characteristics of early Classic Navajo serapes: horizontal design layout of carefully stepped zigzag lines sometimes joining to form diamonds; the use of narrow striped elements; predominant color combination of reds, blues, and white; and the use of imported cloth to create finely ravelled yarns rewoven in an extremely tight weave in a longer-than-wide format. These unparalleled products of the Navajo loom are considered to represent the high point of Navajo weaving.

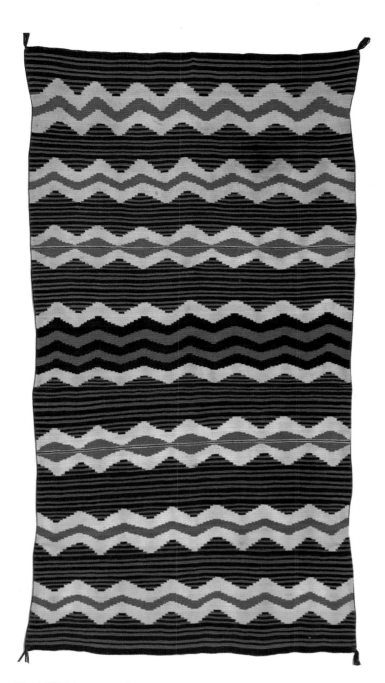

BLANKET, serape, circa 1855–1865
A.5141.42-166
224.9 cm × 116.2 cm

	Color	Count (per inch)	Fiber	Yarn	Ply	Spin	Diameter (mm)
Warp	white	11	wool	handspun	1	Z	
Weft	white	54	wool	handspun	1	Z	
	blue	54	wool	handspun	1	Z	
	red 1	54	wool	ravelled	1	S	0.7
	red 2	36	wool	ravelled	2	S	0.7
	brown	54	wool	handspun	1	Z	

*Selvage:* replaced

*Harvey Company tag:* "H-5421  89474  RAXSS  P.M.  8-28  Full bayetta"

*Ledger book:* "5421  $200.00  $62.00  P. Muniz  8/26  Bayetta-all"

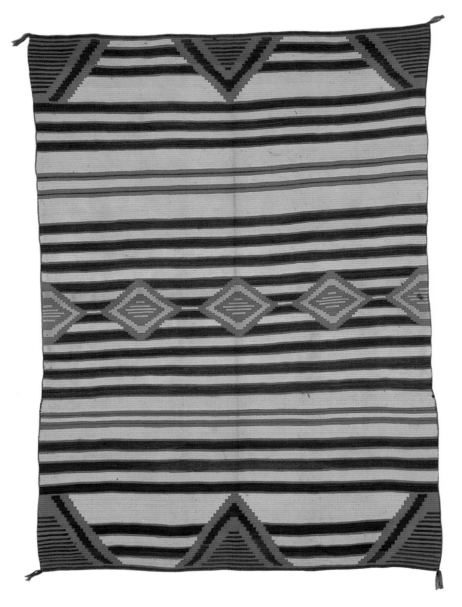

BLANKET, serape, circa 1865–1870
A.5141.42-167
189.0 cm × 134.5 cm

	Color	Count (per inch)	Fiber	Yarn	Ply	Spin	Twist	Diameter (mm)
*Warp*	grey	11	wool	handspun	1	Z		
*Weft*	white	60	wool	handspun	1	Z		
	blue	56	wool	handspun	1	Z		
	red 1	56	wool	commercial	3	Z	S	
	red 2	40	wool	ravelled	3	Z		0.45
	red 3	60	wool	commercial	3	Z	S	
	green (faded from blue-green)	56	wool	commercial	3	Z	S	

*Selvage:* replaced

*Harvey Company tag:* "H-6072    B-516015    RAXSS    S. Coll    1/20/3"

*Ledger book:* "6072    $400.00    $150.00    Seligman Coll. Green diamonds
in center    Blue ½ diamonds in corners & on ends. The blue & white nat'l
wool and saxony yarn is in the red. Selig. #118"

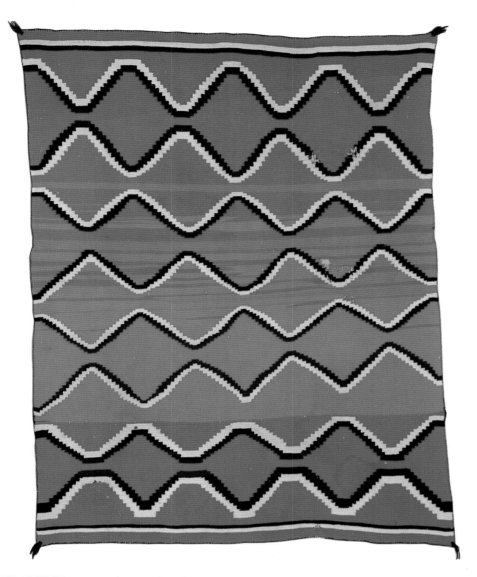

BLANKET, serape, circa 1865–1870

A.5141.42-87

180.0 cm × 145.0 cm

	Color	Count (per inch)	Fiber	Yarn	Ply	Spin	Twist	Diameter (mm)
*Warp*	white	9	wool	handspun	1	Z		
*Weft*	red	50	wool	commercial	3	S	Z	
	burgundy 1	44	wool	ravelled	3	Z		0.4
	burgundy 2	50	wool	commercial	3	Z	S	
	blue	42	wool	handspun	1	Z		
	white	42	wool	handspun	1	Z		

*Selvage:* both: two, 3-ply navy, handspun, Z, S

*Harvey Company tag:* "H-7024     #893015     YYAXS     Sell. Coll.     1-05-03"

*Ledger book [–]:* "7024     $200.00     $105.00     Seligman Coll.     Large Bayetta natural wool     green & white figures     several colors of red S-302"

The ledger book description seems to be somewhat at odds with this textile, for although it does indeed contain "several colors of red," there are no "green and white figures." This discrepancy may be the result of an inadvertent entry as Schweizer was cataloguing the large Seligman purchase in 1903, or the blanket may just have been misnumbered.

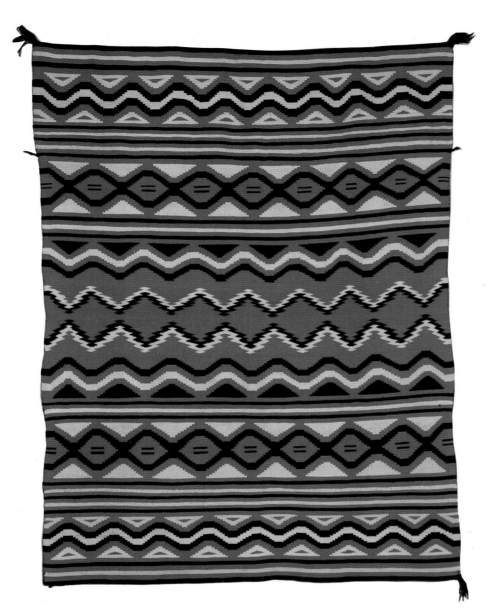

BLANKET, serape, circa 1865–1875
A.5141.42-88
182.0 cm × 135.0 cm

	Color	Count (per inch)	Fiber	Yarn	Ply	Spin	Twist
Warp	white	13	wool	commercial or handspun?	1	S	
Weft	white	52	wool	handspun	1	Z	
	red (cochineal dye)	58	wool	commercial	3	Z	S
	blue	48	wool	handspun	1	Z	

*Selvage:* sides: two, 2-ply blue, handspun, Z, S
ends: two, 3-ply blue, handspun, Z, S

*Harvey Company tag:* "H-15325    B-518115    LAXSS    BR    3/26/8"

*Ledger book:* "15325    $750.00    $175.00    Brizzard    3/26/8    Bayetta
red white and blue    perfect condition"

Handspun Navajo yarns always have a *Z* direction of spin. This serape has a very finely spun, single-ply wool warp with an *S* spin. This may indicate a commercial product or possibly a weaver who preferred to spin opposite the conventional way.

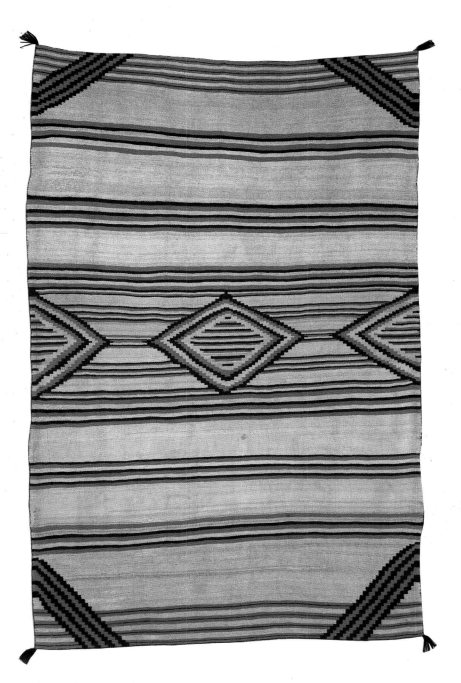

BLANKET, serape, circa 1865–1875

A.5141.42-23

206.5 cm × 131.0 cm

	Color	Count (per inch)	Fiber	Yarn	Ply	Spin	Diameter (mm)
Warp	grey	9	wool	handspun	1	Z	
Weft	grey	28–46	wool	handspun	1	Z	
	red	54	wool	ravelled	3	S	0.5
	blue	46	wool	handspun	1	Z	

*Selvage:* replaced

*Harvey Company tag:* "B-530615   UAXSS   Reed   Blkt   9/25"

*Ledger book:* [Unable to find entry due to missing Harvey number on tag]

This late Classic Period serape has a somber grey ground and a very tightly controlled, stepped diamond pattern.

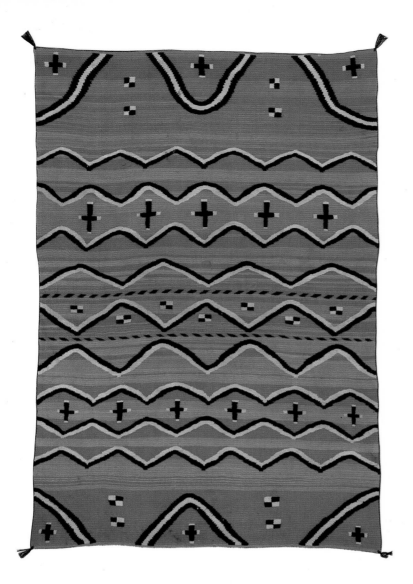

BLANKET, serape, circa 1865–1875
A.5141.42-89
188.0 cm × 125.0 cm

	Color	Count (per inch)	Fiber	Yarn	Ply	Spin
Warp	white	11	wool	handspun	1	Z
Weft	orange (faded from red)	52	wool	handspun	1	Z
	burgundy	66	wool	ravelled	3	S
	navy	52	wool	handspun	1	Z
	white	52	wool	handspun	1	Z

*Selvage:* replaced

*Harvey Company tag:* "H-21819    B-513615    IAXSS    Ed McLeod Coll. 2/20/12"

*Ledger book:* "21,819    $600.00    $110.40    Mrs. G. H. Taylor    2/20/12
Old Bayetta    9 zigzag stripes running crosswise of blanket. Red ground
One row of 5 Black & White crosses and one Row of 6 Crosses each end also
some Black and white Block Paterns."

Ed McLeod, an American Indian artifact collector from Bakersfield, California, died in 1908 and left his huge collection to his sister, Mrs. G. H. Taylor. Schweizer merely wrote the name of the original owner on the tag, but he entered the name of the seller in the ledger books.

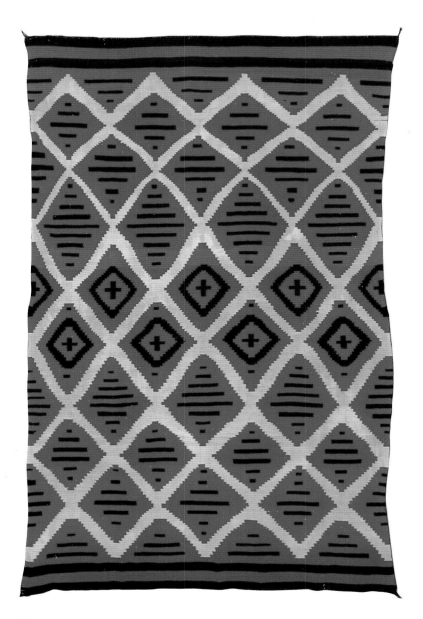

BLANKET, serape, circa 1865–1875

A.5141.42-106

209.0 cm × 130.5 cm

	Color	Count (per inch)	Fiber	Yarn	Ply	Spin	Twist	Diameter (mm)
Warp	white	13	wool	commercial	3	Z	S	
Weft	white	68	wool	handspun	1	Z		
	blue	60	wool	handspun	1	Z		
	red 1	64	wool	ravelled	2	S		0.5
	red 2	60	wool	ravelled	2	1 = Z		0.4
						1 = S		0.45

*Selvage:* both: two, 3-ply blue, handspun, Z, S

*Harvey Company tag:* "H-40371    B-518115    C. C. Upham    5-28-23"

*Ledger book:* "40371    Old    $500.00    518115    Charles C. Upham
   NY City    Bayetta    Maroon red ground, white diamonds"

This late Classic Period serape shows a number of unusual characteristics. The warp is commercially spun and plied, and one of the two ravelled red yarns uses two threads with opposite directions of spin.

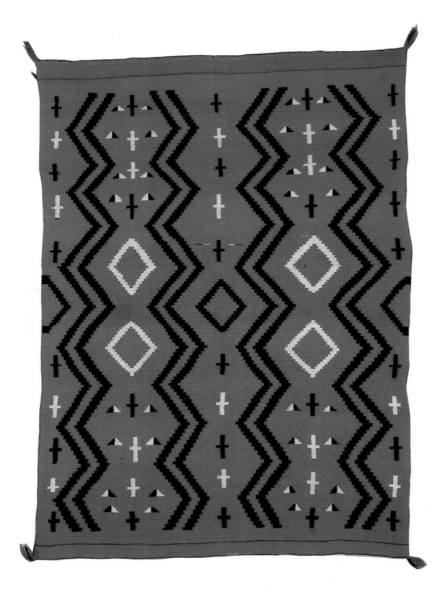

BLANKET, serape, circa 1865–1875
A.5141.42-90
178.0 cm × 125.0 cm

	Color	Count (per inch)	Fiber	Yarn	Ply	Spin	Diameter (mm)
Warp	white	14	wool	handspun	1	Z	
Weft	red 1	54	wool	ravelled	2	Z	0.35
	red 2	54	wool	ravelled	3	Z	0.4
	blue	60	wool	handspun	1	Z	
	white	64	wool	handspun	1	Z	

*Selvage:* both: two, 3-ply blue, handspun, Z, S

*Harvey Company tag:* "H-19026    B-416115    RXSSS    Bert Phillips
    7/13/10"

*Ledger book:* "19026    $155.00    B. Phillips    7/13/10    Red ground
    bayetta. 4 Blue zigzag stripes lengthwise of blanket small blue and white
    crosses. 1 Blue 4 white diamonds."

The horizontal design format characteristic of early Classic Period Navajo textiles
shifted to a vertical layout over the years until it predominated by the late nineteenth
century. This piece, however, retains the stepped terracing of earlier pieces rather
than the serrated lines more common to the vertical format.

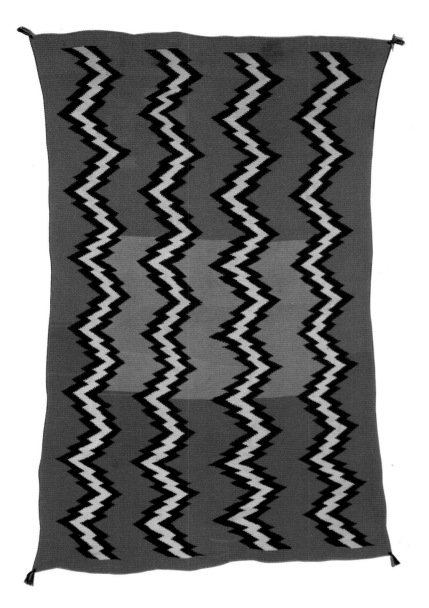

BLANKET, serape, circa 1870–1875

A.5141.42-162

201.0 cm × 131.0 cm

	Color	Count (per inch)	Fiber	Yarn	Ply	Spin	Twist	Diameter (mm)
Warp	white	8	wool	handspun	1	Z		
Weft	burgundy 1	36	wool	recarded and respun ravelled?	1	Z		1.1
	burgundy 2	34	wool	ravelled	2	Z		0.7
	blue	30	wool	handspun	1	Z		
	white	30	wool	handspun	1	Z		
	coral	52	wool	commercial	3	Z	S	

*Selvage:* sides: replaced
     ends: 2 cords: each two, 3-ply coral, commercial, Z, S

*Harvey Company tag:* "H-15363     B-510615     B.P     4-7-8"

*Ledger book:* "15363     $350.00     $80.00     Bert Phillips     4/7/8
     Bayetta     Red White & Blue"

The large, centrally placed square of coral-colored yarn on the burgundy ground is quite unusual. Close examination reveals several small areas of wedge weave.

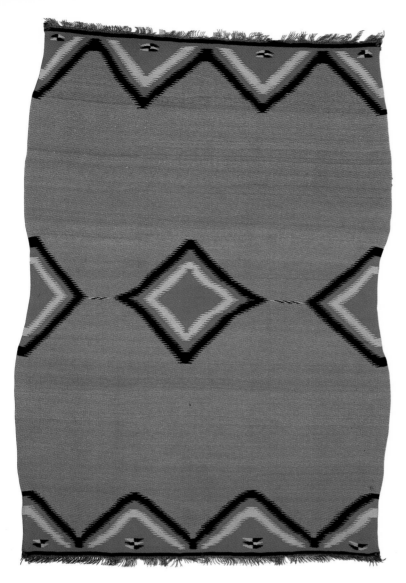

BLANKET, serape, circa 1870–1875

A.5141.42-100

180.0 cm × 127.0 cm

	Color	Count (per inch)	Fiber	Yarn	Ply	Spin	Twist	Diameter (mm)
Warp	purple	9	wool	commercial	3	S	Z	
Weft	pink	44	wool	recombed red and white	1	Z		
	white	58	wool	handspun	1	Z		
	blue	58	wool	handspun	1	Z		
	red	60	wool	ravelled	4	S		0.35

*Selvage:* unusual finish; adjacent warps are paired, tied together, and act as fringe

side cords:  two, 3-ply red, S, Z

end cords:  two, 3-ply red, S, Z

*Harvey Company tag:* "H-7373    B-43115    RAXSS    D.O.    3-11-4"

*Ledger book:* "7373    $175.00    $25.00    Ortega    3/11/3    Balletta squares pink body"

Several noteworthy items can be seen in this blanket: the significant Saltillo influence in the central serrate diamond, the purple commercial warp and fringe, the proportion of length to width, and the use of recombed yarn as the background rather than as just a small design element.

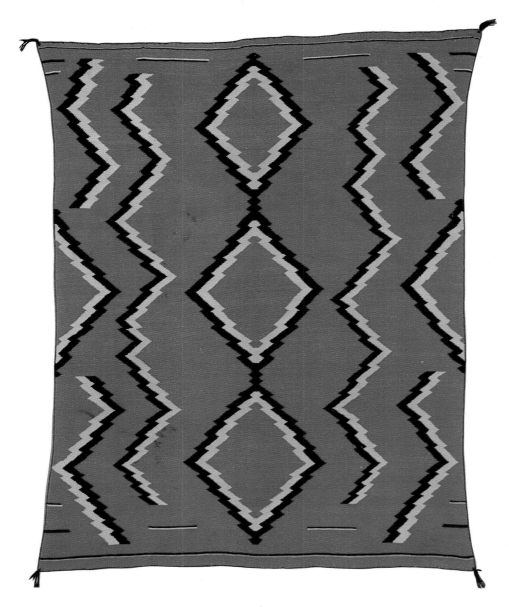

BLANKET, serape, circa 1870–1880
A.5141.42-112
169.0 cm × 125.7 cm

	Color	Count (per inch)	Fiber	Yarn	Ply	Spin
Warp	white	15	wool	handspun	1	Z
Weft	red	44	wool	ravelled or recarded	1	Z
	dark blue	44	wool	handspun	1	Z
	white	44	wool	handspun	1	Z
	dark blue-green	48	wool	handspun	1	Z
	light green	44	wool	handspun	1	Z

*Selvage:* replaced

*Harvey Company tag:* "H-6085    B-531265    HXSSSS    Seligman Coll.
1-20-3"

*Ledger book:* "6085    $1000.00    $300.00    Full bayetta    Ground bayetta
with 3 diamonds running through center made of blue & white zigzags of blue
& white on either side. Perfect condition    three green blue stripes on ends.
Selig. no. 111."

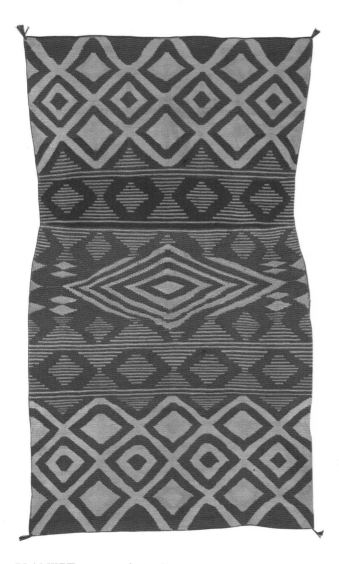

BLANKET, serape, circa 1875
A.5141.42-110
197.0 cm × 110.0 cm

	Color	Count (per inch)	Fiber	Yarn	Ply	Spin	Twist
Warp	white	11	wool	handspun	1	Z	
Weft	white 1	54	wool	handspun	1	Z	
	white 2	68	wool	commercial	3	Z	S
	green	104	wool	commercial	3	Z	S
	yellow	104	wool	commercial	3	Z	S
	red 1	58	wool	commercial	3	Z	S
	red 2	50	wool	commercial	3	Z	S
	maroon	58	wool	commercial	4	Z	S

*Selvage:* replaced

*Harvey Company tag:* "H-42169    B-513115    UAXSS    Fr. Staab Coll., La
Posada Inn, Santa Fe    10/24"

*Ledger book:* "42169    Old    $650.00    513115    Pale bayetta diamond
centre with pale green and yellow figures.    Staab Coll.    10/24"

This textile as we examine it today is a far cry from the blanket woven more than
a hundred years ago. Originally, the Saltillo-style central elongated diamond had a
woven slit enabling the textile to be worn as a poncho. Prominently evident are the
uneven edges, replaced selvages, and multiple repair yarns.

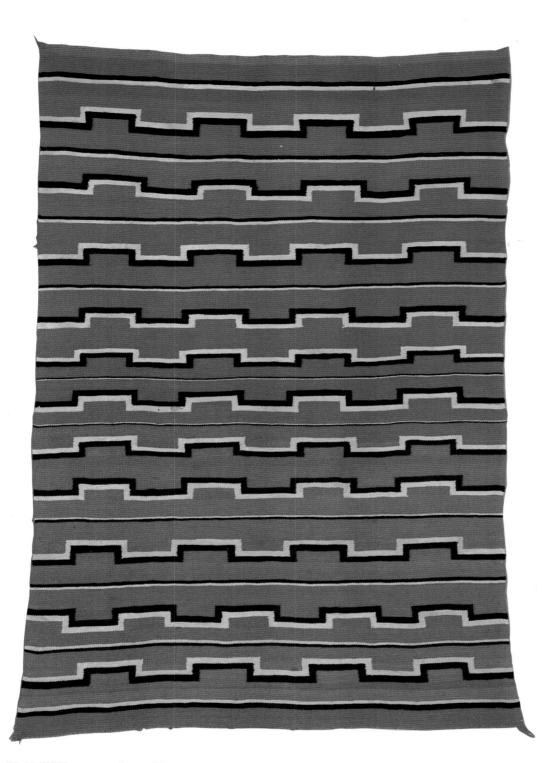

BLANKET, serape, circa 1880
A.5141.42-184
192.5 cm × 128.5 cm

	Color	Count (per inch)	Fiber	Yarn	Ply	Spin
Warp	white	9	wool	handspun	1	Z
Weft	red	44	wool	handspun	1	Z
	blue	36	wool	handspun	1	Z
	white	40	wool	handspun	1	Z

*Selvage:* both: two, 3-ply red, handspun, Z, S

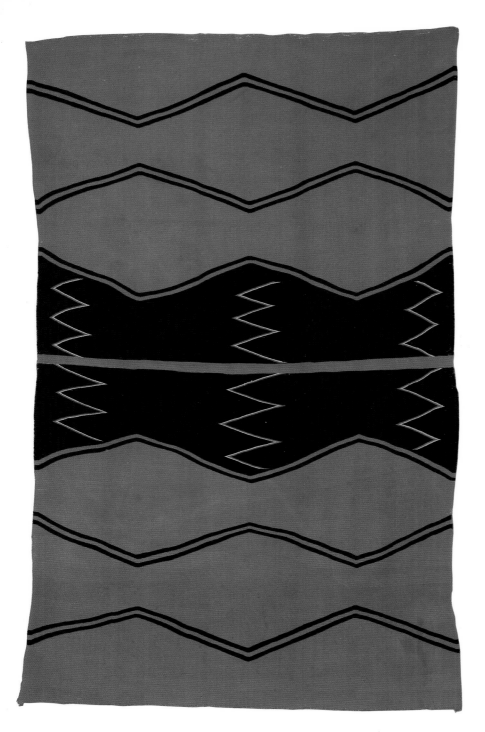

BLANKET, serape, circa 1880–1895
A.5141.42-113
227.5 cm × 135.0 cm

	Color	Count (per inch)	Fiber	Yarn	Ply	Spin	Twist
Warp	white	10	wool	commercial	4	Z	S
Weft	red	44–54	wool	commercial	4	Z	S
	black	52	wool	commercial	4	Z	S
	white	52	wool	commercial	4	Z	S

Selvage: sides: 2 cords: each two, 4-ply red, commercial, Z, S
ends: 2 cords: each three, 4-ply red, commercial, Z, S

# Ponchos

The usual Navajo and Pueblo method of wearing blankets was to wrap them around the person's shoulders with a front overlap. Occasionally, serapes were modified into ponchos either by the weaving of a long, central slit into the textile or by intentionally cutting a hole in the textile and then binding the edges to prevent fraying. This particular atypical modification was most likely another example of Mexican influence.

Only two ponchos are represented in the Hearst collection, and both are fairly unusual in such things as design and choice of yarn.

BLANKET, poncho, circa 1865–1875
A.5141.42-126
218.0 cm × 126.0 cm

	Color	Count (per inch)	Fiber	Yarn	Ply	Spin	Twist
Warp	white (pink?)	12	wool	handspun	1	Z	
Weft	white	46	wool	handspun	1	Z	
	blue	48	wool	handspun	1	Z	
	red 1	50	wool	ravelled	5–9	Z	
	red 2 (cochineal dye)	44	wool	ravelled	3	S	
	red 3	42	wool	ravelled	4	Z	
	grey (faded lavender)	42	wool	ravelled?	5–6		
	green (faded purple)	42	wool	ravelled?	5–6		
	olive green	42	wool	ravelled?	5–6		
	red 4 (arms of 2 people and part of diamond)	42	wool	commercial	(2) 3-ply laid side by side	Z	S

*Selvage:* both: two, 3-ply blue, handspun, Z, S

*Harvey Company tag:* "H-5191   #842015   DAXSS   P.M.   6-10-2"

*Ledger book [-]:* "5191   $85.00   $35.00   Rogers   5/1/2   5½#
Brown and white stripe bayetta fig." [This is obviously a transcription error, as the previous ledger entry ("#5191   $250.00   $103.50   Muniz   6/10 6#   Animated design Poncho Bayeta") does match our textile.]

This textile without a doubt bears the most complex design in the entire Hearst collection. First glance shows overall Saltillo influence, but close inspection reveals dozens of small areas of typical Navajo Classic design motifs combined into one textile with no fewer than nine weft yarns. The pattern and colors change from bottom to top with the inclusion of several human figures and most notably the possible depiction of a Yei figure or holy person. If so, this would be the earliest such use of this figure in a Navajo textile by several decades. The contrast between the two halves almost suggests that two different weavers worked on this most unusual piece. Schweizer's simple description of this textile as "animated" is certainly an understatement.

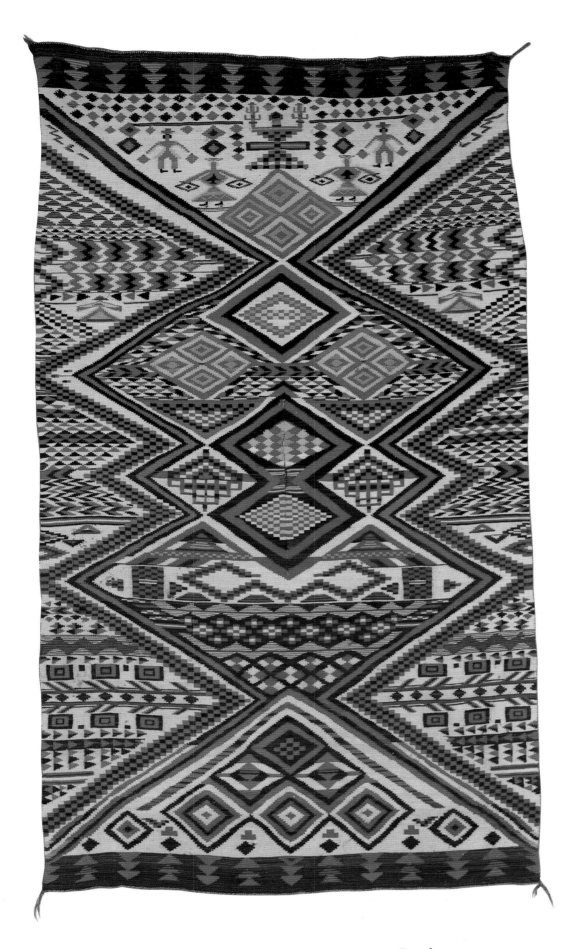

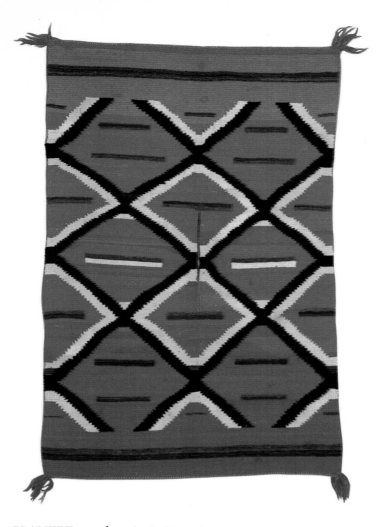

BLANKET, poncho, circa 1880–1895
A.5141.42-190
139.0 cm × 92.0 cm

	Color	Count (per inch)	Fiber	Yarn	Ply	Spin
*Warp*	white	7	wool	handspun	1	Z
*Weft*	red	30	wool	handspun	1	Z
	white	30	wool	handspun	1	Z
	black	30	wool	handspun	1	Z
	grey	30	wool	handspun	1	Z
	green	30	wool	handspun	1	Z

*Selvage:* sides: two, 2-ply red, handspun, Z, S
ends: two, 3-ply red, handspun, Z, S

*Harvey Company tag:* "H-19164    B-41215    RAXS    RW    8-22-10"

*Ledger book:* This particular textile provides an example of Schweizer's practice of using duplicate, but not identical, ledgers.

Ledger at Heard Museum: "19164    $45.00    $8.00    Mrs Wetherell Native wool saddle    red ground    blue and white zigzags."

Ledger at Museum of International Folk Art: "19164    $45.00    $8.00 Mrs. R. Wetherell    8-22-10    Small native wool Poncho    red ground."

The small size of this piece and the central slit indicate its use as a child's poncho. However, the very heavy, coarse handspun yarn and weave must have made it fairly uncomfortable to wear. Even the Harvey Company ledger books disagree, with one calling it a saddle blanket and the other referring to it as a poncho.

# Chief-Style Blankets

This type of Navajo blanket is probably the most easily recognizable and least understood of all of the Classic Period textiles.

As noted in Chapter 1, chief-style blankets evolved through four distinctive patterning phases over the course of the nineteenth century and are numbered by scholars accordingly. The first phase is characterized by simple, broad horizontal stripes, which are interrupted in the second phase by the addition of elongated rectangles in a specific twelve-spot layout. A third phase is distinguished by half, quarter, and whole diamond shapes balanced against the broad horizontal stripes in a reduced nine-spot layout. By the end of the century these diamonds completely overshadow the stripes to create the fourth phase.

Variants can be considered an additional style that do not fit the strict definitions of the formal phases. Hearst recognized the unique nature of these textiles as expressions of a weaver's creativity and added five to his collection.

All of the progressive phases of the chief-style blanket are well represented in the Hearst collection. He was clearly attracted to the beauty and power of these magnificent textiles and amassed a collection of thirty-nine pieces covering the entire hundred-year development of this type of blanket.

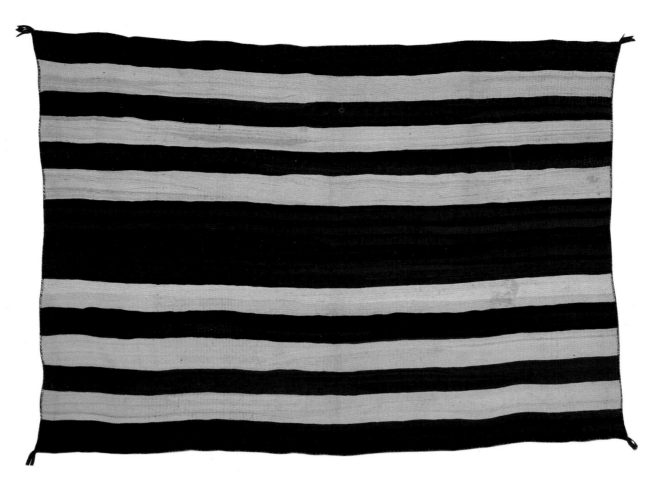

BLANKET, Ute chief style, first phase, circa 1800–1850
A.5141.42-135
142.0 cm × 196.0 cm

	Color	Count (per inch)	Fiber	Yarn	Ply	Spin
*Warp*	white	8	wool	handspun	1	Z
*Weft*	white	44	wool	handspun	1	Z
	black	44	wool	handspun	1	Z
	blue	44	wool	handspun	1	Z

*Selvage:* replaced

*Harvey Company tag:* "H-7582    B-48115    DLAXS    P.M.    10-10-2"

*Ledger book:* Ledger at Heard Museum: "7582    $65.00    $18.00    Muniz Navajo plain stripe."

*Ledger book:* Ledger at Museum of International Folk Art: "7582    42415 $65.00    Muniz    10/10/2    Old Navaho plain stripe."

Historical evidence seems to indicate a preference by Ute peoples of the Great Basin and Plains area for these plain striped textiles in blue, brown, and white only (no red), hence the specific subcategory. Hearst also appears to have favored this particular style, for both chief-style blankets in the collection with first-phase patterning are of the Ute variety.

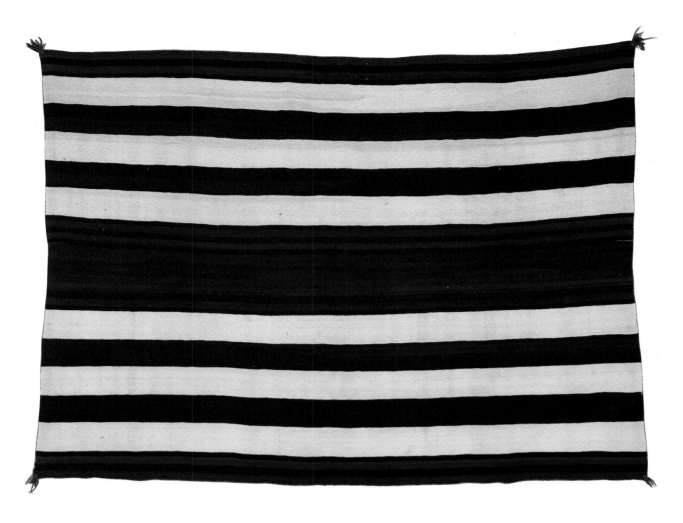

BLANKET, Ute chief style, first phase, circa 1800–1860
A.5141.42-38
132.0 cm × 182.0 cm

	Color	Count (per inch)	Fiber	Yarn	Ply	Spin
Warp	grey, white & black	11	wool	handspun	1	Z
Weft	white	60	wool	handspun	1	Z
	black	60	wool	handspun	1	Z
	blue	60	wool	handspun	1	Z

*Selvage:* both: two, 3-ply blue, handspun, Z, S

*Harvey Company tag:* "H-7027    893215    475    RAXSS    Spiegelberg
    Coll.    Dec. 1901"

*Ledger book:* "7027    $350.00    $125.00    A. F. Spiegelberg Collection No. 1
    purchased in Dec. 1901    Chief's natural blue and white very fine weave"

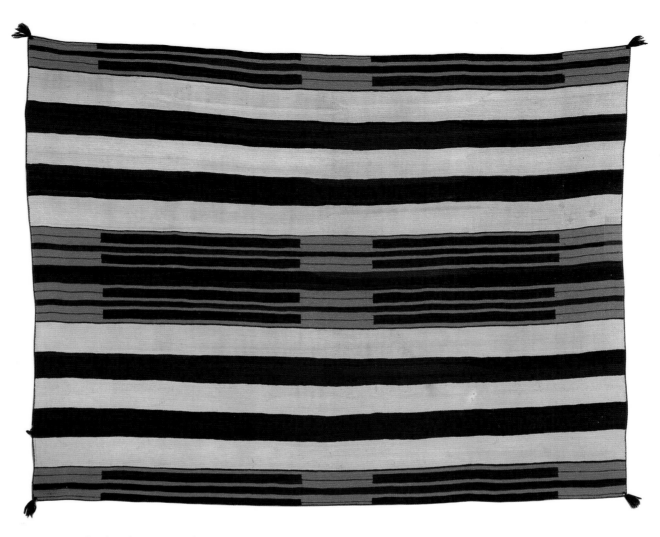

BLANKET, chief style, second phase, circa 1860–1870
A.5141.42-34
145.0 cm × 181.0 cm

	Color	Count (per inch)	Fiber	Yarn	Ply	Spin	Diameter (mm)
Warp	white	10	wool	handspun	1	Z	
Weft	white	52	wool	handspun	1	Z	
	brown-black	54	wool	handspun	1	Z	
	blue	50	wool	handspun	1	Z	
	red	50	wool	ravelled	1	Z	0.8
	blue-green	50	wool	handspun	1	Z	

*Selvage:* replaced

*Harvey Company tag:* "H-20367    B-418115    UXSSS    Mossin Coll."

*Ledger book:* "20367    $450.00    $160.00    Mrs. Mossin    4-3-11
   Chiefs Bayetta squares"

By the middle of the nineteenth century the continuous red and blue horizontal stripes of the first phase had been replaced by elongated rectangles in a twelve-position layout across the blanket; the broad white and brown/black stripes were retained.

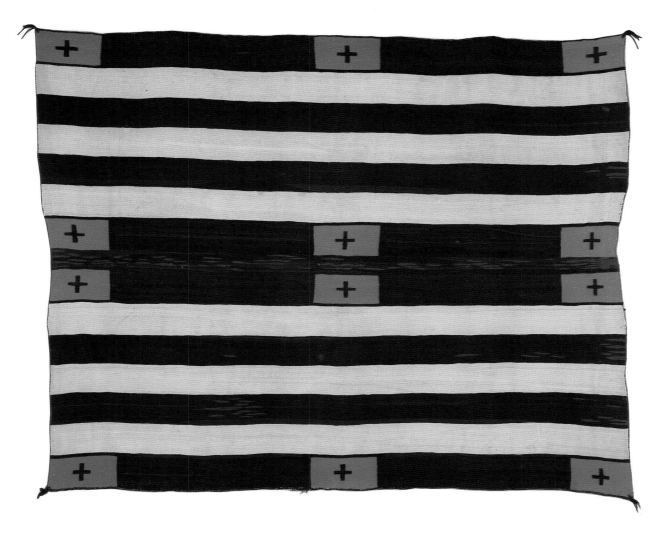

BLANKET, chief style, second phase, circa 1865–1870
A.5141.42-36
148.0 cm × 181.0 cm

	Color	Count (per inch)	Fiber	Yarn	Ply	Spin	Diameter (mm)
Warp	white	13	wool	handspun	1	Z	
Weft	white	54	wool	handspun	1	Z	
	brown-black	60	wool	handspun	1	Z	
	blue	64	wool	handspun	1	Z	
	red (cochineal dye)	64	wool	ravelled	2	Z	0.35

*Selvage:* sides: replaced
ends: two, 3-ply blue, handspun, Z, S

*Harvey Company tag:* "H-5922    89574    $650.00    PM    12/18/2
Very fine bayeta subchief"

*Ledger book:* "5922    $250.00    $55.00    Muniz    Bayetta chiefs"

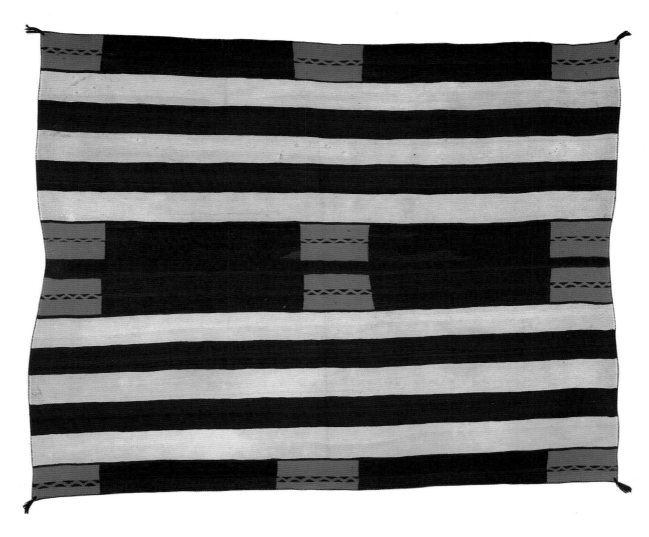

BLANKET, chief style, second phase, circa 1865–1870
A.5141.42-37
150.0 cm × 181.0 cm

	Color	Count (per inch)	Fiber	Yarn	Ply	Spin	Diameter (mm)
*Warp*	white & brown	10	wool	handspun	1	Z	
*Weft*	white	70	wool	handspun	1	Z	
	brown-black	70	wool	handspun	1	Z	
	blue	70	wool	handspun	1	Z	
	medium red	88	wool	ravelled	3	S	0.4
	dark red (cochineal dye)	80	wool	ravelled	3	S	0.4

*Selvage:*  replaced; extensively rewoven in blue areas

*Harvey Company tag:*  "H-24097      B-516615      DAXSS      D. Coll 12/24/13"

*Ledger book:*  "24097      $750.00      $125.00      Diebuis [or Dickens] 12-24-13      Old navaho Bayetta chiefs      12 red bayetta squares with blue intertwined."

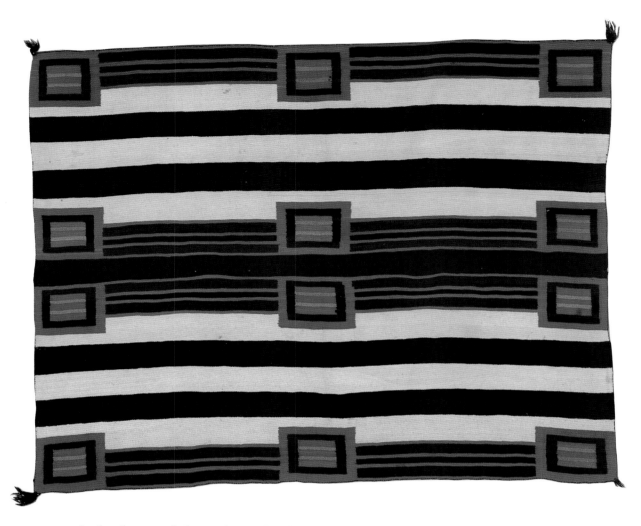

BLANKET, chief style, second phase, circa 1865–1870
A.5141.42-137
140.0 cm × 177.5 cm

	Color	Count (per inch)	Fiber	Yarn	Ply	Spin	Twist	Diameter (mm)
Warp	white	8	wool	handspun	1	Z		
Weft	white	50	wool	handspun	1	Z		
	black	42	wool	handspun	1	Z		
	blue	44	wool	handspun	1	Z		
	burgundy	70	wool	commercial	3	Z	S	
	red	52	wool	ravelled	3	Z		0.5
	green	52	wool	handspun	1	Z		

*Selvage:* both: two, 3-ply navy, handspun, Z, S

*Harvey Company tag:* "A-830    B-520615    Andrus Coll."

*Ledger book:* "830    520615    $850.00    Andrus Collection    4/16/29
   Old chief blanket    red Saxony yarn    native dye green stripes
   block designs"

The block patterns and concentric squares found in blankets 137, 24, 25, and 130 do not easily fit the narrow definition of a second-phase chief-style blanket as having rectangles or squares within the three design bands. Instead, the blocks are enlarged and extend beyond the end and middle bands, well into the ground stripes.

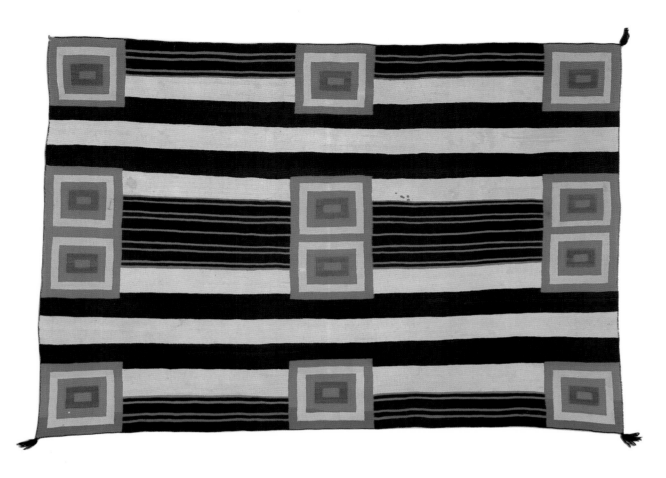

BLANKET, chief style, second phase, circa 1865–1870
A.5141.42-24
139.0 cm × 200.0 cm

	Color	Count (per inch)	Fiber	Yarn	Ply	Spin	Twist	Diameter (mm)
Warp	grey	10	wool	handspun	1	Z		
Weft	white	58	wool	handspun	1	Z		
	black	44	wool	handspun	1	Z		
	blue	52	wool	handspun	1	Z		
	red	48	wool	commercial	3	S	Z	
	maroon	64	wool	commercial	3	S	Z	
	green	56	wool	handspun	1	Z		
	cream	50	wool	ravelled	3	Z		0.5
	cream	64	wool	commercial	3	Z	S	

*Selvage:* replaced

*Harvey Company tag:* "Mr Schweizer: 'Very good Navaho chief design in block design.'"

Instead of limiting herself to narrow blocks within the design bands, the weaver of this textile chose to accentuate the weaving with bold concentric squares that expand well into the background stripes.

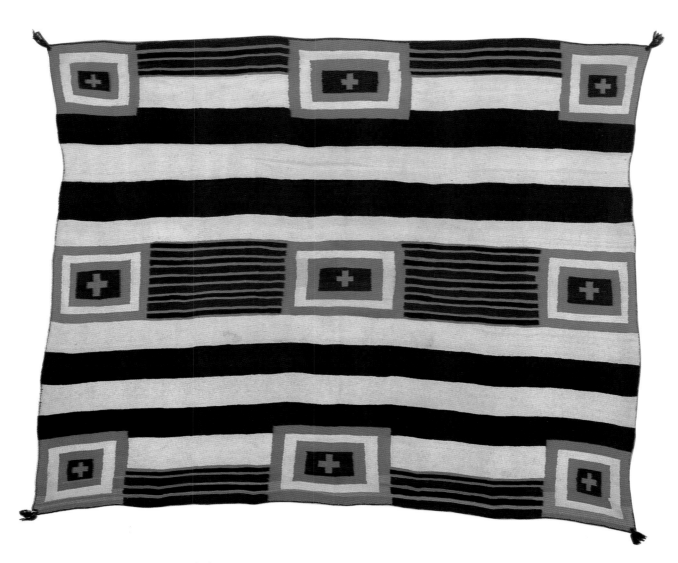

BLANKET, chief style, second phase, circa 1865–1870
A.5141.42-25
163.5 cm × 194.0 cm

	Color	Count (per inch)	Fiber	Yarn	Ply	Spin	Twist
Warp	white	7	wool	handspun	1	Z	
Weft	white	46	wool	handspun	1	Z	
	black	52	wool	handspun	1	Z	
	blue	54	wool	handspun	1	Z	
	red	68	wool	commercial	3	Z	S
	orange	54	wool	commercial	3	Z	S

*Selvage:* replaced

*Harvey Company tag:* "H-17109    B-510315    UXSSS    S. Coll.    4/10/9"

*Ledger book:* "17109    $375.00    $85.00    Arthur Seligman    4/10/9
    Red, white and blue Bayetta chief with squares"

Although all the names, dates, prices, and the descriptions on the tag and in the ledger book match, Schweizer was incorrect in his assessment of the red yarn as bayetta. Neither of the commercial yarns in this textile shows any evidence of having been ravelled.

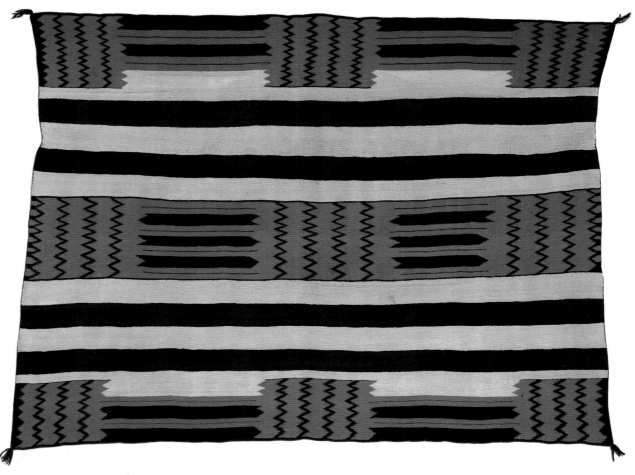

BLANKET, chief style, second phase, circa 1870–1875
A.5141.42-130
136.6 cm × 186.0 cm

	Color	Count (per inch)	Fiber	Yarn	Ply	Spin
*Warp*	grey	10	wool	handspun	1	Z
*Weft*	white	58	wool	handspun	1	Z
	red (cochineal dye)	58	wool	ravelled	3	S
	blue	56	wool	handspun	1	Z
	brown-black	56	wool	handspun	1	Z

*Selvage:* both: three, 2-ply blue, handspun, Z, S

*Harvey Company tag:* "H-24095    B-520115    LAXSS    D. Collection
    12/24/13"

*Ledger book:* "24095    $850.00    $190.00    Dickens    12/24/13
    Chief design with squares    9 squares [        ]ed with blue lightning
    & Red bayetta."

The prominent blocks in this blanket contain vertical zigzag lines in direct opposition to the strong horizontal component.

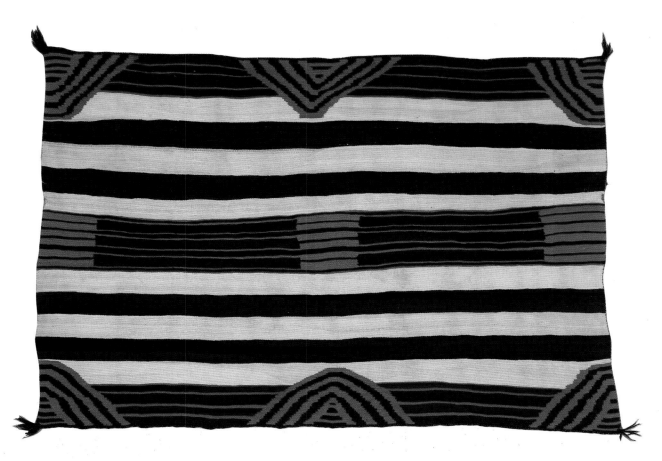

BLANKET, chief style, second and third phase combination, circa 1865–1870
A.5141.42-33
132.0 cm × 189.0 cm

	Color	Count (per inch)	Fiber	Yarn	Ply	Spin	Diameter (mm)
Warp	white	9	wool	handspun	1	Z	
Weft	white	48	wool	handspun	1	Z	
	brown-black	36	wool	handspun	1	Z	
	blue	44	wool	handspun	1	Z	
	red	44	wool	ravelled	1	Z	0.8

*Selvage:* sides: 2 cords: one is three, 3-ply gold, commercial, S, Z
one is one, 3-ply blue, handspun, Z, S
ends: two, 3-ply blue, handspun, Z, S

*Harvey Company tag:* "H-10067    B-48115    B.    6/16/25    $375.00"

*Ledger book:* "10067    $450.00    $50.00    B. G. Wilson    6/16/05
Chiefs blanket, Bayetta and natural wool"

This example of a transitional chief-style blanket shows the block pattern of the
second phase with the quarter and half diamonds of the coming third phase.

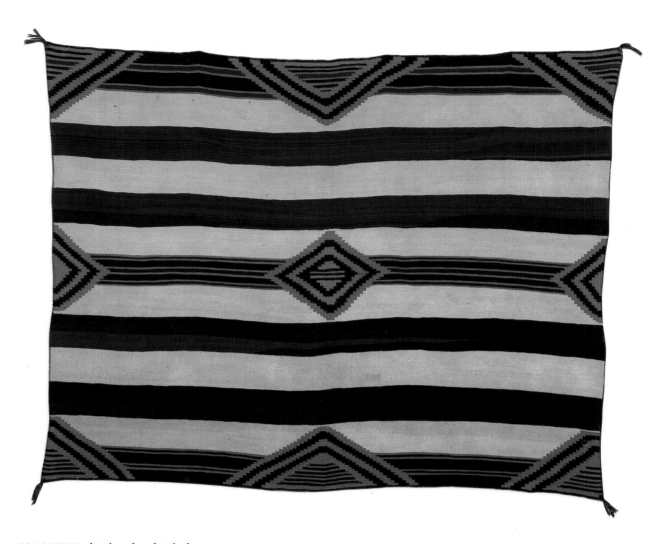

BLANKET, chief style, third phase, circa 1865–1870
A.5141.42-35
135.5 cm × 163.5 cm

	Color	Count (per inch)	Fiber	Yarn	Ply	Spin	Diameter (mm)
*Warp*	white	10	wool	handspun	1	Z	
*Weft*	white	54	wool	handspun	1	Z	
	brown-black	60	wool	handspun	1	Z	
	blue	58	wool	handspun	1	Z	
	red	62	wool	ravelled	3	S	0.4

*Selvage:*  replaced

*Harvey Company tag:*  "H-4475    B-48615    USXSS    WR    12/30/3
    $850.00"

*Ledger book:*  "4475    $95.00    $55.00    W. Rogers    12/20    4⅛#
    Balletta chiefs Blanket"

At first glance the design of a third-phase chief-style blanket might give the impression of unfinished patterning. However, when the textile was worn as intended, around the body and closed in the front, the partial diamonds joined together to complete the symmetry.

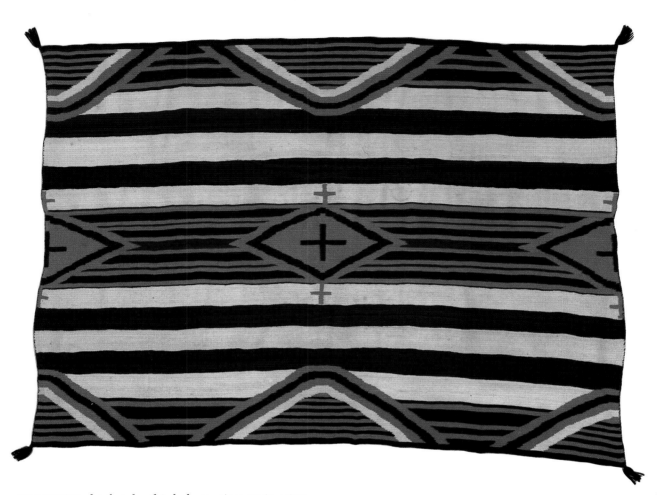

BLANKET, chief style, third phase, circa 1865–1875
A.5141.42-134
124.0 cm × 174.8 cm

	Color	Count (per inch)	Fiber	Yarn	Ply	Spin	Twist	Diameter (mm)
Warp	brown	9	wool	handspun	1	Z		
Weft	white	46	wool	handspun	1	Z		
	brown	46	wool	handspun	1	Z		
	blue	46	wool	handspun	1	Z		
	red 1	48	wool	ravelled	2	Z		0.4
	red 2	56	wool	commercial	3	Z	S	

*Selvage:* both: two, 3-ply navy, handspun, Z, S

*Harvey Company tag:* "A-1088    B-528115    IASXS    JFS    8/19/32"

*Ledger book:* "1088    520615    $550.00    J. F. Snively    Los Angeles
8/19/32    Bayetta chiefs (2 red crosses & 1 blue cross in center)
2 blue half crosses    4 red half crosses    4 Black stripes    49"×67"."

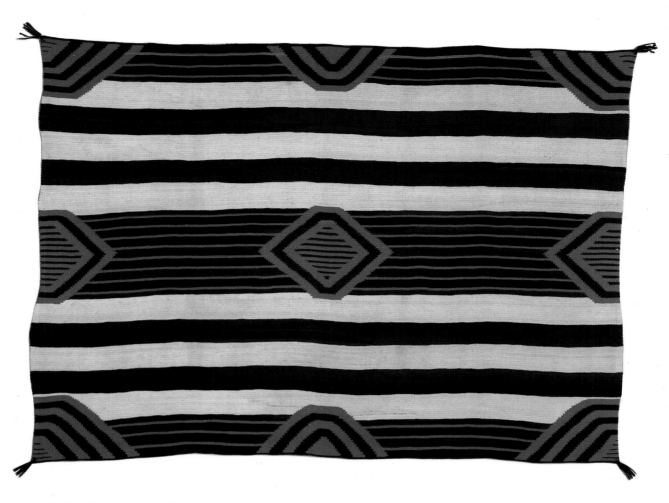

BLANKET, chief style, third phase, circa 1865–1875
A.5141.42-132
128.0 cm × 175.0 cm

	Color	Count (per inch)	Fiber	Yarn	Ply	Spin	Twist	Diameter (mm)
Warp	brown	9	wool	handspun	1	Z		
Weft	white	52	wool	handspun	1	Z		
	brown	52	wool	handspun	1	Z		
	blue	52	wool	handspun	1	Z		
	red 1	68	wool	commercial	3	Z	S	
	red 2	60	wool	ravelled	3	Z		0.45
	rose	56	wool	commercial	3	Z	S	

*Selvage:* sides: two, 3-ply light blue, handspun, Z, S
ends: two, 3-ply navy, handspun, Z, S

*Harvey Company tag:* "H-15326    B-510615    IAXSS    BR    3/26"

*Ledger book:* Ledger at Heard Museum: "$1,000.00    $200.00    Brizzard
3/26/8    Bayetta chiefs    Rare Blkt Color    Perfect condition"

Ledger at Museum of International Folk Art: "$1,000.00    $200.00    Brizzard
3/26/8    Bayetta chief    Rare blkt    rose color    Perfect condition"

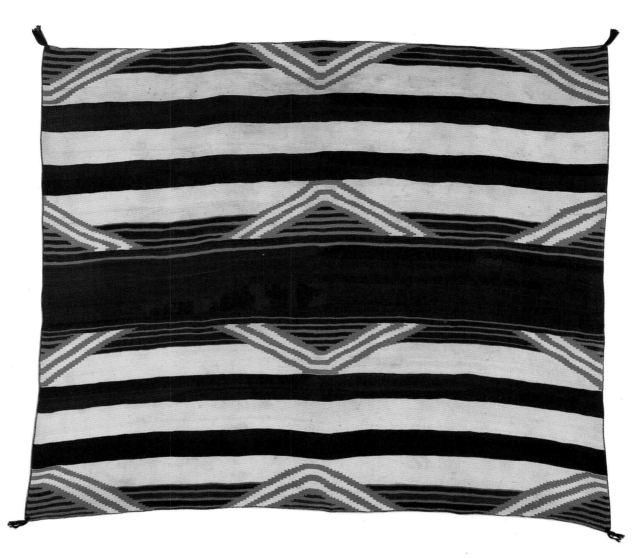

BLANKET, chief style, third phase, circa 1870
A.5141.42-129
141.2 cm × 166.0 cm

	Color	Count (per inch)	Fiber	Yarn	Ply	Spin	Diameter (mm)
Warp	white	12	wool	handspun	1	Z	
Weft	white	64	wool	handspun	1	Z	
	red (lac plus cochineal dye)	66	wool	ravelled	2	S	0.4
	blue	64	wool	handspun	1	Z	
	brown-black	64	wool	handspun	1	Z	

*Selvage:* replaced

*Harvey Company tag:* "H-12012    B-45315    UXSSS    L.    5/7/6"

*Ledger book:* "12,012    $225.00    $25.00    Langer    5/7/6    Chiefs
    rare red white blue and black    all red bayetta wine color."

Laboratory dye analysis of the ravelled red yarn in this blanket shows it to contain
lac *plus* cochineal.

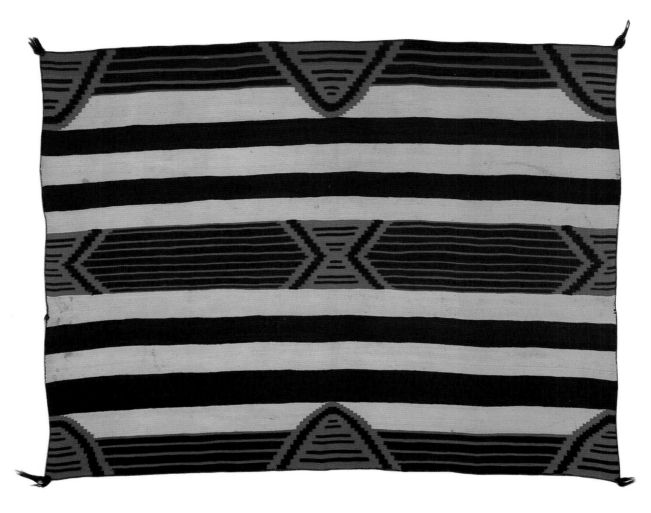

BLANKET, chief style, third phase, variant, circa 1870
A.5141.42-141
137.0 cm × 176.5 cm

	Color	Count (per inch)	Fiber	Yarn	Ply	Spin	Diameter (mm)
*Warp*	lavender	10	wool	handspun	1	Z	
*Weft*	white	60	wool	handspun	1	Z	
	brown	60	wool	handspun	1	Z	
	blue	56	wool	handspun	1	Z	
	red	58	wool	handspun	2	S	0.4

*Selvage:* both: two, 3-ply navy, handspun, Z, S

*Harvey Company tag:* "H-4473    #898415    UXSSS    WR    Balletta"

*Ledger book:* "4473    $325.00    $150.00    W. Rogers    12/20    5#
    Balletta chiefs blanket"

Instead of containing the normal diamond and half-diamond shapes, the central stripe in this blanket uses an hourglass motif.

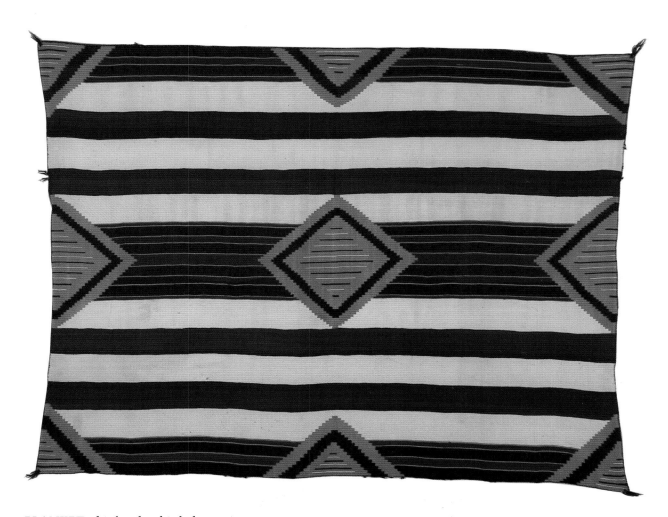

BLANKET, chief style, third phase, circa 1870–1875

A.5141.42-133

144.0 cm × 185.0 cm

	Color	Count (per inch)	Fiber	Yarn	Ply	Spin	Twist	Diameter (mm)
*Warp*	white	12	wool	handspun	1	Z		
*Weft*	white	64	wool	handspun	1	Z		
	brown	64	wool	handspun	1	Z		
	blue	64	wool	handspun	1	Z		
	red	72	wool	commercial	3	Z	S	
	yellow	64	wool	ravelled	2	Z		0.35

*Selvage:* both: two, 3-ply blue, handspun, Z, S

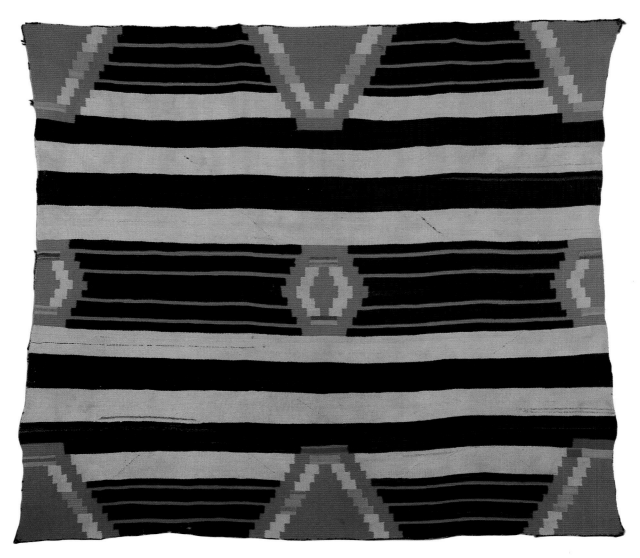

BLANKET, chief style, third phase, circa 1870–1875
A.5141.42-29
157.0 cm × 177.0 cm

	Color	Count (per inch)	Fiber	Yarn	Ply	Spin	Twist
Warp	white	7	wool	handspun	1	Z	
Weft	white	48	wool	handspun	1	Z	
	brown-black	44	wool	handspun	1	Z	
	navy	52	wool	handspun	1	Z	
	orange-red	56	wool	commercial	3	Z	S
	green	42	wool	handspun	1	Z	
	yellow	48	wool	handspun	1	Z	
	dark red	56	wool	commercial	3	S	Z

*Selvage:*    sides:    missing
            ends:     two, 3-ply navy handspun, Z, S

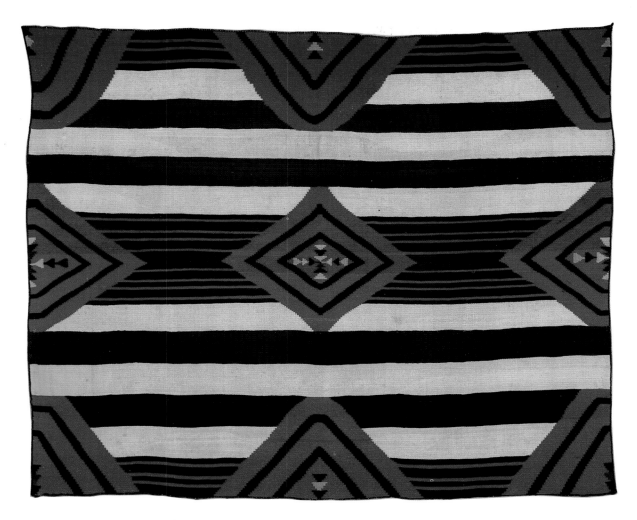

BLANKET, chief style, third phase, circa 1870–1875
A.5141.42-30
153.5 cm × 185.0 cm

	Color	Count (per inch)	Fiber	Yarn	Ply	Spin	Diameter (mm)
Warp	white	10	wool	handspun	1	Z	
Weft	white	64	wool	handspun	1	Z	
	brown-black	58	wool	handspun	1	Z	
	blue	58	wool	handspun	1	Z	
	orange	60	wool	ravelled	3	Z	0.4
	green	56	wool	ravelled	3	Z	0.45
	red 1	56	wool	ravelled	2 red	S	0.4
					1 purple	Z	0.4
	red 2	56	wool	ravelled	1 red	S	0.5
					2 burgundy	S	0.4
	blue-green	46	wool	handspun	1	Z	

*Selvage:* sides: two, 3-ply blue handspun, Z, S
ends: replaced

*Harvey Company tag:* "H-4550    #89894    HSXSXS    PM    2/19/2
    Balletta    chiefs"

*Ledger book:* "4550    $250.00    $100.00    P. Muniz    2/19    6#
    Balletta chiefs blanket    brown & white stripes"

The striking and unusual shade of deep red in this blanket is the result of combining two plies of burgundy yarn with one ply of a more purple shade into a 3-ply ravelled yarn. The mottled color on the other end is also due to the combination of two very different shades of ravelled yarn.

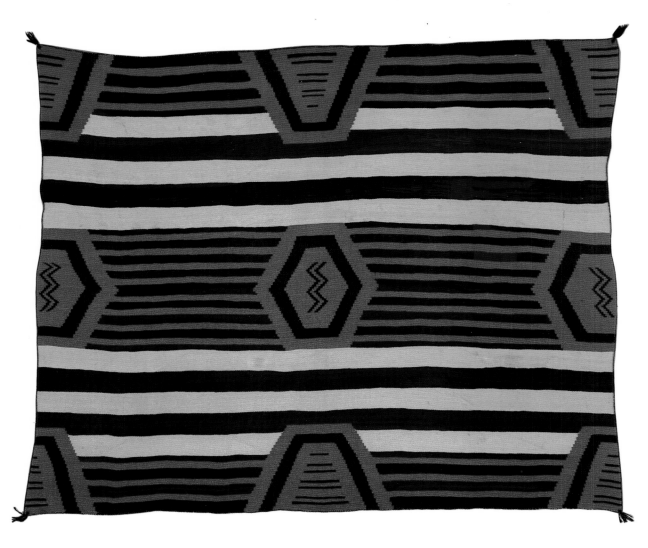

BLANKET, chief style, third phase, circa 1870–1875
A.5141.42-143
150.0 cm × 179.5 cm

	Color	Count (per inch)	Fiber	Yarn	Ply	Spin	Diameter (mm)
*Warp*	white	10	wool	handspun	1	Z	
*Weft*	white	66	wool	handspun	1	Z	
	brown	66	wool	handspun	1	Z	
	blue	66	wool	handspun	1	Z	
	burgundy	50	wool	recarded and respun ravelled?	1	Z	0.7

*Selvage:* replaced

The short, vertical zigzag bars incorporated into the central band signal a shift from the horizontal emphasis found in designs prior to 1870.

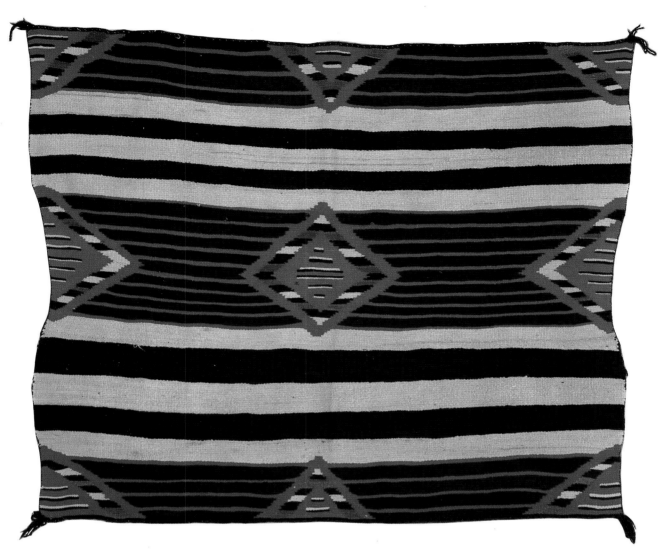

BLANKET, chief style, third phase, circa 1870–1875

A.5141.42-148

125.5 cm × 148.5 cm

	Color	Count (per inch)	Fiber	Yarn	Ply	Spin	Twist
Warp	brown and white	8	wool	handspun	1	Z	
Weft	white	34	wool	handspun	1	Z	
	brown	30	wool	handspun	1	Z	
	blue	30	wool	handspun	1	Z	
	burgundy	54	wool	commercial	3	Z	S
	green	34	wool	handspun	1	Z	

*Selvage:* sides: two, 2-ply blue, handspun, Z, S

ends: two, 3-ply blue, handspun, Z, S

*Harvey Company tag:* "H-8819    #89834    $175.00    Rec. L.    6/30/4"

*Ledger book:* "8819    $175.00    $40.00    Rec. Lost" [possibly: record lost?]

A noticeable feature of this blanket is its small size. Most blankets of this style appear to have been intended for use by men, whose size would thus have required a greater width and length. This one may have been woven for a child.

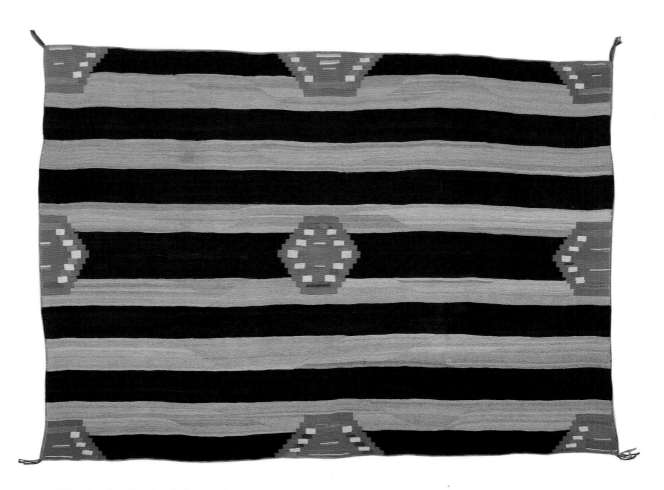

BLANKET, chief style, third phase, circa 1870–1875
A.5141.42-145
123.0 cm × 161.5 cm

	Color	Count (per inch)	Fiber	Yarn	Ply	Spin	Diameter (mm)
*Warp*	white	10	wool	handspun	1	Z	
*Weft*	grey	52	wool	handspun	1	Z	
	brown	48	wool	handspun	1	Z	
	blue	52	wool	handspun	1	Z	
	rose	60	wool	ravelled	2	Z	0.4
	white	52	wool	handspun	1	Z	
	green	52	wool	handspun	1	Z	

*Selvage:* replaced

*Harvey Company tag:* "H-7217    B-47615    AXSSS    P.M.    10-10-2"

*Ledger book [–]:* "7217    $40.00    $15.00    Mex    1/5    Old Chimallo"

The use of grey wool in place of white for the background striping and the soft rose color for the small stepped diamonds gives this blanket an unusually subdued appearance. Also noteworthy is the narrow width of the three design bands, giving, at first glance, the impression of even striping.

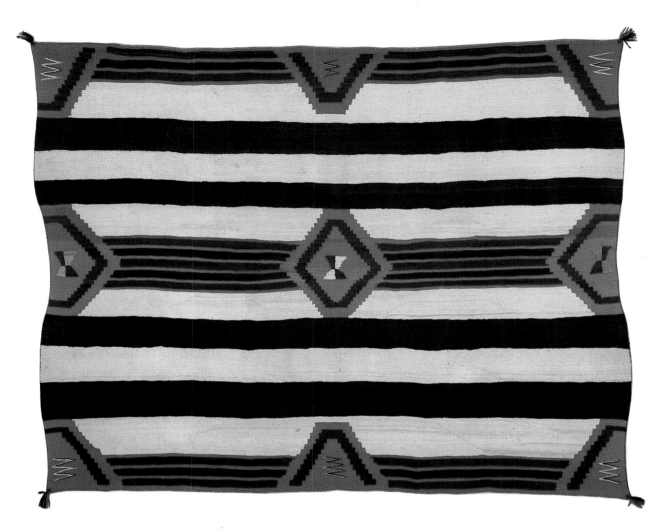

BLANKET, chief style, third phase, circa 1870–1875
A.5141.42-28
147.0 cm × 185.5 cm

	Color	Count (per inch)	Fiber	Yarn	Ply	Spin	Twist
Warp	white	11	wool	handspun	1	Z	
	brown	11	wool	handspun	1	Z	
Weft	white	36	wool	handspun	1	Z	
	brown	38	wool	handspun	1	Z	
	blue	36	wool	handspun	1	Z	
	red	42	wool	commercial	3	Z	S
	burgundy	42	wool	commercial	3	Z	S
	green	44	wool	handspun	1	Z	

*Selvage:* sides: two, 2-ply handspun, blue, Z, S
ends: two, 2-ply handspun, red, Z, S

*Harvey Company tag:* "H-20930    B-413615    DAXSS    D. Albuq.
5-27-11"

*Ledger book:* "20,930    $500.00    $100.00    Lea A. Douglas    5-27-11
Old chief's lightning pattern in corners. Green figures."

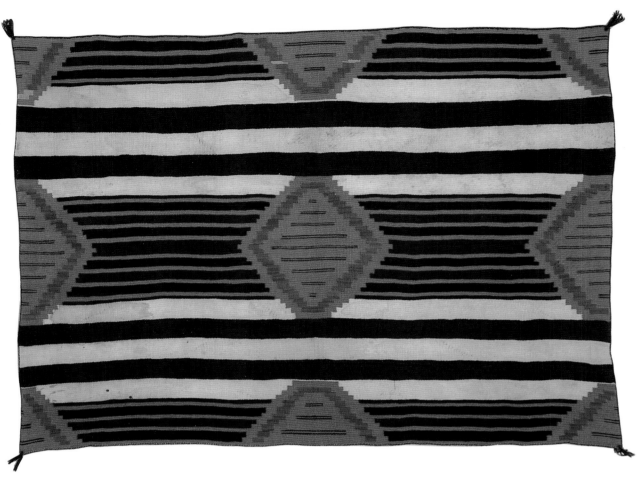

BLANKET, chief style, third phase, circa 1870–1875
A.5141.42-146
133.0 cm × 186.0 cm

	Color	Count (per inch)	Fiber	Yarn	Ply	Spin	Diameter (mm)
*Warp*	white	7	wool	handspun	1	Z	
*Weft*	white	50	wool	handspun	1	Z	
	black	48	wool	handspun	1	Z	
	red	52	wool	recarded and respun ravelled	1	Z	1.0
	green	44	wool	handspun	1	Z	
	blue	48	wool	handspun	1	Z	
	yellow	44	wool	handspun	1	Z	

*Selvage:* replaced

*Harvey Company tag:* "M-24351   B-524615   IAXSS   D. Collection"

*Ledger book:* "24,351   $850.00   $225.00   Dickens   12/24/13
Old Bayetta Chiefs   Dia Fig green   Amer Bayetta"

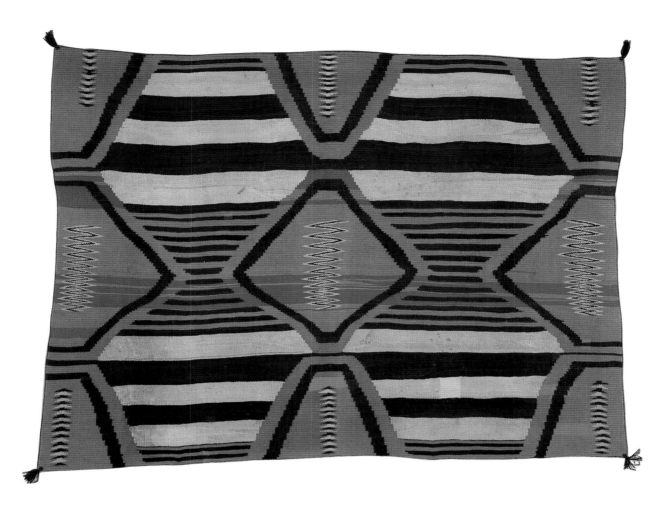

BLANKET, chief style, third phase, circa 1870–1875

A.5141.42-27

127.0 cm × 172.0 cm

	Color	Count (per inch)	Fiber	Yarn	Ply	Spin	Twist	Diameter (mm)
*Warp*	white	9	wool	handspun	1	Z		
*Weft*	white	54	wool	handspun	1	Z		
	brown-black	54	wool	handspun	1	Z		
	blue	56	wool	handspun	1	Z		
	orange-red	58	wool	ravelled	1	S		0.9
	deep red	46	wool	ravelled	3–6	S		0.4
	red	58	wool	commercial	3	Z	S	

*Selvage:* replaced

*Harvey Company tag:* "H-20348 B-49615 DAXSS B.P. 2/26/11"

*Ledger book:* "20,348 $400.00 $55.00 B. Phillips 2-26-11
Chief's bayetta Lightning and diamonds"

As the third phase of the chief-style blanket developed, the design emphasis was increasingly focused on larger and more dominant diamond shapes against the striped ground.

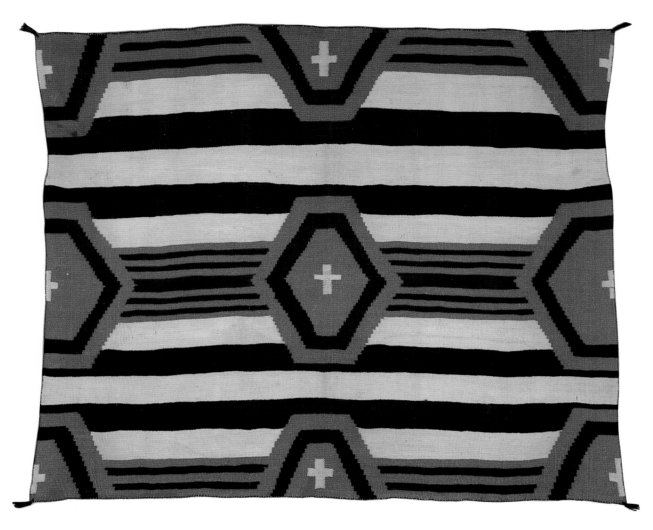

BLANKET, chief style, third phase, circa 1870–1875
A.5141.42-31
145.0 cm × 174.0 cm

	Color	Count (per inch)	Fiber	Yarn	Ply	Spin	Diameter (mm)
Warp	white	9	wool	handspun	1	Z	
Weft	white	48	wool	handspun	1	Z	
	brown-black	38	wool	handspun	1	Z	
	blue	40	wool	handspun	1	Z	
	red	48	wool	ravelled?	1	Z	0.8

*Selvage:* replaced

*Harvey Company tag:* "H-28635    B-510615    UXSSS    TCS    4/15/16"

*Ledger book:* "28,635    $600.00    $80.00    Irene L. Secord    4/15/16
Full bayetta chief white crosses in design."

The slight discrepancy between the initials on the tag and the name in the ledger can be accounted for by Schweizer's handwriting style.

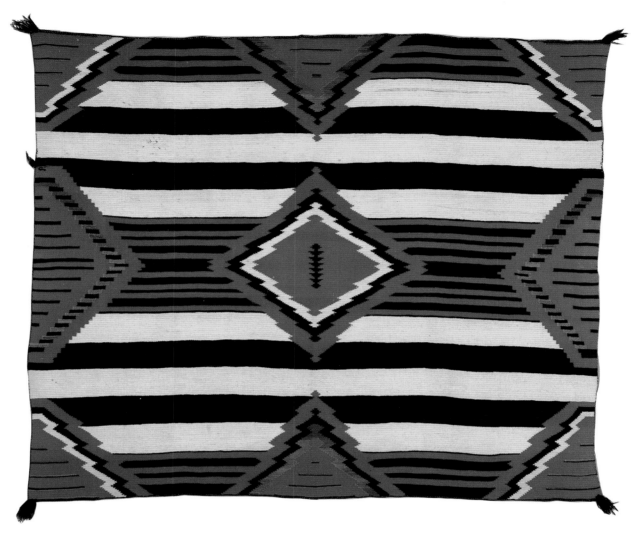

BLANKET, chief style, third phase, circa 1870–1875

A.5141.42-136

152.2 cm × 177.0 cm

	Color	Count (per inch)	Fiber	Yarn	Ply	Spin	Twist
*Warp*	white	9	wool	handspun	1	Z	
*Weft*	white	52	wool	handspun	1	Z	
	black	52	wool	handspun	1	Z	
	blue	52	wool	handspun	1	Z	
	green	50	wool	handspun	1	Z	
	red	52	wool	commercial	3	S	Z

*Selvage:* both: two, 3-ply navy, handspun, Z, S

*Harvey Company tag:* "A-548    B-525615    HAXSXS    Andrus Coll.    B."

*Ledger book [–]:* "548    8443    $22.50    P.M.    12/9/27    Semi-mod
    Double saddle    Red ground    4 bds of light rose    1 band across center
    —4 zigzag stripes in center." [This is obviously not a description of our
    textile.]

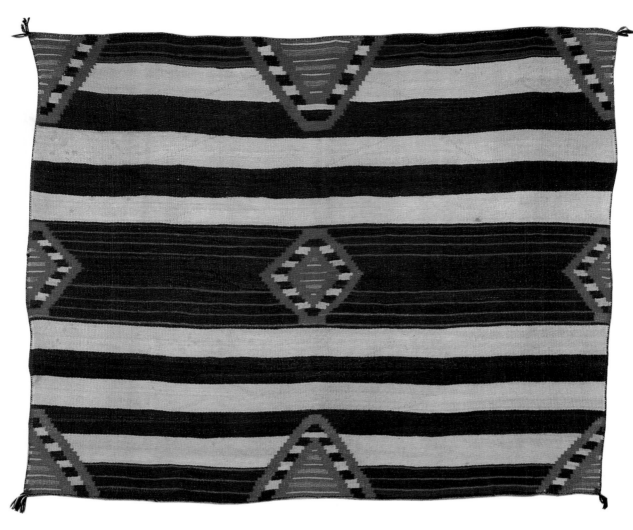

BLANKET, chief style, third phase, circa 1870–1880
A.5141.42-142
115.0 cm × 138.0 cm

	Color	Count (per inch)	Fiber	Yarn	Ply	Spin
*Warp*	white	8	wool	handspun	1	Z
*Weft*	white	42	wool	handspun	1	Z
	brown	40	wool	handspun	1	Z
	blue	40	wool	handspun	1	Z
	burgundy	56	wool	recarded and respun ravelled?	1	Z
	pink	42	wool	recarded red and white	1	Z
	yellow	42	wool	handspun	1	Z

*Selvage:* replaced

*Harvey Company tag:* "H-4474    #89644    WOR    12-2-2    Bayetta chief"

*Ledger book:* "4474    $85.00    $40.00    W. Rogers    12/20    3¼#    Balletta chiefs"

As with number 148, the small size of this blanket may indicate that it was meant to be worn by a child.

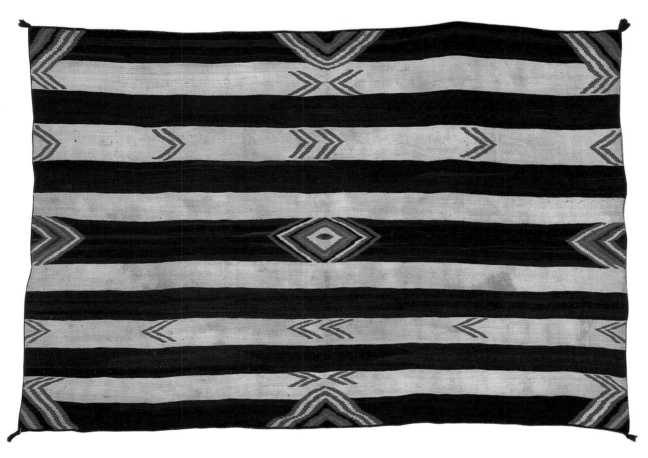

BLANKET, chief style, third phase, circa 1875–1880
A.5141.42-39
158.0 cm × 228.0 cm

	Color	Count (per inch)	Fiber	Yarn	Ply	Spin	Twist	Diameter (mm)
Warp	white	8	wool	handspun	1	Z		
Weft	white	44	wool	handspun	1	Z		
	brown	44	wool	handspun	1	Z		
	blue	48	wool	handspun	1	Z		
	red 1	40	wool	handspun	1	Z		
	red 2	44	wool	ravelled	5–9	S		0.3
	green	44	wool	commercial	4	Z	S	

*Selvage:* replaced

*Harvey Company tag:* "H-4475    B-48615    UAXSS    WR    12/30/3
    $850.00"

*Ledger book:* "4475    $95.00    $55.00    W. Rogers    12/20    4⅛#
    Balletta chiefs Blanket"

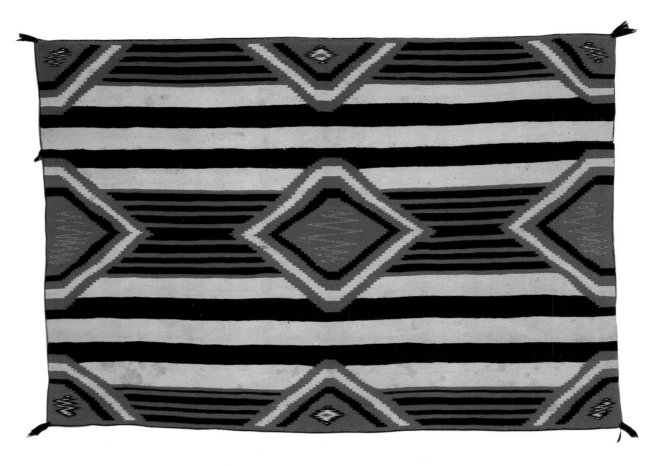

BLANKET, chief style, third phase, circa 1875–1885
A.5141.42-131
134.9 cm × 194.0 cm

	Color	Count (per inch)	Fiber	Yarn	Ply	Spin	Twist
*Warp*	white	11	wool	handspun	1	Z	
*Weft*	red	50	wool	recarded and respun flannel?	1	Z	
	white	50	wool	handspun	1	Z	
	black	50	wool	handspun	1	Z	
	blue	50	wool	handspun	1	Z	
	yellow	64	wool	commercial	4	Z	S
	green	64	wool	commercial	4	Z	S

*Selvage:* both: three, 3-ply navy, handspun, Z, S

*Harvey Company tag:* "H-9114    #89334    HLAXS    Rec. Lab.    12/6/4    Bayetta"

*Ledger book [–]:* "9114    $175.00    $35.00    Manning    10/28/14    Natural wool    red and white    black figures"

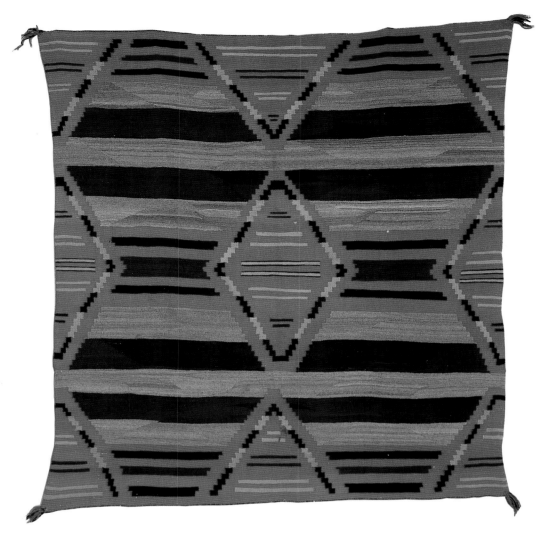

BLANKET, chief style, third phase, circa 1880–1885
A.5141.42-139
171.0 cm × 164.0 cm

	Color	Count (per inch)	Fiber	Yarn	Ply	Spin
Warp	white	9	wool	handspun	1	Z
Weft	red	44	wool	handspun	1	Z
	grey	44	wool	handspun	1	Z
	brown	44	wool	handspun	1	Z
	blue	44	wool	handspun	1	Z
	yellow	44	wool	handspun	1	Z

*Selvage:* sides: 2 cords: each three, 2-ply red, commercial, S, Z
ends: two, 3-ply navy, handspun, Z, S

*Harvey Company tag:* "H-17114    B-513115    RASXS    AS    4-10-09
Green native dye"

*Ledger book:* "17,114    513115    $750.00    Arthur Seligman    4/10/9
Chiefs rose-grey-red black large diamond    all native wool    yellow stripes"

The enlarged diamonds, so large that they almost join, nearly overshadow the grey and black striped ground and are indicators of the culmination of this style of textile. Originally to be used as shoulder blankets, chief-style blankets were woven wider than long: however, the greater length of this piece, combined with a heavier weight, signals the end of this wearing style and the beginning of the development of a rug market. Some scholars might consider this textile an example of the fourth phase of chief-style patterning.

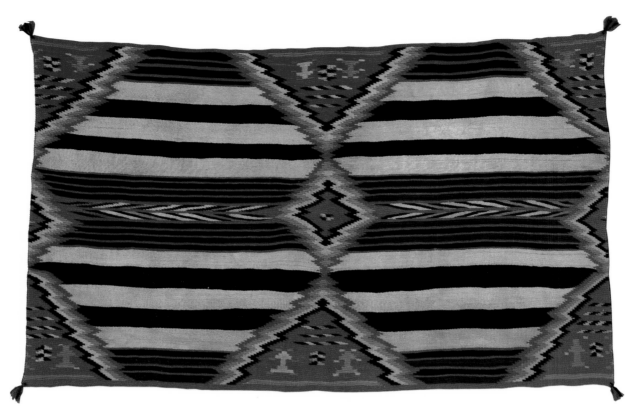

BLANKET, chief style, third phase, circa 1880–1890
A.5141.42-144
122.3 cm × 194.5 cm

	Color	Count (per inch)	Fiber	Yarn	Ply	Spin
*Warp*	grey	6	wool	handspun	1	Z
*Weft*	red	32	wool	handspun	1	Z
	white	32	wool	handspun	1	Z
	black	32	wool	handspun	1	Z
	blue	32	wool	handspun	1	Z
	orange	32	wool	handspun	1	Z
	green	32	wool	handspun	1	Z

*Selvage:* replaced

*Harvey Company tag:* "H-8810    #89024    JFH    5-28-4
   Old native wool & dye    Rare chiefs blanket"

*Ledger book:* 8810    $75.00    $15.00    JFH    5/28

This late chief-style blanket expands upon the traditional format by using highly serrate-edged diamonds and bold color combinations to create an eyedazzler pattern.

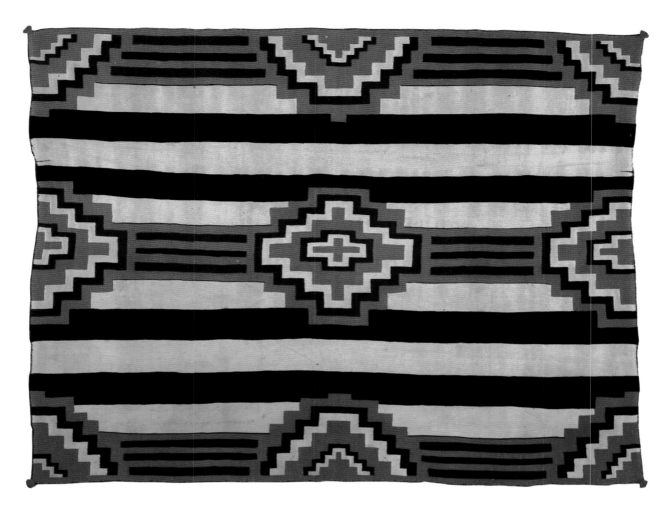

BLANKET, chief style, third phase, circa 1880–1890
A.5141.42-140
161.4 cm × 209.2 cm

	Color	Count (per inch)	Fiber	Yarn	Ply	Spin	Twist
Warp	white	13	cotton string				
Weft	white	50	wool	commercial	4	Z	S
	black	50	wool	commercial	4	Z	S
	red	50	wool	commercial	4	Z	S
	purple	50	wool	commercial	4	Z	S

*Selvage:* both: multiple-ply, purple, commercial yarns

*Harvey Company tag:* "A-361    B-511615    A.N.J.    5-27"

*Ledger book:* "361    511615    $450.00    5/18/27    A. N. Johnson
Old Germantown chief's pattern    large size    fine weave
colors purplish blue white & red"

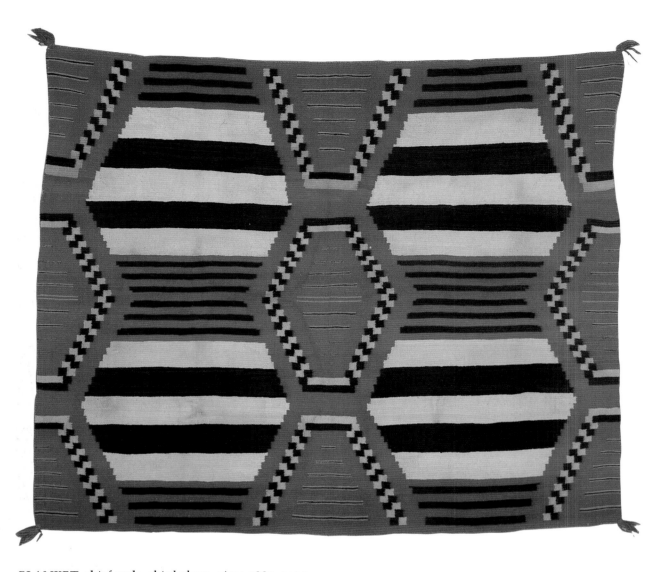

BLANKET, chief style, third phase, circa 1885–1900
A.5141.42-147
168.0 cm × 194.5 cm

	Color	Count (per inch)	Fiber	Yarn	Ply	Spin
Warp	white	10	cotton string			
Weft	red	44	wool	handspun	1	Z
	white	48	wool	handspun	1	Z
	black	44	wool	handspun	1	Z
	blue	48	wool	handspun	1	Z
	orange	44	wool	handspun	1	Z
	yellow	46	wool	handspun	1	Z

*Selvage:* sides: one, 3-ply orange, handspun, Z, S
one, 3-ply red, handspun, Z, S
ends: two, 3-ply red, handspun, Z, S

The diamonds in this end-of-the-century chief-style blanket, which in blankets of earlier phases were separate and less dominant, merge together and are emphasized even further by the bold yellow and blue terracing/checkerboard.

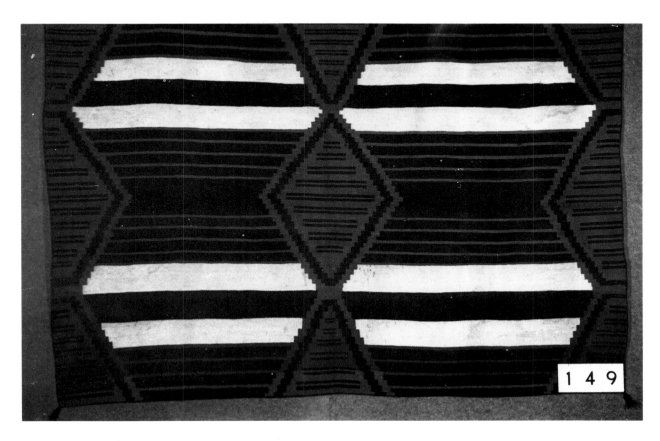

BLANKET (missing), chief style, third phase
A.5141.42-149
56" × 78"

Warp:  9/inch
Weft:  42/inch

*Selvage:*  replaced

*Catalogue card:*  "Man's shoulder blanket, chief style. Broader than long. Very clear pattern. Only one black stripe, two white. Center design band with wide black stripe in middle, and finer indigo and black stripes on red ground at each side. Diamond motifs large, connect at peaks, of red with blue terrace outline, and blue pairs of lines in center. Non-native red yarn."

*Harvey Company tag:*  "H-24,785    B-47115    M.    6-9-14"

*Ledger book:*  "24,785    $50.00    L. R. Markell    6-9-14
    Chiefs full Amer Bayetta    Originally Dickens coll."

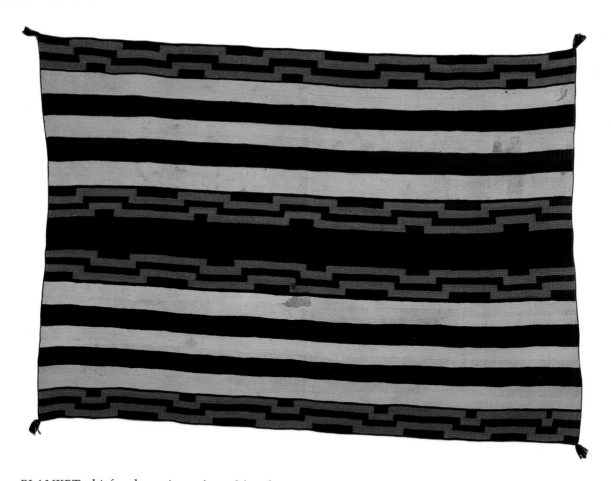

BLANKET, chief style, variant, circa 1865–1875
A.5141.42-32
137.0 cm × 182.0 cm

	Color	Count (per inch)	Fiber	Yarn	Ply	Spin	Diameter (mm)
Warp	white	10	wool	handspun	1	Z	
Weft	red (cochineal dye)	58	wool	ravelled	1	Z	0.8
	blue	56	wool	handspun	1	Z	
	white	48	wool	handspun	1	Z	
	brown-black	54	wool	handspun	1	Z	

*Selvage:* replaced

*Harvey Company tag:* "H-24,102    B-517115    DAXS    D. Coll.
12/24/13"

*Ledger book:* "24,102    $1750.00    $165.00    Dickens    12/24/13
Bayetta chief with grecian design in 4 Red and Blue lines"

Not all blankets adhere to the rigid groupings established and imposed by Navajo textile scholars, nor should the reader expect unfailing conformity. Although cultural pressure to produce within a norm was strong, the Bosque Redondo confinement turned the weaver's world upside down. Furthermore, because chief blankets were often traded to other Indian groups, the weavers probably felt less constrained by custom.

The five blankets in this grouping are variations on the chief theme. In every one the basic background of wide white and black/brown stripes is present. The unusual formatting of the blue and red creates the "variation."

Joe Ben Wheat (pers. comm. 1985) considers blankets exemplified by numbers 32, 150, and 22 "a style unto themselves" and refers to them as "shoulder blankets with continuous band pattern."

Variant 32 has a double meander line in red which Herman Schweizer called a "grecian design."

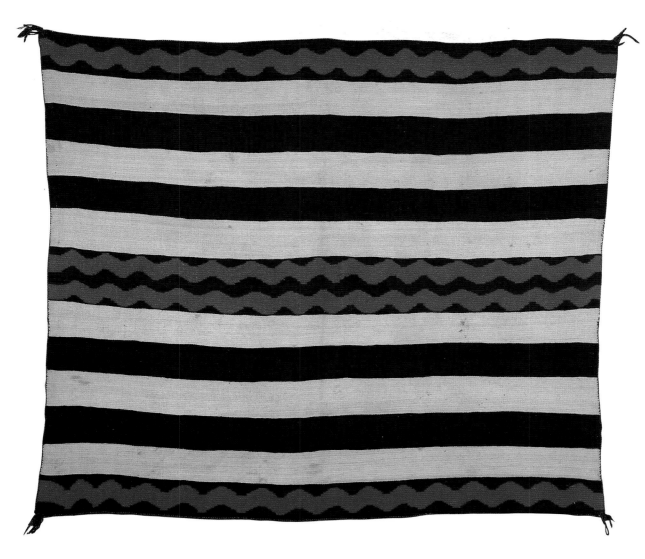

BLANKET, chief style, variant, circa 1865–1875
A.5141.42-150
147.5 cm × 168.0 cm

	Color	Count (per inch)	Fiber	Yarn	Ply	Spin	Diameter (mm)
Warp	grey and white	9	wool	handspun	1	Z	
Weft	white	50	wool	handspun	1	Z	
	brown	46	wool	handspun	1	Z	
	blue	52	wool	handspun	1	Z	
	red	48	wool	recarded and respun ravelled?	1	Z	1.0

*Selvage:*  both:  two, 3-ply blue, handspun, Z, S

*Harvey Company tag:*  "H-7616     B-45265     PM     10-10-2     Bayetta"

*Ledger book:*  "7616     $175.00     $40.00     Muniz     10/10/2
     Stripe with Balletta scroll

In this blanket the traditional plain horizontal stripe layout is embellished with wavy red lines.

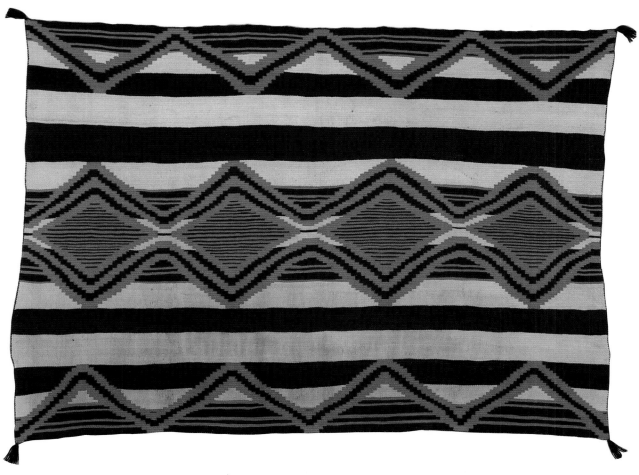

BLANKET, chief style, variant, circa 1870–1875

A.5141.42-138

145.5 cm × 198.0 cm

	Color	Count (per inch)	Fiber	Yarn	Ply	Spin	Diameter (mm)
Warp	white	8	wool	handspun	1	Z	
Weft	white	36	wool	handspun	1	Z	
	black	36	wool	handspun	1	Z	
	red	36	wool	ravelled	2	S	0.7
	blue	36	wool	handspun	1	Z	

*Selvage:* replaced

*Harvey Company tag:* "45242    B-520615    RLAXS    MH    8/26
   Bayetta"

*Ledger book:* "45,242    515615    $450.00    M. Langer    8/9/26
   Old Chiefs pattern    Bayetta    fairly heavy    4½ diamonds"

In a dramatic departure from the standard layout, the connected diamonds and horizontal zigzags in this blanket convey a lively feeling of movement.

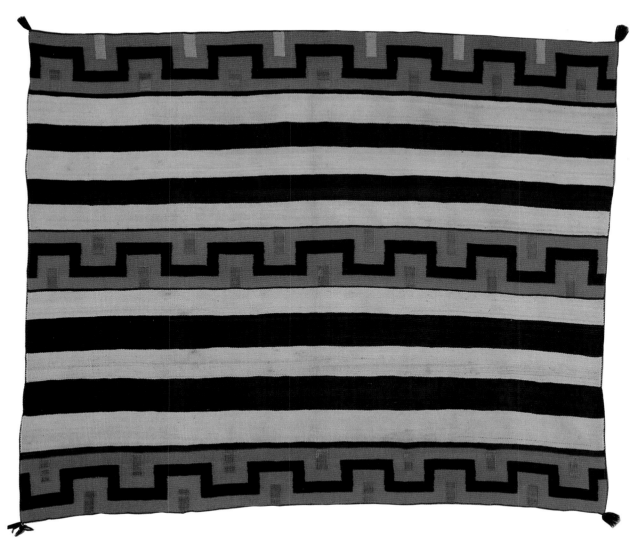

BLANKET, chief style, variant, circa 1875–1885

A.5141.42-22

141.0 cm × 163.5 cm

	Color	Count (per inch)	Fiber	Yarn	Ply	Spin	Twist
*Warp*	brown	9	wool	handspun	1	Z	
*Weft*	red	58	wool	commercial	4	Z	S
	white	52	wool	handspun	1	Z	
	blue	58	wool	handspun	1	Z	
	black	44	wool	handspun	1	Z	
	green	60	wool	recarded blue and yellow	1	Z	
	tan	52	wool	commercial	4	Z	S

*Selvage:* replaced

*Harvey Company tag:* "H-36062    B-48615    DLAXS    W.    8/9/22"

*Ledger book:* "36,062    $175.00    B-44615    48615    $40.00
      Whalen Curio Store L.A.    8/9    Old navajo chief's design
   3 bands of red with blue wall of Troy and green blocks"

Similar to number 32; green rectangles have been added to the red design bands. Schweizer referred to this meandering line specifically as the "wall of Troy" rather than as just a "grecian design."

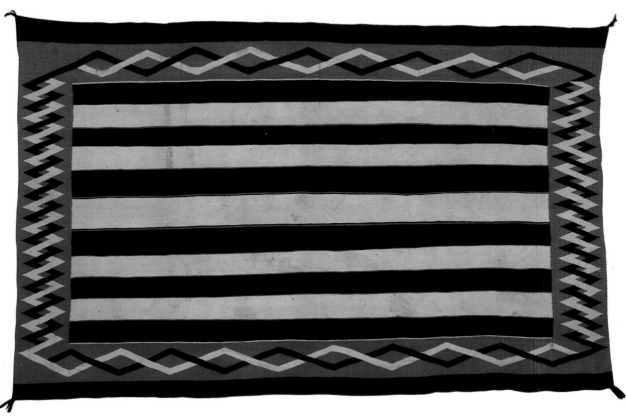

BLANKET, chief style, variant, circa 1885–1895
A.5141.42-26
130.0 cm × 191.0 cm

	Color	Count (per inch)	Fiber	Yarn	Ply	Spin	Twist
*Warp*	white	11	wool	handspun	1	Z	
*Weft*	white	48	wool	commercial	4	Z	S
	red	48	wool	commercial	4	Z	S
	dark blue	48	wool	commercial	4	Z	S
	medium blue	50	wool	commercial	4	Z	S
	black	48	wool	commercial	4	Z	S

*Selvage:* both: two, 3-ply blue commercial, Z, S

*Harvey Company tag:* "H-19136     B-43115     $150.00     W. Coll.     8/22/10
    Mr. Schweizer: 'quite unique.'"

*Ledger book:* "19136     $125.00     $20.00     Mrs. Wetherell     8/22/10
    A chiefs design     black and white stripe center—red border all around"

This late-nineteenth-century textile combines the simple horizontal striping of the earlier chief's blanket with the eyedazzling zigzag so popular at this period, and then adds the newly emerging border technique to create a unique piece.

~~~~~~~~~~~~~~~~~~~~~~~~~~~~~~~~~~~~~~~~~~~~~~~~~~~~~~~~~~~~~~~~~

Women's Garments

According to historic photographs, Navajo women generally wore the same blankets as the men, with two exceptions: chief's blankets and dresses.

The woman's version of the chief-style blanket is generally distinguished from the man's on the basis of narrower horizontal stripes and a use of grey and black instead of white and black. Additionally, the blanket's size is reduced overall.

Dresses were patterned after those worn by Pueblo women. However, rather than being made of a single, wide piece folded in half and sewn only along one edge, Navajo dresses consisted of two separate textiles sewn together along both sides.

BLANKET, woman's wearing-dress style, circa 1875–1895
A.5141.42-120
130.6 cm × 71.0 cm

| | Color | Count (per inch) | Fiber | Yarn | Ply | Spin | Twist |
|---|---|---|---|---|---|---|---|
| *Warp* | white | 14 | cotton string | | 4 | Z | S |
| *Weft* | rose | 54 | cotton string | | 4 | Z | S |
| | black | 54 | cotton string | | 4 | Z | S |
| | green | 54 | cotton string | | 4 | Z | S |
| | yellow | 54 | cotton string | | 4 | Z | S |
| | red | 30 | wool | commercial | 4 | Z | S |
| | maroon | 30 | wool | commercial | 4 | Z | S |

Selvage: sides: 2 cords: each two, 4-ply black, cotton string
ends: 2 cords: each three, 4-ply grey, cotton string

Woven in the style of a woman's wearing dress, this textile is highly unusual because nearly all of it was made from commercial cotton string. Such string was commercially available to the Navajo from the 1860s on, but because it wore out too easily, its use was discouraged by such traders as Hubbell and the Harvey Company.

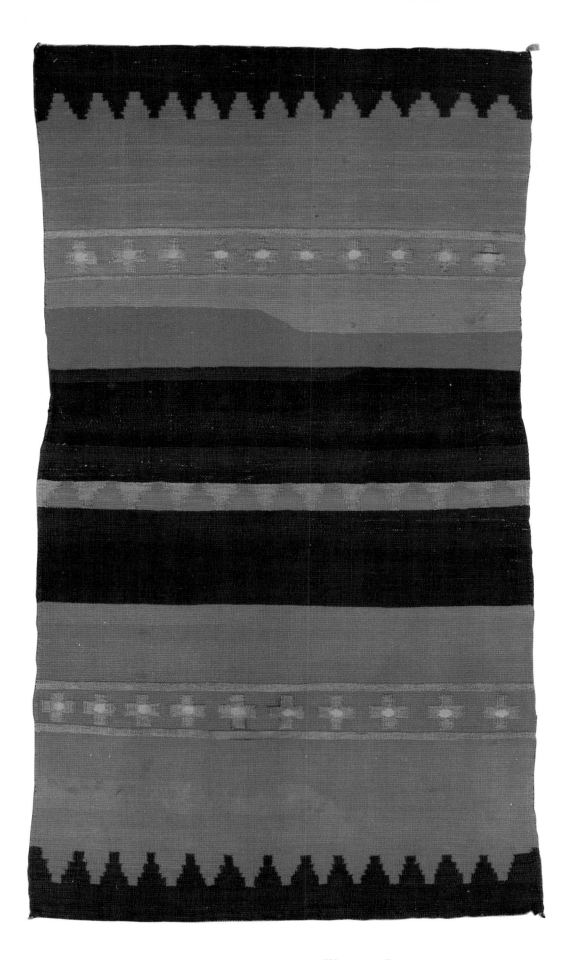

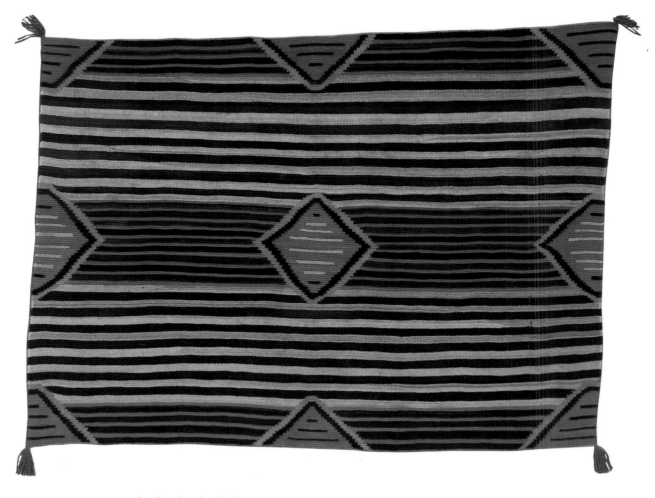

BLANKET, woman's chief style, third phase, circa 1875–1890
A.5141.42-191
98.5 cm × 136.0 cm

| | Color | Count (per inch) | Fiber | Yarn | Ply | Spin |
|---|---|---|---|---|---|---|
| *Warp* | white | 7 | wool | handspun | 1 | Z |
| *Weft* | grey | 34 | wool | handspun | 1 | Z |
| | black | 34 | wool | handspun | 1 | Z |
| | red | 34 | wool | handspun | 1 | Z |
| | orange | 34 | wool | handspun | 1 | Z |
| | blue | 34 | wool | handspun | 1 | Z |

Selvage: sides: replaced
ends: two, 3-ply orange-red, handspun, Z, S

Harvey Company tag: "A-1060 B-44615 Wilbur Coll. #17"

Ledger book: "1060 44615 X $125.00 #17 Wilbur Coll. 1/16/31
Chiefs design sqaw shawl native wool & dyes grey stripes"

The intended wearer of this textile was either a very small woman or a child. A third possibility is that because of the relatively late weaving date of this piece it may not have been intended to be of a functional size but instead was made for sale.

Child's and Saddle Blankets

The confusing, imprecise, and often incorrect terminology involving the classification of Navajo textiles is readily apparent in the next three groupings: child's, child's/saddle, and saddle blankets.

The textiles in the first group are referred to as child's blankets largely because of their small size, complex patterning, and tight weave. Most of them could also be described as serapes, as they exhibit many of the same characteristics merely scaled down.

It is often difficult to distinguish precisely between child's and saddle blankets. Intended for heavy-duty use, saddle blankets are thought to have a thicker and looser weave and also bear less elaborate patterning. To add to the uncertainty, nearly all of the blankets of this size were described in the Harvey Company ledgers as saddle blankets.

Interestingly, the bulk of the child's/saddle blankets in this collection, as well as in others, date to the first or second decade immediately following Bosque Redondo. The shortage of wool, contact with soldiers and their horses, and the establishment of trading posts may all provide clues about the proliferation of this particular size of textile during these years. Once this trend has been examined more closely, perhaps the original question of wearing blanket versus saddle blanket can be answered.

Original intended use aside, this particular type of Navajo textile greatly appealed to Hearst, for he collected no fewer than forty-two examples, making them the most represented blanket type in his collection.

BLANKET, child's, circa 1865
A.5141.42-74
118.0 cm × 72.0 cm

| | Color | Count (per inch) | Fiber | Yarn | Ply | Spin | Twist | Diameter (mm) |
|---|---|---|---|---|---|---|---|---|
| Warp | white | 11 | wool | handspun | 1 | Z | | |
| Weft | white | 64 | wool | handspun | 1 | Z | | |
| | orange-red | 70 | wool | ravelled | 2 | Z | | 0.45 |
| | red 1 | 70 | wool | ravelled | 2 | Z | | 0.4 |
| | burgundy 1 | 70 | wool | ravelled | 2 | Z | | 0.4 |
| | burgundy 2 | 64 | wool | commercial | 3 | Z | S | |
| | red 2 | 64 | wool | commercial | 3 | Z | S | |
| | pink | 64 | wool | recarded red and white | 1 | Z | | |
| | blue | 64 | wool | handspun | 1 | Z | | |
| | green | 70 | wool | ravelled | 3–6 | Z | | 0.35 |

Selvage: sides: two, 5-ply red, ravelled, Z, S
ends: two, 3-ply blue, handspun, Z, S

Harvey Company tag: "H-7808 89614 $125.00 JC [or JO] 5/13/6
Very finest old bayetta saddle"

Ledger book: "7808 $125.00 $18.00 Olivas 5/13
Balletta saddle"

Early LACMNH correspondence files indicate that this blanket once bore a tag on it reading, "Corp. Bloomfield E. Wells, Co. H, Little Rock." Military service records from the National Archives and the state of Iowa indicate that Corporal Wells served in Company H of the 33rd Iowa Volunteer Infantry in Arkansas from 1862 to February 1865. He was then discharged for promotion to second lieutenant and served at Camp Rankin in northeastern Colorado until he was mustered out November 29, 1865. Military pension records further indicate that he lived his entire life in Iowa subsequent to his military service. Corporal Wells may have collected this blanket either in Arkansas or during his brief stay in Colorado before resuming his civilian life as an Iowa farmer.

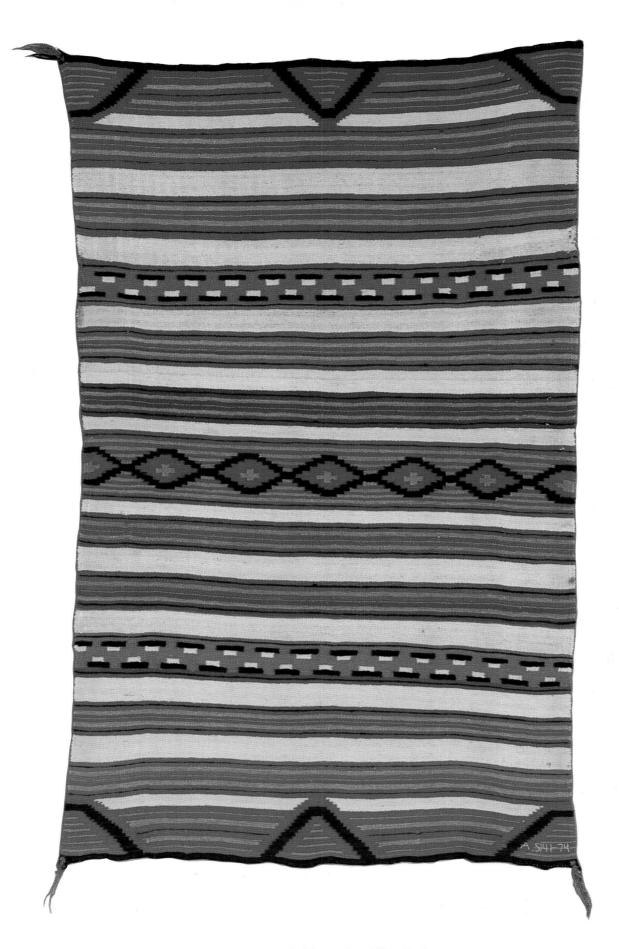

Child's and Saddle Blankets 101

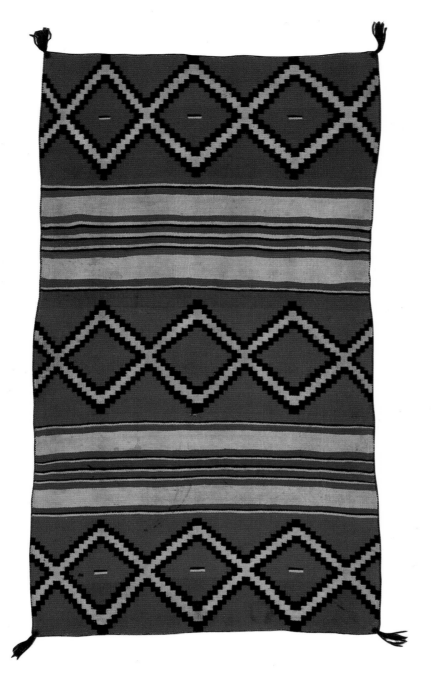

BLANKET, child's, circa 1865–1870

A.5141.42-66

120.0 cm × 70.0 cm

| | Color | Count (per inch) | Fiber | Yarn | Ply | Spin | Twist | Diameter (mm) |
|---|---|---|---|---|---|---|---|---|
| Warp | white | 11 | wool | handspun | 1 | Z | | |
| Weft | white | 66 | wool | handspun | 1 | Z | | |
| | blue | 58 | wool | handspun | 1 | Z | | |
| | red 1 | 58 | wool | commercial | 3 | Z | S | |
| | red 2 | 58 | wool | ravelled | 3 | S | | 0.3 |

Selvage: replaced

Harvey Company tag: "H-13840 B-44615 YYAXS BC 6/10/7"

Ledger book: "13840 $125.00 $30.00 Bert Phillips 6/15/7
 Small bayetta Saddle Red white & blue"

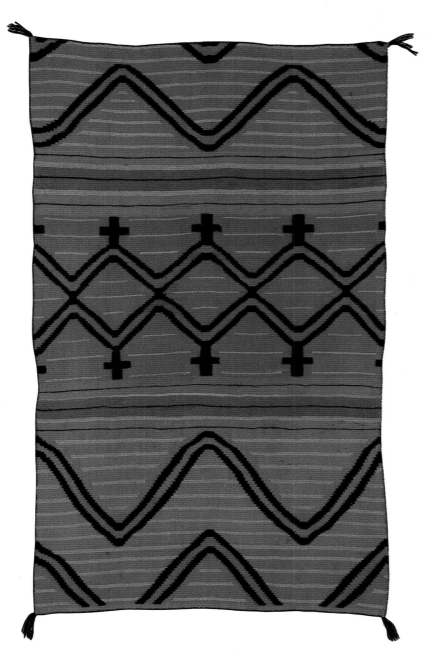

BLANKET, child's, circa 1865–1870
A.5141.42-180
122.5 cm × 74.0 cm

| | Color | Count (per inch) | Fiber | Yarn | Ply | Spin | Twist | Diameter (mm) |
|---|---|---|---|---|---|---|---|---|
| Warp | white | 12 | wool | handspun | 1 | Z | | |
| Weft | red 1 | 60 | wool | ravelled | 3 | Z | | 0.4 |
| | red 2 | 68 | wool | ravelled | 3 | S | | 0.35 |
| | burgundy | 56 | wool | commercial | 3 | Z | S | |
| | blue | 62 | wool | handspun | 1 | Z | | |
| | pink | 62 | wool | red and white recarded | 1 | Z | | |

Selvage: replaced

Harvey Company tag: "H-23769 B-47615 J.C. 11-4-3"

Ledger book: "23,769 $175.00 $70.00 J. W. Clarke 11/4/3
 Full bayetta Saddle Red & blue"

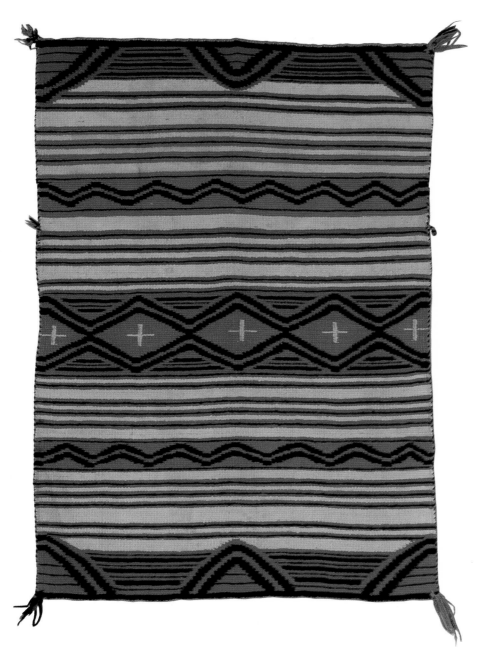

BLANKET, child's, circa 1865–1875
A.5141.42-176
113.2 cm × 77.0 cm

| | Color | Count (per inch) | Fiber | Yarn | Ply | Spin | Diameter (mm) |
|---|---|---|---|---|---|---|---|
| *Warp* | white | 8 | wool | handspun | 1 | Z | |
| *Weft* | white | 44 | wool | handspun | 1 | Z | |
| | red | 64 | wool | ravelled | 3 | S | 0.45 |
| | blue | 44 | wool | handspun | 1 | Z | |
| | orange-red | 50 | wool | handspun | 1 | Z | |

Selvage: sides: one, 3-ply navy, handspun, Z, S
one, 3-ply pink (recarded red and white), handspun, Z, S
ends: two, 3-ply pink (recarded red and white), handspun, Z, S

Harvey Company tag: "H-15331 B-42615 Br 3-26-6"

Ledger book: "15,331 $75.00 $20.00 Brizzard 3-26-8
Bayetta saddle 5 white crosses in center"

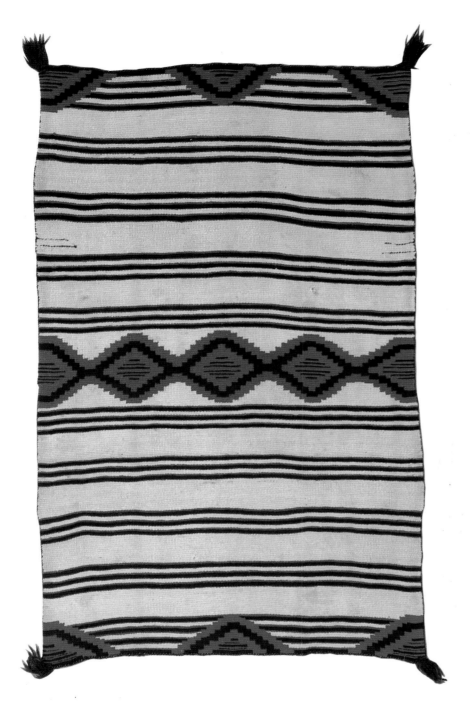

BLANKET, child's, circa 1865–1875
A.5141.42-76
136.0 cm × 86.0 cm

| | Color | Count (per inch) | Fiber | Yarn | Ply | Spin | Twist |
|-------|-------|------------------|-------|------------|-----|------|-------|
| Warp | white | 9 | wool | handspun | 1 | Z | |
| Weft | white | 34 | wool | handspun | 1 | Z | |
| | blue | 34 | wool | handspun | 1 | Z | |
| | red 1 | 40 | wool | handspun? | 1 | Z | |
| | red 2 | 54 | wool | commercial | 3 | Z | S |

Selvage: both: two, 3-ply blue, handspun, Z, S

Harvey Company tag: "H-11719 B-45615 HLAXS FM 3/26/6"

Ledger book: "11,719 $75.00 $13.00 F. Muniz 3/23"

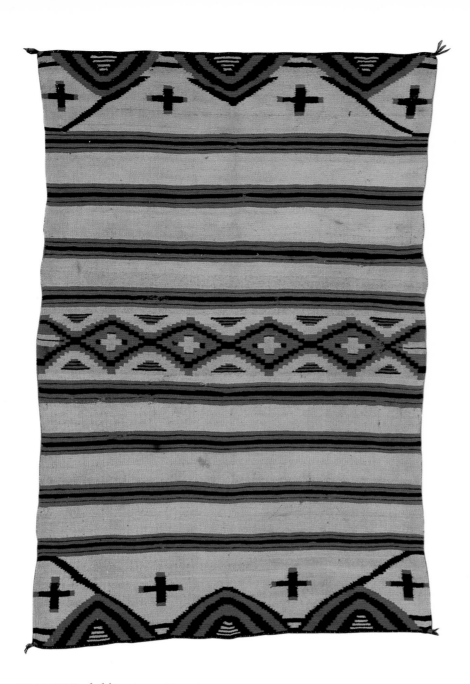

BLANKET, child's, circa 1865–1875
A.5141.42-173
131.0 cm × 84.5 cm

| | Color | Count (per inch) | Fiber | Yarn | Ply | Spin | Diameter (mm) |
|---|---|---|---|---|---|---|---|
| Warp | brown and white | 10 | wool | handspun | 1 | Z | |
| Weft | white | 48 | wool | handspun | 1 | Z | |
| | blue | 48 | wool | handspun | 1 | Z | |
| | red (cochineal dye) | 54 | wool | ravelled | 2–4 | Z | 0.4 |

Selvage: sides: two, 3-ply red, commercial, Z, S
 ends: two, 3-ply navy, handspun, Z, S

Harvey Company tag: "A-649 B-510615 DLAXS"

Ledger book: "649 510615 $375.00 Bettye Willie 3/6/28
 Bayetta saddle, white ground 4 blue & red crosses each end. 4 white &
 center bayetta & blue ½ diamonds on end"

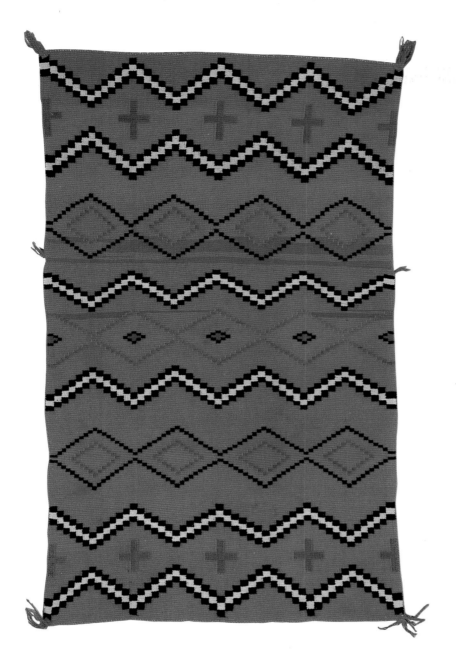

BLANKET, child's, circa 1865–1875
A.5141.42-182
126.5 cm × 77.5 cm

| | Color | Count (per inch) | Fiber | Yarn | Ply | Spin | Twist |
|---|---|---|---|---|---|---|---|
| Warp | white | 10 | wool | handspun | 1 | Z | |
| Weft | orange-red | 58 | wool | commercial | 3 | Z | S |
| | deep red | 58 | wool | commercial | 3 | Z | S |
| | blue | 52 | wool | handspun | 1 | Z | |
| | white | 52 | wool | handspun | 1 | Z | |
| | green | 62 | wool | commercial | 3 | Z | S |

Selvage: sides: 2 cords: each three, 3-ply red, commercial, Z, S
 ends: 2 cords: each four, 3-ply red, commercial, Z, S

Harvey Company tag: "H-15650 B-42615 L. 8-8-8"

Ledger book: "15,650 $85.00 $20.00 M. Langer 8/8/8 Saddle.
 Zepher red white blue green figures"

BLANKET, child's, circa 1865–1875
A.5141.42-181
132.5 cm × 79.0 cm

| | Color | Count (per inch) | Fiber | Yarn | Ply | Spin | Twist | Diameter (mm) |
|---|---|---|---|---|---|---|---|---|
| *Warp* | white | 13 | wool | commercial | 3 | Z | S | |
| *Weft* | red 1 | 54 | wool | commercial | 3 | Z | S | |
| | red 2 | 68 | wool | ravelled | 4 | S | | 0.35 |
| | red 3 | 62 | wool | commercial | 3 | S | Z | |
| | burgundy | 64 | wool | commercial | 3 | Z | S | |
| | white | 58 | wool | handspun | 1 | Z | | |
| | blue | 54 | wool | handspun | 1 | Z | | |
| | purple | 56 | wool | native blue and ravelled red recarded | 1 | Z | | |
| | pink | 56 | wool | native white and ravelled red recarded | 1 | Z | | |
| | yellow | 62 | wool | ravelled | 3 | Z | | 0.35 |
| | brown | 64 | wool | ravelled | 3 | S | | 0.45 |

Selvage: both: two, 3-ply navy, handspun, Z, S

Harvey Company tag: "A-1050 B-514115 RYAXS Wilbur Coll. #1
Bayetta Very rare different kinds of ravelled material"

Ledger book: "1050 $425.00 514115 #1 Wilbur Coll. 1/16/31
Bayetta saddle blkt. Very rare. different kinds of ravelled material"

As is typical of the textiles woven just after internment at Bosque Redondo, many small bits of yarn appear all mixed together in one piece, reflecting the supply shortage. In this piece the textural difference between handspun and commercial yarn is especially obvious.

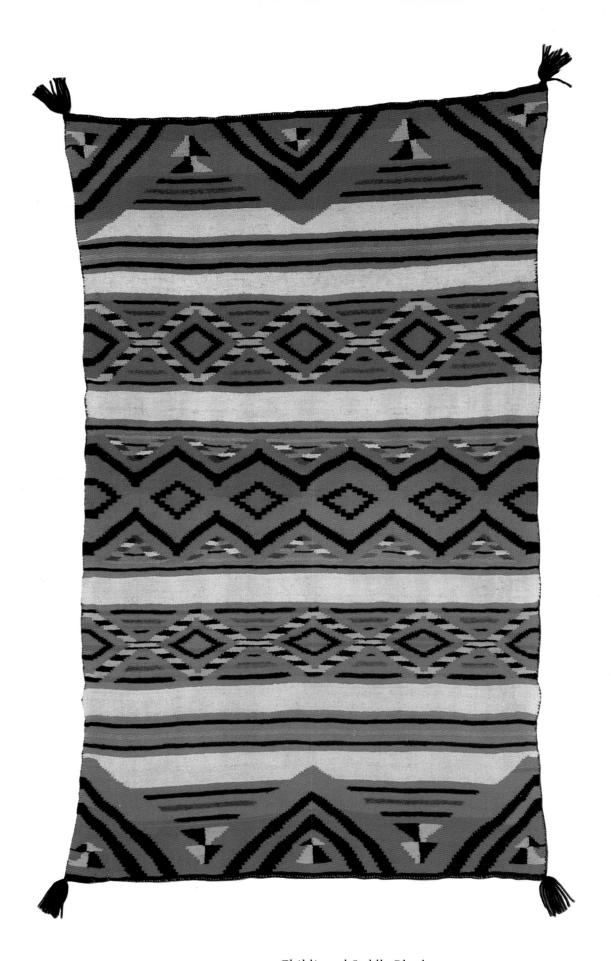

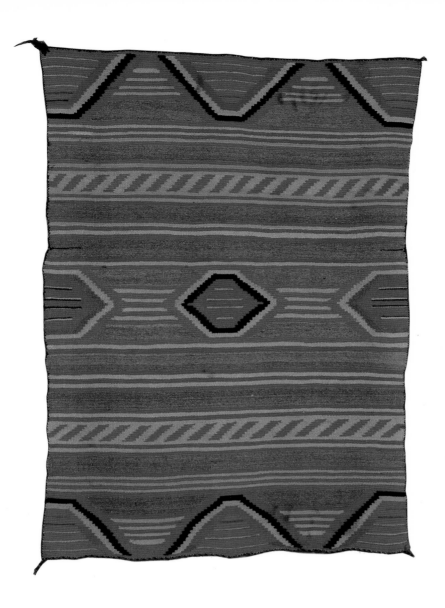

BLANKET, child's, circa 1870–1875

A.5141.42-179

116.0 cm × 84.0 cm

| | Color | Count (per inch) | Fiber | Yarn | Ply | Spin | Twist | Diameter (mm) |
|---|---|---|---|---|---|---|---|---|
| *Warp* | white | 9 | wool | handspun | 1 | Z | | |
| *Weft* | grey-brown | 48 | wool | handspun | 1 | Z | | |
| | red 1 | 50 | wool | handspun | 1 | Z | | |
| | red 2 | 70 | wool | ravelled | 2 | Z | | 0.6 |
| | red 3 | 54 | wool | commercial | 3 | Z | S | |
| | yellow | 56 | wool | handspun | 1 | Z | | |
| | green | 54 | wool | handspun | 1 | Z | | |
| | blue | 48 | wool | handspun | 1 | Z | | |

Selvage: sides: two, 3-ply blue, handspun, Z, S

ends: one, 3-ply light blue, handspun, Z, S

one, 3-ply navy blue, handspun, Z, S

Harvey Company tag: "A-650 B-48115 YLAXS B.W. 3-6-28"

Ledger book: "650 48115 $275.00 Betty Willie 3-6-28 Bayetta saddle 10 grey stripes yellow & red bands ½ diamonds on end— diamond in center."

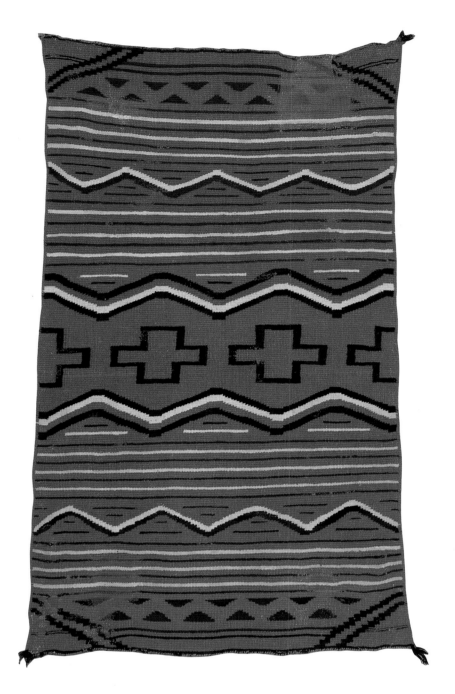

BLANKET, child's, circa 1870–1875
A.5141.42-64
128.0 cm × 76.3 cm

| | Color | Count (per inch) | Fiber | Yarn | Ply | Spin | Diameter (mm) |
|---|---|---|---|---|---|---|---|
| Warp | white | 9 | wool | handspun | 1 | Z | |
| Weft | red | 40 | wool | ravelled | 1 | Z | 0.8 |
| | white | 40 | wool | handspun | 1 | Z | |
| | dark blue | 40 | wool | handspun | 1 | Z | |

Selvage: replaced

Harvey Company tag: "H-34,146 B-47115 $150.00 W. 10/14/19"

Ledger book: "34,146 Purchased from Whalen's Curio Store, L.A. $150.00
 $65.00 Wine color Bayeta saddle blkt has been repaired"

BLANKET, child's, circa 1870–1875
A.5141.42-83
122.5 cm × 79.0 cm

| | Color | Count (per inch) | Fiber | Yarn | Ply | Spin | Diameter (mm) |
|------|------------|------------------|-------|------|-----|------|---------------|
| Warp | white | 12 | wool | handspun | 1 | Z | |
| Weft | grey | 74 | wool | handspun | 1 | Z | |
| | white | 66 | wool | handspun | 1 | Z | |
| | blue | 66 | wool | handspun | 1 | Z | |
| | blue-green | 66 | wool | handspun | 1 | Z | |
| | pink | 68 | wool | red and white recarded | 1 | Z | |
| | red 1 | 68 | wool | ravelled | 3 | S | 0.35 |
| | red 2 | 52 | wool | ravelled | 2 | Z | 0.4 |
| | red 3 | 80 | wool | ravelled | 3 | S | 0.25 |
| | red 4 | 48 | wool | ravelled | 2 | Z | 0.5 |

Selvage: replaced

Harvey Company tag: "H-21066 B-45115 DAXSS JGA 10/19/10"

Ledger book: "21,066 $100.00 $30.00 J. G. Allyn (Chgo 10/19/11)
Saddle bayetta 2 white & black Patern Diamonds in Center Blue Cross
Each diamond Red Body—Red Grey Stripes small green stripes"

This piece exhibits the post–Bosque Redondo characteristic of the use of several types of yarn to complete one textile. Additionally, the undyed grey yarn, the presence of pink yarn (produced by carding white and red fleece together), and the well-integrated cross motif help to date this textile in the 1870s.

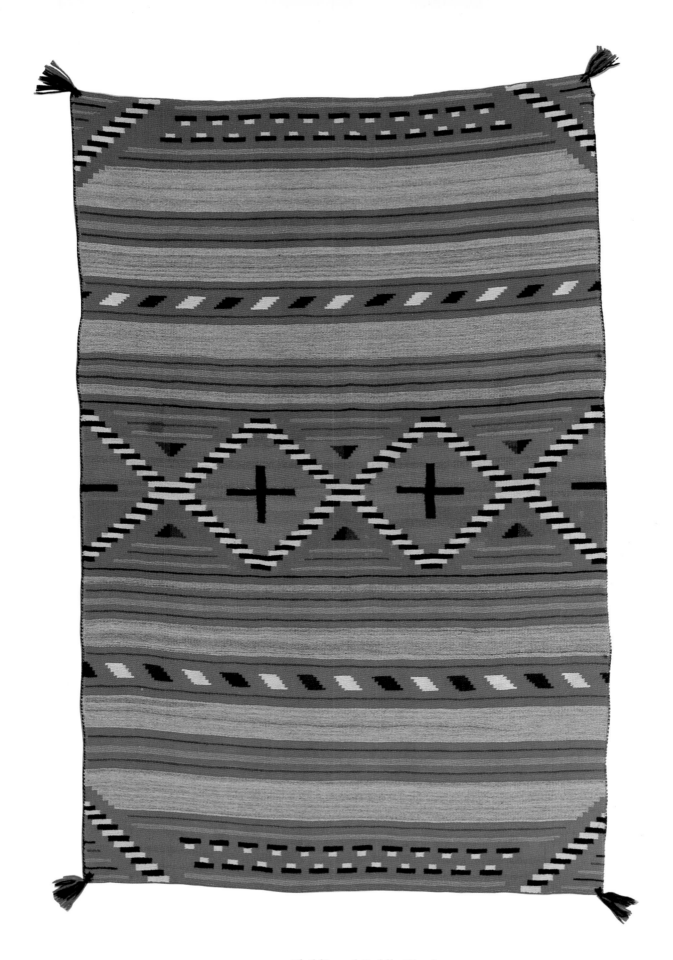

Child's and Saddle Blankets 113

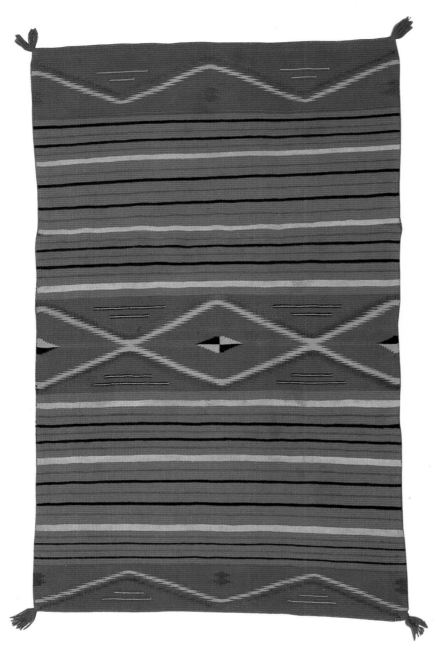

BLANKET, child's, circa 1870–1875
A.5141.42-71
131.0 cm × 82.0 cm

| | Color | Count (per inch) | Fiber | Yarn | Ply | Spin | Twist | Diameter (mm) |
|---|---|---|---|---|---|---|---|---|
| *Warp* | white | 8 | wool | handspun | 1 | Z | | |
| *Weft* | orange-red | 54 | wool | ravelled | 4 | Z | | 0.3 |
| | dark red | 64 | wool | commercial | 3 | Z | S | |
| | green | 64 | wool | commercial | 3 | Z | S | |
| | yellow | 64 | wool | commercial | 3 | Z | S | |
| | blue | 56 | wool | handspun | 1 | Z | | |
| | white | 56 | wool | handspun | 1 | Z | | |

Selvage: sides: two, 3-ply green, commercial, Z, S
ends: one, replaced
one, two, 3-ply red, commercial, Z, S

Harvey Company tag: [illegible]

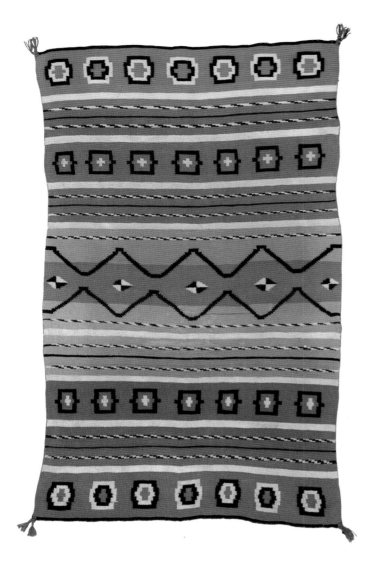

BLANKET, child's, circa 1870–1875
A.5141.42-177
134.0 cm × 80.5 cm

| | Color | Count (per inch) | Fiber | Yarn | Ply | Spin | Twist | Diameter (mm) |
|---|---|---|---|---|---|---|---|---|
| Warp | blue | 12 | wool | handspun | 1 | Z | | |
| | brown | 12 | wool | handspun | 1 | Z | | |
| Weft | white | 60 | wool | handspun | 1 | Z | | |
| | blue | 54 | wool | handspun | 1 | Z | | |
| | black | 58 | wool | commercial | 3 | Z | S | |
| | red 1 | 68 | wool | commercial | 3 | Z | S | |
| | red 2 | 70 | wool | ravelled | 2 | Z | | 0.4 |
| | red 3 | 82 | wool | ravelled | 2 | Z | | 0.3 |
| | pale orange (faded from red) | 50 | wool | ravelled | 4 | Z | | 0.4 |

Selvage: sides: 2 cords: each three, 3-ply red, commercial, Z, S
 ends: two, 3-ply navy, handspun, Z, S

Harvey Company tag: "A-113 B-49615 DLAXS JS 6-24"

Ledger book: "113 49615 $450.00 (orig. R. S. Robinson chgd w a Selig. blkt) Bayetta saddle fine condition 28 blocks of white & blue 5 small diamonds across center."

BLANKET, child's, circa 1870–1875
A.5141.42-73
128.5 cm × 76.0 cm

| | Color | Count (per inch) | Fiber | Yarn | Ply | Spin | Twist | Diameter (mm) |
|---|---|---|---|---|---|---|---|---|
| *Warp* | white | 8 | wool | handspun | 1 | Z | | |
| *Weft* | white | 66 | wool | handspun | 1 | Z | | |
| | blue | 62 | wool | handspun | 1 | Z | | |
| | pink (various shades) | 60 | wool | red and white combed together | 1 | Z | | |
| | green | 60 | wool | handspun | 1 | Z | | |
| | red 1 | 50 | wool | ravelled and recarded? | 1 | Z | | 0.85 |
| | red 2 | 58 | wool | ravelled | 3 | Z | | 0.4 |
| | red 3 | 58 | wool | ravelled | 3–4 | S | | 0.4 |
| | red 4 | 60 | wool | ravelled | 4 | S | | 0.4 |
| | red 5 | 66 | wool | commercial | 3 | Z | S | |

Selvage: sides: two, 2-ply blue-green, handspun, Z, S
　　　　　ends: two, 3-ply blue, handspun, Z, S

Harvey Company tag: "H-6098　　#893015　　YAXSS　　1/20/3"

Ledger book: "6098　　$200.00　　$105.00　　Seligman Coll.
　　　Double saddle. Bayetta white with crosses. Rows of crosses in squares
　　　green thin stripes　　Balance of piece native wool. S-37"

The nine different types of yarns in this blanket with their variety of spins, twists, and plies produce a very uneven surface not uncommon in the 1870s.

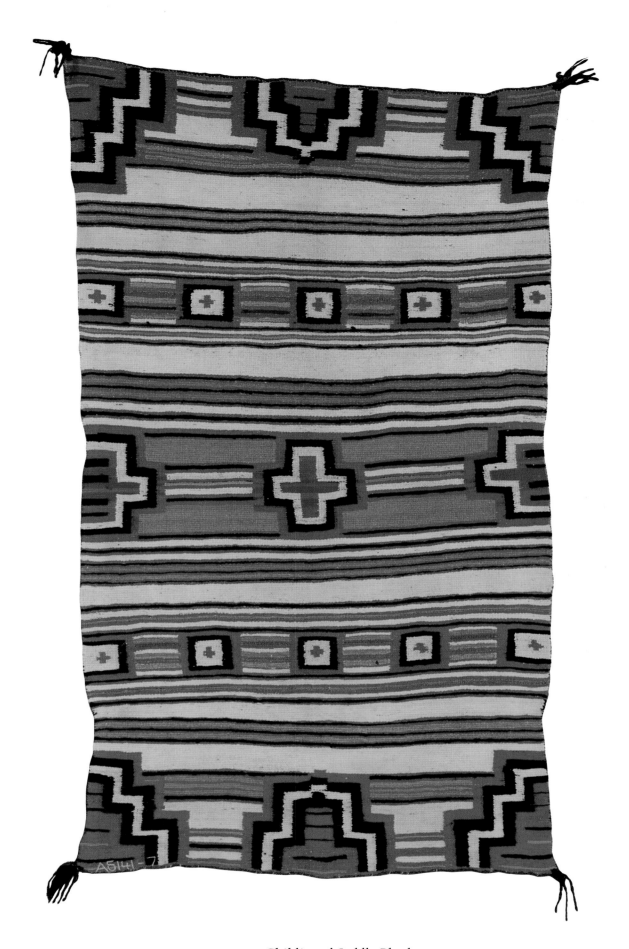

Child's and Saddle Blankets 117

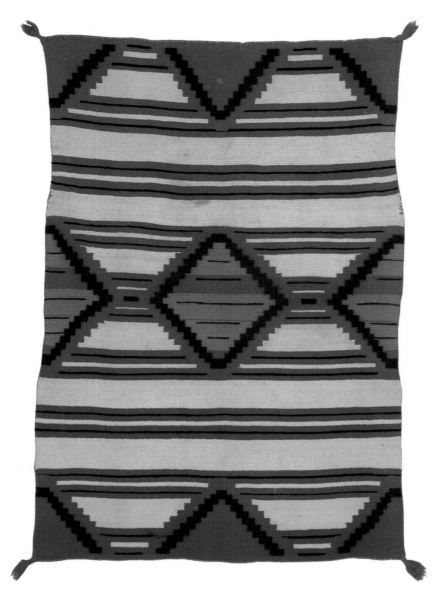

BLANKET, child's, circa 1875
A.5141.42-175
120.0 cm × 81.2 cm

| | Color | Count (per inch) | Fiber | Yarn | Ply | Spin | Twist |
|---|---|---|---|---|---|---|---|
| Warp | yellow | 9 | wool | commercial | 4 | Z | S |
| Weft | white | 40 | wool | handspun | 1 | Z | |
| | red | 60 | wool | commercial | 4 | Z | S |
| | green | 48 | wool | commercial | 4 | Z | S |
| | coral | 56 | wool | commercial | 4 | Z | S |
| | blue | 40 | wool | handspun | 1 | Z | |

Selvage: both: 4 cords: each three, 3-ply red, commercial, S, Z

Harvey Company tag: "H-8699 B-42115 P.M. 3-21-4"

Ledger book: "8699 $75.00 $15.00 P.M. 3-21-4 Small saddle"

Although accurate dating of Navajo textiles is most reliably accomplished by analyz-
ing a combination of factors, including yarns, dyes, and design motifs, it is the use
of both 3- and 4-ply Germantown yarns that allows the fairly precise date of 1875
for this piece, for this was the year 3-ply was phased out and 4-ply was introduced
(Wheat, pers. comm., 1985).

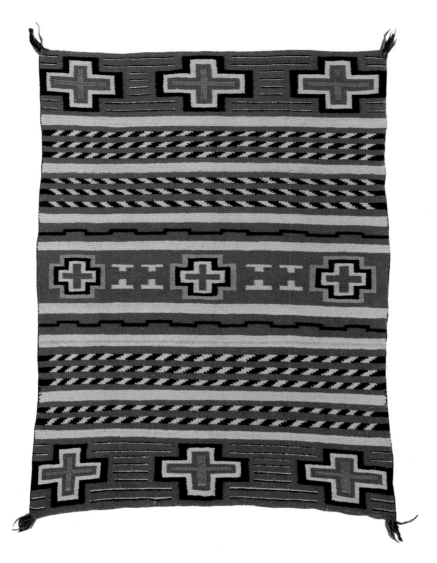

BLANKET, child's, circa 1875
A.5141.42-187
114.0 cm × 86.2 cm

| | Color | Count (per inch) | Fiber | Yarn | Ply | Spin | Diameter (mm) |
|---|---|---|---|---|---|---|---|
| Warp | white | 10 | wool | handspun | 1 | Z | |
| Weft | red | 34 | wool | recarded and respun ravelled | 1 | Z | 1.2 |
| | white | 38 | wool | handspun | 1 | Z | |
| | blue | 34 | wool | handspun | 1 | Z | |
| | green | 34 | wool | handspun | 1 | Z | |
| | yellow | 40 | wool | handspun | 1 | Z | |

Selvage: sides: two, 3-ply blue, handspun, Z, S
ends: replaced

Harvey Company tag: "H-25572 B-46615 HLAXS Mrs. Gordon Coll.
11-11-14"

Ledger book: "25572 $175.00 $60.00 Mrs. Theo. Gowdy [sp.?]
11-11-14 Full bayetta Saddle Perfect condition—3 green Maltese crosses
& 3 yellow crosses."

The green handspun yarns often found in Navajo textiles from the 1870s were some-
times the result of a double-dyeing process. After applying yellow dye, the weaver
could overdye with indigo to produce numerous shades of green.

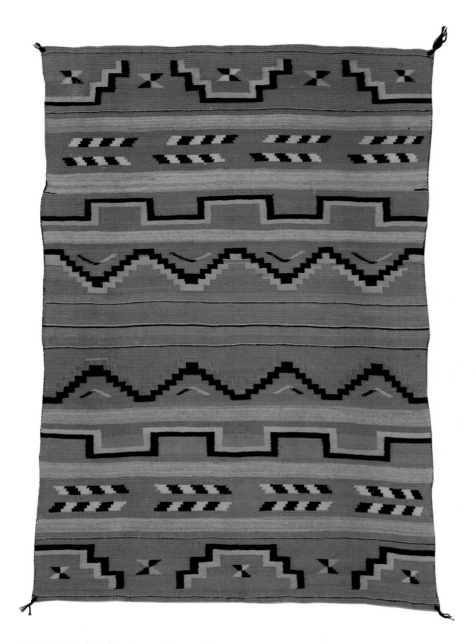

BLANKET, child's, circa 1875–1880
A.5141.42-85
131.5 cm × 91.5 cm

| | Color | Count (per inch) | Fiber | Yarn | Ply | Spin |
|---|---|---|---|---|---|---|
| *Warp* | white | 11 | wool | handspun | 1 | Z |
| *Weft* | red | 48 | wool | handspun | 1 | Z |
| | white | 48 | wool | handspun | 1 | Z |
| | grey | 48 | wool | handspun | 1 | Z |
| | blue | 48 | wool | handspun | 1 | Z |
| | yellow | 48 | wool | handspun | 1 | Z |
| | green | 48 | wool | handspun | 1 | Z |

Selvage: sides: two, 3-ply navy, handspun, Z, S
ends: two, 3-ply yellow, handspun, Z, S

Harvey Company tag: "H-12326 B-41565 P.G. 8-21-6"

Ledger book: "12,326 $55.00 $7.50 Guillion 8/21/6
Fine old saddle red grd yellow & green fig"

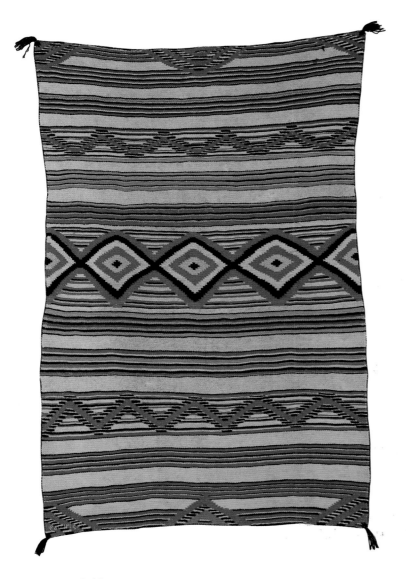

BLANKET, child's, circa 1875–1880
A.5141.42-169
124.5 cm × 81.2 cm

| | Color | Count (per inch) | Fiber | Yarn | Ply | Spin | Twist | Diameter (mm) |
|---|---|---|---|---|---|---|---|---|
| Warp | white | 10 | wool | handspun | 1 | Z | | |
| Weft | white | 36 | wool | handspun | 1 | Z | | |
| | blue | 40 | wool | handspun | 1 | Z | | |
| | red 1 | 44 | wool | ravelled | 5 | S | | 0.3 |
| | red 2 | 40 | wool | ravelled | 3 | S | | 0.4 |
| | burgundy | 80 | wool | ravelled | 2 | S | | 0.35 |
| | yellow 1 | 56 | wool | commercial | 4 | Z | S | |
| | yellow 2 | 36 | wool | handspun | 1 | Z | | |
| | coral | 56 | wool | commercial | 4 | Z | S | |
| | orange | 80 | wool | ravelled | 2 | Z | | 0.4 |
| | green | 54 | wool | commercial | 4 | Z | S | |

Selvage: both: two, 3-ply navy, handspun, Z, S

Harvey Company tag: "H-25,313 B-43365 H. 10/13/14"

Ledger book: "25,313 $175.00 $15.00 Mrs. Hopkins 10/13/14
 Old Saddle Navaho Bayetta 3 Dia Red 2½ dia thru center of blkt
 stripe effect white blue green"

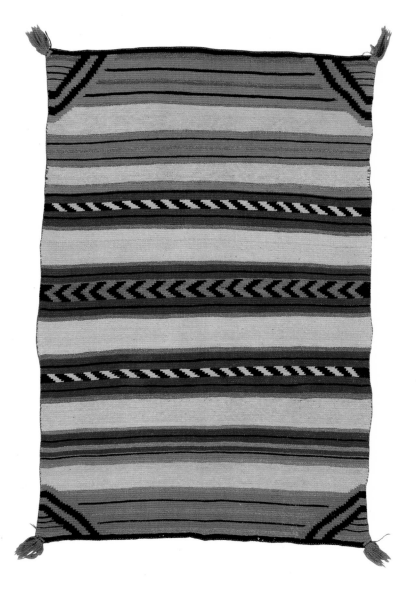

BLANKET, child's, circa 1875–1880
A.5141.42-174
121.2 cm × 79.0 cm

| | Color | Count (per inch) | Fiber | Yarn | Ply | Spin | Twist |
|---|---|---|---|---|---|---|---|
| *Warp* | grey | 8 | wool | handspun | 1 | Z | |
| *Weft* | white | 42 | wool | handspun | 1 | Z | |
| | coral | 44 | wool | commercial | 4 | Z | S |
| | burgundy | 48 | wool | commercial | 4 | Z | S |
| | pink | 40 | wool | red and white recarded | 1 | Z | |
| | light burgundy | 40 | wool | burgundy and white recarded | 1 | Z | |
| | light coral | 36 | wool | coral and white recarded | 1 | Z | |
| | blue | 42 | wool | handspun | 1 | Z | |

Selvage: sides: two, 2-ply light blue, handspun, Z, S
 ends: two, 3-ply medium blue, handspun, Z, S

Harvey Company tag: "H-8507 8973 L. 1-21-4"

Ledger book: "8507 $60.00 $9.00 Langer 1/21 Saddle pink stripe"

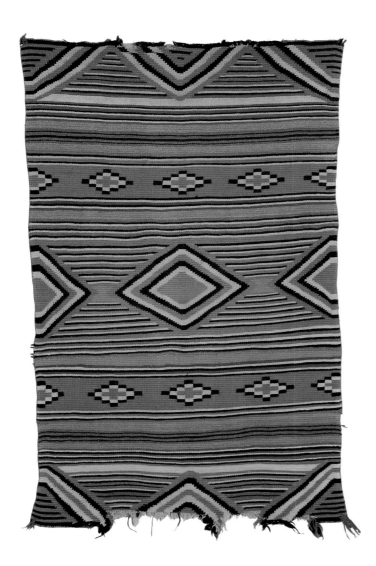

BLANKET, child's, circa 1875–1880
A.5141.42-188
129.0 cm × 80.5 cm

| | Color | Count (per inch) | Fiber | Yarn | Ply | Spin | Twist | Diameter (mm) |
|---|---|---|---|---|---|---|---|---|
| Warp | white | 11 | wool | commercial | 4 | Z | S | |
| Weft | orange-red 1 | 48 | wool | recarded and respun ravelled | 1 | Z | | 0.9 |
| | orange-red 2 | 56 | wool | commercial | 4 | Z | S | |
| | dark burgundy | 56 | wool | commercial | 4 | Z | S | |
| | burgundy | 40 | wool | recarded burgundy and white | 1 | Z | | |
| | pink | 40 | wool | recarded white and burgundy | 1 | Z | | |
| | white | 56 | wool | handspun | 1 | Z | | |
| | blue | 48 | wool | handspun | 1 | Z | | |

Selvage: replaced

This textile, as is typical of those woven in the 1870s, has a number of different red yarns. A skillful weaver could create several shades by carding varying amounts of red, white, and burgundy together.

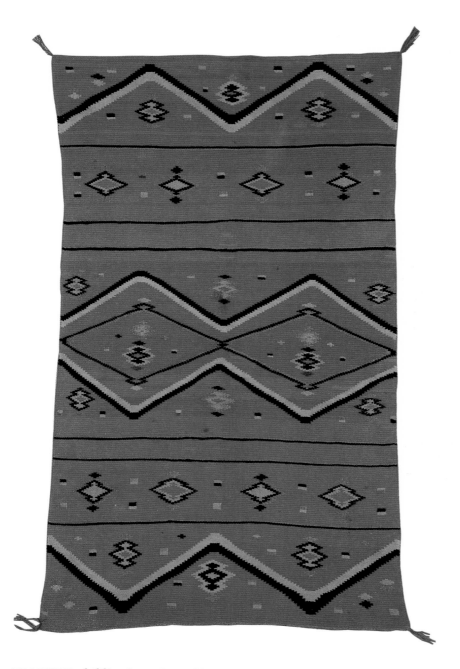

BLANKET, child's, circa 1875–1880
A.5141.42-95
123.0 cm × 75.0 cm

| | Color | Count (per inch) | Fiber | Yarn | Ply | Spin | Twist |
|---|---|---|---|---|---|---|---|
| *Warp* | white | 12 | wool | handspun | 1 | Z | |
| *Weft* | red | 46 | wool | commercial | 4 | Z | S |
| | blue | 40 | wool | handspun | 1 | Z | |
| | cream | 40 | wool | handspun | 1 | Z | |
| | green | 46 | wool | commercial | 4 | Z | S |
| | yellow | 46 | wool | commercial | 4 | Z | S |

Selvage: sides: replaced
ends: 2 cords: each three, 3-ply red, commercial, Z, S

Harvey Company tag: "H-5758 B-43115 G. 11-18-2"

Ledger book: "5758 $6.50 $3.00 Guillion 11/18 Old native"

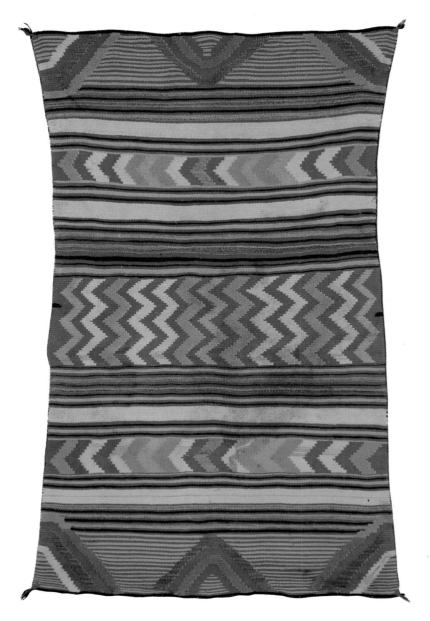

BLANKET, child's, circa 1875–1880

A.5141.42-70

130.5 cm × 82.0 cm

| | Color | Count (per inch) | Fiber | Yarn | Ply | Spin | Twist | Diameter (mm) |
|---|---|---|---|---|---|---|---|---|
| Warp | white | 8 | wool | commercial | 3 | Z | S | |
| Weft | white | 38 | wool | handspun | 1 | Z | | |
| | blue 1 | 38 | wool | handspun | 1 | Z | | |
| | blue 2 | 38 | wool | commercial | 4 | Z | S | |
| | red | 38 | wool | ravelled | 4 | Z | | 0.45 |
| | gold | 38 | wool | commercial | 3 | Z | S | |
| | olive green | 38 | wool | commercial | 4 | Z | S | |
| | kelly green | 38 | wool | commercial | 4 | Z | S | |
| | grey | 38 | wool | handspun | 1 | Z | | |

Selvage: both: two, 3-ply navy, handspun, Z, S

Harvey Company tag: "H-10,040 #84614 $75.00 JOX 5/28/5"

Ledger book: "10,040 $60.00 $15.00 Juan Olivas 5/28/5
 Old native wool & dyes"

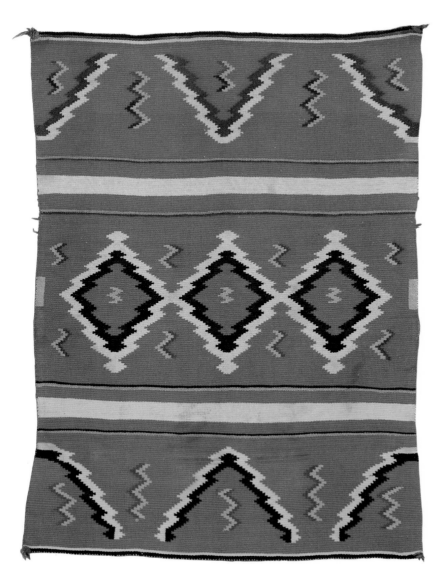

BLANKET, child's, circa 1875–1885
A.5141.42-109
118.0 cm × 82.7 cm

| | Color | Count (per inch) | Fiber | Yarn | Ply | Spin | Twist |
|---|---|---|---|---|---|---|---|
| Warp | white | 9 | wool | handspun | 1 | Z | |
| Weft | red | 46 | wool | commercial | 4 | Z | S |
| | white | 38 | wool | handspun | 1 | Z | |
| | dark blue | 46 | wool | handspun | 1 | Z | |
| | yellow | 46 | wool | handspun | 1 | Z | |
| | green | 38 | wool | handspun | 1 | Z | |
| | purple | 46 | wool | commercial | 4 | Z | S |
| | medium green | 54 | wool | commercial | 4 | Z | S |
| | burgundy | 46 | wool | handspun | 1 | Z | |

Selvage: sides: one, 3-ply red, commercial, Z, S
one, 3-ply burgundy, handspun, Z, S
ends: two, 3-ply blue, handspun, Z, S

Harvey Company tag: "H-4228 #8983 L.T. 2-11 Very fine old weave"

Ledger book: "4228 $30.00 $10.00 Louis Simon 2/11/14 2⅛#
Old Germantown Red with white blue & yellow"

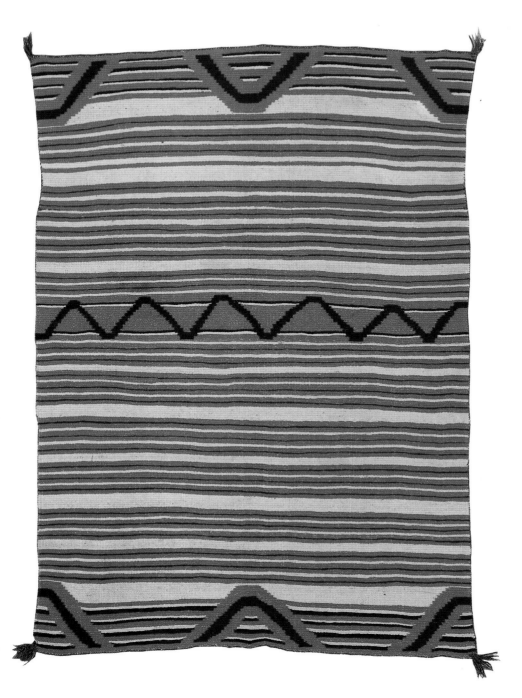

BLANKET, child's, circa 1875–1885

A.5141.42-72

153.0 cm × 106.5 cm

| | Color | Count (per inch) | Fiber | Yarn | Ply | Spin | Diameter (mm) |
|---|---|---|---|---|---|---|---|
| Warp | white | 8 | wool | handspun | 1 | Z | |
| Weft | white | 54 | wool | handspun | 1 | Z | |
| | red | 50 | wool | ravelled and recarded? | 1 | Z | 0.85 |
| | blue | 48 | wool | handspun | 1 | Z | |

Selvage: both: two, 3-ply light blue, handspun, Z, S

Harvey Company tag: "H-19,090 B-46615 $275.00 S. 8/1/10"

Ledger book: "19,090 $275.00 $60.00 D. Smith 8/1/10 Modern bayetta
Red, white & blue stripes & diamonds"

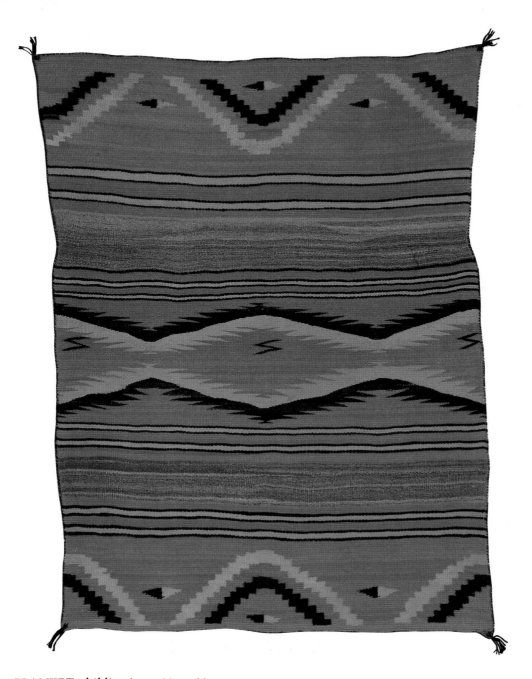

BLANKET, child's, circa 1880–1885
A.5141.42-158
112.0 cm × 80.5 cm

| | Color | Count (per inch) | Fiber | Yarn | Ply | Spin |
|---|---|---|---|---|---|---|
| Warp | white | 10 | wool | handspun | 1 | Z |
| Weft | red | 32 | wool | handspun | 1 | Z |
| | grey | 28 | wool | handspun | 1 | Z |
| | blue | 38 | wool | handspun | 1 | Z |
| | white | 38 | wool | handspun | 1 | Z |
| | yellow | 36' | wool | handspun | 1 | Z |

Selvage: replaced

Harvey Company tag: "H-5252 #8953 P.G. 5-5-2"

Ledger book: "5,252 $15.00 $4.00 Guillion 5/5 1¾#
 Native wool"

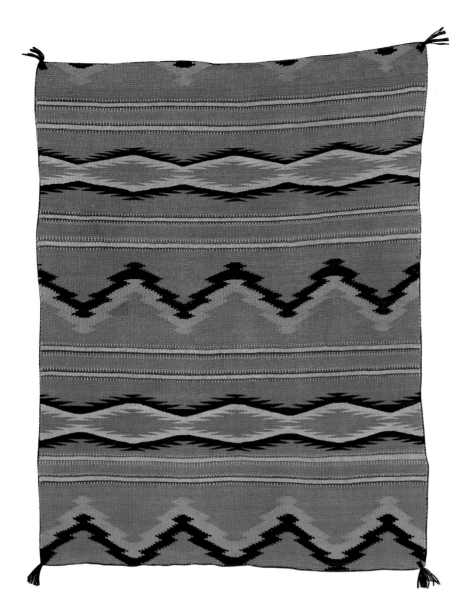

BLANKET, child's, circa 1880–1885
A.5141.42-108
104.6 cm × 76.8 cm

| | Color | Count (per inch) | Fiber | Yarn | Ply | Spin |
|---|---|---|---|---|---|---|
| Warp | white | 8 | wool | handspun | 1 | Z |
| Weft | red | 34 | wool | handspun | 1 | Z |
| | dark blue | 34 | wool | handspun | 1 | Z |
| | light blue | 34 | wool | handspun | 1 | Z |
| | tan | 34 | wool | handspun | 1 | Z |
| | orange | 34 | wool | handspun | 1 | Z |
| | white | 34 | wool | handspun | 1 | Z |

Selvage: replaced

Harvey Company tag: "H-3864 #8463 L.S. 9-4-5 Fine weave, old native dye"

Ledger book: "3864 $8.50 $1.50 L.S. 9/4 2# Old native wool zigzag"

This piece apparently was much larger when originally woven. At some point in its history the ends were evened up and new selvage cords added.

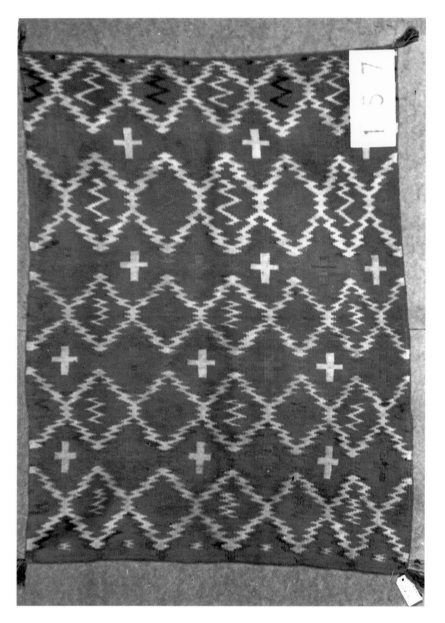

BLANKET, (missing), child's
A.5141.42-157
48″ × 35″

Warp: 10/inch
Weft: 36/inch

Catalogue card: "Child's serape or double saddle-blanket. Red ground with series of 5 rows of diamond-edged diamonds in white and pale green, enclosing a white or green zigzag or cross. Little blue in zigzags at one end. Selvage cord, corner tassels. Native wool and dye."

Harvey Company tag: "H-10,126 B-41815 M.L. 7-15-6"

Ledger book: "10,126 $45.00 $7.00 Langer 7/15 Old native dye saddle."

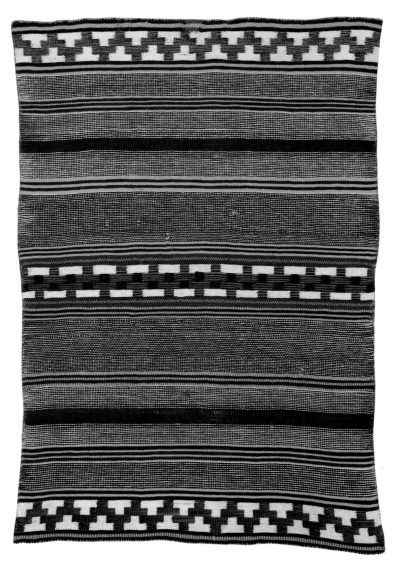

BLANKET, child's/saddle, circa 1865–1875
A.5141.42-82
124.0 cm × 84.5 cm

| | Color | Count (per inch) | Fiber | Yarn | Ply | Spin | Diameter (mm) |
|---|---|---|---|---|---|---|---|
| Warp | white | 10 | wool | handspun | 1 | Z | |
| Weft | white | 36 | wool | handspun | 1 | Z | |
| | brown | 36 | wool | handspun | 1 | Z | |
| | blue | 36 | wool | handspun | 1 | Z | |
| | pink | 48 | wool | ravelled | 4 | Z | 0.4 |
| | red | 48 | wool | ravelled | 4–5 | S | 0.3 |

Selvage: replaced

Harvey Company tag: "H-23772 B-44115 $85.00 J.C. 11/4/13"

Ledger book: "23,772 $175.00 $40.00 J. W. Clarke 11/4/13
 Bayetta—Double Saddle Pepper Salt stripes Grecian border on each end.
 Block design in middle"

This small blanket may have been intended for a child, or perhaps the relatively simple and muted design plus the extensive wear and loose weave indicate its use as a saddle blanket. Note that instead of using the broad bands of grey that were common in the 1870s, the weaver of this piece chose to build her design on many extremely narrow stripes in blue, white, brown, and red.

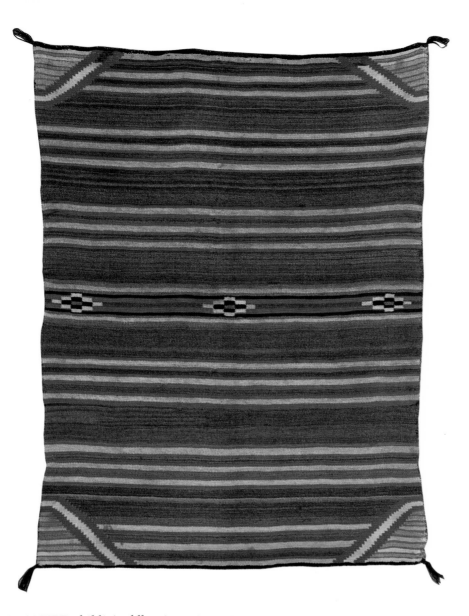

BLANKET, child's/saddle, circa 1870–1875
A.5141.42-171
116.5 cm × 80.3 cm

| | Color | Count (per inch) | Fiber | Yarn | Ply | Spin | Twist | Diameter (mm) |
|---|---|---|---|---|---|---|---|---|
| Warp | white | 9 | wool | handspun | 1 | Z | | |
| Weft | white | 44 | wool | handspun | 1 | Z | | |
| | brown | 50 | wool | handspun | 1 | Z | | |
| | red 1 | 50 | wool | ravelled | 6 | Z | | 0.35 |
| | red 2 | 64 | wool | recarded and respun ravelled | 1 | Z | | 0.7 |
| | red 3 | 56 | wool | commercial | 3 | Z | S | |
| | blue | 56 | wool | handspun | 1 | Z | | |
| | pink | 48 | wool | red and white recarded | 1 | Z | | |

Selvage: both: two, 2-ply navy, handspun, Z, S

Harvey Company tag: "A-1005 B-46115 Bayetta saddle Andras Coll."

Ledger book: "1005 46115 $225.00 Andrus Coll. 3-10-30
 Bayetta Saddle 6 dk grey or lt brown stripes with blue & white stripes & figures"

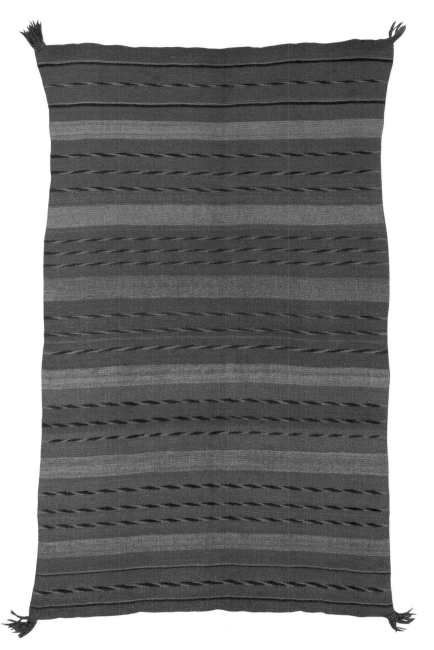

BLANKET, child's/saddle, circa 1870–1875

A.5141.42-98

139.5 cm × 84.0 cm

| | Color | Count (per inch) | Fiber | Yarn | Ply | Spin | Twist |
|---|---|---|---|---|---|---|---|
| Warp | white | 9 | wool | handspun | 1 | Z | |
| Weft | red | 42 | wool | handspun | 1 | Z | |
| | pink | 36 | wool | recombed white and red | 1 | Z | |
| | purple | 42 | wool | commercial | 3 | Z | S |
| | orange | 42 | wool | handspun | 1 | Z | |

Selvage: sides: two, 3-ply red, handspun, Z, S
 ends: two, 3-ply faded orange, handspun, Z, S

Harvey Company tag: "H-43299 B-42115 N.H.T. 5-30-25"

Ledger book: "43,299 Old 42115 $55.00 N. H. Thorpe 5/30/25
 Old saddle blkt red ground small stripe blue yellow 6 lighter red stripes"

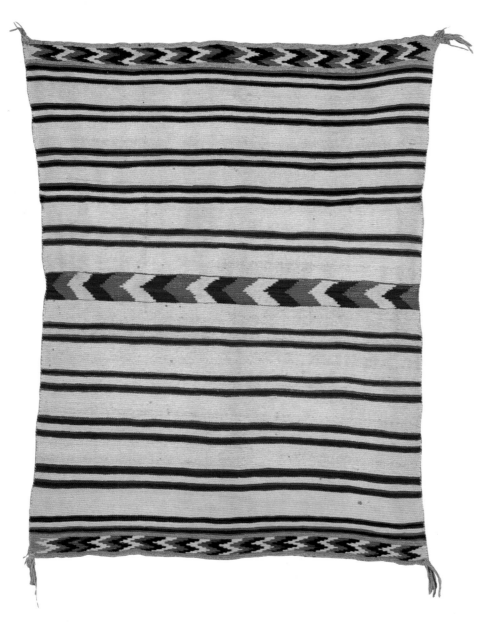

BLANKET, child's/saddle, circa 1875–1880
A.5141.42-97
116.0 cm × 87.0 cm

| | Color | Count (per inch) | Fiber | Yarn | Ply | Spin | Twist | Diameter (mm) |
|---|---|---|---|---|---|---|---|---|
| Warp | white | 15 | wool | handspun | 1 | Z | | |
| Weft | white | 48 | wool | handspun | 1 | Z | | |
| | blue | 44 | wool | handspun | 1 | Z | | |
| | burgundy | 48 | wool | commercial | 4 | Z | S | |
| | pink | 40 | wool | combed burgundy and white | 1 | Z | | |
| | red 1 | 42 | wool | ravelled | 5–7 | S | | 0.3 |
| | red 2 | 40 | wool | ravelled | 2 | Z | | 0.8 |

Selvage: both: two, 3-ply pink (recombed), handspun, Z, S

Harvey Company tag: "H-7040 #89914 Spieg. Collection 1901"

Ledger book: "7040 $60.00 $20.00 Spiegelberg Coll. Dec. 1901
 White double saddle with blue & bayetta stripes. Zigzag pattern in each end
 arrow pattern 2 inches wide in middle."

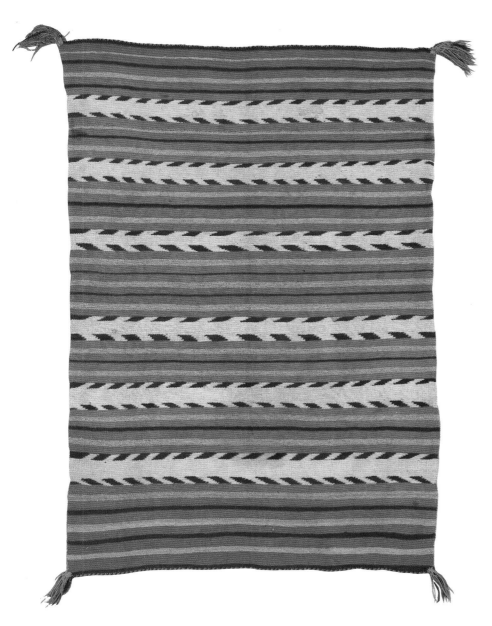

BLANKET, child's/saddle, circa 1875–1885
A.5141.42-122
125.5 cm × 83.0 cm

| | Color | Count (per inch) | Fiber | Yarn | Ply | Spin | Twist |
|---|---|---|---|---|---|---|---|
| Warp | white | 10 | wool | handspun | 1 | Z | |
| Weft | red | 38 | wool | commercial | 4 | Z | S |
| | pink | 34 | wool | recarded red and white | 1 | Z | |
| | white | 36 | wool | handspun | 1 | Z | |
| | blue | 36 | wool | handspun | 1 | Z | |

Selvage: sides: 2 cords: two, 4-ply gold, commercial, Z, S
ends: 2 cords: two, 4-ply green, commercial, Z, S
one, 3-ply blue, handspun, Z, S

Harvey Company tag: "H-3529 #89314 W. 5/12/2 Fine old native
wool & dye saddle"

Ledger book: "3,529 $25.00 $15.00 Averill 5/15 Old native
wool rug native dyes"

Child's and Saddle Blankets 135

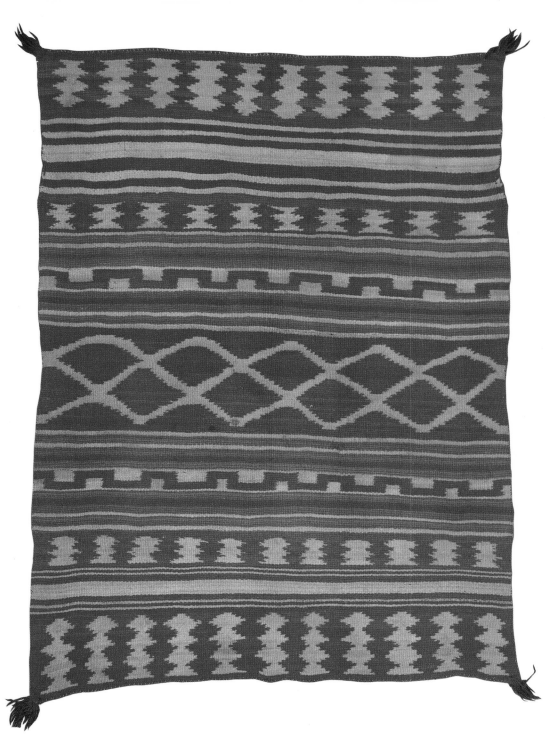

BLANKET, child's/saddle, circa 1880–1885
A.5141.42-186
116.5 cm × 82.0 cm

| | Color | Count (per inch) | Fiber | Yarn | Ply | Spin |
|---|---|---|---|---|---|---|
| *Warp* | white | 9 | wool | handspun | 1 | Z |
| *Weft* | red | 38 | wool | handspun | 1 | Z |
| | white | 36 | wool | handspun | 1 | Z |

Selvage: both: two, 2-ply red, handspun, Z, S

This small textile is unusual in its use of only red and white yarns.

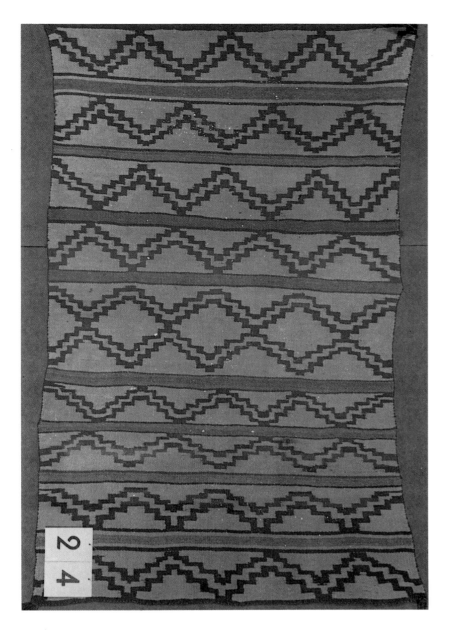

BLANKET (missing), child's/saddle, circa 1870–1880

A.5141.42-75

51" × 31"

Warp: 8/inch

Weft: 46/inch

| | Color | Fiber | Yarn | Ply | Spin |
|---|---|---|---|---|---|
| Warp | white | wool | handspun | 1 | Z |
| Weft | white | wool | handspun | 1 | Z |
| | pink | wool | carded white and red | 1 | Z |
| | crimson | wool | ravelled | | S |
| | scarlet | wool | ravelled | | S |

Selvage: both: 2- (3-? or 5-?) ply red ravelled, S, Z

(Technical analysis by Joe Ben Wheat, 1973)

Harvey Company tag: "H-5442 #8983 MM 7/20/5"

Ledger book: "5,442 $35.00 $10.00 Mones 7/20 Old native white and red."

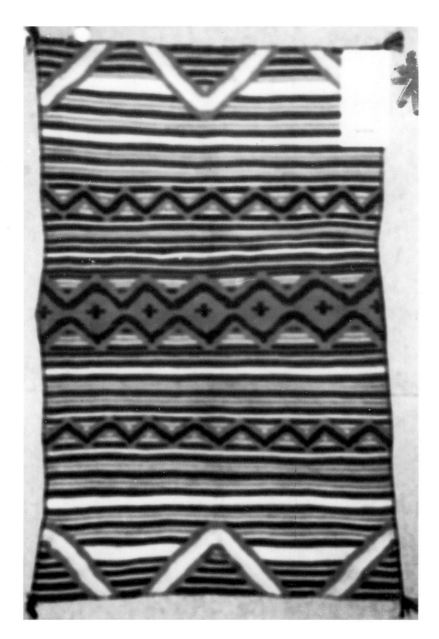

BLANKET (missing), child's/saddle
A.5141.42-178
50" × 31"

Warp: 12/inch
Weft: 48/inch

Catalogue card: "White ground almost covered with stripes of red and blue and
pale tan. In center wide area of red with terraced diamond zigzag lines in blue and
blue crosses in center. At ends diamond motifs in red, white and tan. Intermediate
zig-zag lines of red and blue. White and blue are native wool. Reworked edges. Red,
two shades of tan are non-native, two ply wool."

Harvey Company tag: "H-6076 #8944 HAXSS Sel. Coll. 1-20-3"

Ledger book: "6076 Seligman coll. 1-20-03 $150.00 $49.00
 Saddle bayetta Medium blue with blue and wh. and yellow-brown stripes
 Diamonds on ends. Small blue crosses red[?] curves[?] in centre. Selig. no. 46"

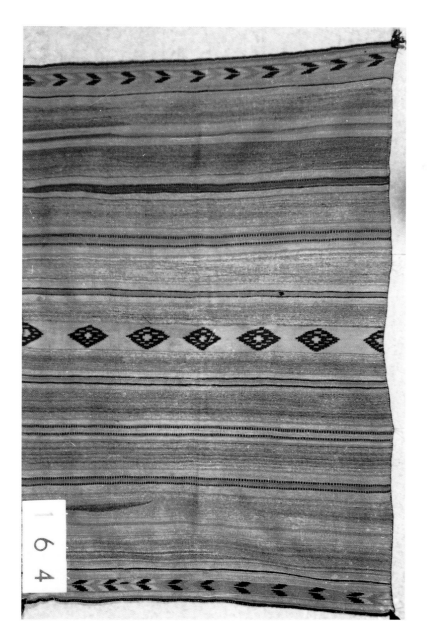

BLANKET (missing), child's/saddle

A.5141.42-164

52" × 35"

Warp: 11/inch
Weft: 42/inch

Catalogue card: "Navaho double saddle blanket, terrace style. Ground natural grey with narrow bands of red and light green and blue stripes. At ends narrow bands of terrace motifs in blue and green on orange ground. In center red band with blue terrace-diamond motifs. Red is non-native, and in places mixed with white native. Rest of wool is native. Selvage cord."

Harvey Company tag: "H-25,576 B-46615 Gowdy Coll. 11-11-14"

Ledger book: "25,576 $225.00 $35.00 Mrs. Theodore Gowdy
 11/11/14 Grey ground saddle Blkt stripe effect 5 Full Dia. & two ½ dia.
 in middle stripe. Deer toe pattern on ends, blue green & yellow."

BLANKET, saddle, circa 1870–1875
A.5141.42-117
132.5 cm × 74.0 cm
twill weave

| | Color | Fiber | Yarn | Ply | Spin | Twist | Diameter (mm) |
|---|---|---|---|---|---|---|---|
| Warp | white | wool | handspun | 1 | Z | | |
| Weft | burgundy | wool | ravelled | 2 | Z | | 0.6 |
| | mottled burgundy | wool | recarded | 1 | Z | | |
| | white | wool | handspun | 1 | Z | | |
| | blue | wool | handspun | 1 | Z | | |
| | green | wool | commercial | 3 | Z | S | |
| | orange-red | wool | ravelled | 2 | Z | | 0.65 |

Selvage: sides: two, 2-ply navy, handspun, Z, S
ends: two, 3-ply purple, commercial, S, Z

Harvey Company tag: "H-10,070 #89814 B.G.W. 6/16/5 Bayetta"

Ledger book: "10,070 $60.00 $20.00 B. G. Wilson 6/16
Native wool & dyes Saddle dark red body green white & blue."

Diamond twill weave, as found in this textile, generally produces a longer-wearing fabric than does plain weave, hence its common usage for saddle blankets.

No weft counts are possible for textiles produced in twill weave, owing to construction technique.

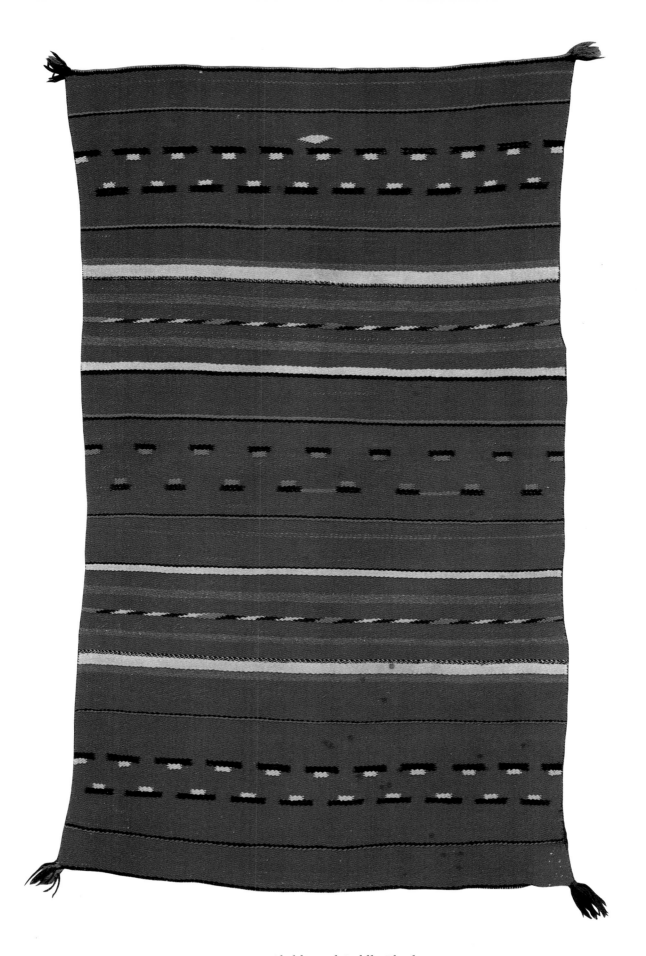

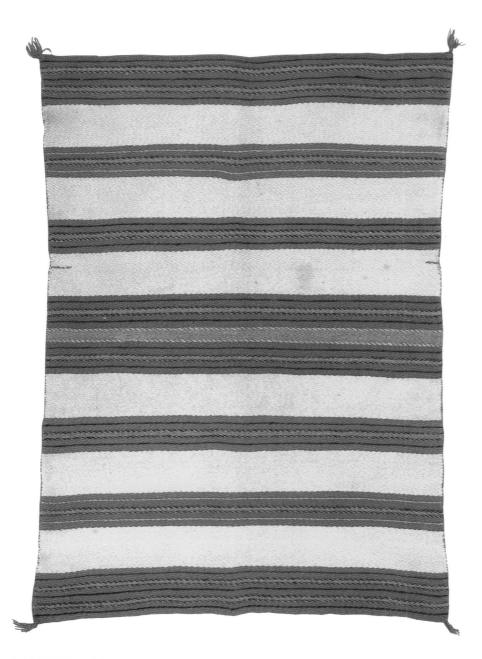

BLANKET, saddle, circa 1870–1875
A.5141.42-116
114.5 cm × 77.8 cm
twill weave

| | Color | Fiber | Yarn | Ply | Spin | Twist |
|------|-------|-------|------|-----|------|-------|
| Warp | white | wool | handspun | 1 | Z | |
| Weft | white | wool | handspun | 1 | Z | |
| | red | wool | commercial | 3 | S | Z |
| | pink | wool | recarded | 1 | Z | |
| | wine | wool | commercial | 3 | Z | S |
| | blue | wool | handspun | 1 | Z | |
| | green | wool | commercial | 3 | Z | S |

Selvage: both: two, 3-ply red, commercial, S, Z

Harvey Company tag: "H-2244 B-42115 UAXSS FCS [or G?] 2-3-4"

Ledger book: "2,244 $40.00 $10.00 Gillenbeck Weight 2¾
 Very fine old Bayetta Native wool mix'd & Red & White"

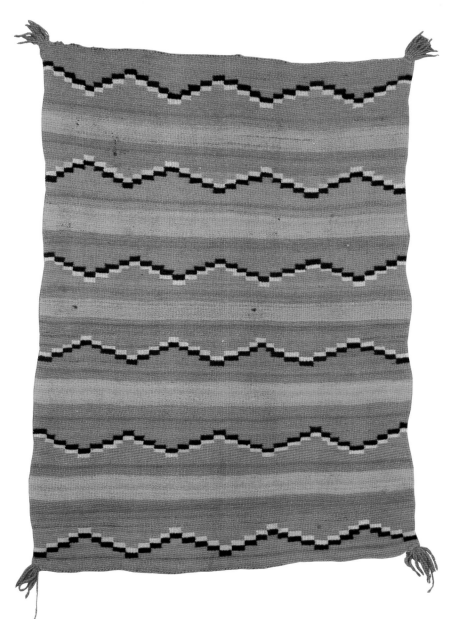

BLANKET, saddle, circa 1880–1890
A.5141.42-86
114.0 cm × 81.0 cm

| | Color | Count (per inch) | Fiber | Yarn | Ply | Spin | Twist |
|---|---|---|---|---|---|---|---|
| Warp | white (in pairs) | 8 | wool | handspun | 1 | Z | |
| | brown | 8 | wool | handspun | 1 | Z | |
| Weft | red | 34 | wool | handspun | 1 | Z | |
| | blue | 34 | wool | handspun | 1 | Z | |
| | grey (faded from purple) | 56 | wool | commercial | 4 | Z | S |
| | white | 56 | wool | commercial | 4 | Z | S |
| | coral | 34 | wool | handspun | 1 | Z | |

Selvage: both: two, 2-ply red, handspun, Z, S

A noticeable feature of this blanket is its unusual warping technique. Approximately half the warp is made up of *pairs* of fairly tightly spun, white handspun yarns, whereas the other half is done in a single, heavy, loosely handspun brown yarn. This feature, plus the thickness of the weft yarns and the sparse patterning, indicates the weaver's intention to produce a heavy-duty saddle blanket.

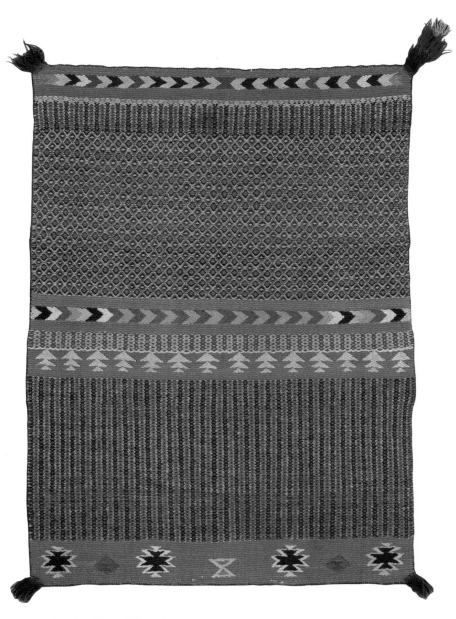

BLANKET, double saddle, circa 1880–1895
A.5141.42-124
136.4 cm × 95.0 cm
twill weave

| | Color | Fiber | Yarn | Ply | Spin | Twist |
|---|---|---|---|---|---|---|
| *Warp* | grey | wool | handspun | 1 | Z | |
| *Weft* | red | wool | handspun | 1 | Z | |
| | yellow | wool | handspun | 1 | Z | |
| | light green | wool | handspun | 1 | Z | |
| | black | wool | handspun | 1 | Z | |
| | white | wool | handspun | 1 | Z | |
| | dark green | wool | commercial | 3 yarns, 4-ply each | Z | S |
| | burgundy | wool | commercial | 3 yarns, 4-ply each | Z | S |
| | purple | wool | handspun | 1 | Z | |

Selvage: both: three, 2-ply brown, handspun, Z, S

Thick yarns and diamond twill weave join in this textile to create a durable saddle blanket. The weaver chose to use handspun yarns in combination with commercial yarns, but due to the extreme difference in thickness between them, she had to bundle together three 4-ply commercial yarns to produce an even surface.

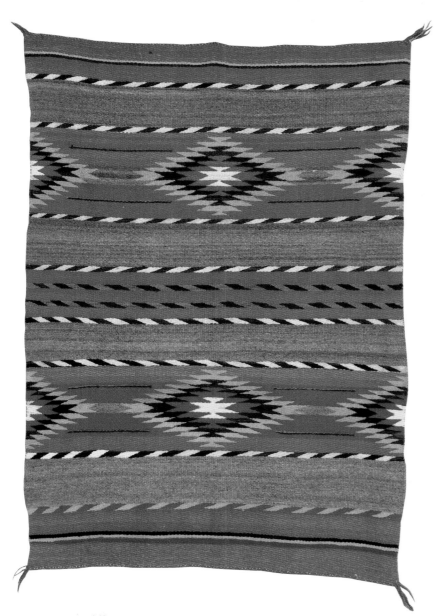

BLANKET, saddle, circa 1885–1895
A.5141.42-96
118.0 cm × 81.0 cm

| | Color | Count (per inch) | Fiber | Yarn | Ply | Spin | Twist |
|---|---|---|---|---|---|---|---|
| Warp | white | 9 | wool | handspun | 1 | Z | |
| Weft | red | 36 | wool | handspun | 1 | Z | |
| | burgundy | 36 | wool | handspun | 1 | Z | |
| | grey | 30 | wool | handspun | 1 | Z | |
| | yellow | 36 | wool | handspun | 1 | Z | |
| | black | 36 | wool | handspun | 1 | Z | |
| | white 1 | 40 | wool | commercial | 4 | Z | S |
| | white 2 | 36 | wool | handspun | 1 | Z | |
| | green | 36 | wool | handspun | 1 | Z | |

Selvage: sides: two, 2-ply red, handspun, Z, S
ends: two, 3-ply red, handspun, Z, S

Harvey Company tag: "H-23,211 #8933 PM 5/3"

Ledger book: "23,211 $35.00 $5.00 Pedro Muniz 5/5
Semi modern saddle stripe effect with 2 Dia & 4½ dia"

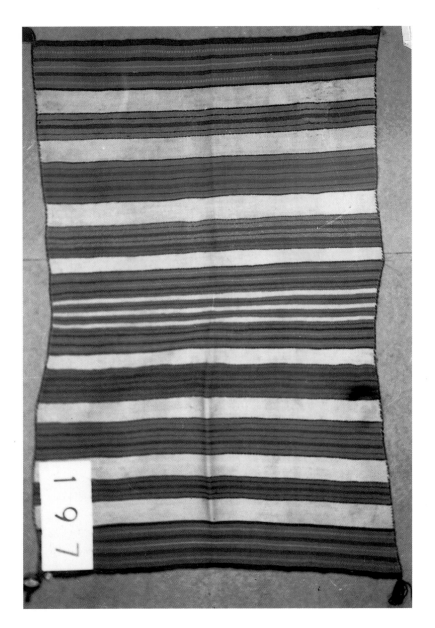

BLANKET (missing), saddle
A.5141.42-197
45″×28″

Warp: 9/inch
Weft: 42/inch

Catalogue card: "Ground creamy white with bands of red and blue stripes.
Number of shades of red ranging from purple to soft rose. Little pale green in end
bands, in a beaded stripe. Reds are all non-native wools, and pale green in
non-native also. Selvage cord, edges have been sewed with silk thread."

Harvey Company tag: "H-5489 B-42615 P.M. 7-28-02 Bayetta"

Ledger book: "5489 8913 $9.00 $3.00 Pedro 7/28
 Navaho old saddle"

Banded-Background Blankets

First proposed by Mera in 1948, the term *banded background* is obviously descriptive of the somber blue and brown/black narrow striped ground common to each of these textiles. Despite the sameness of the ground, however, each piece can be unique, with significant variation appearing in the grouping of the stripes and the colorful designs superimposed upon them.

Although some people find the dark ground of these textiles too somber for their taste, Hearst was obviously not one of them. There are thirty examples of this type in his collection, exhibiting the range of designs developed by the Navajos during the period 1860 to 1890, as well as the changing materials available to them.

Hubbell also appreciated this type of textile, and with his encouragement they underwent a period of revival just before the turn of the century. At his urging, weavers used commercially dyed Germantown yarns in a purple color instead of the earlier indigo blue.

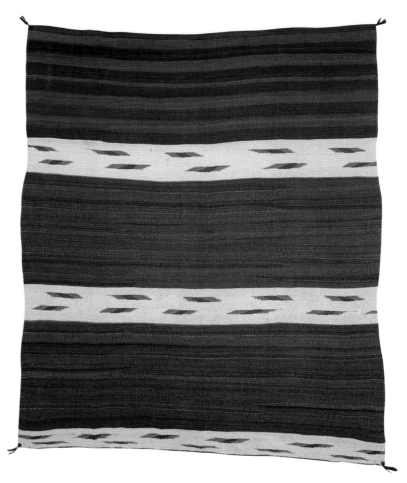

BLANKET, banded background, circa 1860–1880?
A.5141.42-94
168.0 cm × 135.0 cm (partial piece)

| | Color | Count (per inch) | Fiber | Yarn | Ply | Spin | Twist |
|---|---|---|---|---|---|---|---|
| *Warp* | white | 6 | wool | handspun | 2 | Z | S |
| *Weft* | brown | 30 | wool | handspun | 1 | Z | |
| | blue | 30 | wool | handspun | 1 | Z | |
| | white | 30 | wool | handspun | 1 | Z | |
| | red | 30 | wool | handspun | 1 | Z | |

Selvage: sides: two, 3-ply light blue, handspun, Z, S
ends: replaced

Harvey Company tag: "H-7583 B-41965 P.M. 10/10/2 $65.00"

Ledger book: "7,583 $30.00 $10.00 Muniz 10-10-2"

This piece shows cultural influences of both the Navajos and the Spanish weavers of the Rio Grande Valley in New Mexico. The 2-ply handspun warp, extensive use of wide blue bands with beading, and checkerboarding stitches indicate a Rio Grande piece. On the other hand, because this textile lacks the typical Rio Grande center seam or any other evidence of being woven on a narrow loom, and contains several Navajo lazy lines as well as two 3-ply side cords, a Navajo origin could be justified.

Joe Ben Wheat (pers. comm., 1985) suggests that the combination of Navajo and Spanish characteristics found in this piece may classify it as a "servant" blanket. Although documented examples are rare, frequent skirmishes between Navajo and Spaniards commonly resulted in the taking of captives. This textile may have been woven by a Navajo servant or slave living among the Spanish in the Rio Grande Valley of New Mexico. The interested reader should refer to Amsden (1934), Mera (1947), and Museum of International Folk Art (1979) for further discussion.

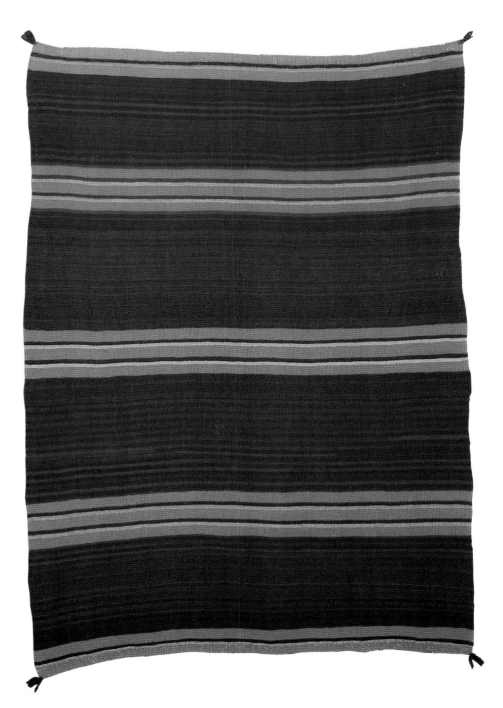

BLANKET, banded background, circa 1865–1870
A.5141.42-50
178.0 cm × 126.0 cm

| | Color | Count (per inch) | Fiber | Yarn | Ply | Spin | Diameter (mm) |
|---|---|---|---|---|---|---|---|
| Warp | white | 8 | wool | handspun | 1 | Z | |
| Weft | green | 36 | wool | handspun | 1 | Z | |
| | blue | 36 | wool | handspun | 1 | Z | |
| | black-brown | 36 | wool | handspun | 1 | Z | |
| | red 1 | 42 | wool | ravelled | 4 | S | 0.5 |
| | red 2 | 44 | wool | ravelled | 3 | S | 0.4 |

Selvage: sides: none
　　　　　 ends: two, 3-ply blue, commercial, Z, S

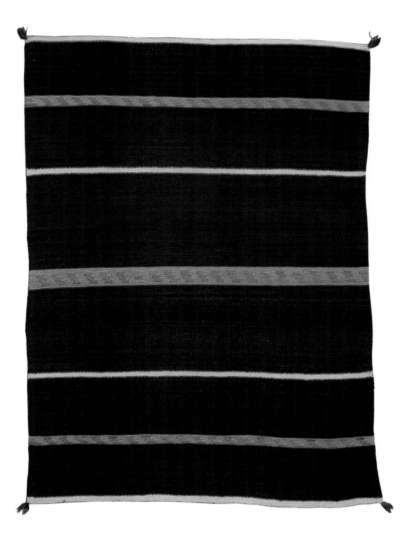

BLANKET, banded background, circa 1865–1875
A.5141.42-205
189.5 cm × 136.0 cm

| | Color | Count (per inch) | Fiber | Yarn | Ply | Spin | Diameter (mm) |
|---|---|---|---|---|---|---|---|
| *Warp* | white | 9 | wool | handspun | 1 | Z | |
| *Weft* | navy | 32 | wool | handspun | 1 | Z | |
| | black | 32 | wool | handspun | 1 | Z | |
| | white | 32 | wool | handspun | 1 | Z | |
| | red | 34 | wool | ravelled | 3 | Z | 0.5 |
| | medium blue | 34 | wool | handspun | 1 | Z | |

Selvage: sides: two, 3-ply navy, handspun, Z, S
ends: two, 3-ply burgundy (recarded white and burgundy), Z, S

Harvey Company tag: "H-4217 #89324 JO 12-18-1 Fine old Moki weave, native dye"

Ledger book: "4217 $60.00 $24.00 Juan Olivas 12/18 5⅛#
Native wool blue and black stripes red & blue fig"

The Harvey Company tags and ledger books sometimes used the alternate name for these textiles: *Moki,* or *Moqui.* This was an early name referring to the Hopi people, neighbors to the Navajo. It is not certain how this name came to be applied to this particular style of blanket. Perhaps it was that the heavy use of stripes in the blankets reminded people of the simply striped blankets produced by the Pueblo weavers. This author agrees with Mera (1948) that *Moki* implies a dubious Hopi connection and thus chooses to use his more descriptive term of "banded background."

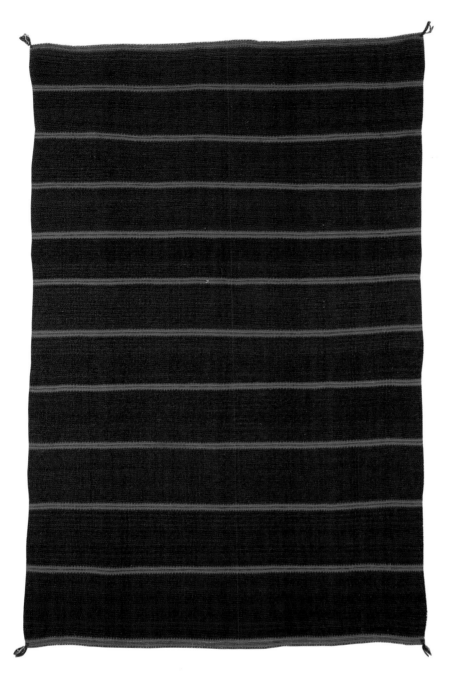

BLANKET, banded background, circa 1865–1875

A.5141.42-41

196.0 cm × 123.0 cm

| | Color | Count (per inch) | Fiber | Yarn | Ply | Spin | Diameter (mm) |
|---|---|---|---|---|---|---|---|
| Warp | white | 7 | wool | handspun | 1 | Z | |
| Weft | blue | 32 | wool | handspun | 1 | Z | |
| | brown-black | 32 | wool | handspun | 1 | Z | |
| | red | 32 | wool | ravelled | 6–8 | S | 0.4 |

Selvage: sides: two, 3-ply white, handspun, Z, S
 ends: replaced

Harvey Company tag: "H-28,122 B-48115 $275.00 DB 1/20/6"

Ledger book: "28,122 $125.00 $6.00 44115 D. Benjamin
 1-20-16"

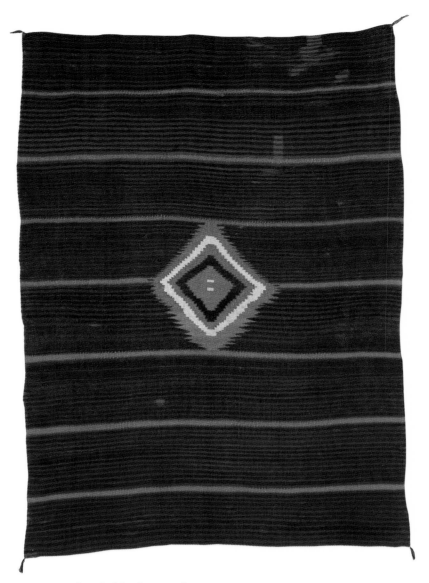

BLANKET, banded background, circa 1870
A.5141.42-51
181.0 cm × 130.5 cm

| | Color | Count (per inch) | Fiber | Yarn | Ply | Spin | Diameter (mm) |
|---|---|---|---|---|---|---|---|
| *Warp* | white | 6 | wool | handspun | 1 | Z | |
| *Weft* | blue | 38 | wool | handspun | 1 | Z | |
| | brown | 38 | wool | handspun | 1 | Z | |
| | white | 38 | wool | handspun | 1 | Z | |
| | red | 36 | wool | ravelled | 4 | S | 0.55 |

Selvage: sides: none
ends: replaced

Harvey Company tag: "H-4106 B-47615 $375.00 WR 11/20/1"

Ledger book: "4106 $125.00 $55.00 W. Rogers 11/20 4¼#
All native wool blue & brown & Balletta stripe Balletta center star"

This example has, as its primary motif, a single, central, serrate-edged diamond borrowed from the Saltillo serape. The striped ground is separated into bands by bright red stripes having characteristic beaded edges. All combine to produce an extremely elegant look with a minimum of color and patterning. This blanket has been extensively repaired.

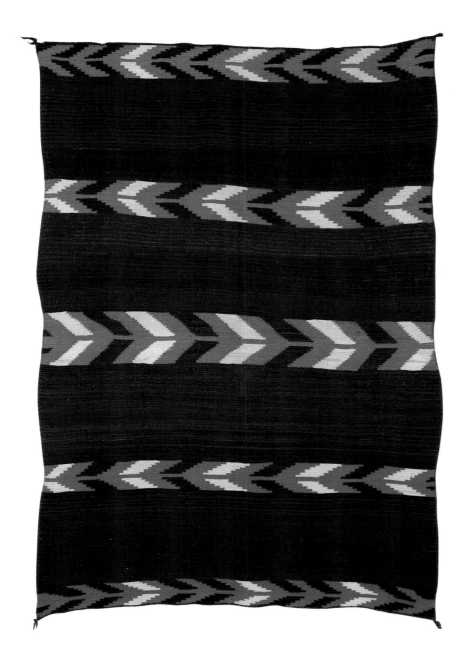

BLANKET, banded background, circa 1870
A.5141.42-58
201.0 cm × 133.5 cm

| | Color | Count (per inch) | Fiber | Yarn | Ply | Spin | Diameter (mm) |
|---|---|---|---|---|---|---|---|
| Warp | white | 7 | wool | handspun | 1 | Z | |
| Weft | blue | 26 | wool | handspun | 1 | Z | |
| | black | 26 | wool | handspun | 1 | Z | |
| | white | 36 | wool | handspun | 1 | Z | |
| | red 1 | 36 | wool | ravelled | 6 | S | 0.35 |
| | red 2 | 38 | wool | ravelled | 4 | S | 0.45 |

Selvage: replaced

Harvey Company tag: "H-6091 #846114 S. Coll. 1/20/3"

Ledger book: "6091 $250.00 $110.00 Seligman Collection Navaho
nat'l Moki pattern black & blue stripes w 5 bands or stripes 8" wide of
continuous arrows of red, white & blue. S. no 59 [? or 54 or 57]"

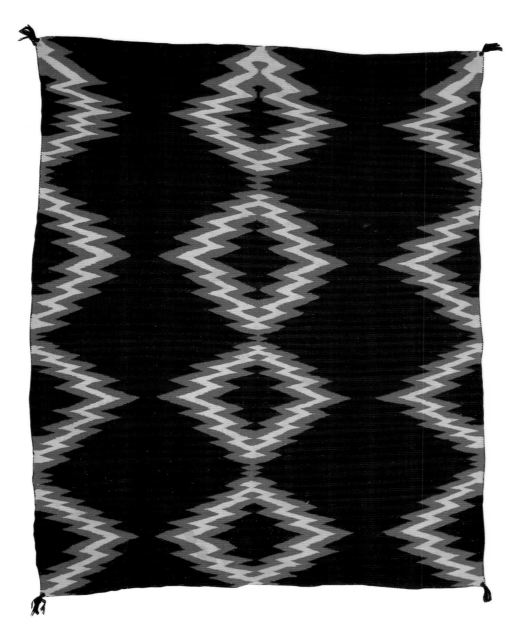

BLANKET, banded background, circa 1870–1875
A.5141.42-62
173.0 cm × 139.0 cm

| | Color | Count (per inch) | Fiber | Yarn | Ply | Spin | Diameter (mm) |
|---|---|---|---|---|---|---|---|
| Warp | white | 9 | wool | handspun | 1 | Z | |
| Weft | blue | 34 | wool | handspun | 1 | Z | |
| | brown-black | 34 | wool | handspun | 1 | Z | |
| | white | 34 | wool | handspun | 1 | Z | |
| | red | 34 | wool | ravelled | 2 | S | 0.65 |

Selvage: replaced

Harvey Company tag: "H-19,123 B-46815 D. 9/16/10"

Ledger book: "19,123 $275.00 $50.00 M. Langer 9/9/10
 Blue Moki Hard weave modern bayetta Four large diamonds in center
 Four ½ diamonds on each side."

Although the Harvey tag information seems to be somewhat at odds with the ledger
figures, the ledger description clearly matches our textile.

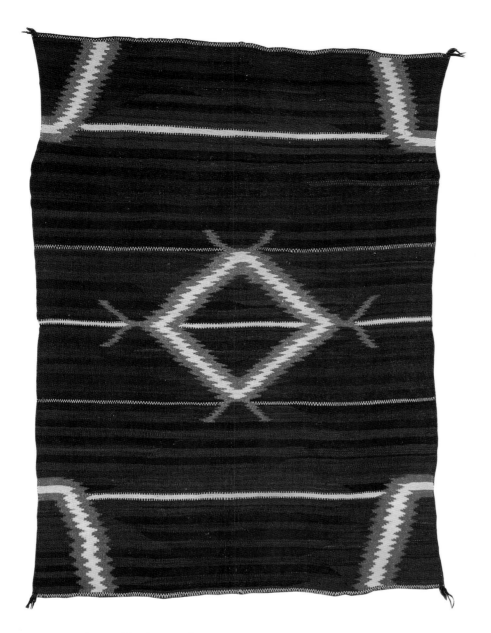

BLANKET, banded background, circa 1870–1875
A.5141.42-55
172.0 cm × 121.5 cm

| | Color | Count (per inch) | Fiber | Yarn | Ply | Spin |
|---|---|---|---|---|---|---|
| Warp | grey | 9 | wool | handspun | 1 | Z |
| Weft | brown-black | 36 | wool | handspun | 1 | Z |
| | blue | 36 | wool | handspun | 1 | Z |
| | white | 40 | wool | handspun | 1 | Z |
| | red | 42 | wool | recarded | 1 | Z |

Selvage: both: two, 3-ply blue, handspun, Z, S

Harvey Company tag: "H-6084 898315 RSSXS Sel. Coll. 1/20/3
 Seligman Coll. purchased 1/20/3"

Ledger book: "6084 $400.00 $140.00 Navaho Moki pattern blue &
 black diamond of bayetta, quarter diamonds of bayetta in corners & three
 white stripes running thro' blanket Perfect. One of the finest specimens we
 have."

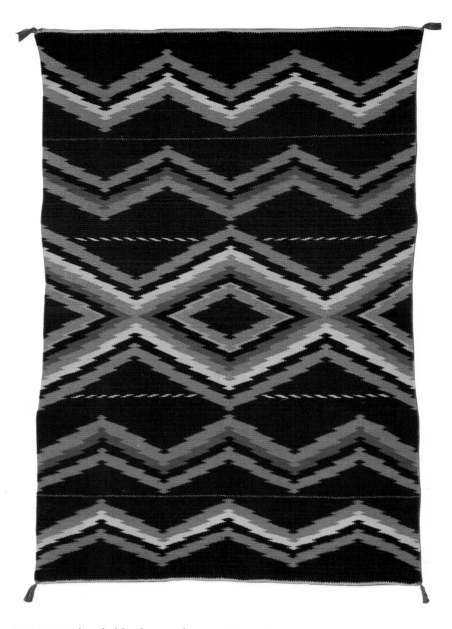

BLANKET, banded background, circa 1870–1875

A.5141.42-54

183.5 cm × 123.0 cm

| | Color | Count (per inch) | Fiber | Yarn | Ply | Spin |
|---|---|---|---|---|---|---|
| Warp | grey | 8 | wool | handspun | 1 | Z |
| Weft | blue | 44 | wool | handspun | 1 | Z |
| | black-brown | 44 | wool | handspun | 1 | Z |
| | white | 48 | wool | handspun | 1 | Z |
| | red | 46 | wool | recarded American flannel | 1 | Z |
| | green | 48 | wool | handspun | 1 | Z |
| | yellow | 44 | wool | handspun | 1 | Z |

Selvage: replaced

Harvey Company tag: "H-14848 84634 DAXSS Romero 2/29/8"

Ledger book: "14,848 $300.00 $30.00 Moki pattern with Red Yellow & Green Figures Diamonds"

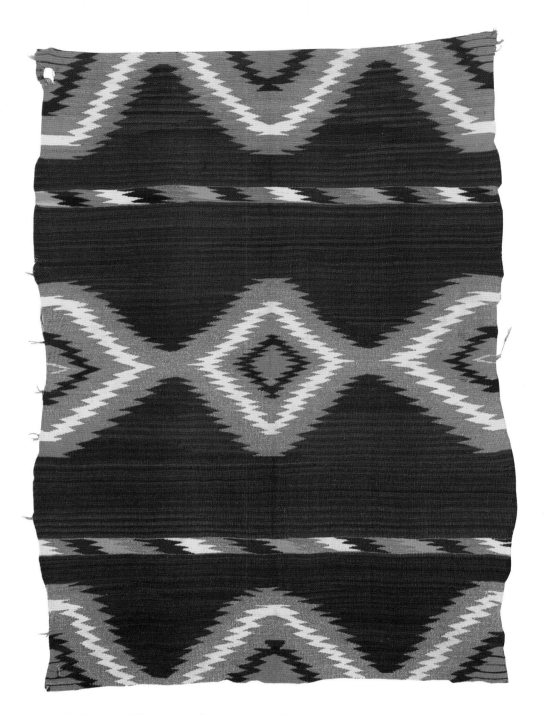

BLANKET, banded background, circa 1870–1875
A.5141.42-43
187.0 cm × 134.5 cm

| | Color | Count (per inch) | Fiber | Yarn | Ply | Spin | Twist | Diameter (mm) |
|---|---|---|---|---|---|---|---|---|
| Warp | brown | 9 | wool | commercial | 3 | S | Z | |
| Weft | blue | 48 | wool | handspun | 1 | Z | | |
| | brown | 48 | wool | handspun | 1 | Z | | |
| | white | 48 | wool | handspun | 1 | Z | | |
| | red 1 | 38 | wool | ravelled | 3 | Z | | 0.65 |
| | red 2 | 54 | wool | ravelled | 6–8 | S | | 0.28 |
| | gold | 50 | wool | ravelled | 4 | Z | | 0.35 |

Selvage: badly fragmented

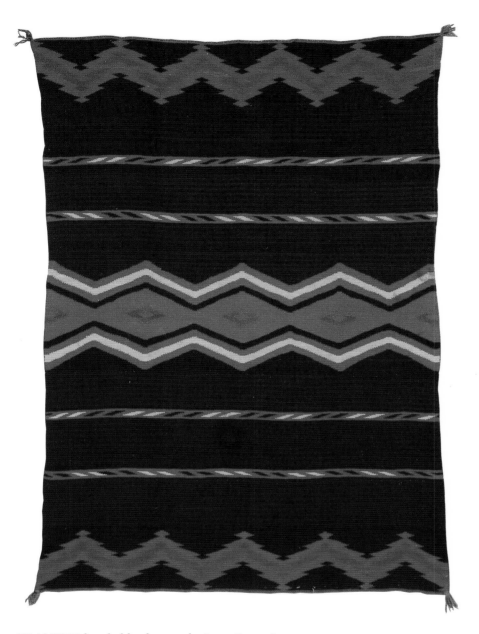

BLANKET, banded background, circa 1870–1875

A.5141.42-207

190.0 cm × 131.5 cm

| | Color | Count (per inch) | Fiber | Yarn | Ply | Spin | Diameter (mm) |
|---|---|---|---|---|---|---|---|
| *Warp* | white | 9 | wool | handspun | 1 | Z | |
| *Weft* | navy | 52 | wool | handspun | 1 | Z | |
| | black | 52 | wool | handspun | 1 | Z | |
| | red | 56 | wool | ravelled | 4 | S | 0.4 |
| | white | 56 | wool | handspun | 1 | Z | |
| | green | 56 | wool | handspun | 1 | Z | |

Selvage: sides: two, 3-ply navy, handspun, Z, S
 ends: two, 3-ply red, commercial, S, Z

Harvey Company tag: "H-41931 B-510615 HXXXSS Mrs. E. S.
 9-1-24"

Ledger book: "41931 510615 $1000.00 Mrs. Edith Sheridan 9/1/24
 Red bayetta green figures Old Nav Hopi pattern"

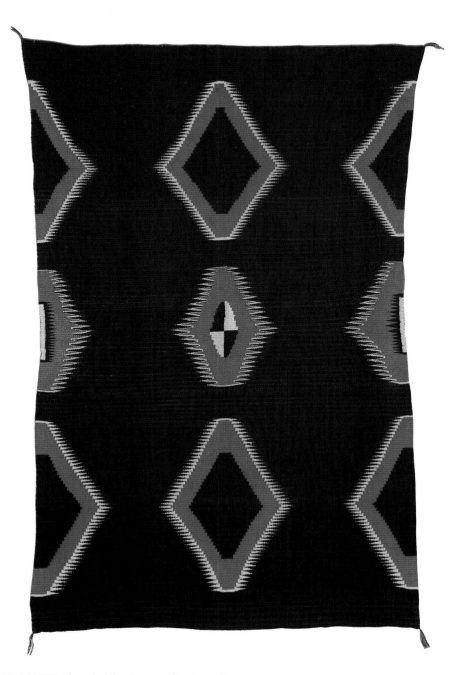

BLANKET, banded background, circa 1875
A.5141.42-203
184.6 cm × 112.0 cm

| | Color | Count (per inch) | Fiber | Yarn | Ply | Spin | Twist |
|---|---|---|---|---|---|---|---|
| Warp | brown | 9 | wool | handspun | 1 | Z | |
| Weft | blue | 48 | wool | handspun | 1 | Z | |
| | black | 48 | wool | handspun | 1 | Z | |
| | red | 58 | wool | commercial | 3 | Z | S |
| | white | 56 | wool | handspun | 1 | Z | |

Selvage: sides: 2 cords: each three, 3-ply red, commercial, Z, S
ends: 2 cords: each three, 4-ply burgundy, commercial, Z, S

Harvey Company tag: "H-20365 B-519615 UAXSS M. 4-3-11"

Ledger book: "20,365 $450.00 $175.00 Mrs. Mossin 4-3-11
 Blue Moki with red zepher diamonds"

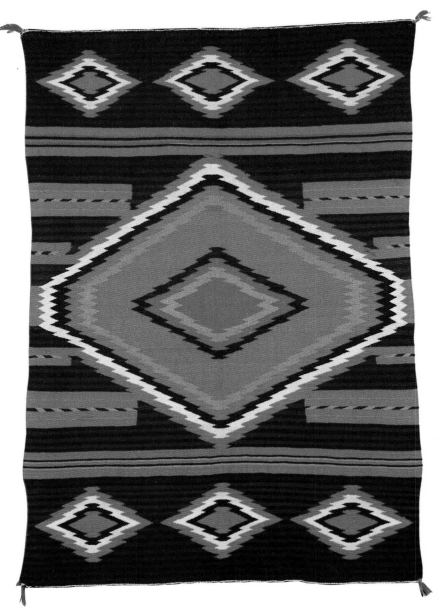

BLANKET, banded background, circa 1875
A.5141.42-57
177.0 cm × 121.0 cm

| | Color | Count (per inch) | Fiber | Yarn | Ply | Spin | Twist |
|---|---|---|---|---|---|---|---|
| *Warp* | white | 11 | wool | handspun | 1 | Z | |
| *Weft* | white | 54 | wool | handspun | 1 | Z | |
| | red | 46 | wool | ravelled | 1 | Z | |
| | blue | 52 | wool | handspun | 1 | Z | |
| | black | 52 | wool | handspun | 1 | Z | |
| | green | 54 | wool | commercial | 4 | Z | S |
| | blue-green | 54 | wool | commercial | 4 | Z | S |

Selvage: sides: 2 cords: each three, 3-ply red, commercial, S, Z
 ends: two, 3-ply blue, handspun, Z, S

Harvey Company tag: "H-17115 B-49115 DLAXS Sel. Coll.
 4/10/9"

Ledger book: "17,115 $375.00 $85.00 Arthur Seligman 4/10/9
 Moki pattern lots of red, large red diamond—6 small diamonds"

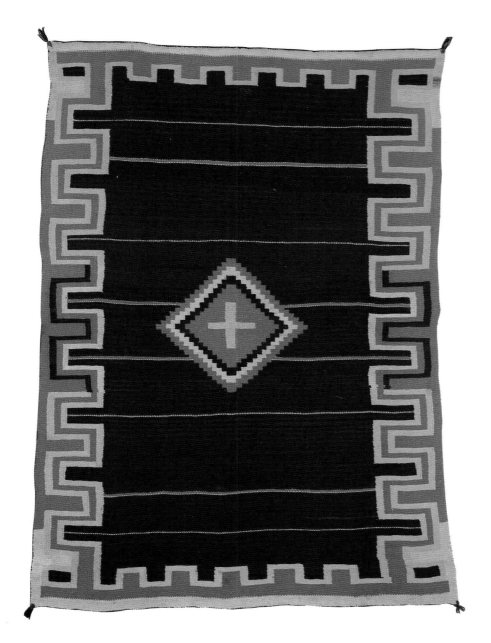

BLANKET, banded background, circa 1870–1880
A.5141.42-60
193.0 cm × 139.0 cm

| | Color | Count (per inch) | Fiber | Yarn | Ply | Spin | Diameter (mm) |
|---|---|---|---|---|---|---|---|
| Warp | white | 9 | wool | handspun | 1 | Z | |
| Weft | white | 48 | wool | handspun | 1 | Z | |
| | red | 56 | wool | ravelled | 1 | Z | 0.75 |
| | blue | 54 | wool | handspun | 1 | Z | |
| | brown-black | 48 | wool | handspun | 1 | Z | |
| | yellow | 62 | wool | handspun | 1 | Z | |

Selvage: sides: two, 3-ply spotty blue, handspun, Z, S
ends: replaced

Harvey Company tag: "H-34261 B-49815 AXXSS W. 10.9/19"

Ledger book: "34,261 Purchased 10/9/19 from E. O. Wilkinson, Los Angeles, CA
$450.00 $70.00 Old Moqui Pattern—red diamond center—yellow
cross in center blue and yellow terrace borders—American bayeta—red."

BLANKET, banded background, circa 1870–1880
A.5141.42-47
187.0 cm × 133.0 cm

| | Color | Count (per inch) | Fiber | Yarn | Ply | Spin | Diameter (mm) |
|---|---|---|---|---|---|---|---|
| *Warp* | white | 10 | wool | handspun | 1 | Z | |
| *Weft* | white | 46 | wool | handspun | 1 | Z | |
| | black | 46 | wool | handspun | 1 | Z | |
| | blue | 46 | wool | handspun | 1 | Z | |
| | red | 48 | wool | ravelled | 2–4 | S | 0.45 |

Selvage: both: two, 3-ply blue, handspun, Z, S

Harvey Company tag: "H-21703 B-411115 $375.00 McCloud Coll.
12/26/11"

Ledger book: "21,703 $275.00 $100.00 H. S. at Fresno 12/26/11
Old Navaho Hopi patern Red Blue & White Diamond center
½ Dia Each corner"

The seeming discrepancy in retail price ($375.00 on the tag and $275.00 in the ledger book) can be explained by an understanding of Schweizer's occasional inconsistency. Late in March 1912 Schweizer scribbled in the ledgers a price increase to $375.00.

Also at odds is the difference in source: "McCloud" versus "H. S. at Fresno." According to correspondence in the Grace Nicholson Papers between Mrs. G. H. Taylor (Ed McLeod's sister; see comment on #89) and Pasadena basket dealer Grace Nicholson, Herman Schweizer twice visited Mrs. Taylor at her home in Fresno about buying her late brother's collection. Although she wished to keep the collection intact, an adverse financial situation forced Mrs. Taylor to sell some material to Schweizer. Thus it is likely that Schweizer misspelled McLeod as "McCloud" and that the entry in the ledger of "H. S. at Fresno" indicates that Schweizer himself bought the piece from Mrs. Taylor.

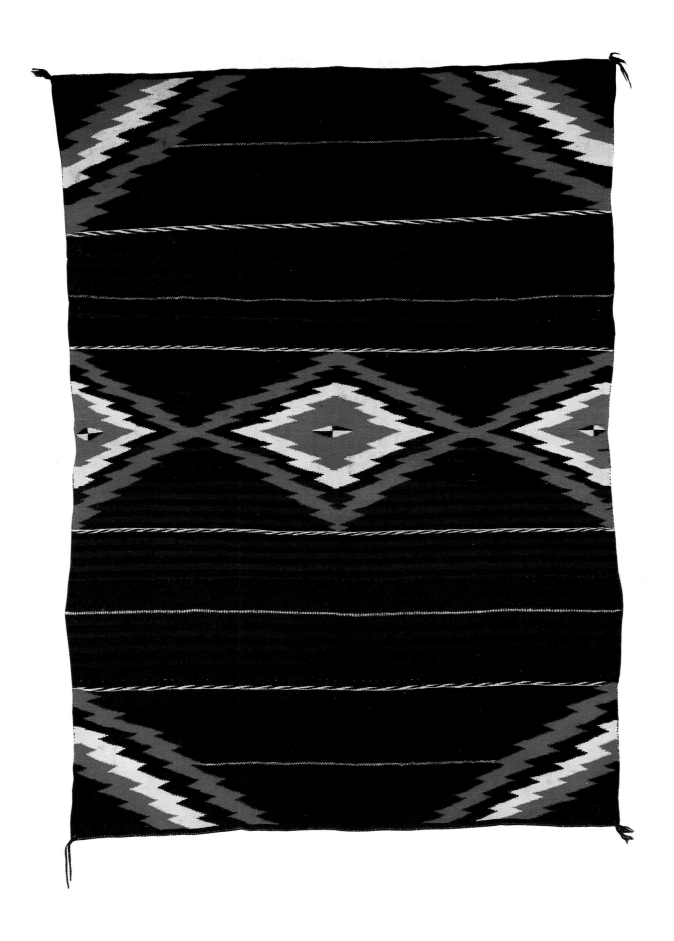

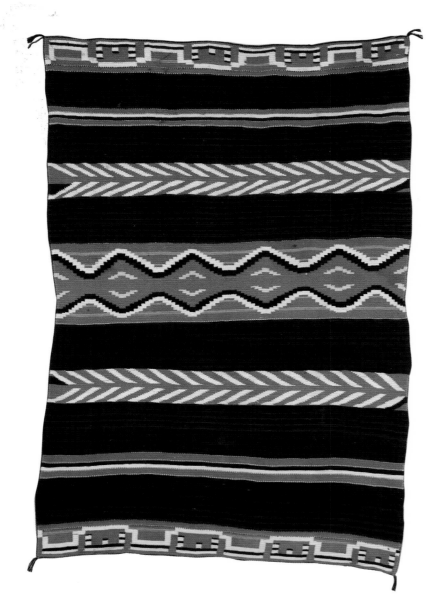

BLANKET, banded background, circa 1870–1880
A.5141.42-201
187.0 cm × 126.0 cm

| | Color | Count (per inch) | Fiber | Yarn | Ply | Spin | Diameter (mm) |
|---|---|---|---|---|---|---|---|
| Warp | white | 10 | wool | handspun | 1 | Z | |
| Weft | blue | 48 | wool | handspun | 1 | Z | |
| | black | 48 | wool | handspun | 1 | Z | |
| | white | 58 | wool | handspun | 1 | Z | |
| | orange-red | 58 | wool | ravelled | 3 | S | 0.5 |
| | red | 64 | wool | ravelled | 3 | S | 0.5 |
| | pink | 48 | wool | recarded red and white | 1 | Z | |
| | yellow | 48 | wool | handspun | 1 | Z | |

Selvage: replaced

Harvey Company tag: "H-13188 B-45115 RAXSS JP 2/19/7"

Ledger book: "13,188 $275.00 $35.00 Julian Padilla 2-19-7
 Old native Moki pattern Bayetta small yellow figures"

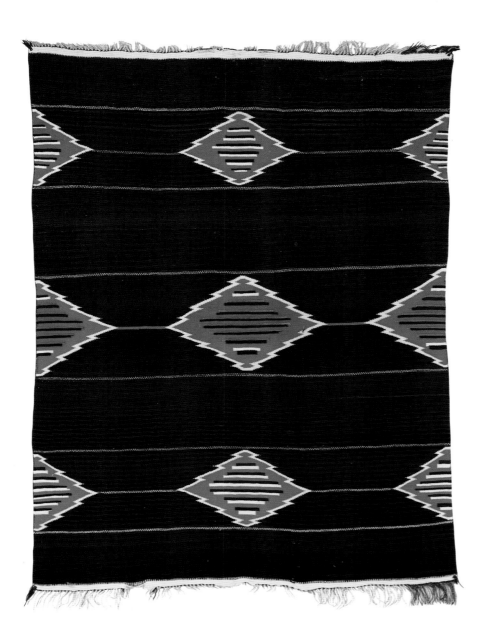

BLANKET, banded background, circa 1870–1880
A.5141.42-45
170.0 cm × 130.0 cm

| | Color | Count (per inch) | Fiber | Yarn | Ply | Spin | Diameter (mm) |
|---|---|---|---|---|---|---|---|
| *Warp* | brown | 9 | wool | handspun | 1 | Z | |
| | white | 9 | wool | handspun | 1 | Z | |
| *Weft* | dark blue | 48 | wool | handspun | 1 | Z | |
| | brown | 48 | wool | handspun | 1 | Z | |
| | red | 56 | wool | ravelled | 3 | Z | 0.4 |
| | medium blue | 64 | wool | ravelled | 3 | Z | 0.35 |
| | white | 48 | wool | handspun | 1 | Z | |

Selvage: sides: two, 2-ply blue, handspun, Z, S
 ends: two, 3-ply blue, handspun, Z, S

Harvey Company tag: "H-18917 B-510615 RAXSS S. 4/26/10"

Ledger book: "18,917 $450.00 $100.00 M. Schuster Moki Pattern
 Fine Bayetta diamonds with blue & white stripes"

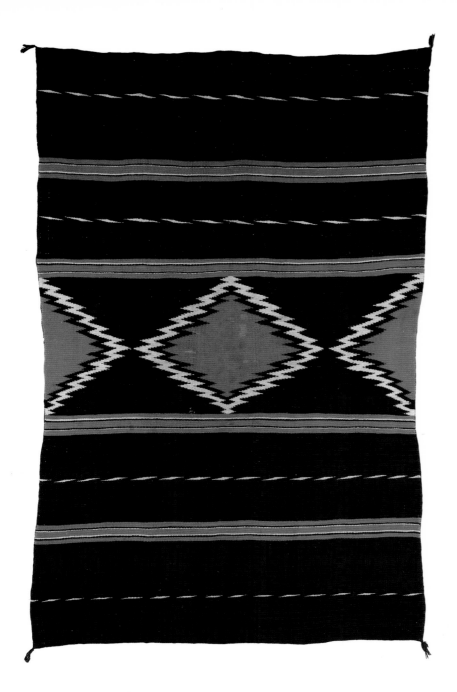

BLANKET, banded background, circa 1870–1880

A.5141.42-48

197.0 cm × 127.0 cm

| | Color | Count (per inch) | Fiber | Yarn | Ply | Spin | Diameter (mm) |
|---|---|---|---|---|---|---|---|
| Warp | white | 7 | wool | handspun | 1 | Z | |
| Weft | white | 40 | wool | handspun | 1 | Z | |
| | blue | 40 | wool | handspun | 1 | Z | |
| | black | 40 | wool | handspun | 1 | Z | |
| | red | 38 | wool | ravelled | 6 | S | 0.35 |

Selvage: replaced

Harvey Company tag: "H-21,486 B-46115 $350.00 HS 11/14/11"

Ledger book: "21,486 $35.00 H. Schweizer 11/14/11 Old Navaho
 Moki Patern Red Diamond in Center"

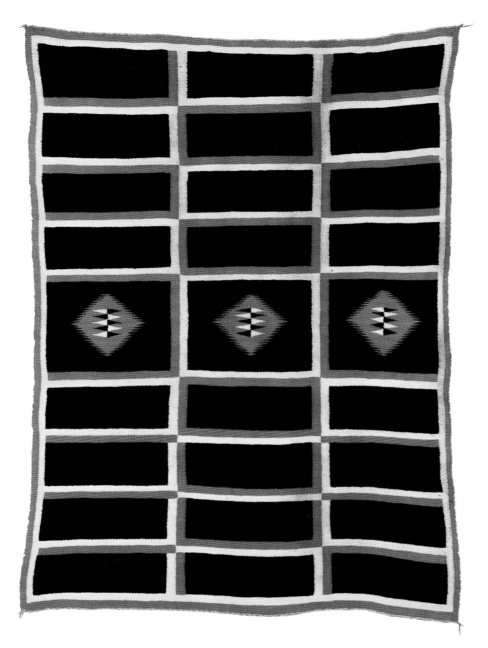

BLANKET, banded background, circa 1870–1880
A.5141.42-59
187.0 cm × 138.5 cm

| | Color | Count (per inch) | Fiber | Yarn | Ply | Spin | Diameter (mm) |
|---|---|---|---|---|---|---|---|
| Warp | brown | 7 | wool | handspun | 1 | Z | |
| Weft | white | 30 | wool | handspun | 1 | Z | |
| | brown-black | 30 | wool | handspun | 1 | Z | |
| | blue | 30 | wool | handspun | 1 | Z | |
| | red | 30 | wool | ravelled | 2 | S | 0.9 |

Selvage: sides: two, 2-ply yellow, handspun(?), Z, S
ends: one, 3-ply yellow, handspun(?), Z, S
one, 3-ply green, handspun(?), Z, S

Harvey Company tag: "H-3973 B-43415 $275.00 PM 9/20/1"

Ledger book: "3,973 $75.00 $25.00 P.M. 9/20 4¾# Rare old
native wool & Balletta Red black ground Red white Fig."

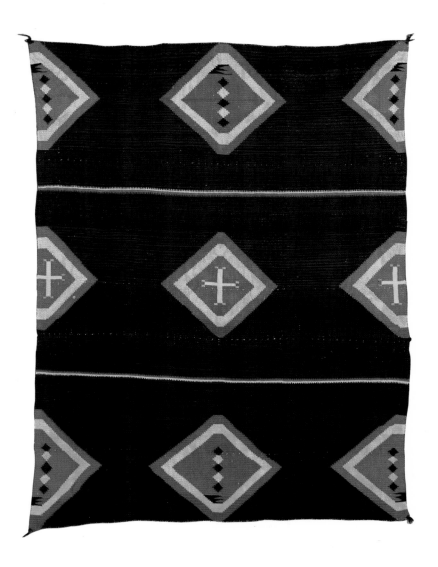

BLANKET, banded background, circa 1875–1880
A.5141.42-202
162.0 cm × 121.5 cm

| | Color | Count (per inch) | Fiber | Yarn | Ply | Spin | Twist |
|---|---|---|---|---|---|---|---|
| Warp | white | 10 | wool | handspun | 1 | Z | |
| Weft | blue | 40 | wool | handspun | 1 | Z | |
| | brown | 40 | wool | handspun | 1 | Z | |
| | red | 32 | wool | commercial | 4[a] | Z | S |
| | green | 32 | wool | commercial | 4[a] | Z | S |
| | yellow | 34 | wool | commercial | 4[a] | Z | S |
| | purple (faded to blue) | 32 | wool | commercial | 4[a] | Z | S |

[a] Each color has two 4-ply yarns laid next to each other.

Selvage: both: two, 3-ply navy, handspun, Z, S

Harvey Company tag: "H-15,651 B-44615 L. 8-8-8"

Ledger book: "15,651 $225.00 $40.00 M. Langer 8-8-8
 Moki pattern zepher red diamonds with yellow crosses."

In an attempt to maintain an even texture, the weaver doubled up on the commercial yarns to equal the weight of the handspun.

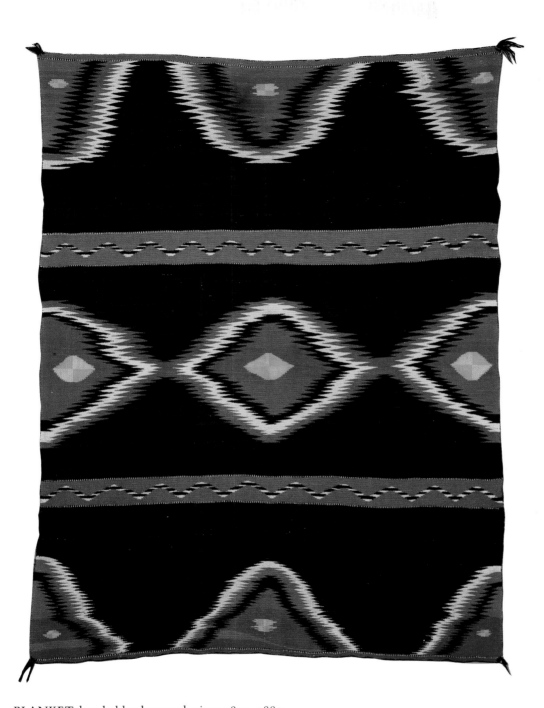

BLANKET, banded background, circa 1875–1880
A.5141.42-61
179.0 cm × 136.0 cm

| | Color | Count (per inch) | Fiber | Yarn | Ply | Spin | Twist | Diameter (mm) |
|---|---|---|---|---|---|---|---|---|
| *Warp* | white | 9 | wool | handspun | 1 | Z | | |
| *Weft* | white | 56 | wool | handspun | 1 | Z | | |
| | blue | 64 | wool | handspun | 1 | Z | | |
| | brown | 64 | wool | handspun | 1 | Z | | |
| | red | 60 | wool | ravelled | 3 | S | | 0.45 |
| | orange-red | 54 | wool | ravelled | 1 | Z | | 0.7 |
| | yellow | 58 | wool | commercial | 4 | Z | S | |
| | green | 58 | wool | commercial | 4 | Z | S | |

Selvage: both: two, 3-ply blue, handspun, Z, S

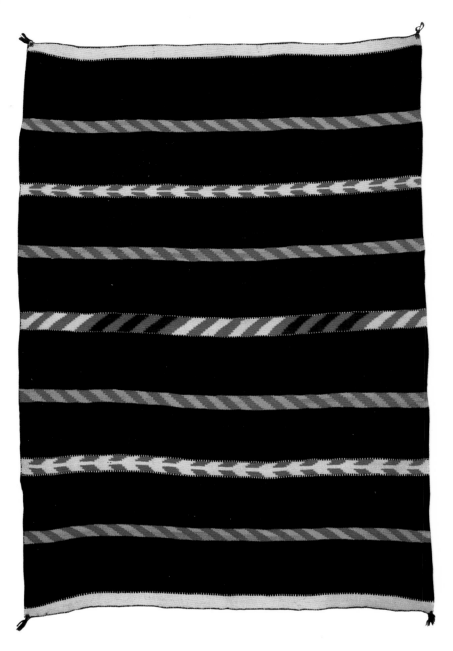

BLANKET, banded background, circa 1875–1880
A.5141.42-52
178.0 cm × 122.0 cm

| | Color | Count (per inch) | Fiber | Yarn | Ply | Spin | Twist |
|------|-------|------------------|-------|------|-----|------|-------|
| *Warp* | white | 7 | wool | handspun | 1 | Z | |
| *Weft* | blue | 34 | wool | handspun | 1 | Z | |
| | brown | 34 | wool | handspun | 1 | Z | |
| | white | 32 | wool | handspun | 1 | Z | |
| | yellow | 46 | wool | handspun | 1 | Z | |
| | red | 46 | wool | commercial | 4 | Z | S |
| | green | 42 | wool | handspun | 1 | Z | |

Selvage: both: two, 3-ply blue, handspun, Z, S

Harvey Company tag: "H-3736 89514 FCG 6/23/1"

Ledger book: "3,736 $45.00 $15.00 F. C. Gillenbeck 6/23 4#
 Native wool Black and blue stripe yellow & red design"

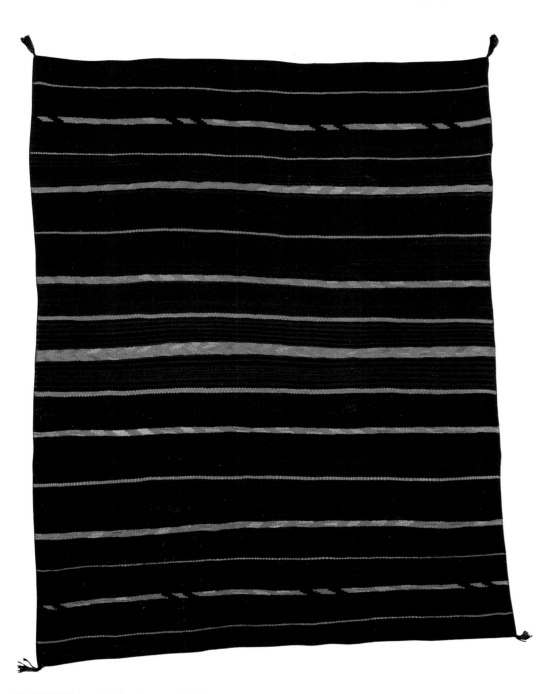

BLANKET, banded background, circa 1875–1880
A.5141.42-46
177.0 cm × 133.0 cm

| | Color | Count (per inch) | Fiber | Yarn | Ply | Spin | Twist |
|------|-------|------------------|-------|------|-----|------|-------|
| *Warp* | grey | 7 | wool | handspun | 1 | Z | |
| *Weft* | blue | 38 | wool | handspun | 1 | Z | |
| | brown | 38 | wool | handspun | 1 | Z | |
| | red | 52 | wool | commercial | 4 | Z | S |
| | green | 38 | wool | handspun | 1 | Z | |

Selvage: replaced

Harvey Company tag: "H-13936 B-43115 $125.00 JP 8/26/7"

Ledger book: "13,936 $75.00 $17.50 J. Padia 7/26/7 Old native
 Moki Pattern Red & Green Figures"

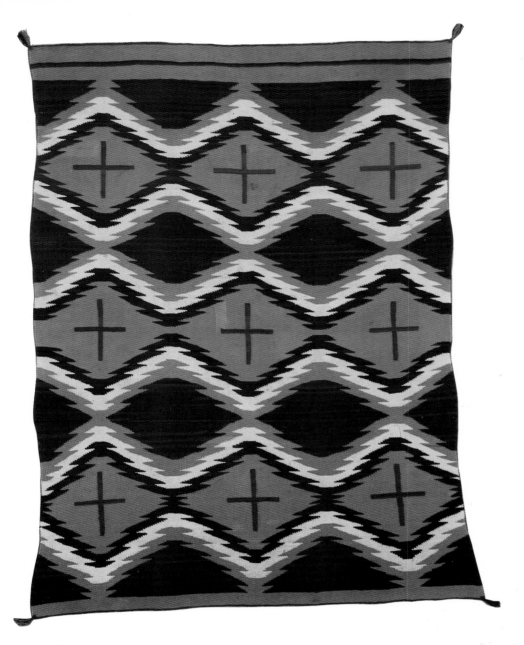

BLANKET, banded background, circa 1875–1880
A.5141.42-40
173.0 cm × 132.0 cm

| | Color | Count (per inch) | Fiber | Yarn | Ply | Spin | Twist | Diameter (mm) |
|---|---|---|---|---|---|---|---|---|
| Warp | white | 9 | wool | handspun | 1 | Z | | |
| Weft | white | 40 | wool | handspun | 1 | Z | | |
| | blue | 40 | wool | handspun | 1 | Z | | |
| | brown-black | 40 | wool | handspun | 1 | Z | | |
| | red 1 | 46 | wool | ravelled | 1 | Z | | 0.9 |
| | red 2 | 48 | wool | commercial | 4 | Z | S | |
| | blue-green | 44 | wool | handspun | 1 | Z | | |

Selvage: replaced

Harvey Company tag: "H-21820 B-48115 UXSS FS 2/23/12
 Moki bayetta"

Ledger book: "21,820 $350.00 $60.00 J. Seligman 2-23-12
 Old Bayetta Hopi Patern Blkt Blue Ground 9 Green crosses"

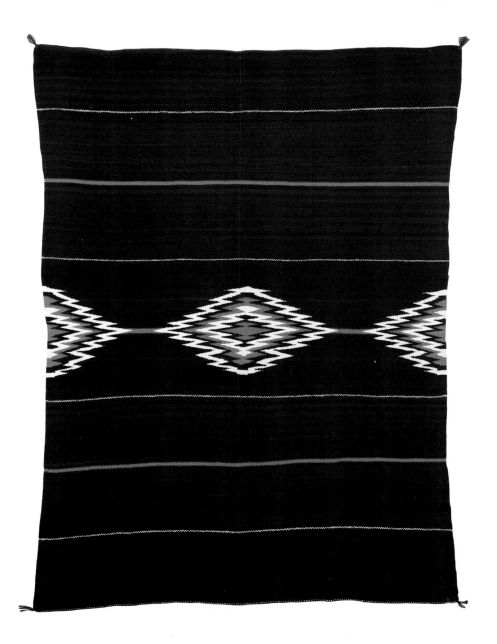

BLANKET, banded background, circa 1875–1885
A.5141.42-53
170.5 cm × 127.0 cm

| | Color | Count (per inch) | Fiber | Yarn | Ply | Spin | Diameter (mm) |
|---|---|---|---|---|---|---|---|
| Warp | brown | 9 | wool | handspun | 1 | Z | |
| Weft | brown | 34 | wool | handspun | 1 | Z | |
| | blue | 34 | wool | handspun | 1 | Z | |
| | white | 34 | wool | handspun | 1 | Z | |
| | red | 42 | wool | ravelled | 6 | Z | 0.35 |

Selvage: sides: no cord
 ends: replaced

Harvey Company tag: "H-7004 842615 RXXSS S. Coll. 1/20/3″

Ledger book: "7004 $350.00 $160.00 Seligman Collection Moki Pattern
 Black stripe with thin red & white stripes running through 1 ft apart
 diamond in center made of white red & blue A very fine blanket.
 Excellent weave. S-56″

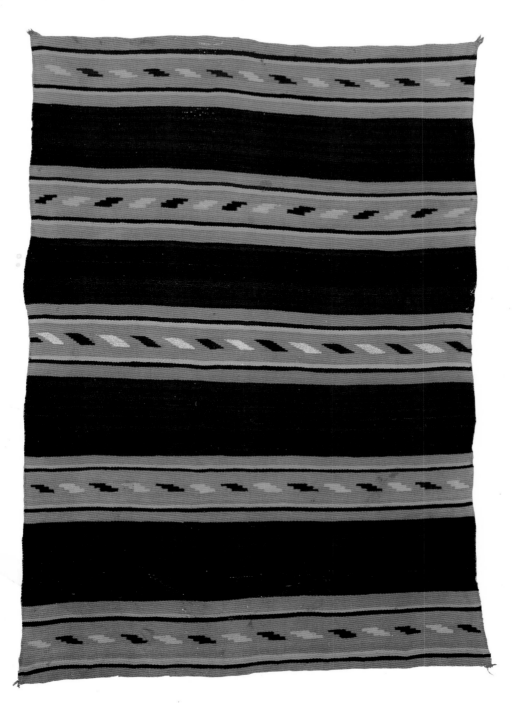

BLANKET, banded background, circa 1880
A.5141.42-44
189.0 cm × 136.0 cm

| | Color | Count (per inch) | Fiber | Yarn | Ply | Spin |
|---|---|---|---|---|---|---|
| *Warp* | white | 7 | wool | handspun | 1 | Z |
| *Weft* | orange-red | 26 | wool | handspun | 1 | Z |
| | blue | 26 | wool | handspun | 1 | Z |
| | black | 26 | wool | handspun | 1 | Z |
| | yellow | 26 | wool | handspun | 1 | Z |
| | green | 26 | wool | handspun | 1 | Z |

Selvage: sides: two, 2-ply red, handspun, Z, S
ends: two, 3-ply red, handspun, Z, S

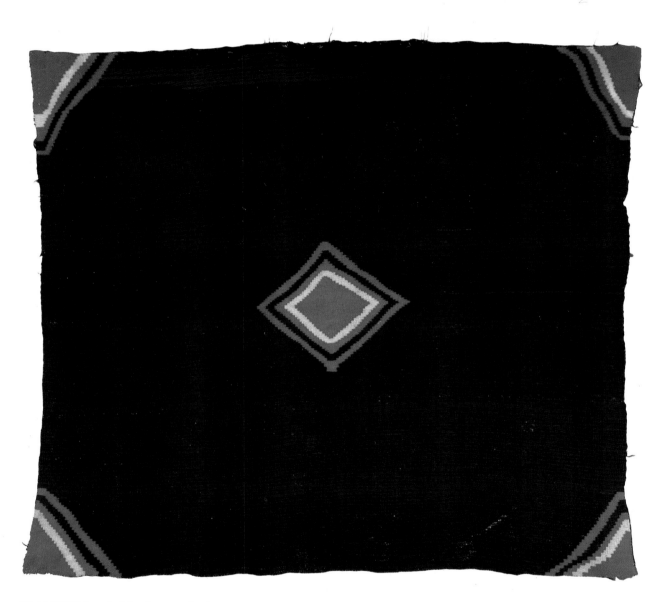

BLANKET, banded background, circa 1880
A.5141.42-63
150.0 cm × 166.0 cm

| | Color | Count (per inch) | Fiber | Yarn | Ply | Spin | Twist |
|--------|-------------|------------------|-------|------------|-----|------|-------|
| Warp | white | 10 | wool | commercial | 4 | Z | S |
| Weft | blue | 48 | wool | handspun | 1 | Z | |
| | brown-black | 48 | wool | handspun | 1 | Z | |
| | red | 48 | wool | handspun | 1 | Z | |
| | white | 48 | wool | handspun | 1 | Z | |

Selvage: both: two, 2-ply blue, handspun, Z, S

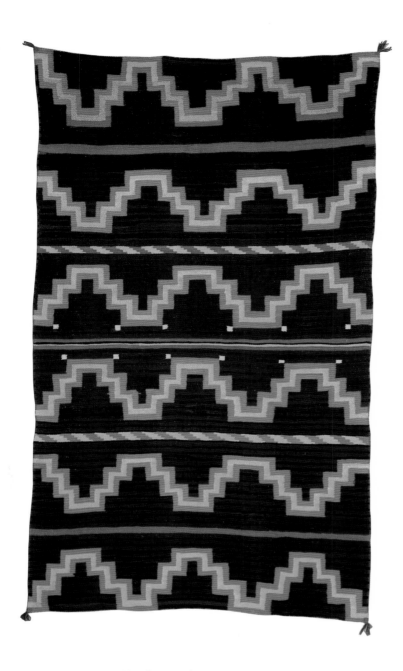

BLANKET, banded background, circa 1880
A.5141.42-206
180.2 cm × 107.2 cm

| | Color | Count (per inch) | Fiber | Yarn | Ply | Spin |
|---|---|---|---|---|---|---|
| Warp | white | 10 | wool | handspun | 1 | Z |
| Weft | black | 36 | wool | handspun | 1 | Z |
| | navy | 36 | wool | handspun | 1 | Z |
| | medium blue | 36 | wool | handspun | 1 | Z |
| | orange-red | 36 | wool | handspun | 1 | Z |
| | red | 38 | wool | handspun | 1 | Z |

Selvage: replaced

Harvey Company tag: "H-7802 B-43898 O. 5-13-3"

Ledger book: "7802 $75.00 $25.00 Olivas 5/13 Moki pattern"

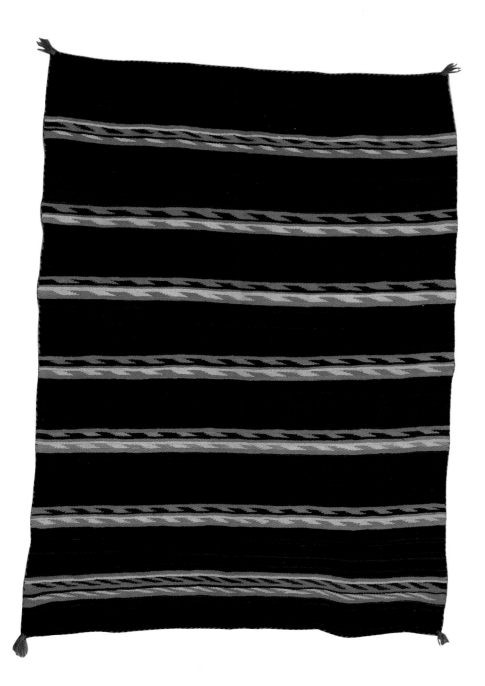

BLANKET, banded background, circa 1880–1885
A.5141.42-49
188.0 cm × 129.0 cm

| | Color | Count (per inch) | Fiber | Yarn | Ply | Spin |
|---|---|---|---|---|---|---|
| Warp | brown | 7 | wool | handspun | 1 | Z |
| Weft | brown-black | 32 | wool | handspun | 1 | Z |
| | blue | 32 | wool | handspun | 1 | Z |
| | orange-red | 32 | wool | handspun | 1 | Z |
| | cream (faded from yellow) | 32 | wool | handspun | 1 | Z |

Selvage: both: two, 4-ply red, commercial, Z, S
two, 4-ply blue, commercial, Z, S

Harvey Company tag: "H-5944 89324 $85.00 9/9/2"

Ledger book: "5944 $60.00 $25.00 Sieg. Aug/9/02 old native"

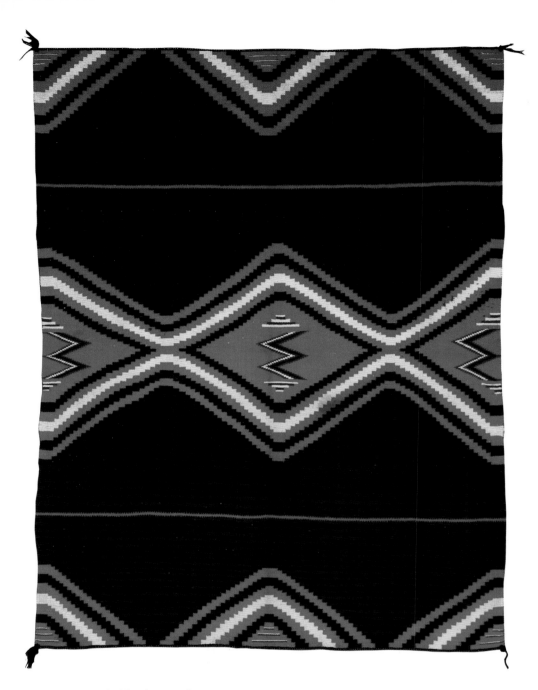

BLANKET, banded background, circa 1880–1890
A.5141.42-56
178.0 cm × 135.5 cm

| | Color | Count (per inch) | Fiber | Yarn | Ply | Spin | Twist |
|---|---|---|---|---|---|---|---|
| *Warp* | white | 8 | wool | handspun | 1 | Z | |
| *Weft* | blue | 48 | wool | handspun | 1 | Z | |
| | black | 48 | wool | handspun | 1 | Z | |
| | white | 48 | wool | handspun | 1 | Z | |
| | red | 50 | wool | commercial | 4 | Z | S |
| | green | 50 | wool | commercial | 4 | Z | S |

Selvage: both: two, 3-ply blue, handspun, Z, S

Harvey Company tag: "H-5437 89924 $175.00 MC 7/20"

Ledger book: "5,437 $65.00 $30.00 Mrs. Crary 7/20 old Germantown"

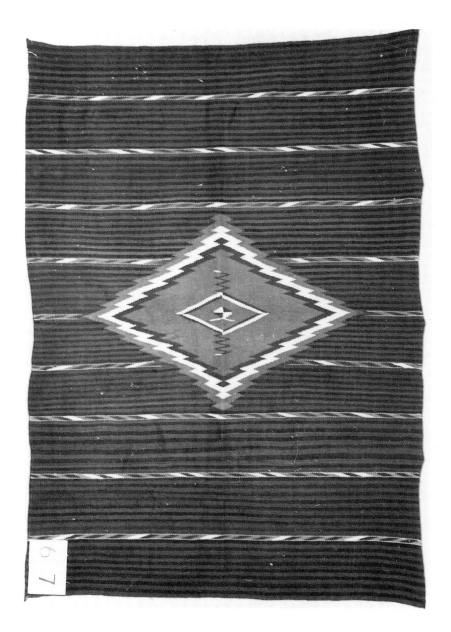

BLANKET (missing), banded background

A.5141.42-42

63″×44″

Warp: 8/inch

Weft: 46/inch

Selvage: replaced

Catalogue Card: "Blue & black narrow striped background with intervals of red bayeta, white and blue diamond stripes. Center oblique-angled diamond with red center, blue, white and red border. 'Lightning' zigzags and smaller diamond in center of diamond motif. Bayeta a soft rose."

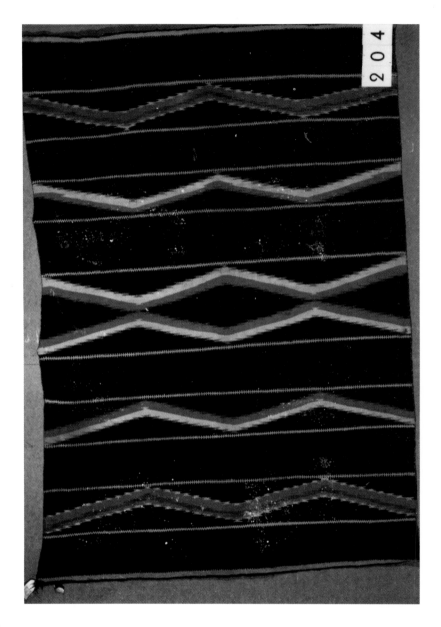

BLANKET (missing), banded background
A.5141.42-204
76" × 52"

Warp: 9/inch
Weft: 28/inch

Catalogue card: "Beaded white lines divide banded background into horizontal band areas. In every other one of these areas is oblique-angled edged wide zigzag in red and white and green. Two center zigzags meet to form diamond in center, half diamonds at edges. Native wool and dye."

Harvey Company tag: "H-4684 #89334 HLAXS Old native wool and dye 2-26-2"

Ledger book: "4,684 $125.00 $35.00 Juan Olivas 2/26 4⅝#
 Old Native wool Blue with Red Green and White"

Banded Blankets

The term *banded,* or *zoned, blanket* refers to the fact that the textile is divided into several horizontal bands with any additional design motifs arranged within them. The sixteen examples in the Hearst collection range from simple horizontal striping in numbers 1, 69, 198, and 199 to the more complex patterning seen in numbers 156 and 185.

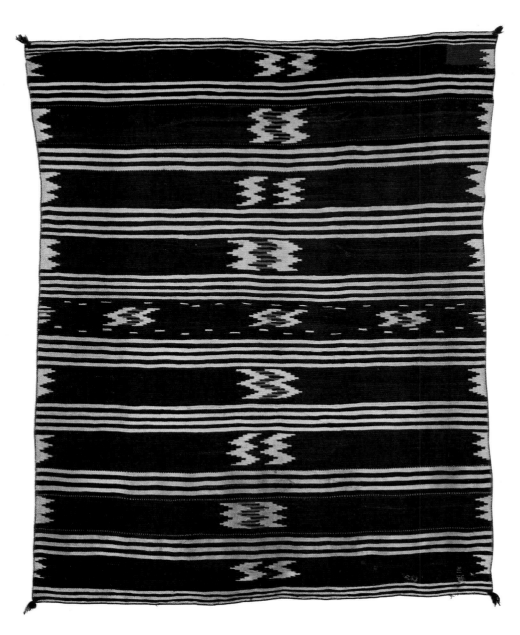

BLANKET, banded, circa 1865–1875
A.5141.42-68
182.5 cm × 145.0 cm

| | Color | Count (per inch) | Fiber | Yarn | Ply | Spin | Diameter (mm) |
|---|---|---|---|---|---|---|---|
| *Warp* | white | 9 | wool | handspun | 1 | Z | |
| *Weft* | brown | 58 | wool | handspun | 1 | Z | |
| | blue | 58 | wool | handspun | 1 | Z | |
| | white | 58 | wool | handspun | 1 | Z | |
| | red | 58 | wool | ravelled | 3 | Z | 0.6 |

Selvage: replaced; ends rewoven

Harvey Company tag: "H-5414 #89824 P.M. 8/26/2 M-654"

Ledger book: "5414 $55.00 $18.00 P. Muniz 8/26 Fine Old Chimallo Zig"

This blanket is most unusual in the extensive use of brown, the blue and white bands, and the multiple, small terraced segments in the middle and along the edges, all indicating some Rio Grande influence.

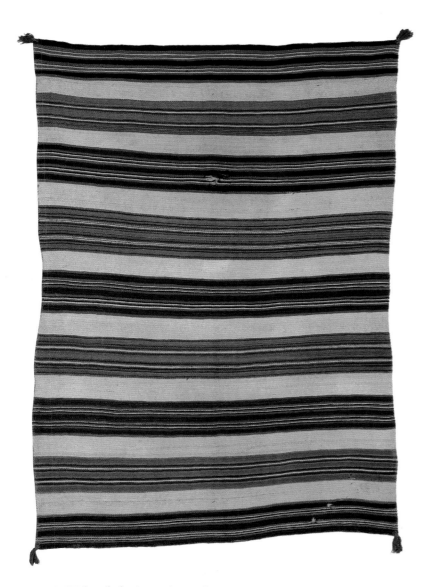

BLANKET, banded, circa 1870–1875
A.5141.42-69
161.5 cm × 114.5 cm

| | Color | Count (per inch) | Fiber | Yarn | Ply | Spin | Diameter (mm) |
|------|-------|------------------|-------|------|-----|------|---------------|
| Warp | white | 9 | wool | handspun | 1 | Z | |
| Weft | white | 42 | wool | handspun | 1 | Z | |
| | light blue | 42 | wool | handspun | 1 | Z | |
| | medium blue | 42 | wool | handspun | 1 | Z | |
| | red 1 | 42 | wool | ravelled | 3–4 | S | 0.35 |
| | red 2 | 42 | wool | handspun | 1 | Z | |
| | pink | 42 | wool | recarded white and red | 1 | Z | |
| | green | 42 | wool | handspun | 1 | Z | |

Selvage: replaced

Harvey Company tag: "H-8125 #8983 LS 6/26/2"

Ledger book: "8125 $20.00 $5.00 L. Simon 6/26 Old native wool & dye"

Even though this blanket bears no more design than striping, the use of the normal blue, white, and red mixed with the rarer light blue produces a lively and beautiful effect.

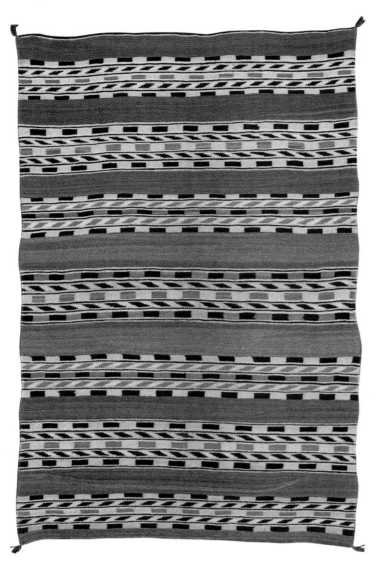

BLANKET, banded, circa 1870–1875
A.5141.42-67
199.0 cm × 129.0 cm

| | Color | Count (per inch) | Fiber | Yarn | Ply | Spin |
|---|---|---|---|---|---|---|
| *Warp* | white | 7 | wool | handspun | 1 | Z |
| *Weft* | brown | 20 | wool | handspun | 1 | Z |
| | blue | 28 | wool | handspun | 1 | Z |
| | green | 28 | wool | handspun | 1 | Z |
| | yellow | 28 | wool | handspun | 1 | Z |
| | white | 28 | wool | handspun | 1 | Z |

Selvage: replaced. Both ends have been cut off and repaired with cotton string
warp, presumably by Fred Harvey Co.

Harvey Company tag: "H-2267 #89814 YAXSS A.G. 12-19-1
Rare old native dyes"

Ledger book: [no entry]

Although this piece was woven with quite an agitated design of many small squares
and parallelograms to create a sense of movement, the overall effect is very somber
due to the color combinations. The unusually extensive use of yellow and green yarn
prompted Herman Schweizer to comment: "This may be Hopi or what Dr. Mera
calls a slave blanket."

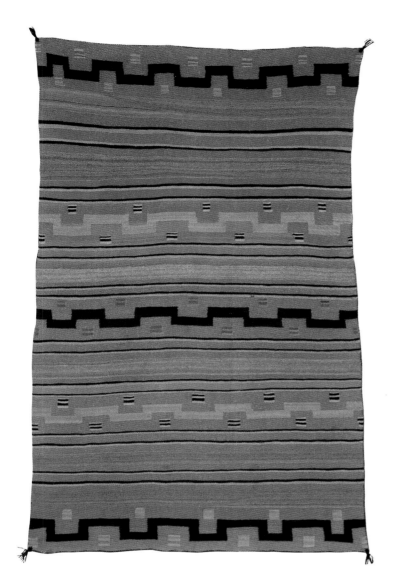

BLANKET, banded, circa 1870–1875
A.5141.42-183
184.0 cm × 115.0 cm

| | Color | Count (per inch) | Fiber | Yarn | Ply | Spin | Twist | Diameter (mm) |
|---|---|---|---|---|---|---|---|---|
| Warp | white | 8 | wool | handspun | 1 | Z | | |
| Weft | red 1 | 56 | wool | recarded and respun ravelled | 1 | Z | | 1.0 |
| | grey | 56 | wool | handspun | 1 | Z | | |
| | blue | 58 | wool | handspun | 1 | Z | | |
| | yellow | 54 | wool | handspun | 1 | Z | | |
| | red 2 | 52 | wool | commercial | 3 | S | Z | |
| | red 3 | 56 | wool | ravelled | 2 | S | | 0.5 |
| | green | 56 | wool | handspun | 1 | Z | | |

Selvage: replaced

Harvey Company tag: "H-7573 #89414 P.M. 10-10-2 Bayetta"

Ledger book: "7573 $65.00 $16.00 Muniz 10/10/2 Chimallo"

Schweizer's incorrect characterization of this piece as Chimayo refers to the small village in northern New Mexico, famous for its handwoven textiles in the Spanish and Mexican traditions. The ledger-book misnomer of this Navajo textile as "Chimallo" or Chioraya could reflect a mistaken entry or merely a misplaced number.

BLANKET, banded, circa 1875–1880
A.5141.42-185
179.0 cm × 126.5 cm

| | Color | Count (per inch) | Fiber | Yarn | Ply | Spin | Twist |
|---|---|---|---|---|---|---|---|
| Warp | white | 8 | wool | handspun | 1 | Z | |
| Weft | grey 1 | 40 | wool | handspun | 1 | Z | |
| | red 1 | 52 | wool | commercial | 3 | Z | S |
| | red 2 | 48 | wool | commercial | 4 | Z | S |
| | white | 50 | wool | handspun | 1 | Z | |
| | navy | 50 | wool | handspun | 1 | Z | |
| | grey 2 (faded from blue) | 58 | wool | commercial | 3 | Z | S |
| | green | 50 | wool | commercial | 4 | Z | S |
| | yellow 1 | 52 | wool | commercial | 4 | Z | S |
| | yellow 2 | 48 | wool | handspun | 1 | Z | |

Selvage: sides: 2 cords: one, multiple-ply ravelled red, Z, S
one, multiple-ply ravelled dark grey, Z, S
ends: 2 cords: one, 3-ply pink, handspun, Z, S
one, multiple-ply ravelled red, Z, S

Harvey Company tag: "A-768 B-518115 LASXS J. W. Stebbins
9-27-28"

Ledger book: "768 518115 $750.00 J. W. Stebbins 9/27/28
Old Hopi stripe effect 4 wide grey bands with terraced figures
and bars in blue, yellow, green & white, 2 narrow red bands with
some colored figures"

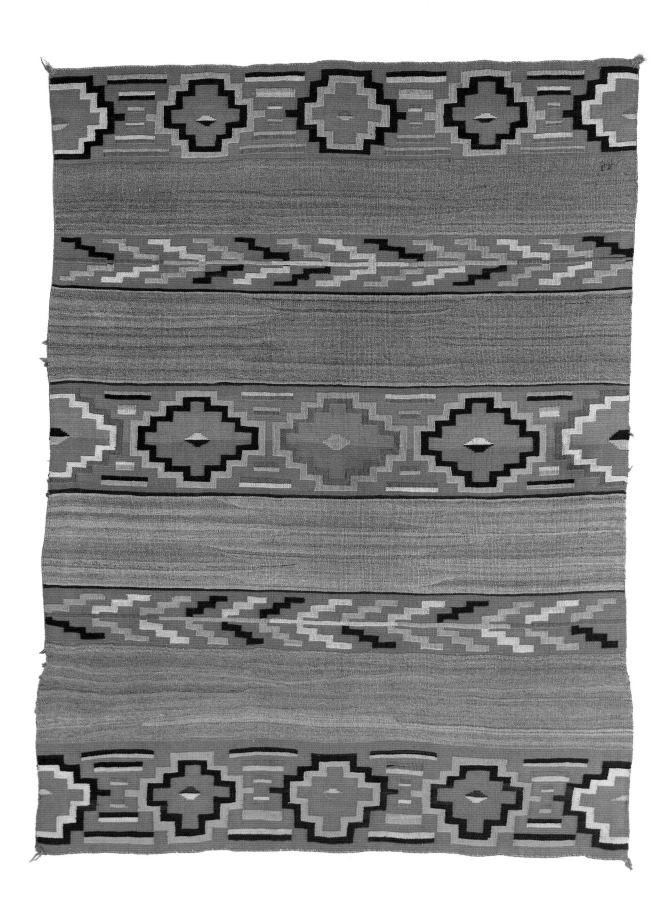

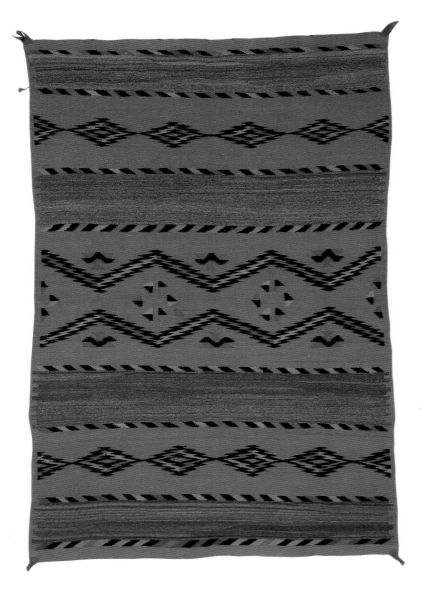

BLANKET, banded, circa 1875–1880
A.5141.42-156
192.0 cm × 128.5 cm

| | Color | Count (per inch) | Fiber | Yarn | Ply | Spin | Twist | Diameter (mm) |
|---|---|---|---|---|---|---|---|---|
| Warp | grey | 8 | wool | commercial | 3 | Z | S | |
| Weft | red 1 | 36 | wool | recarded and respun ravelled | 1 | Z | | 1.1 |
| | red 2 | 46 | wool | ravelled | 4 | Z | | 0.4 |
| | grey | 34 | wool | handspun | 1 | Z | | |
| | blue | 36 | wool | handspun | 1 | Z | | |
| | green | 54 | wool | ravelled | 3 | Z | | 0.4 |
| | yellow | 38 | wool | handspun | 1 | Z | | |

Selvage: 2 cords: each three, 4-ply red, commercial, Z, S

Harvey Company tag: "H-5436 #89324 MC 7-20-01
 Rare old bayetta mixed with wool"

Ledger book: "5436 892 $900.00 Mrs. Crary 1/20 Old native &
 Bayetta chiefs small"

As with number 183, the ledger-book description is incorrect in calling this textile
a chief blanket and most likely represents another misplaced number.

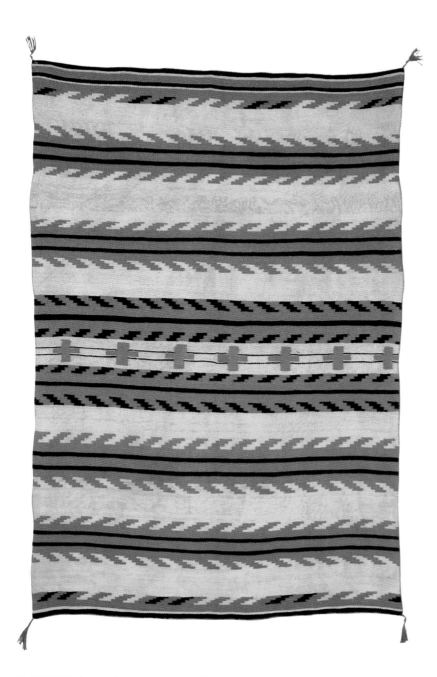

BLANKET, banded, circa 1875–1880
A.5141.42-119
165.4 cm × 107.4 cm

| | Color | Count (per inch) | Fiber | Yarn | Ply | Spin | Twist | Diameter (mm) |
|---|---|---|---|---|---|---|---|---|
| Warp | white | 11 | wool | handspun | 1 | Z | | |
| Weft | white | 32 | wool | handspun | 1 | Z | | |
| | red 1 | 32 | wool | ravelled | 2 | S | | 0.6 |
| | blue | 32 | wool | handspun | 1 | Z | | |
| | red 2 | 30 | wool | commercial | 4 | Z | S | |

Selvage: replaced

Harvey Company tag: "H-11508 B-43165 L. 2/22/6 Red material of
 unravelled flannel"

Ledger book: "11,508 $275.00 $20.00 M. Langer 2/22/06
 Stripe effect red white & blue row of crosses in center"

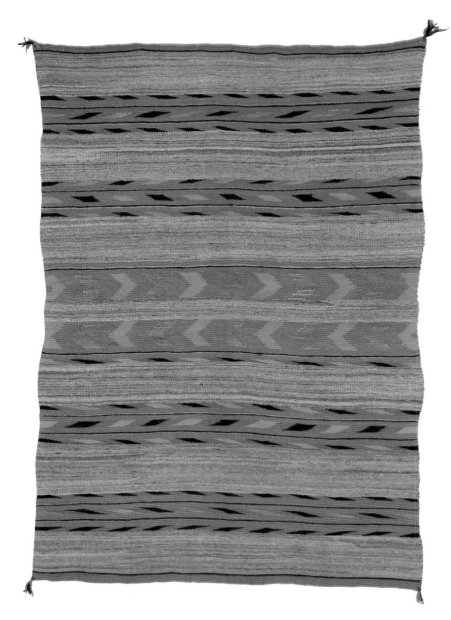

BLANKET, banded, circa 1875–1885
A.5141.42-154
196.5 cm × 132.6 cm

| | Color | Count (per inch) | Fiber | Yarn | Ply | Spin |
|---|---|---|---|---|---|---|
| Warp | white | 7 | wool | handspun | 1 | Z |
| Weft | grey | 18 | wool | handspun | 1 | Z |
| | red | 22 | wool | handspun | 1 | Z |
| | blue | 20 | wool | handspun | 1 | Z |
| | green | 22 | wool | handspun | 1 | Z |
| | orange | 22 | wool | handspun | 1 | Z |

Selvage: sides: one, 3-ply orange, handspun, Z, S
one, 3-ply brown, handspun, Z, S
ends: three, 3-ply orange, handspun, Z, S

Harvey Company tag: "A-419 B-45615 NHT 9-21-26"

Ledger book: "419 49615 49915 $375.00 9/21/26 NHT
Old native wool stripe effect 7 grey stripes 6 colored bands
with good old green"

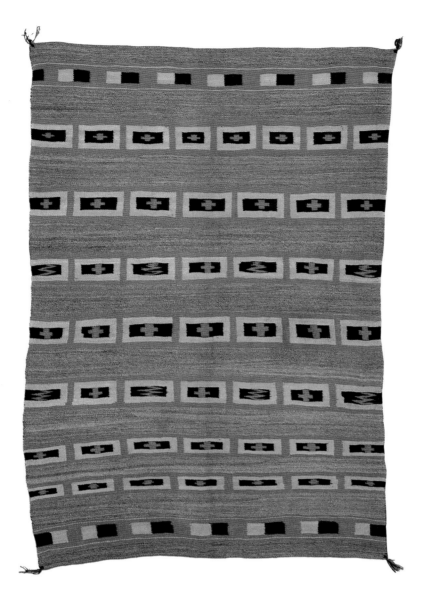

BLANKET, banded, circa 1875–1885
A.5141.42-78
178.0 cm × 120.0 cm

| | Color | Count (per inch) | Fiber | Yarn | Ply | Spin |
|------|--------|------------------|-------|------|-----|------|
| Warp | grey | 7 | wool | handspun | 1 | Z |
| Weft | grey | 24 | wool | handspun | 1 | Z |
| | red | 40 | wool | coarse ravelled or 2-ply handspun? | 2 | Z |
| | blue | 42 | wool | handspun | 1 | Z |
| | yellow | 38 | wool | handspun | 1 | Z |

Selvage: sides: two, 2-ply blue, handspun, Z, S
 ends: replaced

Harvey Company tag: "H-4211 B-42615 $85.00 PS [or PG]
 12/12/1"

Ledger book: "4211 $30.00 $12.00 P. Guillon 12/12 3¾#
 Old native grey with red black and yellow fig."

This appears to be the same textile that is seen hanging from a hook in the center of a 1905 G. W. Hance photograph, reproduced in Chapter 2, of a room in the Fred Harvey Company Indian Building in Albuquerque.

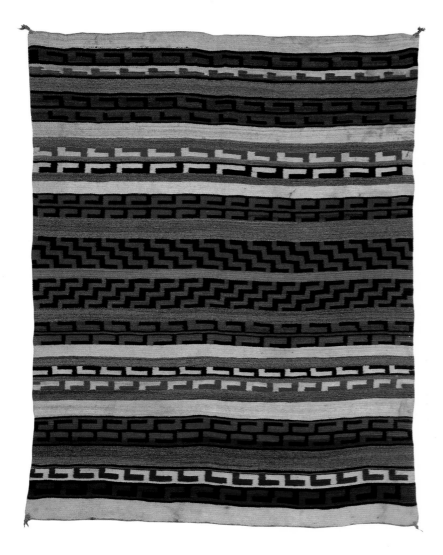

BLANKET, banded, circa 1875–1885
A.5141.42-77
187.0 cm × 145.0 cm

| | Color | Count (per inch) | Fiber | Yarn | Ply | Spin |
|---|---|---|---|---|---|---|
| Warp | white | 7 | wool | handspun | 1 | Z |
| Weft | white | 36 | wool | handspun | 1 | Z |
| | black | 34 | wool | handspun | 1 | Z |
| | grey | 38 | wool | handspun | 1 | Z |
| | dark purple | 30 | wool | handspun | 1 | Z |
| | light purple | 38 | wool | handspun | 1 | Z |
| | salmon | 42 | wool | handspun | 1 | Z |

Selvage: sides: two, 2-ply purple-white mix, handspun, Z, S
ends: two, 3-ply (one purple, one salmon), handspun, Z, S

Harvey Company tag: "H-19058 B-45715 $275.00 Sauerwein Coll.
7/18/10"

Ledger book: "19,058 $275.00 $50.00 Mrs. J. P. Martin 7/18/10
Sauerwein Coll. Navaho mostly purple and black Grecian design
throughout"

The extreme thickness of this blanket and its soft yarn and loose weave are typical of
the "diyugi," a Navajo utilitarian textile. The somewhat atypical, complex patterning
ranks it a cut above more simply striped pieces of the time.

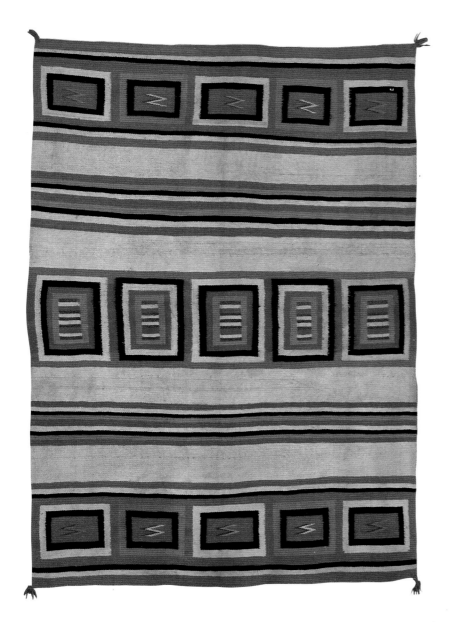

BLANKET, banded, circa 1880–1890
A.5141.42-79
203.0 cm × 139.5 cm

| | Color | Count (per inch) | Fiber | Yarn | Ply | Spin |
|---|---|---|---|---|---|---|
| Warp | brown | 8 | wool | handspun | 1 | Z |
| Weft | white | 26 | wool | handspun | 1 | Z |
| | orange | 26 | wool | handspun | 1 | Z |
| | red | 26 | wool | handspun | 1 | Z |
| | black | 26 | wool | handspun | 1 | Z |
| | green | 26 | wool | handspun | 1 | Z |
| | yellow | 26 | wool | handspun | 1 | Z |

Selvage: sides: two, 3-ply red, handspun, Z, S
 ends: two, 3-ply orange, handspun, Z, S

Harvey Company tag: "H-3325 #89814 $50.00 JFH 5/11
 Fine old weave native wool & dye"

Ledger book: "3325 $37.50 $20.00 JFH Isleta 5/1 7½#
 Old native wool and dye Very fine old weave"

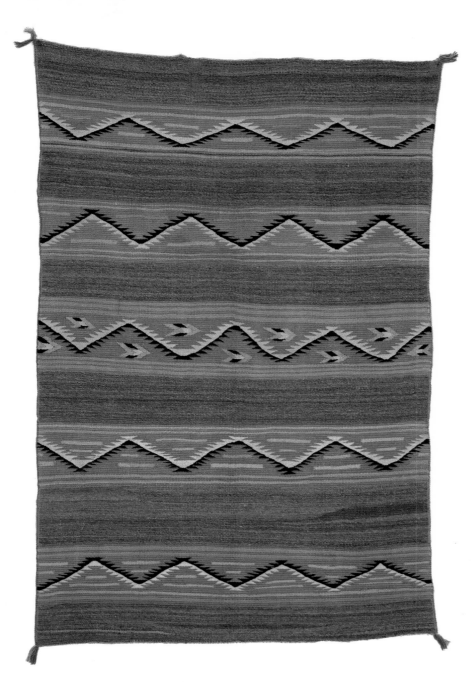

BLANKET, banded, circa 1880–1890
A.5141.42-105
168.0 cm × 110.5 cm

| | Color | Count (per inch) | Fiber | Yarn | Ply | Spin |
|-------|--------|------------------|-------|----------|-----|------|
| Warp | white | 9 | wool | handspun | 1 | Z |
| Weft | grey | 22 | wool | handspun | 1 | Z |
| | red | 22 | wool | handspun | 1 | Z |
| | yellow | 22 | wool | handspun | 1 | Z |
| | blue | 22 | wool | handspun | 1 | Z |
| | white | 22 | wool | handspun | 1 | Z |

Selvage: replaced

Harvey Company tag: "H-20952 B-42865 M. 7-22-11"

Ledger book: "20,952 $65.00 $8.00 McCasy[?] Jr. 7-22-11"

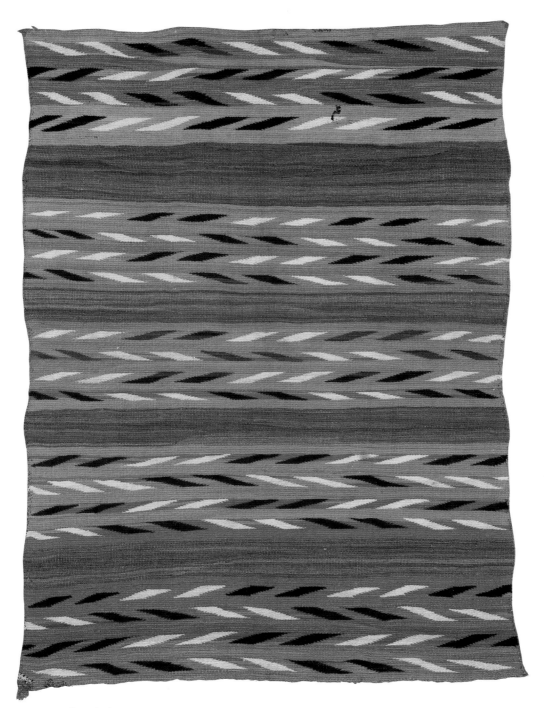

BLANKET, banded, circa 1880–1890
A.5141.42-93
133.0 cm × 83.0 cm

| | Color | Count (per inch) | Fiber | Yarn | Ply | Spin |
|---|---|---|---|---|---|---|
| Warp | white | 7 | wool | handspun | 1 | Z |
| Weft | red 1 | 30 | wool | handspun | 1 | Z |
| | red 2 | 24 | wool | handspun | 1 | Z |
| | purple | 24 | wool | handspun | 1 | Z |
| | black | 24 | wool | handspun | 1 | Z |
| | white | 24 | wool | handspun | 1 | Z |
| | blue | 24 | wool | handspun | 1 | Z |

Selvage: both: two, 3-ply red, handspun, Z, S

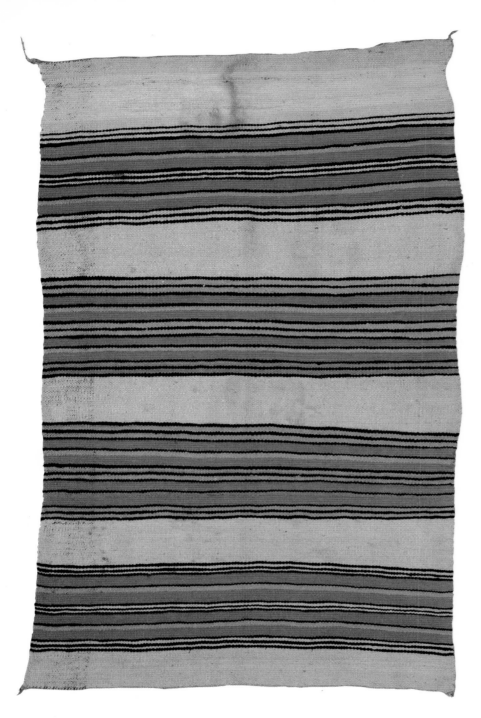

BLANKET, banded, circa 1880–1890
A.5141.42-1
160.0 cm × 101.5 cm

| | Color | Count (per inch) | Fiber | Yarn | Ply | Spin |
|---|---|---|---|---|---|---|
| *Warp* | white | 7 | wool | handspun | 1 | Z |
| | brown | 7 | wool | handspun | 1 | Z |
| *Weft* | white | 20 | wool | handspun | 1 | Z |
| | orange | 18 | wool | handspun | 1 | Z |
| | brown | 20 | wool | handspun | 1 | Z |
| | yellow | 18 | wool | handspun | 1 | Z |

Selvage: sides: two, 3-ply yellow handspun, Z, S
 ends: two, 2-ply orange handspun, Z, S

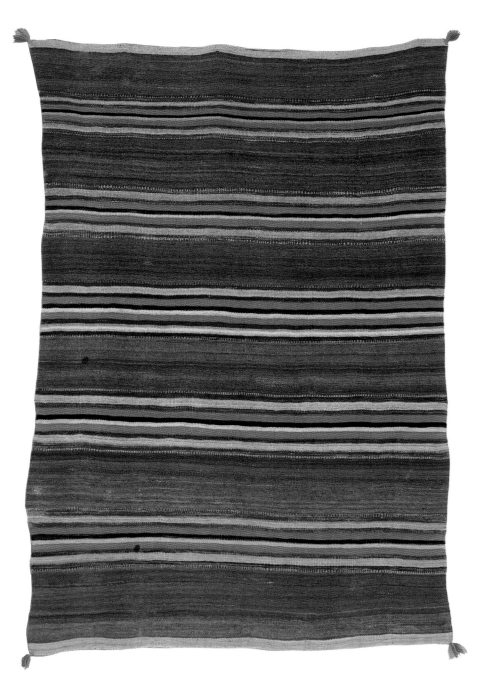

BLANKET, banded, circa 1880–1890

A.5141.42-199

198.3 cm × 128.4 cm

| | Color | Count (per inch) | Fiber | Yarn | Ply | Spin |
|---|---|---|---|---|---|---|
| Warp | brown | 8 | wool | handspun | 1 | Z |
| Weft | brown | 20 | wool | handspun | 1 | Z |
| | light blue | 20 | wool | handspun | 1 | Z |
| | grey | 20 | wool | handspun | 1 | Z |
| | pink | 20 | wool | handspun | 1 | Z |
| | red | 20 | wool | handspun | 1 | Z |
| | yellow | 20 | wool | handspun | 1 | Z |
| | navy | 20 | wool | handspun | 1 | Z |

Selvage: sides: 2 cords: each four, 4-ply red, commercial, Z, S

ends: 2 cords: each four, 4-ply blue, commercial, Z, S

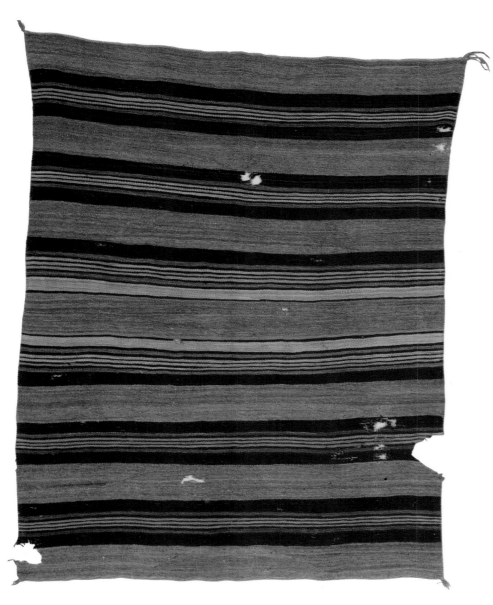

BLANKET, banded, circa 1885–1900
A.5141.42-198
179.4 cm × 134.3 cm

| | Color | Count (per inch) | Fiber | Yarn | Ply | Spin |
|---|---|---|---|---|---|---|
| Warp | white | 7 | wool | handspun | 1 | Z |
| Weft | grey | 20 | wool | handspun | 1 | Z |
| | light purple | 20 | wool | handspun | 1 | Z |
| | black | 20 | wool | handspun | 1 | Z |
| | blue | 20 | wool | handspun | 1 | Z |
| | yellow | 20 | wool | handspun | 1 | Z |
| | dark purple | 20 | wool | light purple and black carded | 1 | Z |
| | red | 20 | wool | handspun | 1 | Z |

Selvage: sides: two, 3-ply red, handspun, Z, S
ends: two, 3-ply orange, handspun, Z, S

Harvey Company tag: "H-8591 B-44215 Old Hopi"

Ledger book: "8591 44215 $125.00 From Span Room—tag lost
Old Navaho purple stripes"

~~~~~~~~~~~~~~~~~~~~~~~~~~~~~~~~~~~~~~~~

# *Pictorials*

Although a few early examples exist, Navajo textiles containing pictorial design elements of animals, flowers, people, and so on were not commonly woven until the last quarter of the nineteenth century. New sources of inspiration, brought about by increasing contact with non-Indian cultures as well as the expanded market for Navajo textiles, caused the weavers to experiment with new designs.

The Hearst collection contains ten (including #126 in Ponchos, #194 in Rugs, and #196 in Rugs) examples of this type, and they are quite representative of pictorials woven in the late nineteenth and early twentieth centuries, with two deserving special mention. Number 126 (the exquisite poncho) is actually one of the earliest known Navajo textiles in existence containing human figures. Less technically refined, Hearst's train textile (#192) is equally significant, as there are fewer than ten such pieces extant.

BLANKET, pictorial, circa 1870–1875
A.5141.42-114
142.0 cm × 112.6 cm

|  | Color | Count (per inch) | Fiber | Yarn | Ply | Spin | Twist | Diameter (mm) |
|---|---|---|---|---|---|---|---|---|
| Warp | white | 12 | cotton string | | | | | |
| Weft | red | 48 | wool | ravelled | 2 | Z | | 0.75 |
| | purple | 52 | wool | commercial | 3 | Z | S | |
| | green | 52 | wool | commercial | 3 | Z | S | |
| | *Pile yarns:* | | | | | | | |
| | white | | wool | commercial | 3 | Z | S | |
| | blue | | wool | commercial | 3 | Z | S | |
| | yellow | | wool | commercial | 3 | Z | S | |
| | red (synthetic dye) | | wool | commerical | 3 | Z | S | |
| | pink | | wool | commercial | 3 | Z | S | |

*Selvage:* both: 2 cords: each three, 3-ply purple, commercial, Z, S

*Harvey Company tag:* "H-7235    B-45115    NA [or R]    Bayetta ceremonial blkt."

*Ledger book:* "7235    $27.50    $15.75    Hubbell    native grey"

This entry obviously does not match our textile, but the ledger entry for number 7335 does correspond: "7335  $150.00  $50.00  N. Raphael  ceremonial." The entry is undated, but number 7334 was purchased on 1/29/03 and number 7336 was purchased on 2/20/03, so we can assume with some certainty that number 7335 was obtained by the Harvey Company between those dates.

The piece is not strictly a pictorial blanket; its highly unusual nature defies categorization. The Harvey Company ledger books refer to it as a "bayetta ceremonial blanket." The ground is a fuzzy, two-ply ravelled yarn with bright green and purple commercially plied yarns as striping. To this simple design was added a series of stars, diamonds, and crosses in a very unconventional technique. Yarns were inserted directly through the woven textile (with a needle?) and then cut to an even depth of pile on both faces (see close-up).

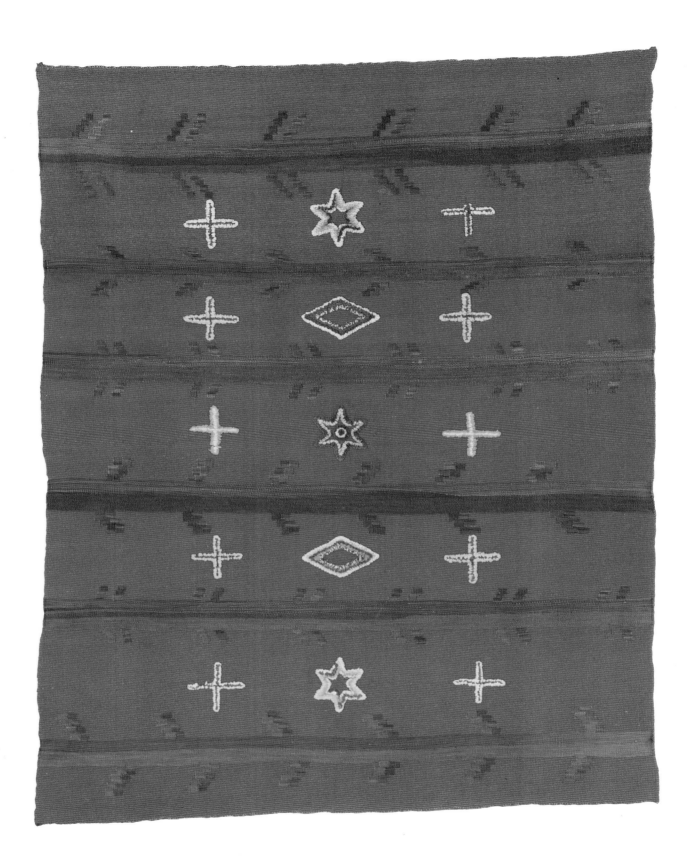

BLANKET, pictorial, circa 1875–1885
A.5141.42-189
185.5 cm × 132.0 cm

|  | Color | Count (per inch) | Fiber | Yarn | Ply | Spin | Twist | Diameter (mm) |
|---|---|---|---|---|---|---|---|---|
| *Warp* | brown | 10 | wool | commercial | undetermined | Z | S | |
| *Weft* | red | 54 | wool | recarded and respun ravelled | 1 | Z | | 0.9 |
| | blue | 60 | wool | handspun | 1 | Z | | |
| | white | 52 | wool | handspun | 1 | Z | | |
| | green | 58 | wool | commercial | 4 | Z | S | |
| | yellow | 58 | wool | commercial | 4 | Z | S | |
| | grey | 58 | wool | commercial | 4 | Z | S | |

*Selvage:* both: 2 cords: each composed of several commercial yarns braided together

The original Harvey Company tag ("A-549    B-520115") and corresponding ledger-book description ("549    8983    $45.00    P.M.    12/9/27    Semi-mod. Double saddle    5 stripes of white black pink    2 bds of blk and white designs    2 wide grey stripes in center") do not seem to match our textile.

A further examination of the ledgers revealed that the entry for textile 978 ("520115    $1000.00    Andrus Coll.    12/30/29    American bayetta w/animal figures in yellow & green at both ends") *does* appear to match our textile on two counts: the code number and the description of its appearance. The entry for number 978 also states that the Harvey Company bought the piece from W. J. Andrus. We can only speculate whether Andrus commissioned the textile with the letter *A* woven into it, or purchased it because it contained his initial.

The three central diamonds in this textile contain several letters. Perhaps it was a conscious attempt on the part of the weaver to spell out a particular word or perhaps she was merely copying the shapes of letters she found interesting. Each end has four elegant horses with graceful, flowing manes.

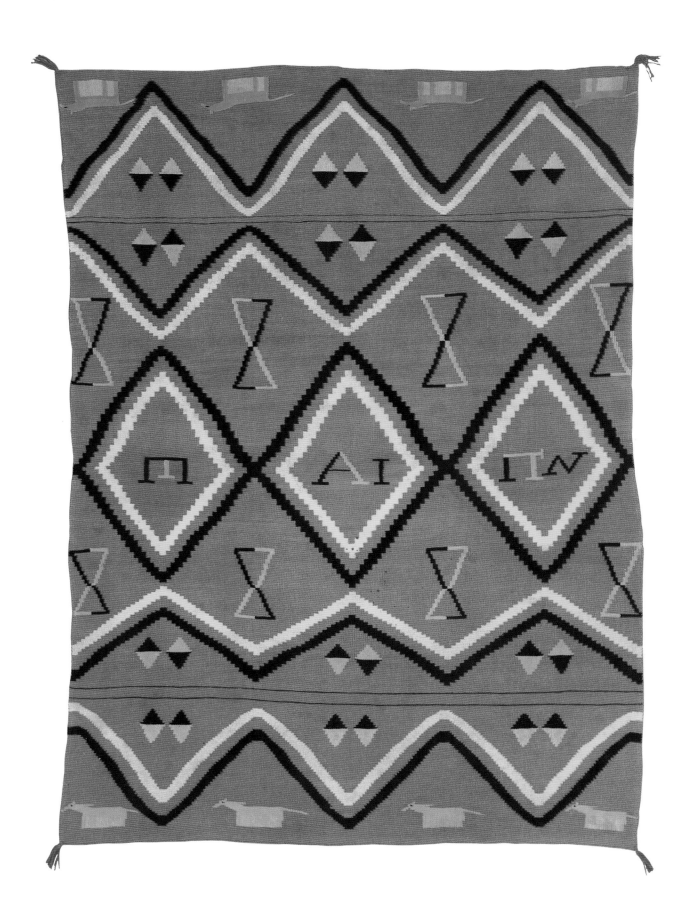

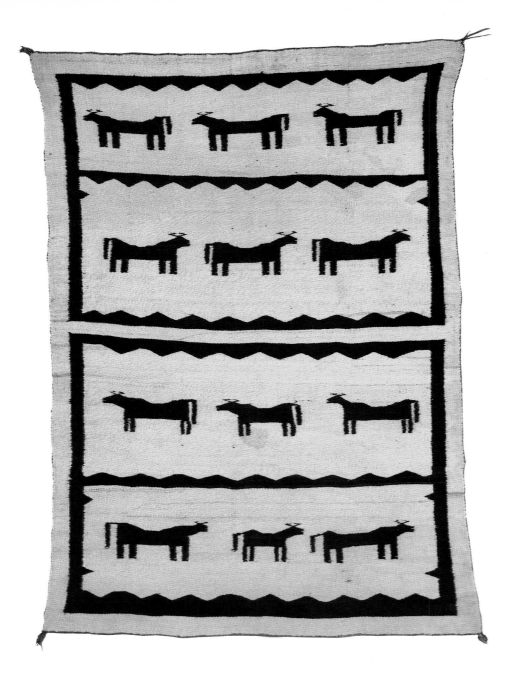

BLANKET, pictorial, circa 1880–1890

A.5141.42-125

207.5 cm × 146.0 cm

|  | Color | Count (per inch) | Fiber | Yarn | Ply | Spin |
|---|---|---|---|---|---|---|
| Warp | brown | 6 | wool | handspun | 1 | Z |
| Weft | white | 20 | wool | handspun | 1 | Z |
|  | brown | 20 | wool | handspun | 1 | Z |

*Selvage:* sides: two, 2-ply brown, handspun, Z, S
ends: two, 3-ply brown, handspun, Z, S

*Harvey Company tag:* "H-9017    #84114    L.S.    6/26/3"

*Ledger book:* "9017    $40.00    $12.50    L. Simon    6/26    Old Native wool with figures"

Large, heavy, loosely woven textiles bearing designs of horses and cows were common pictorial elements in the 1880s and 1890s.

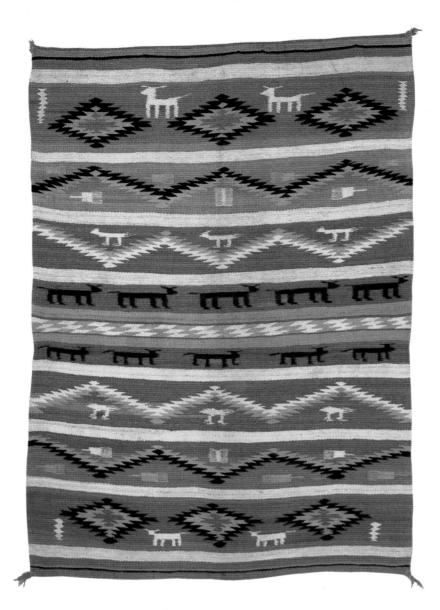

BLANKET/RUG, pictorial, circa 1880–1890
A.5141.42-127
190.0 cm × 132.0 cm

|  | Color | Count (per inch) | Fiber | Yarn | Ply | Spin |
|---|---|---|---|---|---|---|
| Warp | brown | 6 | wool | handspun | 1 | Z |
|  | tan | 6 | wool | handspun | 1 | Z |
| Weft | white | 22 | wool | handspun | 1 | Z |
|  | gold | 22 | wool | handspun | 1 | Z |
|  | black | 22 | wool | handspun | 1 | Z |
|  | red | 22 | wool | handspun | 1 | Z |

*Selvage:* both: two, 2-ply red, handspun, Z, S

*Harvey Company tag:* "H-3898   #89814   L.S.   9/19   Old native wool and dye"

*Ledger book:* "3,898   $45.00   $10.00   L.S.   9/19/01(?)   7#
Old native wool   red and white stripe. Animated design"

This soft thick textile combines serrated diamonds and zigzag lines with the pictorial motifs of cows and birds and the unusual depiction of several weaver's combs, used to pack weft yarns during weaving.

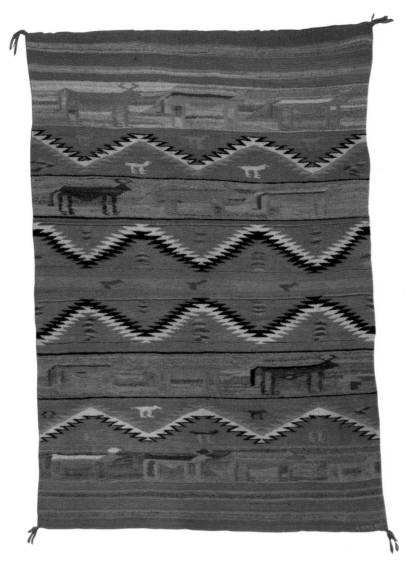

BLANKET/RUG, pictorial, circa 1880–1890
A.5141.42-128
183.0 cm × 119.2 cm

|  | Color | Count (per inch) | Fiber | Yarn | Ply | Spin |
|---|---|---|---|---|---|---|
| Warp | brown-grey | 5 | wool | handspun | 1 | Z |
| Weft | red | 20 | wool | handspun | 1 | Z |
|  | red-brown | 20 | wool | handspun | 1 | Z |
|  | white | 20 | wool | handspun | 1 | Z |
|  | grey | 20 | wool | handspun | 1 | Z |
|  | yellow | 20 | wool | handspun | 1 | Z |
|  | brown | 20 | wool | handspun | 1 | Z |
|  | black | 20 | wool | handspun | 1 | Z |
|  | orange | 20 | wool | carded red and yellow | 1 | Z |
|  | purple | 20 | wool | handspun | 1 | Z |

*Selvage:* sides: two, 2-ply red, handspun, Z, S
ends: two, 3-ply red, handspun, Z, S

*Harvey Company tag:* "H-5598    #89014    P.G.    6/30/2"

*Ledger book:* "5598    $25.00    $12.00    Guillion    2/30/2"

This textile has many of the same design elements as number 127 but lacks the combs. Unusual shades of yarn were created by carding several colors together.

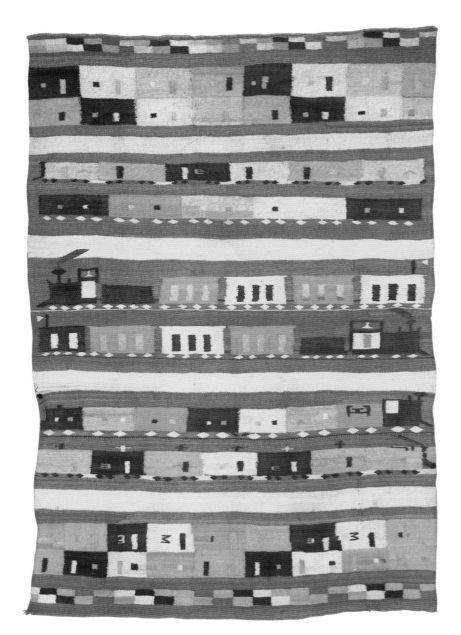

BLANKET/RUG, pictorial, circa 1880–1890
A.5141.42-192
211.5 cm × 143.0 cm

|       | Color  | Count (per inch) | Fiber | Yarn     | Ply | Spin |
|-------|--------|------------------|-------|----------|-----|------|
| Warp  | white  | 7                | wool  | handspun | 1   | Z    |
| Weft  | white  | 20               | wool  | handspun | 1   | Z    |
|       | red    | 20               | wool  | handspun | 1   | Z    |
|       | brown  | 20               | wool  | handspun | 1   | Z    |
|       | orange | 20               | wool  | handspun | 1   | Z    |
|       | green  | 20               | wool  | handspun | 1   | Z    |

*Selvage:* both: two, 2-ply red, handspun, Z; top edge repaired with thread.

The coming of the railroad in 1880 must indeed have been an amazing event for the Navajos! In addition to bringing new products, services, and tourists, trains themselves served as sources of design for Navajo weavers. This is one of only a handful of known Navajo textiles from the nineteenth century depicting the train. Although woven very loosely of heavy yarn, the design is quite detailed. The two central engines even have stylized engineers in place and smoke emanating from the stacks.

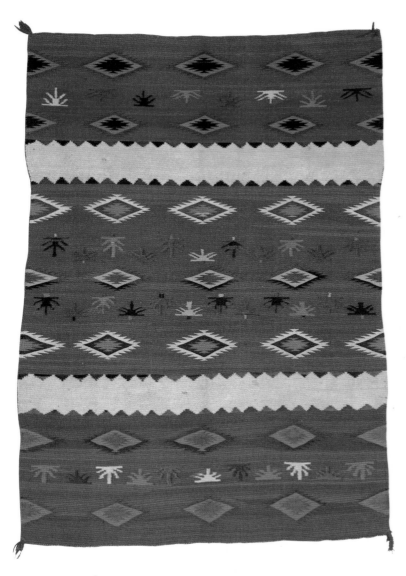

RUG, pictorial, circa 1885–1895

A.5141.42-101

179.6 cm × 122.0 cm

|  | Color | Count (per inch) | Fiber | Yarn | Ply | Spin | Twist |
|---|---|---|---|---|---|---|---|
| Warp | white | 9 | wool | handspun | 1 | Z | |
| Weft | red | 38 | wool | handspun | 1 | Z | |
| | white | 40 | wool | handspun | 1 | Z | |
| | green (faded) | 50 | wool | commercial | 4 | Z | S |
| | purple (faded) | 50 | wool | commercial | 4 | Z | S |
| | orange | 48 | wool | handspun | 1 | Z | |
| | cream | 52 | wool | commercial | 4 | Z | S |

*Selvage:* both: two, 3-ply red, handspun, Z, S

*Harvey Company tag:* "H-17377     B-41815     L.     9-13-9"

*Ledger book:* "17,377     $65.00     $12.50     M. Langer     9/13/9
    Old native     red ground     2 white stripes     lots of flowers & diamonds"

The commercial yarns in this blanket have faded over the years to subtle green and grey tones, which create quite a more softened color scheme than the original bright purple and blue-green chosen by the weaver. The figures in the piece are somewhat problematical—the Harvey ledger books refer to them as flowers, yet those in the center band have an added square shape perhaps signifying a stylized insect form.

# Eyedazzlers

Navajo weavers, previously limited by vegetally dyed yarns, eagerly experimented in the later part of the nineteenth century with the readily available bright, chemically dyed commercial yarns, which they wove into dizzying design combinations. The immediate visual impact of these textiles gave them the name *eyedazzlers*.

Although this type is represented in Hearst's collecting efforts, it appears not to have been as important to him as earlier, Classic types.

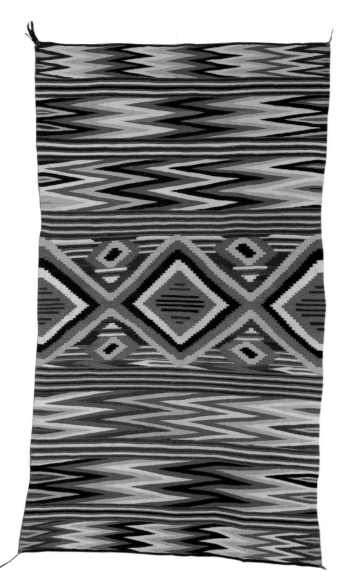

BLANKET, eyedazzler, circa 1870–1875
A.5141.42-121
202.2 cm × 110.0 cm

|  | Color | Count (per inch) | Fiber | Yarn | Ply | Spin | Twist |
|---|---|---|---|---|---|---|---|
| *Warp* | white | 10 | wool | handspun | 1 | Z | |
| *Weft* | white | 60 | wool | handspun | 1 | Z | |
| | dark blue | 60 | wool | handspun | 1 | Z | |
| | medium blue | 60 | wool | handspun | 1 | Z | |
| | green | 74 | wool | commercial | 3 | Z | S |
| | peach | 76 | wool | commercial | 3 | Z | S |
| | red 1 | 74 | wool | commercial | 3 | Z | S |
| | red 2 | 58 | wool | commercial | 3 | Z | S |

*Selvage:* sides: two, 3-ply medium blue, handspun, Z, S
ends: two, 3-ply dark blue, handspun, Z, S

*Harvey Company tag:* "H-19129    B-416115    UAXSS    RW    8-22-10"

*Ledger book [-]:* "19,129    $850.00    $150.00    Mrs. Wetherell    8/22/10
Bayetta poncho    red white & blue with 4 white snakes."

Although the names and dates match on the tag and ledger entry, the price and description signal a serious discrepancy for this piece.

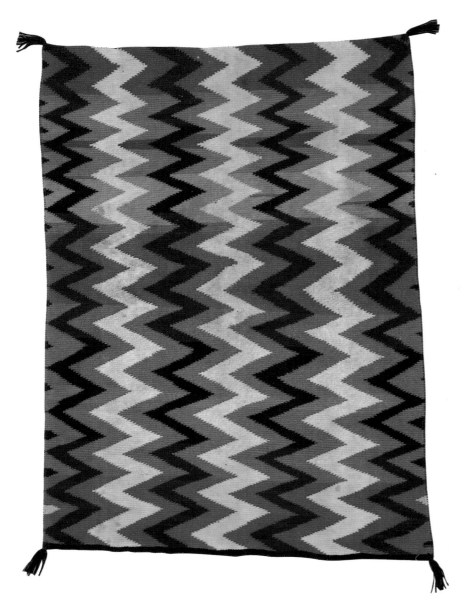

BLANKET, eyedazzler, circa 1870–1875
A.5141.42-123
84.0 cm × 62.0 cm

|  | Color | Count (per inch) | Fiber | Yarn | Ply | Spin | Twist | Diameter (mm) |
|---|---|---|---|---|---|---|---|---|
| Warp | brown | 13 | wool | handspun | 1 | Z |  |  |
| Weft | white | 50 | wool | handspun | 1 | Z |  |  |
|  | green | 50 | wool | handspun | 1 | Z |  |  |
|  | blue | 50 | wool | handspun | 1 | Z |  |  |
|  | red 1 | 52 | wool | ravelled | 3 | S |  | 0.4 |
|  | red 2 | 50 | wool | commercial | 3 | S | Z |  |
|  | red 3 | 54 | wool | ravelled | 3 | S |  | 0.4 |
|  | yellow | 50 | wool | commercial | 3 | Z | S |  |
|  | burgundy 1 | 52 | wool | ravelled | 3 | S |  | 0.4 |
|  | burgundy 2 | 50 | wool | commercial | 3 | S | Z |  |

*Selvage:* replaced

*Harvey Company tag:* "H-12178    B-41415    L.    6/12/6    $22.50"

*Ledger book:* "12,178    $7.50    $0.50    Fraet [sp.?]    6/12/6
     Saddle zigzag & very colored"

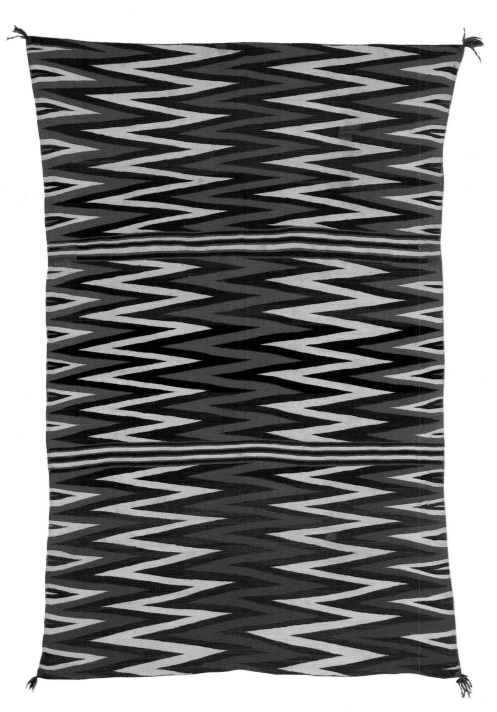

BLANKET, eyedazzler, circa 1870–1880
A.5141.42-118
147.0 cm × 93.0 cm

|  | Color | Count (per inch) | Fiber | Yarn | Ply | Spin | Twist |
|---|---|---|---|---|---|---|---|
| Warp | white | 12 | wool | handspun | 1 | Z | |
| Weft | white | 60 | wool | handspun | 1 | Z | |
| | blue | 64 | wool | handspun | 1 | Z | |
| | red | 58 | wool | commercial | 3 | Z | S |

*Selvage:* replaced

*Harvey Company tag:* "H-5807    #89834    HAXSS    PM    10-10-2"

*Ledger book:* "5,807    $75.00    $30.00    P.M.    10/10    Fine Navajo"

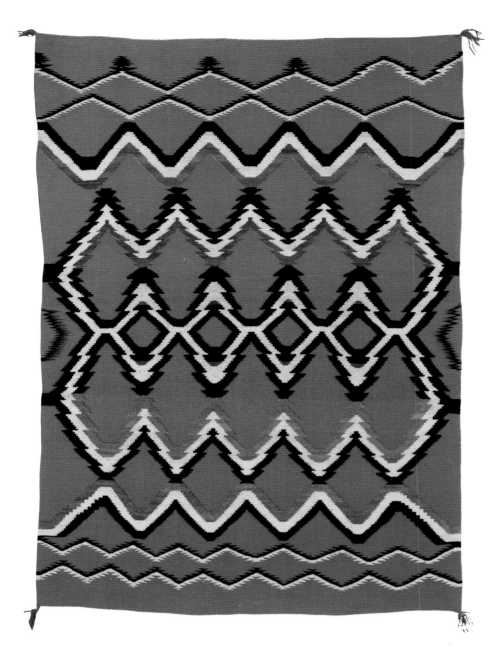

BLANKET, eyedazzler, circa 1875–1890
A.5141.42-151
197.5 cm × 139.3 cm

|  | Color | Count (per inch) | Fiber | Yarn | Ply | Spin |
|---|---|---|---|---|---|---|
| Warp | grey | 8 | wool | handspun | 1 | Z |
| Weft | red | 40 | wool | handspun | 1 | Z |
|  | white | 38 | wool | handspun | 1 | Z |
|  | blue | 38 | wool | handspun | 1 | Z |
|  | green | 38 | wool | handspun | 1 | Z |

*Selvage:* sides: two, 3-ply red, handspun, Z, S
ends: two, 4-ply red, handspun, Z, S

*Harvey Company tag:* "H-10039     #84624     JOH     5-28-5
Old native wool & dye"

*Ledger book:* "10,039     $65.00     $27.50     Juan Olivas     5/28/5
Old native wool & dye"

BLANKET, eyedazzler, circa 1880–1890
A.5141.42-103
205.0 cm × 136.0 cm

|  | Color | Count (per inch) | Fiber | Yarn | Ply | Spin | Twist |
|---|---|---|---|---|---|---|---|
| Warp | white | 9 | wool | handspun | 1 | Z | |
| Weft | red 1 | 34 | wool | handspun | 1 | Z | |
|  | orange | 34 | wool | handspun | 1 | Z | |
|  | medium green | 42 | wool | commercial | 4 | Z | S |
|  | purple 1 | 40 | wool | commercial | 4 | Z | S |
|  | purple 2 | 34 | wool | handspun | 1 | Z | |
|  | white 1 | 34 | wool | handspun | 1 | Z | |
|  | dark red | 38 | wool | commercial | 4 | Z | S |
|  | burgundy[a] | 38 | wool | commercial | 4 | Z | S |
|  | white 2[a] | 38 | wool | commercial | 4 | Z | S |
|  | red 2[a] | 38 | wool | commercial | 4 | Z | S |
|  | dark green[a] | 38 | wool | commercial | 4 | Z | S |
|  | light green[a] | 38 | wool | commercial | 4 | Z | S |
|  | yellow[a] | 38 | wool | commercial | 4 | Z | S |
|  | blue | 34 | wool | handspun | 1 | Z | |

[a] Variegated color, single yarn.

*Selvage:* sides: two, 2-ply green and orange, handspun, Z, S
ends: two, 3-ply orange, handspun, Z, S

The effects of Mexican contact are very apparent in this blanket, in both the borrowing of Saltillo design elements and the use of variegated yarn in the central diamonds.

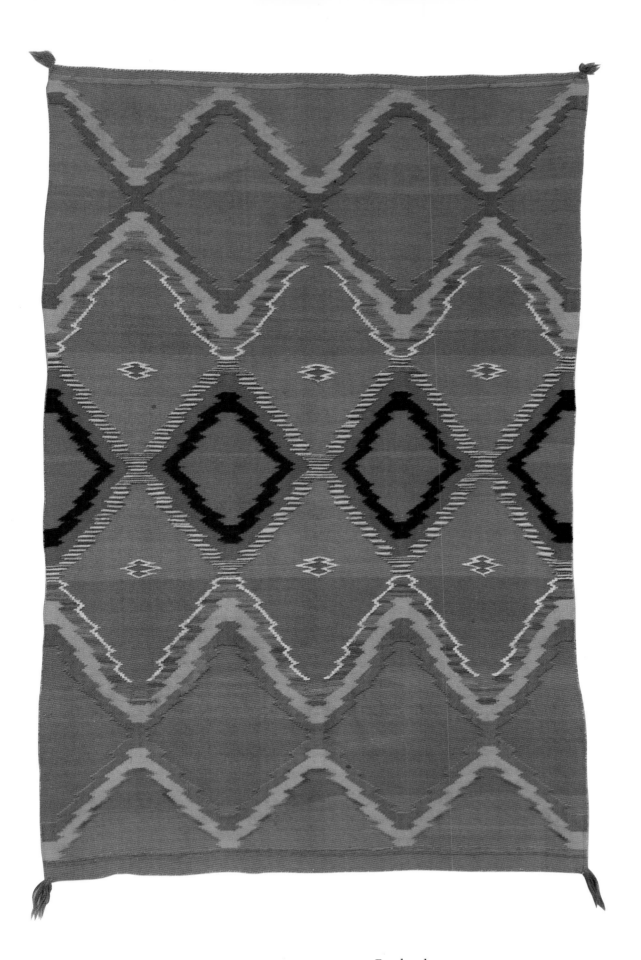

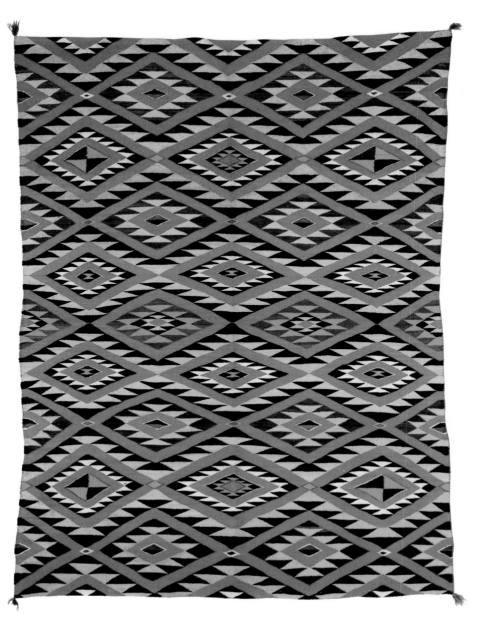

BLANKET, eyedazzler, circa 1880–1890
A.5141.42-161
215.0 cm × 158.0 cm

|  | Color | Count (per inch) | Fiber | Yarn | Ply | Spin |
|---|---|---|---|---|---|---|
| Warp[a] | white | 8 | cotton string | | | |
| Weft | red | 24 | wool | handspun | 1 | Z |
| | yellow | 24 | wool | handspun | 1 | Z |
| | black | 24 | wool | handspun | 1 | Z |
| | green | 24 | wool | handspun | 1 | Z |
| | white | 24 | wool | handspun | 1 | Z |
| | orange | 24 | wool | handspun | 1 | Z |

[a] Warp is noncontinuous, cut off the loom, and its ends tucked back into the textile.

*Selvage:* replaced

*Harvey Company tag:* "A-226    B-45115    NHT    7-9-26"

*Ledger book:* "226    511115    $375.00    NHT    7/9/26    #38
  Old Navaho wool    diamond effect    22 diamond varied colored
  of black white green red yellow canary orange"

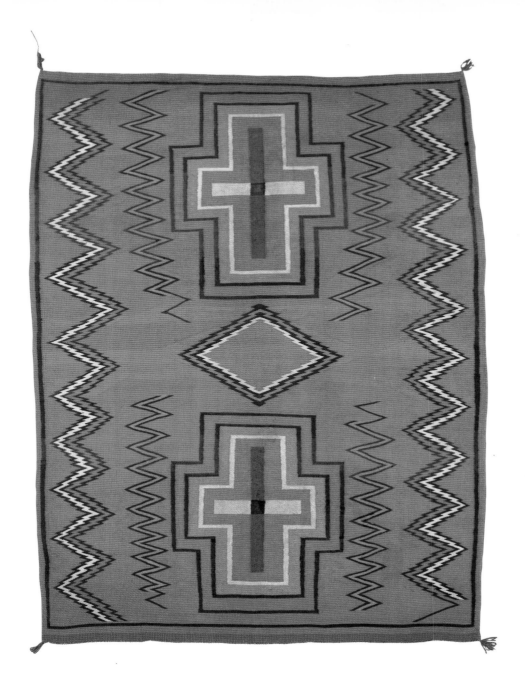

BLANKET, eyedazzler, circa 1880–1890
A.5141.42-160
173.5 cm × 133.5 cm

|  | Color | Count (per inch) | Fiber | Yarn | Ply | Spin | Twist |
|---|---|---|---|---|---|---|---|
| Warp | white | 12 | cotton string | | | | |
| Weft | red | 50 | wool | commercial | 4 | Z | S |
|  | blue | 50 | wool | commercial | 4 | Z | S |
|  | gold | 52 | wool | commercial | 4 | Z | S |
|  | green | 48 | wool | commercial | 4 | Z | S |
|  | white | 48 | wool | commercial | 4 | Z | S |
|  | burgundy | 44 | wool | commercial | 4 | Z | S |

*Selvage:* replaced

*Harvey Company tag:* "A-1057    B-44615    Wilbur Coll."

*Ledger book:* "1057    $125.00    46115    #12 Wilbur Collection    1/16/31
     Germantown red ground 2 green crosses"

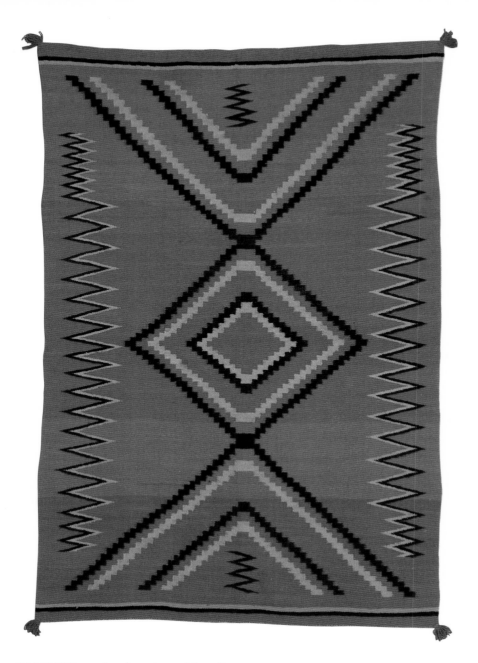

BLANKET, eyedazzler, circa 1880–1890
A.5141.42-152
209.0 cm × 134.8 cm

|       | Color  | Count (per inch) | Fiber | Yarn     | Ply | Spin |
|-------|--------|------------------|-------|----------|-----|------|
| Warp  | white  | 8                | wool  | handspun | 1   | Z    |
| Weft  | red    | 28               | wool  | handspun | 1   | Z    |
|       | black  | 30               | wool  | handspun | 1   | Z    |
|       | yellow | 36               | wool  | handspun | 1   | Z    |
|       | blue   | 28               | wool  | handspun | 1   | Z    |

*Selvage:* sides: two, 2-ply red, handspun, Z, S
ends: two, 3-ply red, handspun, Z, S

*Harvey Company tag:* "H-3974    #89324    P.M.    9-20    Rare design, old
native wool & dye"

*Ledger book:* "3,974    $125.00    $25.00    P.M.    9/20    9#    Rare old
native wool    Red yellow & black"

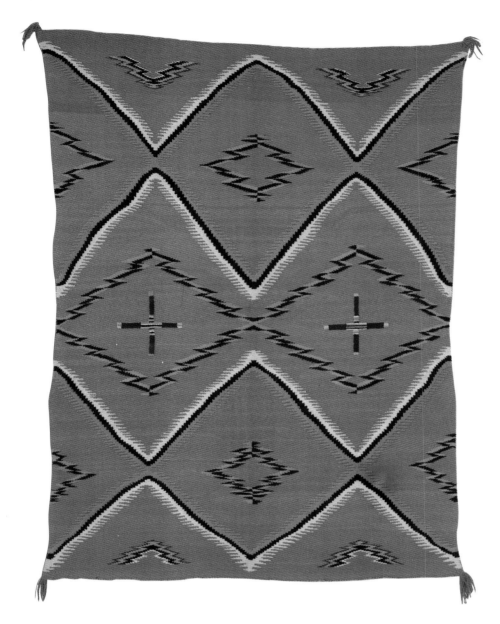

BLANKET, eyedazzler, circa 1880–1890
A.5141.42-111
180.0 cm × 129.0 cm

|  | Color | Count (per inch) | Fiber | Yarn | Ply | Spin | Twist | Diameter (mm) |
|---|---|---|---|---|---|---|---|---|
| Warp | brown | 7 | wool | handspun | 1 | Z |  |  |
| Weft | red | 28 | wool | handspun | 1 | Z |  |  |
|  | white | 28 | wool | handspun | 1 | Z |  |  |
|  | blue | 28 | wool | handspun | 1 | Z |  |  |
|  | green | 32 | wool | commercial | 4 | Z | S |  |
|  | gold | 28 | wool | handspun | 1 | Z |  |  |
|  | brown 1 | 32 | wool | ravelled? | 3 | S |  | 0.6 |
|  | brown 2 | 28 | wool | handspun | 1 | Z |  |  |
|  | orange | 32 | wool | commercial | 4 | Z | S |  |

*Selvage:* both: two, 3-ply red, handspun, Z, S

*Harvey Company tag:* "H-20181    B-46115    P.G.    2-2-11"

*Ledger book:* "20,181    $225.00    $47.50    P. Guillon    2-2-11"
   Old native wool    red ground. Green & yellow figures    lightning design"

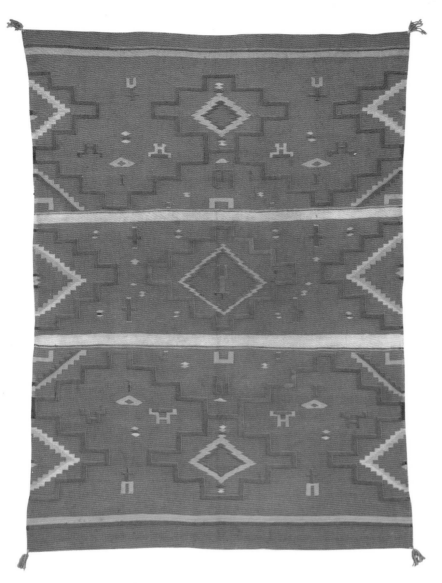

BLANKET, eyedazzler and pictorial, circa 1880–1890
A.5141.42-163
177.5 cm × 128.0 cm

|  | Color | Count (per inch) | Fiber | Yarn | Ply | Spin | Twist |
|---|---|---|---|---|---|---|---|
| Warp | white | 10 | wool | handspun? | 1 | S | |
| Weft | red | 50 | wool | commercial | 4 | Z | S |
| | white | 50 | wool | handspun | 1 | Z | |
| | yellow | 52 | wool | handspun | 1 | Z | |
| | blue | 50 | wool | commercial | 4 | Z | S |
| | purple | 50 | wool | commercial | 4 | Z | S |
| | green | 50 | wool | commercial | 4 | Z | S |

*Selvage:* sides:  2 cords:  each two, 4-ply yellow, commercial, Z, S
   ends:  two, 3-ply red, handspun, Z, S

*Harvey Company tag:*  "A-857     B-45615     $375.00     ELG     6-26-29
   R-41815"

*Ledger book [–]:*  "857     45615     $225.00     E. L. Griego     6-26-29
   Old native wool     red ground     8 zigzag stripes of black & white
   6 zigzag faded blue & white"

The ledger-book description and the textile are an obvious mismatch.

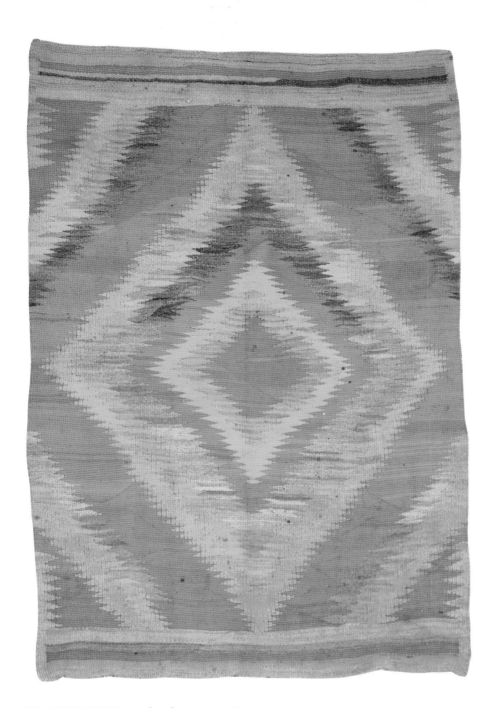

BLANKET/RUG, eyedazzler, circa 1885–1900
A.5141.42-99
214.0 cm × 145.0 cm

|  | Color | Count (per inch) | Fiber | Yarn | Ply | Spin |
|---|---|---|---|---|---|---|
| Warp | white | 5 | wool | handspun | 1 | Z |
| Weft | purple (faded) | 14 | wool | handspun | 1 | Z |
|  | red (faded) | 14 | wool | handspun | 1 | Z |
|  | grey | 14 | wool | handspun | 1 | Z |
|  | yellow | 14 | wool | handspun | 1 | Z |

*Selvage:* both: two, 2-ply purple, handspun, Z, S

Although this piece seems quite muted due to the extreme degree of fading, when first woven it must certainly have lived up to its name with its bright colors and serrate-edged design.

BLANKET, eyedazzler, circa 1880–1900?
A.5141.42-84
197.0 cm × 137.0 cm

| | Color | Count (per inch) | Fiber | Yarn | Ply | Spin |
|---|---|---|---|---|---|---|
| *Warp* | white | 9 | wool | handspun | 1 | Z |
| *Weft* | white | 34 | wool | handspun | | |
| | orange | 34 | wool | handspun | 1 | Z |
| | red | 34 | wool | handspun | 1 | Z |
| | yellow | 34 | wool | handspun | 1 | Z |
| | lavender | 34 | wool | handspun | 1 | Z |
| | light burgundy | 34 | wool | handspun | 1 | Z |
| | apricot | 34 | wool | handspun | 1 | Z |
| | blue | 34 | wool | handspun | 1 | Z |

*Selvage:* both: two, 3-ply pink, handspun, Z, S

*Harvey Company tag:* "H-13646     B-42115     $85.00     APW     4/17/7"

*Ledger book:* "13,646     $75.00     $15.00     Adolf P. Weiller [sp.?]     4/19/7
  White ground     red white grey & black zigzag stripes"

The ledger-book description and the textile are an obvious mismatch.

This textile is a puzzlement from its color to its design. Though the yarns are all very thickly handspun, the colors used are an unusual mixture of the bright anilines popular among Navajo weavers in the late nineteenth century and several pastels most commonly associated with the vegetals used by Spanish weavers in the upper Rio Grande Valley of New Mexico. The design is decidedly eccentric, being dominated by a large stepped hourglass shape with the remaining space filled with squares, crosses, and checkerboards.

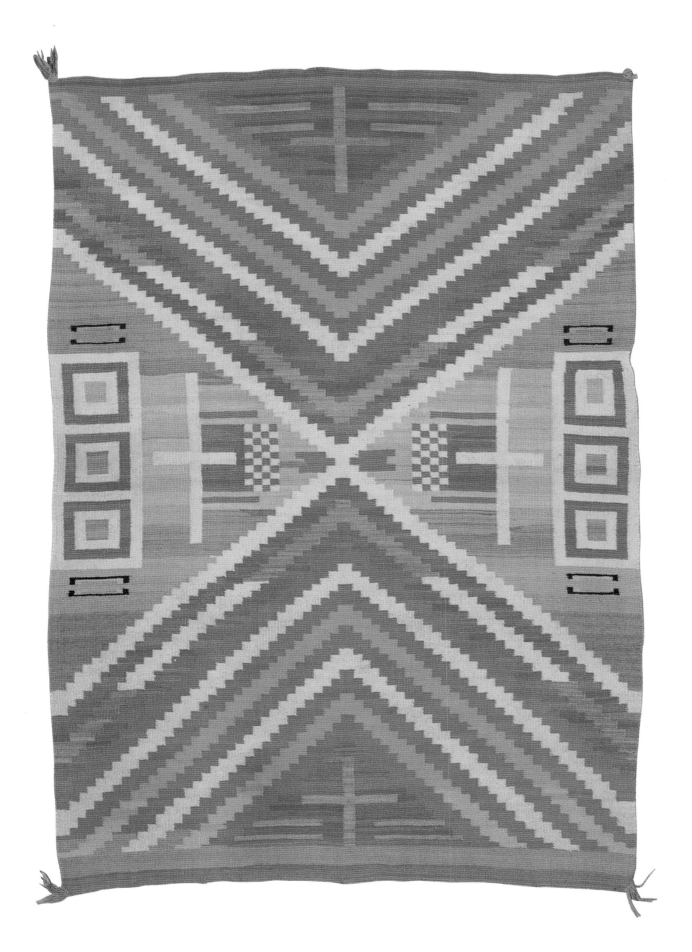

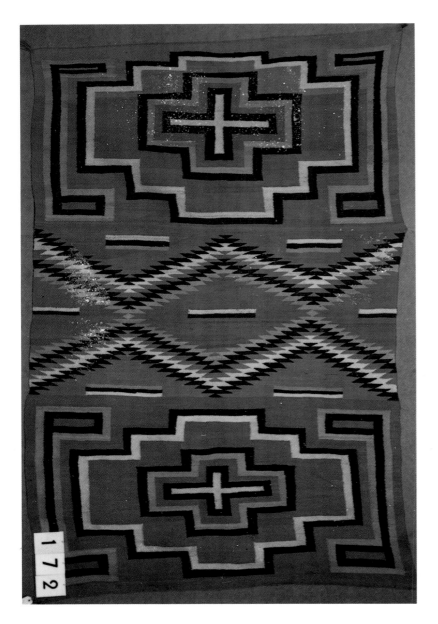

BLANKET (missing), eyedazzler
A.5141.42-172
80" × 50"

Warp:   8/inch
Weft:   32/inch

*Catalogue card:*   "Red ground with large oblique angle diamonds across center. In the end areas a series of large enclosing terrace motifs, the center of which is a white cross. Design in black, white and pale green throughout. Native wool, selvage cord, lazy lines visible."

*Harvey Company tag:*   "H-13807      B-42440      P.M.      6-2-7"

*Ledger book:*   "13,807      $125.00      $14.25      P. Muniz      6/2/7
      Old native wool      red ground      Crosses      Green figures."

# Wedge Weaves

The origin of this particular weaving phenomenon is unknown and its duration among the Navajos particularly short-lived, being confined to the last two decades of the nineteenth century. Not strictly a new weaving technique, *wedge weave,* or *pulled warp,* is a variation on plain tapestry weave that results in scalloped edges. The weaver begins by inserting a few weft yarns in a wedge shape and continues to build on them with subsequent wefts. This creates diagonal stress on the warps and pulls them out of their normal vertical alignment. When the textile is removed from the loom and tension is released, a scalloped edge results.

The limited number of wedge-weave textiles that have survived are typically similar to the format seen in numbers 195 and 193 with contrasting white plain-weave bands and colorful bands of vertical zigzags done in wedge weave. The third example collected by Hearst (#92) uses the wedge technique unusually and sparingly.

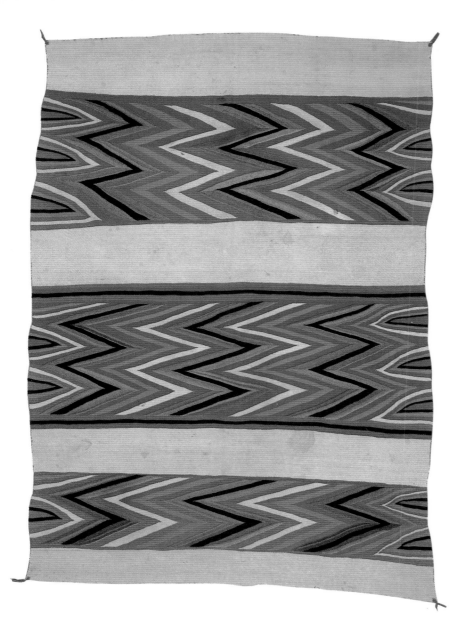

BLANKET, circa 1880–1890
A.5141.42-195
207.5 cm × 151.0 cm
wedge weave

|  | Color | Count (per inch) | Fiber | Yarn | Ply | Spin |
|---|---|---|---|---|---|---|
| Warp | white 1 | 8 | wool | handspun | 1 | Z |
|  | white 2 | 8 | cotton string |  |  |  |
| Weft | white | 42 | wool | handspun | 1 | Z |
|  | red | 32–48 | wool | handspun | 1 | Z |
|  | orange | 32–44 | wool | handspun | 1 | Z |
|  | grey | 42 | wool | handspun | 1 | Z |
|  | blue | 40–44 | wool | handspun | 1 | Z |

*Selvage:* sides: 2 cords: each two, 4-ply red, commercial, Z, S
ends: two, 3-ply white, handspun, Z, S

*Harvey Company tag:* "H-12161    B-42215    M.L.    5-29-6"

*Ledger book:* "12,161    $75.00    $15.00    Langer    5-29-6    White
ground [    ] [    ] lightning stripes"

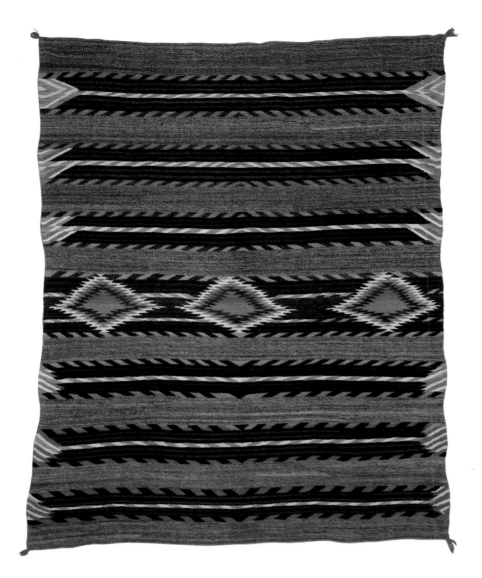

BLANKET, circa 1880–1890
A.5141.42-92
181.0 cm × 148.0 cm
wedge weave

|      | Color  | Count (per inch) | Fiber | Yarn     | Ply | Spin |
|------|--------|------------------|-------|----------|-----|------|
| Warp | white  | 7                | wool  | handspun | 1   | Z    |
| Weft | grey   | 18               | wool  | handspun | 1   | Z    |
|      | black  | 18               | wool  | handspun | 1   | Z    |
|      | blue   | 18               | wool  | handspun | 1   | Z    |
|      | red    | 18               | wool  | handspun | 1   | Z    |
|      | yellow | 18               | wool  | handspun | 1   | Z    |
|      | white  | 18               | wool  | handspun | 1   | Z    |

*Selvage:* both: two, 2-ply red, handspun, Z, S

*Harvey Company tag:* "H-18792    B-42615    L.    4-8-10"

*Ledger book:* "18,792    $125.00    $17.50    M. Langer    4/8/10
Moki pattern    Red diamonds    lots of yellow"

This brightly colored and vividly patterned blanket has contrasting bands of somber grey with banded background striping. Superimposed on this basic structure are three serrate-edged diamonds in the center and the very unusual use of wedge weave for the six orange, white, and yellow triangles along each edge.

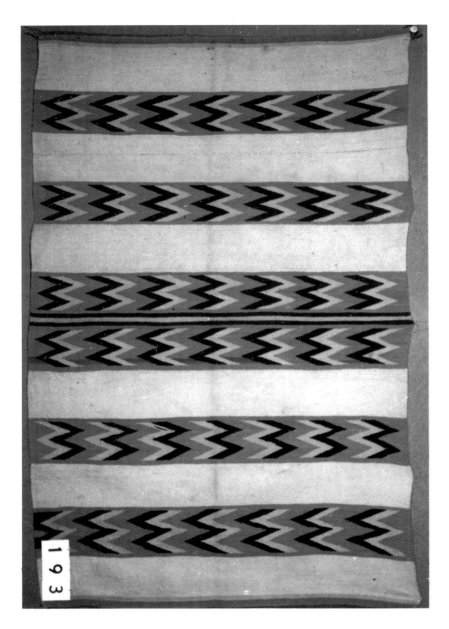

BLANKET (missing)
A.5141.42-193
86" × 54"
wedge weave

Warp:  7/inch
Weft:  22/inch

*Catalogue card:*  "White ground with design bands in soft rose with vertical zigzags in black and tan. Six design bands, two of which are together in center of blanket. Native wool and dye."

*Harvey Company tag:*  "A-1138    B-45616    Andrus Coll."

*Ledger book:*  "1138    45615    $150.00    Andrus Collection #52
     Old native wool     white background designs     5 bands Black red yellow"

# Transitional Blankets/Rugs

Technically neither blankets nor rugs, the pieces categorized as *transitional* were woven at the end of the nineteenth century, when the market for Navajo textiles was in a state of flux. The demand for lightweight wearing blankets had disappeared, and the newer market for heavy rugs in a western design format was not yet fully developed.

BLANKET/RUG, circa 1880–1890
A.5141.42-102
220.0 cm × 130.0 cm

|  | Color | Count (per inch) | Fiber | Yarn | Ply | Spin |
|---|---|---|---|---|---|---|
| Warp | white | 7 | cotton string | | | |
| Weft | orange-red | 22 | wool | handspun | 1 | Z |
|  | grey | 22 | wool | handspun | 1 | Z |
|  | green | 22 | wool | handspun | 1 | Z |
|  | white | 22 | wool | handspun | 1 | Z |
|  | black | 22 | wool | handspun | 1 | Z |
|  | deep red | 22 | wool | handspun | 1 | Z |

*Selvage:* both: two, 3-ply deep red, handspun, Z, S

*Harvey Company tag:* "H-25595    B-46615    Chapman Coll.    11-17-13"

*Ledger book:* "25,595    $225.00    $60.00    E. E. Chapman    11/17/13
    Very heavy twill weave    old native wool    3 wide grey bands
    4 red bands"

Although described in the Harvey Company ledgers as being "a very heavy twill weave," the many lazy lines and mottled yarn colors only give the illusion of diagonal yarn build-up resulting from a twill technique. These same characteristics heighten the eyedazzling design.

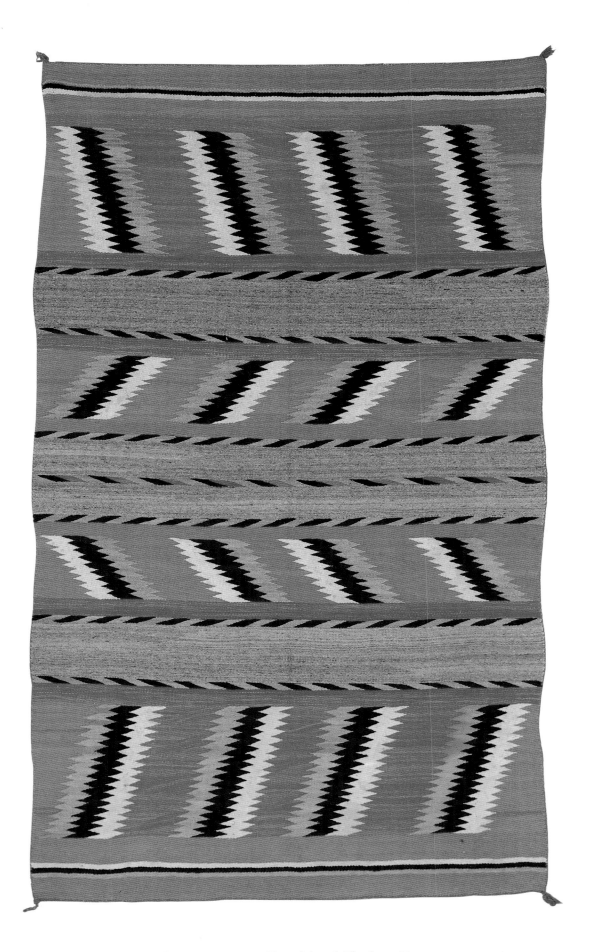

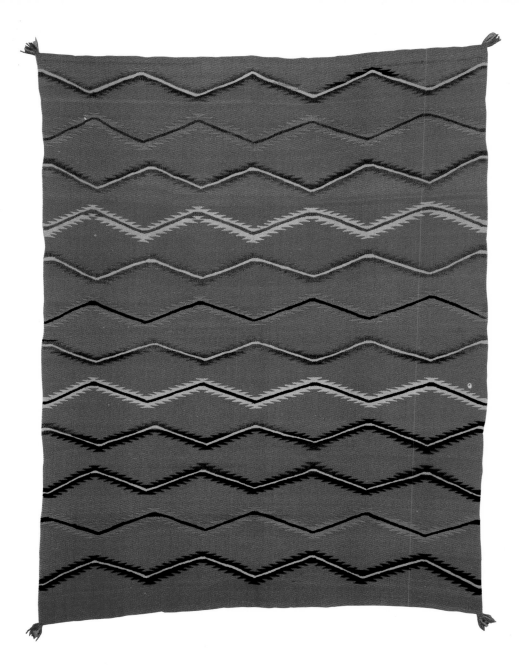

BLANKET/RUG, circa 1880–1890
A.5141.42-104
183.0 cm × 137.4 cm

|  | Color | Count (per inch) | Fiber | Yarn | Ply | Spin |
|---|---|---|---|---|---|---|
| *Warp* | pink | 9 | wool | handspun | 1 | Z |
| *Weft* | red | 38 | wool | handspun | 1 | Z |
|  | blue | 38 | wool | handspun | 1 | Z |
|  | green | 38 | wool | handspun | 1 | Z |
|  | pink | 38 | wool | handspun | 1 | Z |
|  | grey | 38 | wool | handspun | 1 | Z |

*Selvage:* both: two, 3-ply pink, handspun, Z, S

*Harvey Company tag:* "H-23248    B-43415    J.P.    6-14-13"

*Ledger book:* "23,248    $125.00    $28.00    J. Padilla    6/14
  Old Navaho    Red Ground consisting of Blue Green white zig-zag
  & Stripes running crosswise of Blkt"

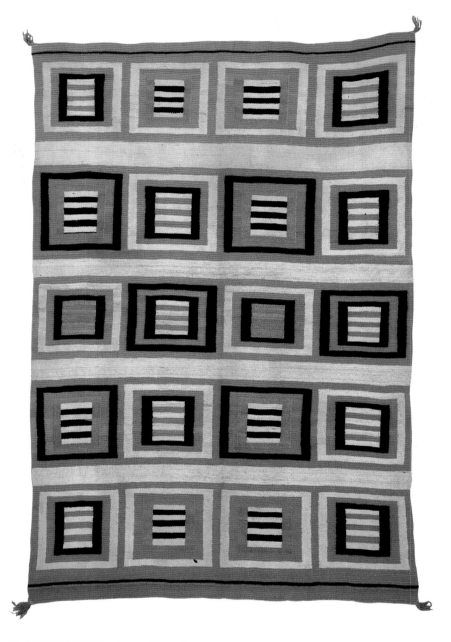

BLANKET/RUG, circa 1880–1895
A.5141.42-80
212.5 cm × 138.0 cm

|  | Color | Count (per inch) | Fiber | Yarn | Ply | Spin |
|---|---|---|---|---|---|---|
| Warp | brown | 10 | wool | handspun | 1 | Z |
| Weft | white | 30 | wool | handspun | 1 | Z |
|  | red | 30 | wool | handspun | 1 | Z |
|  | brown-black | 30 | wool | handspun | 1 | Z |
|  | green | 30 | wool | handspun | 1 | Z |
|  | blue | 30 | wool | handspun | 1 | Z |

*Selvage:* both: two, 3-ply red, handspun, Z, S

*Harvey Company tag:* "H-5250    89224    $95.00    P.G.    5/5/2
    Fine old vegetable dyes    rare design & colors"

*Ledger book:* "5,250    $75.00    $22.00    5/31/6    Guillion    5/5
    7¾#    Native wool"

BLANKET/RUG, circa 1885–1895
A.5141.42-153
207.8 cm × 140.5 cm

| | Color | Count (per inch) | Fiber | Yarn | Ply | Spin |
|---|---|---|---|---|---|---|
| Warp | white | 7 | cotton string | | | |
| Weft | red | 22 | wool | handspun | 1 | Z |
| | black | 20 | wool | handspun | 1 | Z |
| | white | 22 | wool | handspun | 1 | Z |
| | purple | 20 | wool | handspun | 1 | Z |
| | orange | 24 | wool | handspun | 1 | Z |
| | grey | 24 | wool | handspun | 1 | Z |
| | gold | 22 | wool | handspun | 1 | Z |
| | brown | 22 | wool | handspun | 1 | Z |

*Selvage:* sides: none
ends: two, 3-ply red, handspun, Z, S

*Harvey Company tag:* "A-922    B-43790    JEC    8-29"

*Ledger book:* "922    43790    J. E. Chavez    8-29-29    Semi-modern cot
warp    black ground    2 half diamonds in red    2 large red blocks."

The use of commercial cotton string as warping material for Navajo textiles occurs throughout the second half of the nineteenth century, as weavers found it to be a quick and easy substitute for their own tediously spun yarns. However, traders discouraged its use as lacking the strength and durability of handspun. In fact, so opposed was Herman Schweizer to its use that he went to some length to eliminate the practice. In a 1907 letter addressed "To All Concerned" and circulated to other dealers, Schweizer warned reservation traders of the continuing use of cotton string warp. He explained the danger it posed to the long life of textiles and even went so far as to say that the Harvey Company considered these products to be "practically worthless." Additionally, he emphasized that he would not buy blankets without wool warp, encouraged others to follow his lead, and urged them to educate the buying public as well.

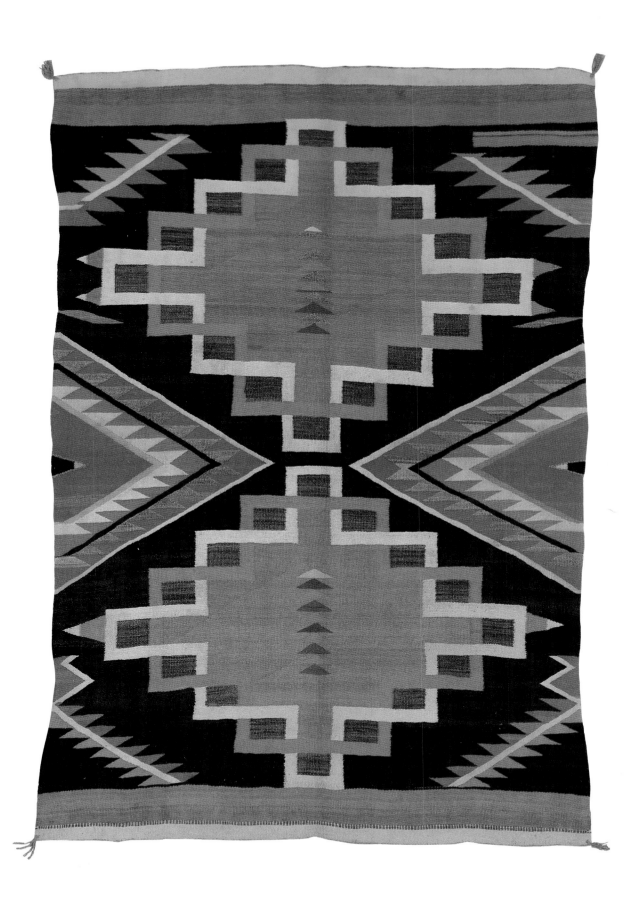

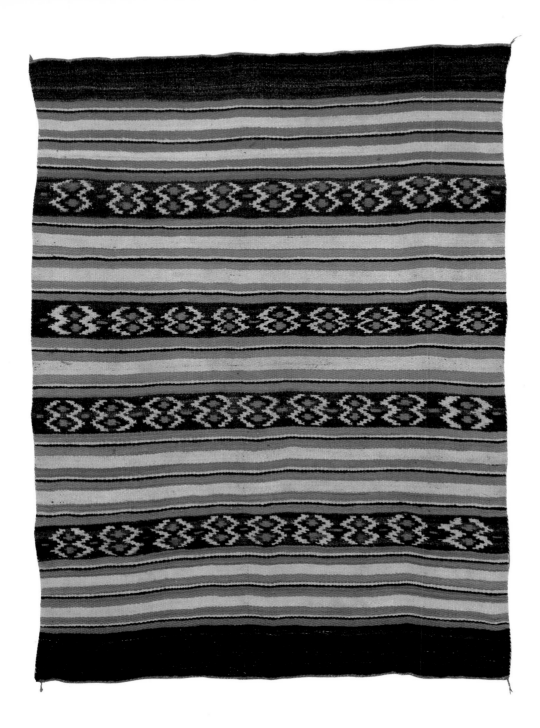

BLANKET/RUG, circa 1885–1900
A.5141.42-159
172.4 cm × 126.5 cm

|  | Color | Count (per inch) | Fiber | Yarn | Ply | Spin |
|---|---|---|---|---|---|---|
| Warp | white | 7 | wool | handspun | 1 | Z |
| Weft | white | 24 | wool | handspun | 1 | Z |
|  | red | 22 | wool | handspun | 1 | Z |
|  | brown | 22 | wool | handspun | 1 | Z |
|  | blue | 22 | wool | handspun | 1 | Z |

Selvage:  sides:  two, 3-ply white, handspun, Z, S
          ends:   two, 3-ply red, handspun, Z, S

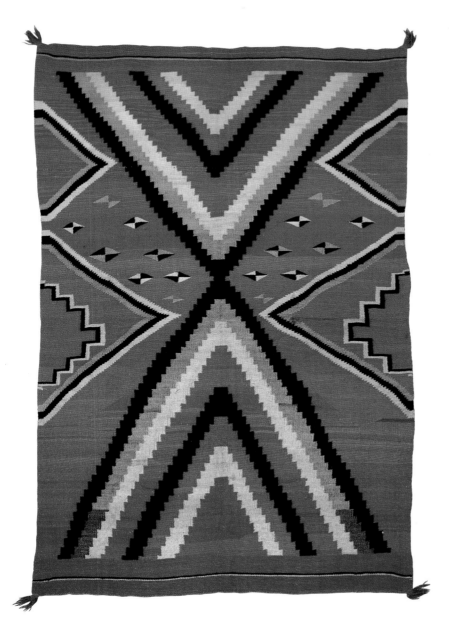

RUG/BLANKET, circa 1890–1895
A.5141.42-155
217.8 cm × 142.0 cm

|  | Color | Count (per inch) | Fiber | Yarn | Ply | Spin |
|---|---|---|---|---|---|---|
| *Warp* | white | 8 | wool | handspun | 1 | Z |
| *Weft* | orange-red | 26 | wool | handspun | 1 | Z |
|  | red | 24 | wool | handspun | 1 | Z |
|  | purple | 26 | wool | handspun | 1 | Z |
|  | black | 24 | wool | handspun | 1 | Z |
|  | white | 26 | wool | handspun | 1 | Z |
|  | green | 26 | wool | handspun | 1 | Z |

*Selvage:* sides: two, 2-ply red, handspun, Z, S
ends: two, 3-ply red, handspun, Z, S

*Harvey Company tag:* "A-963    B-47615    EWS    10-29"

*Ledger book:* "963    47115    $175.00    E. W. Shufse [sp.?]    10/30/29
Old Navaho    red ground    4 large ½ diamonds of red green white red black
2½ diam."

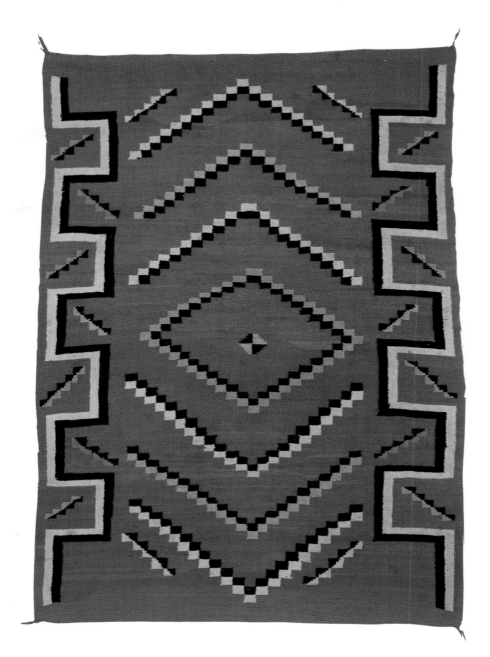

RUG/BLANKET, circa 1890–1900
A.5141.42-81
195.5 cm × 142.5 cm

|  | Color | Count (per inch) | Fiber | Yarn | Ply | Spin |
|---|---|---|---|---|---|---|
| Warp | grey | 8 | wool | handspun | 1 | Z |
| Weft | red | 28 | wool | handspun | 1 | Z |
|  | white | 28 | wool | handspun | 1 | Z |
|  | black | 28 | wool | handspun | 1 | Z |
|  | orange | 28 | wool | handspun | 1 | Z |
|  | yellow | 28 | wool | handspun | 1 | Z |
|  | green | 28 | wool | handspun | 1 | Z |

*Selvage:*  both:  two, 2-ply red, handspun, Z, S

*Harvey Company tag:*  "H-7935    #84224    $125.00    H.    5/27/3"

*Ledger book:*  "7935    $750.00    $400.00    Hubbell    5/27    Native wool grey"

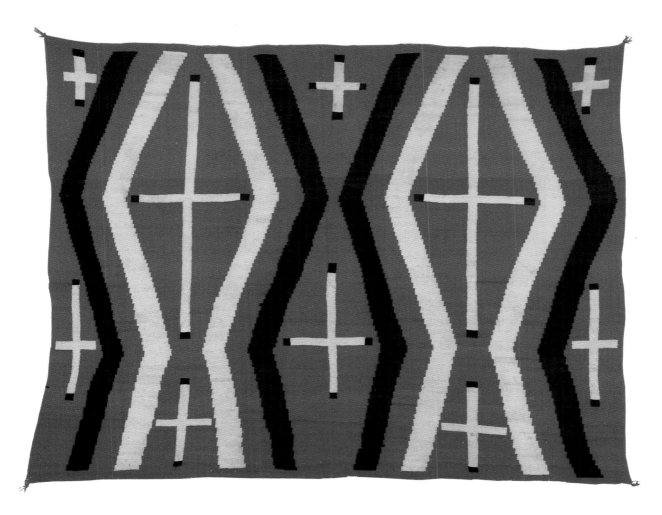

BLANKET/RUG, circa 1890–1900?
A.5141.42-91
138.0 cm × 183.0 cm

| | Color | Count (per inch) | Fiber | Yarn | Ply | Spin |
|---|---|---|---|---|---|---|
| Warp | white | 11 | wool | handspun | 1 | Z |
| Weft | red | 48 | wool | handspun | 1 | Z |
| | orange-red | 48 | wool | handspun | 1 | Z |
| | blue | 48 | wool | handspun | 1 | Z |
| | white | 48 | wool | handspun | 1 | Z |

*Selvage:* both: two, 3-ply orange-red, handspun, Z, S

*Harvey Company tag:* "H-10068      #89044      $225.00      BGW      6/16/05"

*Ledger book:* "10,068      $225.00      $40.00      B. G. Wilson      6/16
          Native wool & dyes. Red body      Blue & White Stripes"

This is clearly an unusual piece. The width is greater than the length, as is common in Classic chief-style blankets. The design is exceptionally large and atypically unbalanced. Judging only by the design, the piece appears to be a partial weaving; however, close inspection shows intact original edges. Further studies could determine whether or not this was a special order for an eastern buyer encouraged by a trader such as Lorenzo Hubbell at Ganado.

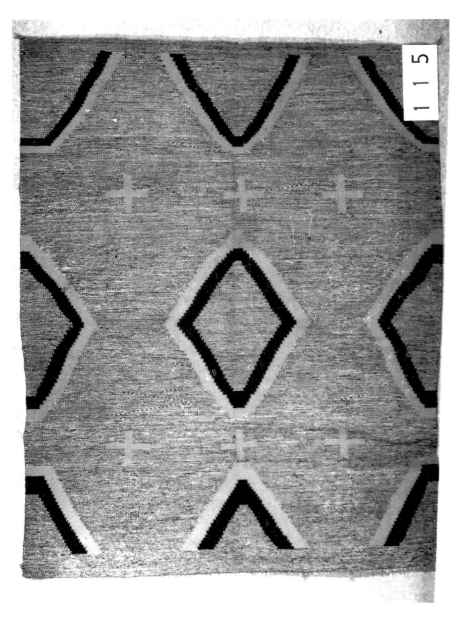

BLANKET/RUG (missing), circa 1880–1900
A.5141.42-115
62″ × 48″

Warp:  10/inch
Weft:  54/inch

|  | Color | Fiber | Yarn | Ply | Spin | Twist |
|---|---|---|---|---|---|---|
| *Warp* | white | cotton | commercial string | 4 | Z | S |
| *Weft* | black | wool | commercial | 4 | Z | S |
|  | white | wool | commercial | 4 | Z | S |
|  | red | wool | commercial | 4 | Z | S |

*Selvage:*  both:  2- (3-? or 4-?) ply red commercial, Z, S

(Technical analysis by Joe Ben Wheat, 1973)

*Catalogue card:*  "Navajo blanket in very unusual pattern. Background is made up by alternating a black and white weft thread."

# Rugs

The end of the nineteenth century brought with it an end to the market for the Navajo wearing blanket and a switch to the production of rugs. Woven to suit the needs of the eastern buyer who wished to decorate his home in the new "Indian style," rugs were characterized by heavier yarns designed to withstand foot traffic. Patterning also changed to accommodate the textile's new location on the floor instead of across the shoulders. A new inventory of design motifs, inspired to a great extent by Oriental rugs, was suggested by reservation traders.

Another important development in Navajo weaving at this time was the use of sacred figures as design motifs in rugs. Two of these sandpainting-style rugs were collected by Hearst.

RUG, circa 1911–1920
A.5141.42-200
230.0 cm × 173.5 cm

|  | Color | Count (per inch) | Fiber | Yarn | Ply | Spin | Twist |
|---|---|---|---|---|---|---|---|
| *Warp* | white | 8 | wool | handspun | 3 | Z | S |
| *Weft* | grey | 24 | wool | handspun | 1 | Z | |
| | red | 24 | wool | handspun | 1 | Z | |
| | black | 24 | wool | handspun | 1 | Z | |
| | white | 24 | wool | handspun | 1 | Z | |
| | brown | 24 | wool | handspun | 1 | Z | |

*Selvage:*  sides:  three, 2-ply red, handspun, Z, S
          ends:  two, 2-ply red, handspun, Z, S

Although no information has been found to indicate where Hearst purchased this rug, it clearly originated at Crystal Trading Post, New Mexico. In 1911 J. B. Moore, then owner of the post, published a mail-order catalogue of available rug designs produced by weavers working for him. The Hearst rug conforms to Plate XIX of the catalogue (reproduced in Chapter 1) and was described by Moore as "one of our best sellers." In pristine condition, the Hearst textile shows no evidence of ever having been used as a rug.

RUG, sandpainting style with yei figures, circa 1920s
A.5141.42-196
216.5 cm × 254.6 cm

|  | Color | Count (per inch) | Fiber | Yarn | Ply | Spin |
|---|---|---|---|---|---|---|
| *Warp* | white | 6 | wool | handspun | 1 | Z |
| *Weft* | grey | 26 | wool | handspun | 1 | Z |
|  | brown | 22 | wool | handspun | 1 | Z |
|  | burgundy | 26 | wool | handspun | 1 | Z |
|  | black | 22 | wool | handspun | 1 | Z |
|  | orange | 24 | wool | handspun | 1 | Z |
|  | green | 28 | wool | handspun | 1 | Z |
|  | blue | 24 | wool | handspun | 1 | Z |
|  | white | 26 | wool | handspun | 1 | Z |

*Selvage:* both: two, 3-ply burgundy, handspun, Z, S

*Harvey Company tag:* "H-48,147    B-48615    CGS    4-28    12414
    $125.00"

*Ledger book:* "48,147    510615    $225.00    10    C. G. Shillingburg
    4/11/28"

Adaptations of figures from Navajo sacred rituals began to be incorporated as design elements in Navajo weavings by the turn of the century over the protests of medicine men and elders. These textiles were enormously popular with tourists, and the weavers eventually overcame their fears of punishment for reproducing these sacred figures in a purely commercial product and began weaving them in great numbers.

RUG (missing), sandpainting
A.5141.42-194
60" × 44"

Warp: 10/inch
Weft: 32/inch

*Catalogue card:* "White ground with cornstalk in center, two yei figures on each side of it with hands held up grasping rattles(?) and feathers streaming down from arms. Rainbow encircles three sides of blanket, top left open. Colors red, black, orange, green, purple, brown, etc. Native wool, aniline dye. Selvage cords, corner tassels."

*Harvey Company tag:* "5311      B-42865      W.G.S."

*Ledger book:* "5311      42865      $45.00      409      W. G. Stallings      3-25-36"

# Appendix

~~~~~~~~~~~~~~~~~~~~~~~~~~~~~~~~~~~~~~~~~~~~~~~~

Economic History of the Hearst Collection

Presented here is a listing of all of the Hearst textiles by LACMNH accession number, their source, and associated documentation.

The original Fred Harvey Company number comes from tags on the textiles themselves and early LACMNH catalogue cards. The Harvey sources, dates, and prices were gleaned from original company business ledgers and decoded with the assistance of Byron Harvey III. Occasionally, there is a discrepancy between the wholesale and retail prices listed in the ledger books and those coded on the tags affixed to the textiles. A close examination of the ledger books shows that Schweizer changed the prices—both up and down—as the market changed and the piece remained in the inventory. The prices listed here always reflect the original entry in the ledger.

For twenty-five of the textiles we have the exact date when Hearst purchased them and the amount he paid. The information regarding these transactions was obtained from bills of sale from the Harvey Company to Hearst. In some instances, Schweizer apparently increased his retail price when Hearst was the buyer—perhaps because he knew that Hearst could and would pay more for good pieces.

| LACMNH Acc. # A.5141.42- | Harvey Co. Number | Harvey Co. Source | Date Purchased by Harvey Co. | Price (in Dollars) | | Paid by Hearst | Date Purchased by Hearst |
|---|---|---|---|---|---|---|---|
| | | | | Wholesale | Retail | | |
| 1 | none | | | | | | |
| 22 | 36,062 | Whalen's Curio Store, Los Angeles | 8/9/02 | 40.00 | 175.00 | unknown | unknown |
| 23 | unknown | Reed | 9/25/? | 300.00 | 650.00 | unknown | unknown |
| 24 | none | | | | | | |
| 25 | 17,109 | Arthur Seligman | 4/10/09 | 85.00 | 375.00 | unknown | unknown |
| 26 | 19,136 | Mrs. Wetherell | 8/22/10 | 20.00 | 125.00 | 120.00 | 3/15/13 |
| 27 | 20,348 | Bert Phillips, Taos, NM | 2/26/11 | 55.00 | 400.00 | 600.00 | 3/15/13 |
| 28 | 20,930 | Lea A. Douglas, Albuquerque | 5/27/11 | 100.00 | 500.00 | unknown | unknown |
| 29 | none | | | | | | |
| 30 | 4,550 | Pedro Muniz | 2/19/02 | 100.00 | 250.00 | unknown | unknown |
| 31 | 28,635 | Irene L. Secord | 4/15/16 | 80.00 | 600.00 | unknown | unknown |
| 32 | 24,102 | Dickens | 12/24/13 | 165.00 | 1,750.00 | unknown | unknown |
| 33 | 10,067 | B. G. Wilson | 6/16/05 | 50.00 | 450.00 | unknown | unknown |
| 34 | 20,367 | Mrs. Mossin | 4/3/11 | 160.00 | 450.00 | 480.00 | 3/15/13 |
| 35 | 4,475 | W. Rogers | 12/20/03 | 55.00 | 95.00 | 440.00 | 12/3/11 |
| 36 | 5,922 | Pedro Muniz | 12/18/02 | 55.00 | 250.00 | unknown | unknown |
| 37 | 24,097 | Dickens (or Diebuis) | 12/24/13 | 125.00 | 750.00 | 600.00 | 10/20/15 |
| 38 | 7,027 | A. F. Spiegelberg | 12/1901 | 125.00 | 350.00 | unknown | unknown |
| 39 | (same as #35) | | | | | | |
| 40 | 21,820 | J. Seligman | 2/23/12 | 60.00 | 350.00 | 480.00 | 3/15/13 |
| 41 | 28,122 | D. Benjamin | 1/20/16 | 6.00 | 125.00 | unknown | unknown |
| 42 | none | | | | | | |
| 43 | none | | | | | | |
| 44 | none | | | | | | |
| 45 | 18,917 | M. Schuster | 3/26/10 | 100.00 | 450.00 | 450.00 | 8/17/15 |
| 46 | 13,936 | J. Padia | 7/26/07 | 17.50 | 75.00 | 337.50 | 10/20/15 |
| 47[–] | 21,703 | Possibly Herman Schweizer from McLeod Collection | 12/26/11 | 100.00 | 275.00 | unknown | unknown |
| 48 | 21,486 | H. Schweizer | 11/14/11 | 35.00 | 75.00 | 280.00 | 6/5/13 |
| 49 | 5,944 | Sieg | 8/9/02 | 25.00 | 60.00 | 68.00 | 3/15/13 |
| 50 | none | | | | | | |
| 51 | 4,106 | W. Rogers | 11/20/01 | 55.00 | 125.00 | 300.00 | 6/5/13 |
| 52 | 3,736 | F.C. Gillenbeck | 6/23/01 | 15.00 | 45.00 | unknown | unknown |
| 53 | 7,004 | Seligman | 1/20/03 | 160.00 | 350.00 | unknown | unknown |
| 54 | 14,848 | Romero | 2/29/08 | 30.00 | 300.00 | 262.50 | 1/11/17 |
| 55 | 6,084 | Seligman | 1/20/03 | 140.00 | 400.00 | unknown | unknown |
| 56 | 5,437 | Mrs. Crary | 7/20/? | 30.00 | 65.00 | unknown | unknown |
| 57 | 17,115 | Arthur Seligman | 4/20/09 | 85.00 | 375.00 | unknown | unknown |
| 58 | 6,091 | Seligman | 1/20/03 | 110.00 | 250.00 | unknown | unknown |
| 59 | 3,973 | Pedro Muniz | 9/20/01 | 25.00 | 75.00 | unknown | unknown |
| 60 | 34,261 | E. O. Wilkinson, Los Angeles | 10/9/19 | 70.00 | 450.00 | unknown | unknown |
| 61 | none | | | | | | |
| 62 | 19,123 | M. Langer | 9/9/10 | 50.00 | 275.00 | 260.00 | 12/3/11 |
| 63 | none | | | | | | |
| 64 | 34,146 | Whalen's Curio Store, Los Angeles | 10/14/19 | 65.00 | 150.00 | unknown | unknown |
| 66 | 13,840 | Bert Phillips, Taos, NM | 6/15/07 | 30.00 | 125.00 | unknown | unknown |
| 67 | 2,267 | A. Gold | 12/19/01 | 20.00 | 250.00 | unknown | unknown |
| 68 | 5,414 | Pedro Muniz | 8/26/02 | 18.00 | 55.00 | unknown | unknown |

| LACMNH Acc. # A.5141.42- | Harvey Co. Number | Harvey Co. Source | Date Purchased by Harvey Co. | Price (in Dollars) | | Paid by Hearst | Date Purchased by Hearst |
|---|---|---|---|---|---|---|---|
| | | | | Wholesale | Retail | | |
| 69 | 8,125 | L. Simon | 6/26/02 | 5.00 | 20.00 | unknown | unknown |
| 70 | 10,040 | Juan Olivas | 5/28/05 | 15.00 | 60.00 | unknown | unknown |
| 71 | illegible | | | | | | |
| 72 | 19,090 | D. Smith | 8/1/01 | 60.00 | 275.00 | unknown | unknown |
| 73 | 6,098 | Seligman | 1/20/03 | 105.00 | 200.00 | unknown | unknown |
| 74 | 7,808 | Juan Olivas | 5/13/06 | 18.00 | 125.00 | unknown | unknown |
| 75 | 5,442 | M. Mones | 7/20/05 | 10.00 | 35.00 | unknown | unknown |
| 76 | 11,719 | Pedro Muniz | 3/20/06 | 13.00 | 75.00 | 131.25 | 5/20/15 |
| 77 | 19,058 | Mrs. J. P. Martin (Sauerwein Collection) | 7/18/10 | 50.00 | 275.00 | 220.00 | 3/14/12 |
| 78 | 4,211 | P. Guillon | 12/12/01 | 12.00 | 30.00 | unknown | unknown |
| 79 | 3,325 | J.F.H.,[a] Isleta | 5/1/? | 20.00 | 37.50 | unknown | unknown |
| 80 | 5,250 | P. Guillion | 5/5/02 | 22.00 | 75.00 | unknown | unknown |
| 81 | 7,935 | Hubbell | 5/27/03 | 400.00 | 750.00 | unknown | unknown |
| 82 | 23,772 | J. W. Clarke | 11/4/13 | 40.00 | 175.00 | unknown | unknown |
| 83 | 21,066 | J. G. Allyn, Chicago | 10/19/11 | 30.00 | 100.00 | 262.50 | 11/20/15 |
| 84[–] | 13,646 | Adolf P. Weiller | 4/19/07 | 15.00 | 75.00 | unknown | unknown |
| 85 | 12,326 | P. Guillion | 8/21/06 | 7.50 | 55.00 | unknown | unknown |
| 86 | none | | | | | | |
| 87[–] | 7,024 | Seligman | 1/5/03 | 105.00 | 200.00 | unknown | unknown |
| 88 | 15,325 | Brizzard | 5/26/08 | 175.00 | 750.00 | unknown | unknown |
| 89 | 21,819 | Mrs. G. H. Taylor | 2/20/12 | 110.40 | 600.00 | unknown | unknown |
| 90 | 19,026 | Bert Phillips | 7/13/10 | 155.00 | 400.00 | unknown | unknown |
| 91 | 10,068 | B. G. Wilson | 6/16/05 | 40.00 | 225.00 | unknown | unknown |
| 92 | 18,792 | M. Langer | 4/8/10 | 17.50 | 125.00 | unknown | unknown |
| 93 | none | | | | | | |
| 94 | 7,583 | Pedro Muniz | 10/10/02 | 10.00 | 30.00 | unknown | unknown |
| 95 | 5,758 | Guillion | 11/18/02 | 3.00 | 6.50 | 120.00 | 12/3/11 |
| 96 | 23,211 | Pedro Muniz | 5/5/? | 5.00 | 35.00 | 120.00 | 12/3/11 |
| 97 | 7,040 | Spiegelberg | 12/1901 | 20.00 | 60.00 | unknown | unknown |
| 98 | 43,299 | N. H. Thorpe | 5/30/25 | 15.00 | 55.00 | unknown | unknown |
| 99 | none | | | | | | |
| 100 | 7,373 | D. Ortega | 3/11/03 | 25.00 | 175.00 | unknown | unknown |
| 101 | 17,377 | M. Langer | 9/13/09 | 12.50 | 65.00 | unknown | unknown |
| 102 | 25,595 | E. E. Chapman | 11/17/13 | 60.00 | 225.00 | unknown | unknown |
| 103 | none | | | | | | |
| 104 | 23,248 | J. Padilla | 6/14/13 | 28.00 | 125.00 | unknown | unknown |
| 105 | 20,952 | McCasy, Jr. | 7/22/11 | 8.00 | 65.00 | unknown | unknown |
| 106 | 40,371 | C. C. Upham, New York City | 5/28/23 | 175.00 | 500.00 | unknown | unknown |
| 107 | 7,833 | Pedro Muniz | 5/13/03 | 50.00 | 225.00 | unknown | unknown |
| 108 | 3,864 | L. S. | 9/4/05 | 1.50 | 8.50 | unknown | unknown |
| 109 | 4,228 | Louis Simon | 2/11/14 | 10.00 | 30.00 | unknown | unknown |
| 110 | 42,169 | Fr. Staab, La Posada Inn, Santa Fe, NM | 10/24/? | 125.00 | 650.00 | unknown | unknown |
| 111 | 20,181 | P. Guillion | 2/2/11 | 47.50 | 225.00 | unknown | unknown |
| 112 | 6,085 | Seligman | 1/20/03 | 300.00 | 1,000.00 | 750.00 | 5/20/15 |
| 113 | none | | | | | | |
| 114[–] | 7,335 | N. Raphael | 1 or 2/03 | 50.00 | 150.00 | 168.75 | 5/20/15 |
| 115 | none | | | | | | |
| 116 | 2,244 | F. C. Gillenbeck | 2/2/04 | 10.00 | 40.00 | unknown | unknown |
| 117 | 10,070 | B. G. Wilson | 6/16/05 | 20.00 | 60.00 | 48.00 | 5/20/15 |
| 118 | 5,807 | Pedro Muniz | 10/10/02 | 30.00 | 75.00 | unknown | unknown |
| 119 | 11,508 | M. Langer | 2/22/06 | 20.00 | 275.00 | unknown | unknown |
| 120 | none | | | | | | |
| 121[–] | 19,129 | Mrs. R. Wetherell | 8/22/10 | 150.00 | 850.00 | unknown | unknown |
| 122 | 3,529 | Averill | 5/15/02 | 15.00 | 25.00 | unknown | unknown |
| 123 | 12,178 | Fraet (sp.?) | 6/12/06 | 0.50 | 7.50 | unknown | unknown |

| LACMNH Acc. # A.5141.42- | Harvey Co. Number | Harvey Co. Source | Date Purchased by Harvey Co. | Wholesale | Retail | Paid by Hearst | Date Purchased by Hearst |
|---|---|---|---|---|---|---|---|
| 124 | none | | | | | | |
| 125 | 9,017 | L. Simon | 6/26/03 | 12.50 | 40.00 | unknown | unknown |
| 126[–] | 5,191 | Pedro Muniz | 6/10/02 | 103.50 | 250.00 | unknown | unknown |
| 127 | 3,898 | L. S. | 9/9/01(?) | 10.00 | 45.00 | unknown | unknown |
| 128 | 5,598 | P. Guillion | 2/30/02 | 12.00 | 25.00 | unknown | unknown |
| 129 | 12,012 | M. Langer | 5/7/06 | 25.00 | 225.00 | unknown | unknown |
| 130 | 24,095 | Dickens | 12/24/13 | 190.00 | 850.00 | unknown | unknown |
| 131 | 9,114 | Manning | 10/28/04 | 35.00 | 175.00 | unknown | unknown |
| 132 | 15,326 | Brizzard | 3/26/08 | 200.00 | 1,000.00 | unknown | unknown |
| 133 | none | | | | | | |
| 134 | 1,088 | J. F. Snively, Los Angeles | 8/19/32 | 200.00 | 650.00 | unknown | unknown |
| 135 | 7,582 | Pedro Muniz | 10/10/02 | 18.00 | 65.00 | unknown | unknown |
| 136[–] | 548 | Andrus | n.d. | 250.00 | 1,500.00 | unknown | unknown |
| 137 | 830 | Andrus | 4/16/29 | 200.00 | 850.00 | unknown | unknown |
| 138 | 45,242 | M. Langer | 8/9/26 | 150.00 | 450.00 | unknown | unknown |
| 139 | 17,114 | Arthur Seligman | 4/10/09 | 125.00 | 750.00 | unknown | unknown |
| 140 | 361 | A. N. Johnson | 5/18/27 | 110.00 | 450.00 | unknown | unknown |
| 141 | 4,473 | W. Rogers | 12/20/02 | 150.00 | 325.00 | unknown | unknown |
| 142 | 4,474 | W. Rogers | 12/20/02 | 40.00 | 85.00 | unknown | unknown |
| 143 | none | | | | | | |
| 144 | 8,810 | J. F. H.[a] | 5/28/04 | 15.00 | 75.00 | unknown | unknown |
| 145 | 7,217 | Pedro Muniz | 10/10/02 | 70.00 | 500.00 | unknown | unknown |
| 146 | 24,351 | Dickens | 12/24/13 | 225.00 | 850.00 | unknown | unknown |
| 147 | none | | | | | | |
| 148 | 8,819 | unknown | 6/30/04 | 40.00 | 175.00 | 131.25 | 5/20/15 |
| 149 | 24,785 | L. R. Markell | 6/9/14 | 50.00 | 450.00 | 337.50 | 5/20/15 |
| 150 | 7,616 | Pedro Muniz | 10/10/02 | 40.00 | 175.00 | unknown | unknown |
| 151 | 10,039 | Juan Olivas | 5/28/05 | 27.50 | 65.00 | unknown | unknown |
| 152 | 3,974 | Pedro Muniz | 9/20/? | 25.00 | 125.00 | unknown | unknown |
| 153 | 922 | J. E. Chavez | 8/29/29 | unknown | 95.00 | unknown | unknown |
| 154 | 419 | N. H. Thorpe | 9/21/26 | 90.00 | 375.00 | unknown | unknown |
| 155 | 963 | E. W. Shufse[b] | 10/30/29 | 65.00 | 175.00 | unknown | unknown |
| 156 | 5,436 | Mrs. Crary | 7/20/01 | 30.00 | 125.00 | unknown | unknown |
| 157 | 10,126 | M. Langer | 7/15/06 | 7.00 | 45.00 | unknown | unknown |
| 158 | 5,252 | P. Guillion | 5/5/02 | 4.00 | 15.00 | unknown | unknown |
| 159 | none | | | | | | |
| 160 | 1,057 | Wilbur | 1/16/31 | 55.00 | 125.00 | unknown | unknown |
| 161 | 226 | N. H. Thorpe | 7/9/26 | 105.00 | 375.00 | unknown | unknown |
| 162 | 15,363 | Bert Phillips | 4/7/08 | 80.00 | 350.00 | 480.00 | 3/14/12 |
| 163[–] | 857 | E. L. Griego | 6/26/29 | 50.00 | 225.00 | unknown | unknown |
| 164 | 25,576 | Mrs. Theo. Gowdy | 11/11/14 | 35.00 | 225.00 | unknown | unknown |
| 165 | 13,560 | M. Langer | 4/4/07 | 55.00 | 350.00 | unknown | unknown |
| 166 | 5,421 | Pedro Muniz | 8/28/? | 62.00 | 200.00 | unknown | unknown |
| 167 | 6,072 | Seligman | 1/20/03 | 150.00 | 400.00 | unknown | unknown |
| 168 | 6,055 | A. F. Spiegelberg | 1/16/03 | 200.00 | 450.00 | unknown | unknown |
| 169 | 25,313 | Mrs. Hopkins | 10/13/14 | 15.00 | 175.00 | unknown | unknown |
| 170[–] | 11,575 | (discrepancy between tag and ledger book) | | | | | |
| 171 | 1,005 | Andrus | 3/10/30 | 55.00 | 225.00 | unknown | unknown |
| 172 | 13,807 | Pedro Muniz | 6/2/07 | 14.25 | 125.00 | unknown | unknown |
| 173 | 649 | Betty Willie | 3/6/28 | 100.00 | 375.00 | unknown | unknown |
| 174 | 8,507 | M. Langer | 1/21/04 | 9.00 | 60.00 | unknown | unknown |
| 175 | 8,699 | Pedro Muniz | 3/21/04 | 15.00 | 75.00 | unknown | unknown |
| 176 | 15,331 | Brizzard | 3/26/06 | 20.00 | 75.00 | unknown | unknown |
| 177 | 113 | Seligman | n.d. | 90.00 | 450.00 | unknown | unknown |
| 178 | 23,769 | J. W. Clarke | 11/4/03 | 70.00 | 175.00 | unknown | unknown |
| 179 | 650 | Betty Willie | 3/6/28 | 75.00 | 275.00 | unknown | unknown |

| LACMNH Acc. # A.5141.42- | Harvey Co. Number | Harvey Co. Source | Date Purchased by Harvey Co. | Price (in Dollars) | | | Date Purchased by Hearst |
|---|---|---|---|---|---|---|---|
| | | | | Wholesale | Retail | Paid by Hearst | |
| 180 | 23,769 | J. W. Clarke | 11/4/03 | 70.00 | 175.00 | unknown | unknown |
| 181 | 1,050 | Wilber | 11/16/31 | 135.00 | 425.00 | unknown | unknown |
| 182 | 15,650 | M. Langer | 8/8/08 | 20.00 | 85.00 | unknown | unknown |
| 183 | 7,573 | Pedro Muniz | 10/10/02 | 16.00 | 65.00 | unknown | unknown |
| 184 | none | | | | | | |
| 185 | 768 | J. W. Stebbins | 9/27/28 | 175.00 | 750.00 | unknown | unknown |
| 186 | none | | | | | | |
| 187 | 25,572 | Mrs. Theo. Gowdy | 11/11/14 | 60.00 | 175.00 | unknown | unknown |
| 188 | none | | | | | | |
| 189[–] | 978 | Andrus | 12/30/29 | 195.00 | 1,000.00 | unknown | unknown |
| 190 | 19,164 | Mrs. R. Wetherell | 8/22/10 | 8.00 | 45.00 | unknown | unknown |
| 191 | 1,060 | Wilber | 1/16/31 | 35.00 | 125.00 | unknown | unknown |
| 192 | none | | | | | | |
| 193 | 1,138 | Andrus | unknown | 50.00 | 150.00 | unknown | unknown |
| 194 | 5,311 | W. G. Stallings | 3/25/36 | 22.50 | 45.00 | unknown | unknown |
| 195 | 12,161 | M. Langer | 5/29/06 | 15.00 | 75.00 | unknown | unknown |
| 196 | 48,147 | C. G. Shillingburg | 4/11/28 | 100.00 | 225.00 | unknown | unknown |
| 197 | 5,489 | Pedro Muniz | 7/28/02 | 3.00 | 9.00 | unknown | unknown |
| 198 | 8,591 | unknown | unknown | 36.00 | 125.00 | unknown | unknown |
| 199 | none | | | | | | |
| 200 | none | | | | | | |
| 201 | 13,188 | Julian Padilla | 2/19/07 | 35.00 | 275.00 | unknown | unknown |
| 202 | 15,651 | M. Langer | 8/8/08 | 40.00 | 225.00 | unknown | unknown |
| 203 | 20,365 | Mrs. Mossin | 4/3/11 | 175.00 | 450.00 | 520.00 | 3/14/12 |
| 204 | 4,684 | Juan Olivas | 2/26/02 | 35.00 | 125.00 | unknown | unknown |
| 205 | 4,217 | Juan Olivas | 12/18/01 | 24.00 | 60.00 | unknown | unknown |
| 206 | 7,802 | Juan Olivas | 5/13/03 | 25.00 | 75.00 | unknown | unknown |
| 207 | 41,931 | Mrs. Edith Sheridan | 9/1/24 | 100.00 | 1,000.00 | unknown | unknown |

Source: Harvey Company business ledgers
Note: Discrepancies among the Harvey tag, the ledger-book entry, and/or the LACMNH textile are indicated by [–]. The reader should refer to the individual textile descriptions, in the catalogue proper, for a complete discussion.
a Probably J. F. Huckel, according to Byron Harvey III (pers. comm., 1979).
b Possibly E. W. Shupe, Taos dealer, according to Joe Ben Wheat (pers. comm., 1985).

Bibliography

Amsden, Charles Avery
 1934 *Navajo Weaving: Its Technic and History*. Santa Ana, California: Fine
 Arts Press. Reprint. Glorieta, New Mexico: Rio Grande Press, 1971.
Bailey, Garrick, and Roberta Glenn Bailey
 1986 *A History of the Navajos: The Reservation Years*. Santa Fe, New Mexico:
 School of American Research Press.
Bennett, Kathleen Whitaker
 1981 "The Navajo Chief Blanket." *American Indian Art* 7(1): 62–69.
Bennitt, Mark (ed.)
 1976 *History of the Louisiana Purchase Exposition*. New York: Arno Press.
Berlant, Anthony, and Mary Hunt Kahlenberg
 1977 *Walk in Beauty*. Boston: New York Graphic Society.
Boles, Joann F.
 1977 "The Development of the Navaho Rug, 1890–1920, as Influenced by
 Trader J. L. Hubbell." Ph.D. dissertation, Ohio State University.
Coblentz, Edmond D. (ed.)
 1952 *William Randolph Hearst: A Portrait in His Own Words*. New York:
 Simon & Schuster.
Davies, Cindy (ed.)
 1976 *Fred Harvey Fine Arts Collection*. Phoenix, Arizona: Heard Museum.
Donkin, R. A.
 1977 "Spanish Red: An Ethnogeographical Study of Cochineal and the Opuntia
 Cactus." *Transactions of the American Philosophical Society* 67:5.
Eisner, Thomas, and Stephen Nowicki
 1980 "Red Cochineal Dye (Carminic Acid): Its Role in Nature." *Science* 208
 (May): 1039–42.
Everett, Marshall
 1904 *The Book of the Fair*. Henry Neil.
Fairlie, S.
 1965 "Dyestuffs in the Eighteenth Century." *Economic History Review* 17
 (second series): 488–510.
Fierman, Floyd S.
 1964 "The Spiegelbergs of New Mexico: Merchants and Bankers, 1844–1893."
 Southwestern Studies 1(4): 3–48.
Fred Harvey Company
 Navajo Blanket Ledgers. Spanish Colonial Arts Society, Inc. Collections
 on loan to the Museum of New Mexico, Museum of International Folk
 Art, Santa Fe, New Mexico.
 Navajo Blanket Ledgers. Heard Museum, Phoenix, Arizona.
 Papers. Ortega's Indian Shop, La Fonda Hotel, Santa Fe, New Mexico.
Hammer Galleries, Inc.
 1941 *Art Objects and Furnishings from the William Randolph Hearst
 Collection*. New York: William Bradford Press.

Hamnett, Brian R.
 1971 "Dye Production, Food Supply, and the Laboring Population of Oaxaca, 1750–1820." *Hispanic American Historical Review* 51(1): 51–78.
Harvey, Byron III
 1963 "The Fred Harvey Collection, 1899–1963." *Plateau* 36(1): 33–53.
Hegemann, Elizabeth Compton
 1963 *Navaho Trading Days.* Albuquerque: University of New Mexico Press.
Hill, W. W.
 1940 "Some Navajo Culture Changes During Two Centuries (with a Translation of the Early Eighteenth Century Rabal Manuscript)." In *Essays in Historical Anthropology of North America*, Smithsonian Miscellaneous Collections 100, Washington, D.C.
 1944 "Navajo Trading and Trading Ritual: A Study of Cultural Dynamics." *Southwestern Journal of Anthropology* 4(4): 371–96.
Hollister, U. S.
 1903 *The Navajo and His Blanket.* Reprint. Glorieta, New Mexico: Rio Grande Press, 1972.
Hubbell, Lorenzo
 Papers. Special Collections, University of Arizona Library, Tucson.
James, George Wharton
 1920 *Indian Blankets and Their Makers.* Chicago: A. C. McClurg.
Kahlenberg, Mary Hunt, and Anthony Berlant
 1972 *The Navajo Blanket.* New York: Praeger Publishers, in association with the Los Angeles County Museum of Art.
Kent, Kate Peck
 1985 *Navajo Weaving: Three Centuries of Change.* Santa Fe, New Mexico: School of American Research Press.
Lummis, Charles F.
 1896 "The Best Blanket in the World." *Land of Sunshine* 6:8–11.
McNitt, Frank
 1957 *Richard Wetherill: Anasazi.* Albuquerque: University of New Mexico Press.
 1962 *The Indian Traders.* Norman: University of Oklahoma Press.
Mera, H. P.
 1947 *Navajo Textile Arts.* Santa Fe, New Mexico: Laboratory of Anthropology.
Mera, H. P., and Joe Ben Wheat
 1978 *The Alfred I. Barton Collection of Southwestern Textiles.* Coral Gables, Florida: Lowe Art Museum.
Moore, J. B.
 1911 *The Navajo.* Denver: Williamson-Haffner Company.
Museum of International Folk Art
 1979 *Spanish Textile Tradition of New Mexico and Colorado.* Santa Fe, New Mexico: Museum of New Mexico Press.
Nicholson, Grace
 Papers. The Huntington Library, San Marino, California.
Older, Mrs. Fremont
 1936 *William Randolph Hearst, American.* New York and London: D. Appleton-Century Company.
Reichard, Gladys A.
 1934 *Spider Woman: A Story of Navajo Weavers and Charters.* New York: Macmillan.
Rodee, Marian E.
 1977 *Southwestern Weaving.* Albuquerque: University of New Mexico Press.
 1981 *Old Navajo Rugs.* Albuquerque: University of New Mexico Press.
Schweizer, Herman
 1942 Correspondence. Los Angeles County Museum of Natural History.
Spiegelberg, A. F.
 1925 "Navajo Blankets." *El Palacio* 18(10 and 11): 223–29. Reprinted from *Out West*, May 1904.
Tebbel, John
 1952 *The Life and Good Times of William Randolph Hearst.* New York: E. P. Dutton.

Twitchell, Ralph Emerson

1917 *The Leading Facts of New Mexican History*. Cedar Rapids, Iowa: The
 Torch Press.

Utley, Robert M.

1961 "The Reservation Trader in Navajo History." *El Palacio* 68:1.

Wheat, Joe Ben

1974 *Navajo Blankets from the Collection of Anthony Berlant*. Tucson:
 University of Arizona Museum of Art.

1976 "The Navajo Chief Blanket." *American Indian Art Magazine* 1(3): 44–53.

1976 "Documentary Basis for Material Changes and Design Styles in Navajo
 Blanket Weaving." In *Ethnographic Textiles of the Western Hemisphere*,
 Proceedings of the Irene Emery Roundtable on Museum Textiles, edited
 by Irene Emery and Patricia Fiske, pp. 420–40. Washington, D.C.: Textile
 Museum.

Winkler, John K.

1928 *W. R. Hearst: An American Phenomenon*. London: Jonathan Cape.

Index

About the Author

~~~~~~~~~~~~~~~~~~~~~~~~~~~~~~~~~~~~~~~~~~~~~~~~~~~~~~~~~~~~~~~~~~~~~~~~~~~~~~~~~~~~~~~~

Nancy J. Blomberg has long been interested in Native American technology and culture change. As Assistant Curator at the Natural History Museum of Los Angeles County since 1977, she has worked extensively, through research and exhibition, to bring audiences to a greater understanding of the depth and diversity of Native American cultures. She continues in these efforts with further textile and basketry studies.